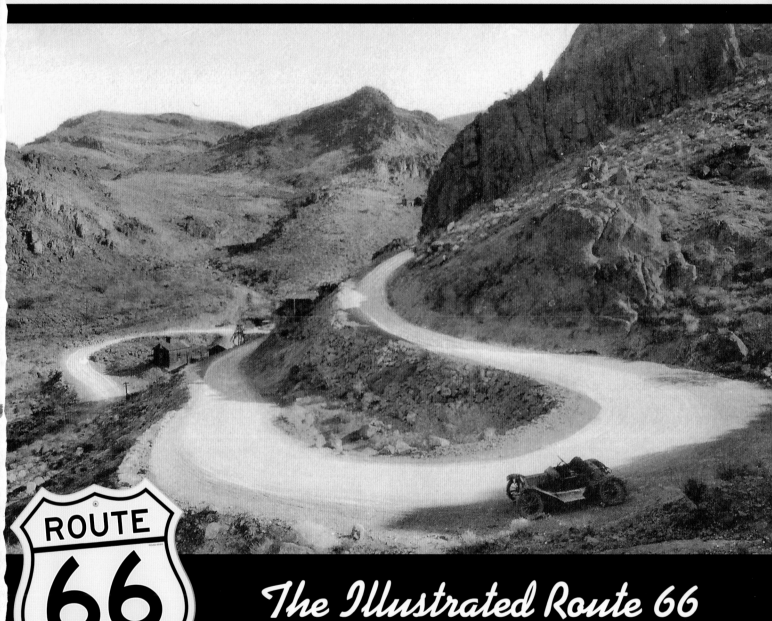

ROUTE 66

The Illustrated Route 66
Historical Atlas

JIM HINCKLEY

Voyageur
Press

Quarto is the authority on a wide range of topics.

Quarto educates, entertains and enriches the lives of our readers—enthusiasts and lovers of hands-on living.

www.quartoknows.com

First published in 2014 by Voyageur Press, an imprint of Quarto Publishing Group USA Inc., 400 First Avenue North, Suite 400, Minneapolis, MN 55401 USA

© 2014 Quarto Publishing Group USA Inc.
Text © 2014 Jim Hinckley

quartoknows.com
Visit our blogs at quartoknows.com

Voyageur Press titles are also available at discounts in bulk quantity for industrial or sales-promotional use. For details write to Special Sales Manager at Quarto Publishing Group USA Inc., 400 First Avenue North, Suite 400, Minneapolis, MN 55401 USA.

Acquisitions Editor: Dennis Pernu
Project Manager: Madeleine Vasaly
Art Director: Cindy Samargia Laun
Cover Designer: Kim Winscher
Layout Designer: Amelia LeBarron
Maps: Otto Vondrak

Printed in China

10 9 8 7 6 5 4 3

ISBN-13: 978-0-7603-4543-6

Library of Congress Cataloging-in-Publication Data

Hinckley, James, 1958-
 The illustrated Route 66 historical atlas / Jim Hinckley.
 pages cm
 Summary: "A look at 500 of Route 66's most significant past and present sites in seven categories, illustrated with hundreds of photographs and specially commissioned maps"-- Provided by publisher.
 ISBN 978-0-7603-4543-6 (hardback)
 1. United States Highway 66--Guidebooks. 2. United States Highway 66--History. 3. United States Highway 66--Pictorial works. 4. United States Highway 66--Maps. I. Title.
 HE356.U55H558 2014
 917.8--dc23
 2014009606

On the front cover: Art from a Standard Oil road map of Missouri, ca. 1956. *Voyageur Press collection*
On the back cover: *expression photo/Shutterstock* (main); *Steve Rider* (inset, top); *Joe Sonderman* (insets, middle, and images at bottom); *Judy Hinckley* (inset, bottom)
On the title page: Postcard view of a section of Route 66 near Kingman, Arizona. *Mike Ward*

Contents

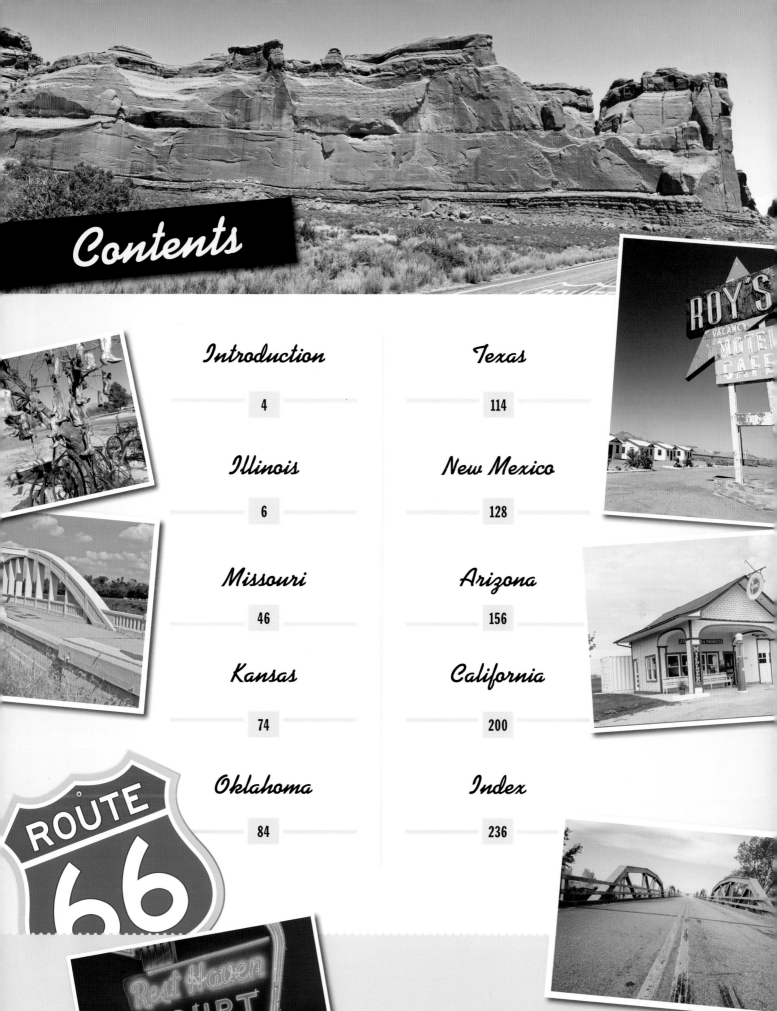

ROY'S
VACANCY
MOTEL
CAFE

ROUTE
66

Rest Haven
COURT

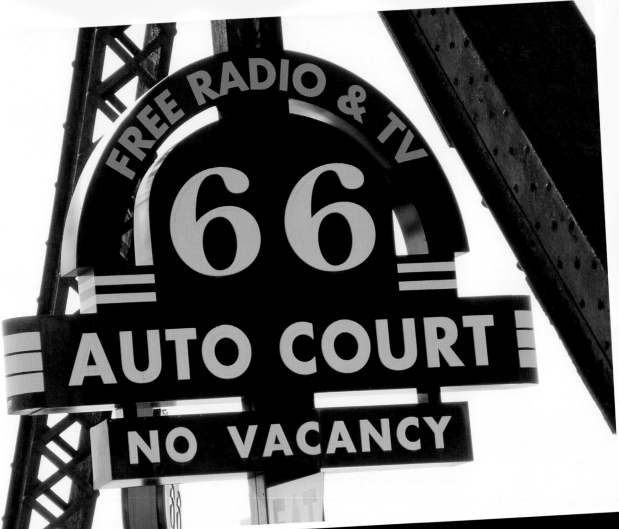

FREE RADIO & TV

66

AUTO COURT

NO VACANCY

HISTORIC
ROUTE
66

COME
BACK
AGAIN

Introduction

As with Route 66 itself, this atlas defies traditional descriptors. *The Illustrated Route 66 Historical Atlas* is more than a companion work to *The Route 66 Encyclopedia*. It is also more than a mere reference book and is unlike a traditional atlas in that it is also a travel guide.

There were two primary aspects for the initial development of this atlas, the first of which was as a means to add depth and context to the Route 66 experience as well as encourage exploration beyond the traditional search for neon and roadside time capsules. The second aspect was a bit more grandiose in that I envisioned it as a repository for some of the more obscure and colorful aspects of this storied highway's history for future generations of enthusiasts.

Of the seven categories carefully selected to accomplish these goals, only the segment about crime scenes gave me pause. The foundation for the era of Route 66 renaissance is a quest for fun with a veneer of history, of escape from the worries of the modern world. Subjects as dark as mayhem, robbery, and murder cast a pall over the neon glow, even on a starlit desert night. Additionally, there was the concern over the reopening of old wounds.

Still, this too is an important aspect of Route 66 history. It also promotes a bit of exploration, especially for those with a touch of morbid curiosity.

If you are a fan of the double six, I am quite confident you will find *The Illustrated Route 66 Historical Atlas* a welcome addition to your library. If you are unfamiliar with the Route 66 phenomena and mystique, then this book will serve as an ideal introduction to the colorful history of America's most famous highway and inspiration for a voyage of discovery along the old road that still serves as the Main Street of America from Chicago to Santa Monica.

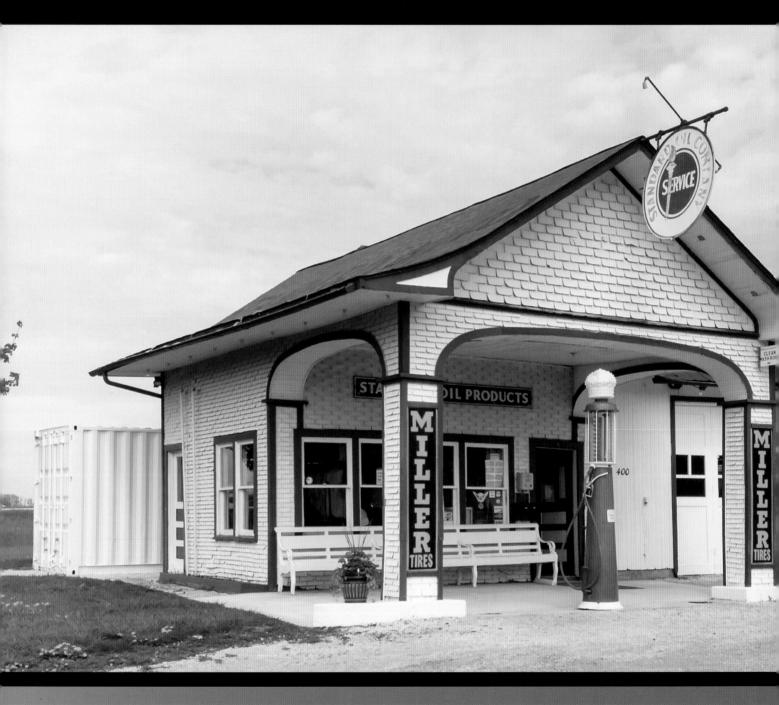

InsatiableWanderlust/Shutterstock

ROUTE 66

Illinois

Pre-1926 Historic Sites

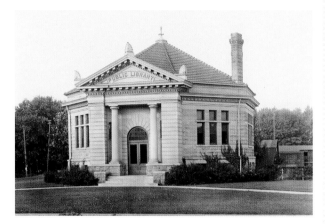

The unusual octagonal library in **Atlanta** dates to 1908.
Joe Sonderman

Atlanta

Built of white granite in 1908, Atlanta's distinctively designed octagonal library dominates the west end of the town's historic district. The library is shadowed by the 40-foot clock tower that replaced an older wooden structure. A viewing window allows an opportunity to watch the winding of the original 1909 Seth Thomas clock, required every eight days, and an innovative program initiated in 2013 to promote tourism allows visitors to partake in the clock's winding.

Also of historical importance are the J. H. Hawes Grain Elevator Museum, housed in a building from 1903, and the Downey block that dates to the 1860s. The architecturally significant Downy block houses the Palms Grill Café as well as the Atlanta Museum, which includes artifacts associated with Abraham Lincoln.

Benld

A unique historic site in Benld is the Holy Dormition of the Theotokos, part of the Patriarchal Russian Orthodox Catholic Church. Built in 1907

and rebuilt after a fire in 1915, it is the only Russian Orthodox parish under the Moscow Patriarchate in the state of Illinois.

Bloomington

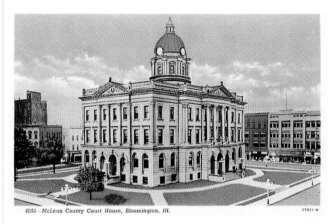

4005—McLean County Court House, Bloomington, Ill.

The **McLean County Courthouse** in **Bloomington**, built in 1903, houses a museum. *Joe Sonderman*

Located at 200 North Main Street (Route 66), the Old McLean County Courthouse dates to 1903. It continued to serve its original courthouse function until 1976. The building currently houses the McLean County Courthouse and Museum of History and one of the leading genealogical research libraries in the country.

Carlinville

The stunning Macoupin County Courthouse, derisively dubbed the "million-dollar courthouse" upon its completion in 1870, was at the time the largest county courthouse in the United States. Resultant of graft and cronyism, the exorbitant cost was more than 2,000 percent above original estimates. Authorization to build the courthouse, and the issuance of $50,000 in bonds to cover the projected cost of construction, came in March 1867, and in October of that year, a well-attended ceremony accompanied the setting of the cornerstone. By January 1869, the costs had climbed to $449,604, but the courthouse was still in need of its dome, roof, and interior appointments. Approval for the issuance of additional bonds allowed construction to proceed. The final cost

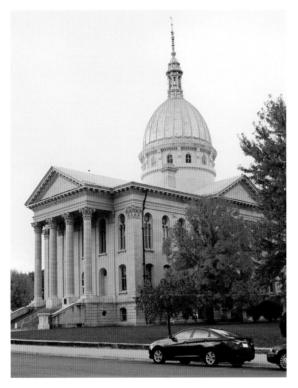

The historic courthouse in **Carlinville** is an unintentional monument to grift and cronyism.

for the Carlinville courthouse was a staggering $1,342,226.31.

The Carlinville town square has a distinctly Victorian feel with its historic gazebo, surrounded by brick-lined streets and an array of late nineteenth-century buildings that now house shops and offices. The massive Loomis House opened

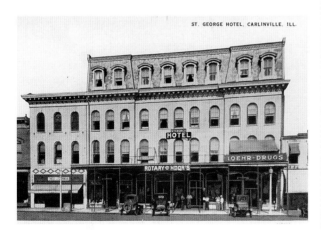

The **Loomis House**, previously known as the **St. George Hotel**, is one of many historic treasures in **Carlinville**. *Joe Sonderman*

as a fifty-room hotel in 1870 and later became the St. George Hotel after being purchased by new owners. The building currently houses various businesses.

Another historic treasure in this community is the Standard Addition, which contains the largest collection (152) of Sears, Roebuck & Company mail-order houses in the nation. Purchased and built by Standard Oil Company as housing for mineworkers in 1918, the addition originally consisted of 156 homes, purported to be the largest order ever received by the Sears Modern Homes Department. Pictures of these homes appeared extensively in catalogs through the 1920s, including the popular Carlin model named for the homes built in Carlinville. Maps of the addition are available at most shops in the historic district.

Chenoa

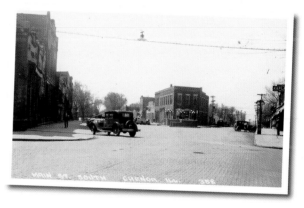

Chenoa's historic business district includes the 1889 Chenoa Pharmacy. *Joe Sonderman*

The Chenoa Pharmacy dates to 1889 and retains much of its original custom cabinetry. As it has remained in continuous operation since its opening as Schuirman's Drug Store, it is the oldest such business in Illinois. Inducted into the Route 66 Hall of Fame in 2005, the pharmacy also serves as an unofficial drug store museum.

At 227 North 1st Street is the home of Matthew Scott, built from 1854 to 1855. Retention of the original house allowed for dramatic expansion of the property in 1863, and the home's massive front was added at this time in an imposing Georgian style. It is now listed on the National Register of Historic Places.

Collinsville

Cahokia Mounds State Historic Site and Interpretive Center, located on Ramey Street immediately south of Collinsville, is a UNESCO World Heritage Site and the largest pre-Columbian Native American settlement north of Mexico. The site includes hiking trails through the complex, a gift shop, and a museum, and it is the location for numerous festivals throughout the year.

The historic district in Collinsville is a treasure trove of architectural styles from the mid-nineteenth century to early twentieth century and features a number of historically significant buildings.

The Chester Knitting Mill, built in 1915 at 701 West Main Street, figured prominently in the unionization and workers' rights movements of the late 1910s. After major renovations, the complex now serves as apartments.

The Becker Home at 237 North Clinton Street is the oldest residence in the community. Dating to 1864, it was the home of John Becker, the town's first mayor.

Built in 1879, the former Beidler Hotel at 315 East Church Street is linked to a woman who served as an inspiration for the women's suffrage movement. The imposing structure was built in an architectural style that blended the then-popular Italianate movement with Federal touches. It was a popular hotel during the 1880s due to its location on Depot Hill.

Angeline Penny Beidler had worked as a schoolteacher prior to her marriage to Frederick Beidler and the establishment of the hotel. In the closing years of the nineteenth century, she became the first woman to sit on the Presbyterian Board, and in 1894, she was the first woman to run for a seat on the school board. She was also active in the temperance movement.

An unusual historical artifact is located in the First United Methodist Church at 207 West Church Street. Built in 1906 to replace a smaller structure, the new church utilized a bell that was originally cast in Cincinnati in 1848 and was salvaged from the steamer *Glasgow* after it sank in the Red River in 1873.

The Blum House at 414 West Main Street dates to 1906. J. Henry Blum owned the Blum Bell Factory, the only manufacturer of stock bells in the United States and one of three such facilities in the world.

Currently utilized by the Collinsville School District, the former U.S. Post Office at 201 West Clay Street dates to 1916 and remained in use as a post office until 1965. Its architectural details garnered national acclaim at the time of its construction.

At 501 East Main Street is the former home of Dr. Charles Oatman. Oatman was the father of Dr. Louis Oatman and had a familial relationship to Olive Oatman, who was famously captured and enslaved by a Native American tribe in Arizona in the 1850s. Dr. Louis Oatman, who pioneered the development of medically-based actuary tables for insurance companies, began his studies in Collinsville but later interned at hospitals in St. Louis.

Listed on the National Register of Historic Places, the city hall at 125 South Center Street was built in 1885 and originally housed city offices as well as the jail, library, and post office. This is where German-born coal miner Robert Prager was held in 1918 before an enraged anti-German lynch mob stormed the building, removed him from his cell, and hanged him on the edge of town.

The cemetery at Glenwood and Cemetery Streets is one of the oldest in the state of Illinois. Established in 1822, the cemetery includes graves of a Medal of Honor recipient, a Revolutionary War veteran, and veterans of the Civil War, Black Hawk War, Mexican-American War, and Spanish-American War.

Dwight

The business district in Dwight is a veritable cornucopia of historic sites and architecturally significant structures. Most predate the certification of U.S. 66 and are located within blocks of that highway's original course through the city on Macnamara Street, Waupansie Street, and Odell Road.

Dr. Leslie Keeley established the Keeley Institute—the first medical institution to offer treatment of alcoholism as a disease—here in 1879. The former Keeley Institute building, built in 1891 and remodeled in 1902, features a world famous series of stained glass windows depicting the five senses affected by alcoholism. The windows were designed by Louis J. Millet, a student of Lewis Tiffany.

The former Chicago & Alton Railroad Depot at 119 West Main Street also dates to 1891. Listed on

The former **Keeley Institute building in Dwight** is an architectural gem, featuring distinctive stained-glass windows.

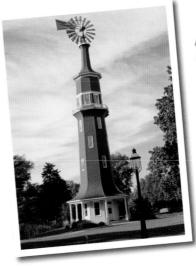

A unique landmark in **Dwight** is this windmill, built in 1896.

the National Register of Historic Places in 1982, the historic depot was designed by renowned Chicago architect Henry Ives Cobb. It still serves its original purpose as a stop for Amtrak passengers and also houses the Dwight Historical Society Museum.

The Bank of Dwight is housed in a building built in 1910 at 132 East Main Street. Organized in 1855, this is the oldest bank still operating under its original charter in the state of Illinois.

At 122 West Main Street is the First National Bank of Dwight, built in 1905. This is the only bank building of the three designed by Frank Lloyd Wright that is still operating as a bank today.

The uniquely styled Dwight Windmill is an octagonal tower that resembles a lighthouse built on a small garden cottage. Built in 1896, it dominates the grounds of the Country Mansion restaurant, which is housed in the former John R. Oughton home located at 101 West South Street and listed on the National Register of Historic Places. Originally built in 1891 to serve as a boarding house and relocated to its current site in 1895,

the Oughton home served as a private residence until 1928. From that date until 1977, the Keeley Institute utilized it as a boarding home and for other purposes, after which it was converted to the privately owned Country Mansion restaurant.

The carriage house for the Oughton estate was built in 1895 and currently houses the Prairie Creek Public Library. It was converted into a library in 1926.

Edwardsville

In 1890, visionary industrialist N. O. Nelson purchased a tract of land immediately to the south of Edwardsville for the construction of a larger, more modern manufacturing facility for his plumbing supply business. In addition, he intended for the property to serve as the site for a model community named Leclaire. The planned community, where Nelson's employees could partake of low-interest home loans, free schools, educational lectures, and park facilities, was one manifestation of Nelson's vision. Another was the radical concept of profit sharing for employees.

Today, Lewis and Clark Community College utilizes the former factory building, and the Leclaire Academy building houses the Edwardsville Children's Museum.

Numerous historic structures with distinctive architectural attributes dominate the business district of Edwardsville. These include the 1903 public library, the 1909 Wildey Theater, the 1915 courthouse, and the octagonal-fronted post office, built in 1915.

On Vandalia Street (Route 66), the Narodni Sin is a building of particular interest. The structure

with its ornate façade dates to 1906 and originally served as the Czechoslovakian national hall.

Each October, Edwardsville's Leclaire Historic District, which was listed on the National Register of Historic Places in 1979, is the site of the Friends of Leclaire Festival, featuring a range of activities from tractor parades to book sales.

Elkhart

In the classic *A Guide Book to Highway 66* penned by Jack Rittenhouse in 1946, the author notes that the "dozen ancient store buildings which compromise the town [of Elkhart] are off to the left on the one main street which crosses U.S. 66." The majority of this one-block business district, with buildings constructed between 1900 and 1920, still stands. The former bank building houses the Wild Hare Café and antique store.

More than a century of family tradition makes **Funks Grove** a unique destination near Route 66.

Funks Grove

The Funk family first settled at this site in central Illinois in about 1824. Isaac Funk served as an Illinois state representative and senator in the 1840s. In 1891, the family diversified into business endeavors with the production of maple syrup.

Directly south of Route 66 on Funks Grove Road is the former Funk store noted in Rittenhouse's 1946 guidebook to Route 66. Nearby, in the Sugar Grove Nature Preserve, stands the clapboard Funks Grove church built in 1845 and a cemetery dating to at least 1825.

Gardner

Located on Center Street (Route 66) next to the village hall is a squat, dressed-stone, two-cell jail. Built in 1906, the historic jail is a favored photo stop for travelers. On the grounds stands a monument to Reverend Christian Christiansen, a hero of World War II.

Glen Carbon

Built in about 1853, the William Yanda cabin in Glen Carbon underwent extensive renovation in 1989 after its acquisition by the city. It served as the centerpiece for the community's centennial celebration in June 1962. William and Anne Zeola Yanda immigrated to the area from Austria shortly before construction of the cabin. William worked as the area's blacksmith, a craft he taught his son. The family continued to live in the home until the early twentieth century. Yanda's grandson, Frank Jr., served as mayor of Glen Carbon.

Granite City

The Lewis & Clark State Historic Site Interpretive Center near Granite City, which serves as the starting point for the National Lewis and Clark Heritage Trail, is located at the site of the winter encampment of the Lewis and Clark expedition. It was here that the outfitting, planning, and launching of the expedition took place beginning in December 1803. The centerpiece of the exhibit is a 55-foot, full-sized replica of the keelboat utilized by the expedition.

Lincoln

After Henry Ford relocated the original courthouse, built from 1840 to 1847, to Greenfield Village in Dearborn, Michigan, a reproduction was built at Pottsville Courthouse State Historic Park (914 5th Street). Abraham Lincoln served as an attorney on the Eighth Judicial Circuit and

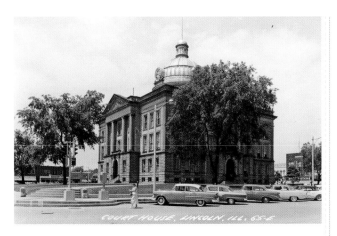

The historic courthouse in **Lincoln** is an architectural masterpiece. *Joe Sonderman*

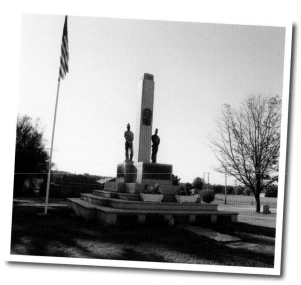

The landmark monument at the **Union Miners Cemetery** in **Mt. Olive** commemorates the tragedy of the 1897 Virden Riot and the union hero Mother Jones.

conducted business here.

A small monument at 101 North Chicago Street commemorates the town's official christening. The event took place on August 27, 1853, with Abraham Lincoln officiating and using the juice of a watermelon.

The Logan County Courthouse at 601 Broadway Street dates to 1905. Various architectural organizations consistently list the structure as one of the most spectacular historic courthouses in the state of Illinois.

Litchfield

Two structures of particular note in Litchfield are the former Wabash Railroad Depot and the Litchfield Public Library. The library dates to the receipt of a $15,000 gift from Andrew Carnegie for construction of the facility and its stocking with books in 1903.

Mt. Olive

Listed on the National Register of Historic Places, the Mt. Olive Union Miners Cemetery is a monument to a tumultuous period in American history. It is also the final resting place for Mary "Mother" Jones, an early labor organizer.

The origins of the cemetery date to an incident known as the Virden Riot, which marked a crucial moment in the United Mine Workers strike of 1898. The deadly encounter between the miners and the enforcers employed by mining companies, which left twelve men dead,

commenced with the arrival of African American miners recruited in the South to replace the striking mine workers.

When the Lutheran minister in Mt. Olive denounced the deceased miners as murderers and prohibited their internment in the Lutheran cemetery, the local union purchased an acre of land and established the Union Miners Cemetery. The official dedication of the facility took place in 1899.

Pontiac

Completed in November 1875, the courthouse in Pontiac designed by Chicago architect C. J. Cochrane replaced the previous structure that had been destroyed by fire in 1873. Built at a cost of $75,000, the ornate structure received several updates during the closing years of the nineteenth century, including the addition of electricity and steam heat in 1891 and of the clock in the center spire in 1892. It is listed in the National Register of Historic Places.

A life-sized bronze statue of President Abraham Lincoln stands on the courthouse square. The statue is rare in that it portrays Lincoln as a young man.

The courthouse square is also the location for the Civil War Soldiers and Sailors Monument. The official dedication of this monument occurred in 1903 with President Theodore Roosevelt officiating.

LEFT: The courthouse in **Pontiac**, listed in the National Register of Historic Places, dates to 1875.

BELOW: President Theodore Roosevelt dedicated the Civil War Soldiers and **Sailors Monument** in **Pontiac** in 1903.

The Jason W. Strevell House at 401 West Livingston Street dates to the early 1850s. Strevell, a lawyer and associate of Abraham Lincoln, often hosted the future president when he visited Pontiac.

Riverside

The Riverside Landscape Architecture District, designated a National Historic Landmark in 1970, incorporates much of the original village of Riverside, one of the first planned communities in America. Designed by acclaimed landscape architect and city planner Frederick Law Olmstead, the designer of New York City's Central Park, and his partner, Calvert Vaux, in 1869, the village was incorporated in 1875. The unique designs for the Chicago suburb included use of curvilinear streets to follow the contours of the land, a central village square centered on the railroad depot, and a series of linked parks and plazas.

The buildings in the historic district—which covers an area bounded by 26th Street, Forbes Road, the Des Plaines River, and alignments of Route 66 on Harlem and Ogden Avenues—represent the work of architects such as Frank Lloyd Wright, Louis Sullivan, and Daniel Burnham. Of particular note for their architectural details are the chateau-esque Riverside Township Hall (1895), the train station (1901), and the Riverside Golf Club (1893).

Romeoville

Situated in and along the Des Plaines River at Romeoville is the Isle a la Cache (or "Island of the Hiding Place") Museum complex, a site that serves as a landmark to seventeenth- and eighteenth-century European explorers as well as a wildlife refuge and expansive park area. The museum, housed in the former Murphy's Restaurant, chronicles the development of French and Indian fur trading along the Great Lakes and the subsequent colonization of the region. Included are exhibits on Native American culture and history during the period as well as in the years before the arrival of European traders.

In June, the park serves as the venue for the Island Rendezvous, an annual celebration with re-enactors that transforms the island into an eighteenth-century time capsule of life at the end of the trapping season when trappers, traders, and travelers gathered to celebrate and trade goods.

Though settlement in the area dates to the 1830s, the origins of the community of Romeoville are as a port on the Illinois and Michigan Canal, a key transportation corridor in the 1850s. The I & M Canal opened in 1848 and was a link in a system that connected Chicago with the Mississippi River.

The 96-mile canal dug by Irish immigrants was 60 feet wide and 6 feet deep and utilized mule-pulled packet boats and a system of seventeen locks. As the canal provided the fastest and most secure means of traversing the area, it should not be surprising to learn that it is associated with notables of the era such as Abraham Lincoln and Harriet Beecher Stowe.

Historical sites and interpretive parks dot the landscape along the former towpath. Several historic sites in Romeoville also have direct association with the canal.

Springfield

The Abraham Lincoln Presidential Library and Museum is the primary site in the city of Springfield associated with the president. The centerpiece of the museum is the Lincoln collection, which consists of materials gathered in the 1890s as part of the Illinois State Historical Library, items and documents donated by the Lincoln family, and items gathered by collectors Henry

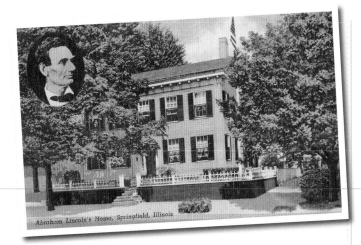

Abraham Lincoln's home is located just a few blocks from Route 66 in **Springfield**. *Joe Sonderman*

Horner, Governor of Illinois from 1933 to 1940, and Louise and Barry Taper.

Louise Taper collected materials pertaining to Abraham Lincoln for more than three decades and amassed the largest privately-held collection of materials related to this president. Through donation and purchase, the museum acquired the collection between 2004 and 2007. As a result, the holdings of the museum and library are extensive. They include the blood-stained gloves and handkerchief carried by the president on the night of his assassination as well as other personal effects such as his shaving mirror. There is also a large collection of materials relating to John Wilkes Booth; more than 1,500 original letters and manuscripts penned by the president; 320 pieces of correspondence from Mary Todd Lincoln; and a book from 1824 containing the earliest known sample of Lincoln's handwriting.

Located a few blocks to the east of the museum is the Lincoln neighborhood. The four-block area contains twelve historic homes from the time that Abraham Lincoln lived in Springfield, restored to their late 1860s appearance. Among the homes in the area is the Shutt House, built in stages before 1859. In 1860, attorney George Shutt, a supporter of Stephen A. Douglas, resided here with his family. The Sprigg House dates to about 1851. Julia Sprigg was a close friend of Mary Lincoln, and her daughter often assisted with care for the Lincoln sons.

Built in 1839, the Lincoln Home and its property were purchased by Abraham and Mary Todd Lincoln in 1844. In 1845, they commenced renovations and upgrades that would include the addition of a second floor. This was the only home ever owned by Abraham Lincoln.

Another Springfield historic landmark is the Old State Capitol building at 2nd Street (Route 66 from 1926 to 1930) and Capitol Avenue. Completed in 1888 after two decades of construction, the architectural masterpiece is 361 feet tall, 74 feet taller than the U.S. Capitol building in Washington, D.C.

Designed by Frank Lloyd Wright and built between 1902 and 1903, the 12,000-square-foot Dana-Thomas House is the only historic site in

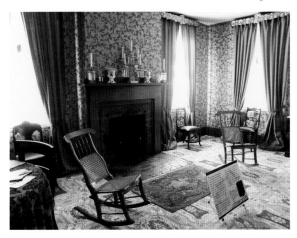

The sitting room at the **Lincoln Home** reflects the furnishings and décor of the period during which the president and Mrs. Lincoln lived in **Springfield**. *Judy Hinckley*

The **Old Illinois State Capitol** building in **Springfield** is a historic landmark, and it served as the backdrop for then-Senator Barack Obama's announcement of his presidential candidacy in 2007. *Joe Sonderman*

the state of Illinois chosen for solely its architectural merit. Marking a radical departure from traditional Victorian architecture, the house commissioned by Susan Lawrence Dana featured coordinated art glass designs for 250 doors, windows, and partitions, and more than 200 light fixtures. Wright envisioned the home as a means to provide a blending of a natural and organic atmosphere, and it often served as an onsite study used by the acclaimed architect for his students.

The **Eagle Hotel** in **Wilmington** is the oldest commercial structure along Route 66 in Illinois.

Wilmington

The Eagle Hotel in Wilmington was established as an inn and stage station by David Lizer in 1837 or 1838. Historical evidence indicates that prior to that it may have served as a trading post and warehouse. Further research suggests that the transition to hotel took place shortly after construction was completed as a means to compete with Henry Brown's general store and hotel directly across the street. With completion of the Chicago & Alton Railroad to Wilmington in the early 1850s, the hotel business flourished.

The building, located at 100 Water Street, has housed a variety of businesses, including a bank and a tavern. In the 1940s, interior renovations transformed it into a complex of apartments on the upper floor. Storefront businesses operated on the street level until 1982. In that year, the Wilmington Area Historical Society purchased the building and established a museum. A fire in 1990 damaged the structure and necessitated the relocation of the museum. The building is currently empty.

Listed in the National Register of Historic Places in 1994, the former hotel is the oldest commercial structure located along the Illinois alignments of Route 66.

Landmarks

Atlanta

The recently refurbished Palms Grill Café at 110 Southwest Arch Street (Route 66) appears as it did in 1935 when the café opened. Indicative of its popularity with the resurging interest in Route 66 is the café's inclusion in the 2011 television special *Billy Connolly's Route 66*.

Another Route 66 landmark of note is the towering fiberglass statue of a giant holding a hot dog, which was manufactured by International Fiberglass in the 1960s. The statue originally stood in front of a restaurant in Berwyn, Illinois, along Route 66.

Auburn

Becky's Barn, located just south of Auburn along the earliest alignment of Route 66, has evolved from a small retirement project that included the sale of miscellaneous items acquired from farm and estate auctions into a favored destination for Route 66 enthusiasts. As the business developed, it expanded into new buildings, with inventory including furniture, vintage gasoline pumps, and related memorabilia, as well as signs and similar items.

Berwyn

Ogden Top & Trim at 6609 West Ogden Avenue is a family owned business that opened in 1919. The business currently provides high quality interior components and convertible tops for vintage vehicles.

Located at 7155 West Ogden Avenue (Route 66) is the oldest White Castle restaurant. The restaurant is one of the most original remaining in the chain.

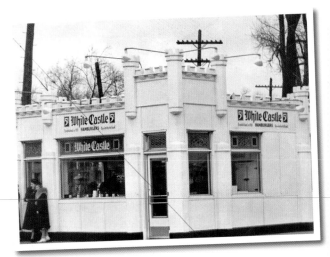

This original **White Castle** stands along Route 66 in **Berwyn**. *Joe Sonderman*

Bloomington

The Sprague Super Service Station at 305 East Pine Street (Route 66) opened in 1931 and remained in operation until 1976. Originally built with a café, gas station, and garage, with housing for the owner upstairs, the building remained vacant as of 2014. Plans for its rehabilitation include use as an information center, soda fountain, and bed and breakfast. It has been nominated for inclusion in the National Register of Historic Places.

Located at 116 East Market Street (Route 66), the Lucca Grill was established in 1936 by brothers Fred and John Baldini, who named the restaurant for their hometown of Lucca, Italy. Current advertisement promotes the restaurant as the oldest continuously operated pizzeria in the Midwest. The *Route 66 Dining & Lodging Guide* published by the National Historic Route 66 Federation calls the grill a very special "must stop." Additionally, Lucca Grill has received mention in numerous publications for its historic nature, consistent attention to quality and service, and ambiance. Lining the walls are framed articles from local newspapers, the *Washington Post*, and the *New York Times*, among others.

The origins of the Beer Nuts Factory and Company Store at 103 North Robinson Street date to 1937 when Edward Shirk became the manager of Caramel Crisp, a confectionary store that specialized in "redskins" or glazed peanuts. He changed the name to Beer Nuts in 1953 and began selling the packaged nuts through the National Liquor Store in Bloomington. The current manufacturing facility opened in 1973. It includes a popular store that sells the trademark nuts as well as souvenirs.

Braidwood

Chester Fife established the now iconic Polk-A-Dot Drive In in 1956. The restaurant initially operated from a school bus covered with colorful polka dots from which the owner took orders. The drive-in opened in the current building in 1962. With the exception of life-sized fiberglass figures of James Dean, Elvis Presley, the Blues Brothers, Marilyn Monroe, and Betty Boop that add a delightful touch of whimsy, the restaurant is a near perfect time capsule.

The Braidwood Motel at 120 North Washington Street is another notable Route 66 landmark of note. It also has an interesting historic association. Italian immigrant Peter Rossi initiated his business enterprise in Braidwood after the fire of 1879 that decimated the business district. He used monies derived from reconstruction projects to purchase the Broadbent Hotel in 1898 and finance its conversion into a macaroni factory. His son, Stephen, expanded the family business with establishment of a bakery and saloon, and after the advent of Route 66 in 1926, he added a service station, grocery store, two auto courts, and a restaurant. The second of these auto courts, the one currently signed as the Braidwood Motel, evolved in direct correlation to the increased flow of traffic along Route 66. In 1954, the *AAA Western Accommodations Directory* described the Rossi Motel as a "modern brick motel on spacious grounds."

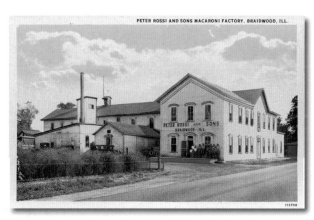

The Rossi family enterprises in **Braidwood** were diverse. *Joe Sonderman*

Chicago

Opened in 1898, the Berghoff Restaurant at 17 West Adams Street (Route 66) is housed in a building that dates to 1871, one of the oldest structures in Chicago's Loop District. Still managed by the original family, the restaurant began as a saloon offering free sandwiches with the purchase of a nickel beer. After relocating to its current location less than a block east of the original saloon in the early 1920s, the owner, Herman Berghoff, obtained the first liquor license issued after the repeal of the Volstad Act in 1933. The restaurant remains a popular establishment for locals as well as Route 66 travelers.

Lou Mitchell's Restaurant was established in 1923 and has operated from its current location at 565 West Jackson Boulevard (Route 66) since 1926. The neon signage and interior appointments such as booths, coat racks, and tables, as well as the aluminum and glass façade, date to an extensive remodeling in 1949. Listed in the National Register of Historic Places in 2006, the restaurant has an additional link to an earlier time with the practice of presenting female customers with a box of Milk Duds, a tradition that commenced in about 1930.

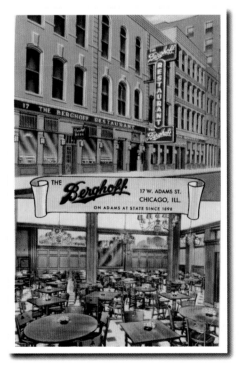

The **Berghoff Restaurant** in **Chicago** dates to 1898. *Steve Rider*

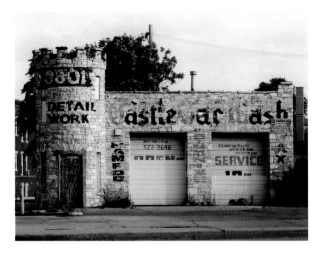

The uniquely styled **Castle Car Wash** in **Chicago** is a favorite photo stop. *Steve Rider*

On the northwest corner of Adams (post-1953 Route 66) and Dearborn Streets stands the Marquette Building, with its recently renovated façade and lobby. Constructed in 1895, the building once housed the offices of more than thirty railroad companies. The two-story lobby is a showpiece featuring original decorative carved marble and mosaics depicting scenes of Father Jacques Marquette's expeditions of the seventeenth century. They were designed by J. A. Holzer and executed by the Tiffany Glass and Decorating Company. The building was listed on the National Register of Historic Places in 1973 and received recognition as a Chicago Landmark in 1975.

Located at 233 Wacker Drive is the Willis Tower, formerly the Sears Tower. The Skydeck on the 103rd floor provides stunning views of Route 66 and the city.

The Castle Car Wash Building is located at 3801 West Ogden Avenue (Route 66) in Chicago's North Lawndale district. Built by Louis Ehrenberer in 1925 as a gas station and garage, the currently closed building has housed several different businesses. Due to its unique architectural attributes and persistent legends about an association with Al Capone, the former Castle Car Wash is a common photo stop for fans of Route 66.

Cicero

The Cindy Lyn Motel at 5029 West Ogden Avenue opened in 1960 as an eighteen-unit complex. Promoted as the "last motel before the city," rates were

six dollars per night. It is still owned and operated by the same family and retains its vintage charms.

At 6031 West Ogden Avenue (Route 66), Henry's Drive In is a roadside landmark that dates to the mid-1950s. An institution for both area residents and travelers, it is known for its Chicago-style hot dogs and for the giant hot dog sign under which a neon sign proclaims, "Henry's—It's a Meal in Itself." Henry's was initially a simple walk-up stand, but within five years of its opening, the owner transformed the restaurant into its current configuration with indoor seating as well as drive-up service.

Collinsville

Located immediately to the south of Route 66 in Collinsville, a 170-foot water tower shaped like a catsup bottle was built in 1949 for the G. S. Suppiger bottling plant, a company that produced Brooks Catsup. The tower received recognition of its significance with inclusion in the National Register of Historic Places in 2002. In 1995, the distinctive tower underwent a thorough restoration.

Dwight

Ambler's Texaco was built in 1933 at the intersection of Illinois Highway 17 and U.S. 66 in Dwight by Jack Schore and his son utilizing a domestic style developed by Standard Oil Company in 1916. The station is now an internationally recognized landmark.

After extensive renovation and its addition to the National Register of Historic Places in 2001, Ambler's reopened as a visitor center for Dwight and a Route 66 interpretative center.

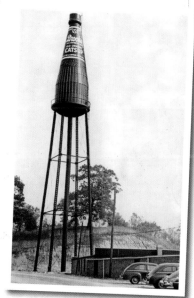

This distinctive water tower was built in **Collinsville** in 1949.

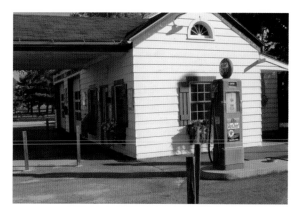

Ambler's Texaco, built in 1933, now serves as a Dwight visitor center.

The station's name is in reference to Basil "Tubby" Ambler, who owned and operated it from 1938 to 1965. During his management, the two service bays were constructed, resulting in the building's current appearance. The station remained in operation until 1999, at which time the sale of gasoline was suspended, and from then until 2002, it housed an automotive repair facility. With the closure of this business, the property's owner, Phillip Becker, donated it to the City of Dwight. Matching funds grants from the National Park Service Route 66 Corridor Preservation Program provided some of the monies needed for the restoration of the property to its 1940s appearance.

Farmersville

The origins of Art's Motel at exit 72 on I-55 date to 1937 when Art McAnarney leased the Hendricks Brothers Café and service station at this site. Sometime prior to 1940, he added six cabins to the complex. Renovations and expansion after a major fire in 1952 included an expansion of the restaurant. Art's sons, Joe and Elmer, inherited the property after his death in 1957, and in 1960, they transformed it into a traditional thirteen-room motel complex in an L configuration.

Unlike many Route 66 businesses, Art's Motel survived into the modern era thanks to its location at the Farmersville exit on Interstate 55. A brief closure during the 1980s, followed by induction into the Illinois Route 66 Hall of Fame in 1995, preceded refurbishment of the building and the circa 1960 signage.

Gardner

The Street Car Diner in Gardner represents the entrepreneurial spirit that transformed the Route 66 corridor during the highway's infancy. The diner was a converted Kankakee street car relocated to a site along Route 66 near the popular Riviera bar and restaurant in 1932. In the summer of 2010, a fire destroyed the historic Riviera, and the long-abandoned Street Car Diner was refurbished and relocated to a site beside the historic two-room nineteenth-century Gardner jail. In 2001, the historic significance of the diner earned it induction into the Route 66 Hall of Fame.

Girard

Established in 2007, Doc's Soda Fountain and Deck's Pharmacy Museum at 133 South 2nd Street offers lunch and traditional soda fountain treats. In addition, a free museum chronicles the evolution of the drug store from 1884.

Joliet

The recently refurbished Rialto Theater on Chicago Street (Route 66) in Joliet is a stunning structure that consistently rates as one of the most beautiful theaters in the nation. Built in 1926, the building's unique blending of classic Roman and Greek, Baroque, and Byzantine architecture gives its exterior façade an unforgettable appearance. The interior design, which features more than one hundred hand-cut crystal chandeliers, continues the theater's elegant theme. One of these fixtures, dubbed the Duchess, is the largest of its kind in the United States.

The Route 66 Visitor Center at the corner of Cass Street and Ottawa Street (Route 66 and the Lincoln Highway) utilizes a wide array of interactive displays to depict travel on Route 66 before the introduction of the interstate highway system. Examples of such displays include a motel room with functioning Magic Fingers bed and a snack bar similar to those found in drive-in theaters.

At 501 Chicago Street, in a nondescript building, is the first Dairy Queen. This is probably the least noticeable landmark in the city of Joliet, as others are either well signed or are architectural masterpieces.

Walt Anderson, a masonry contractor, built another landmark of note at the junction of U.S. 6 and U.S. 66: the Manor Motel. The project com-

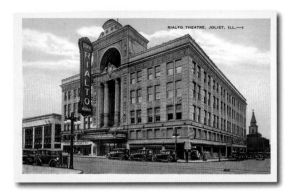

Joliet's **Rialto Theater**, with its distinctive architecture, dates to 1926. *Joe Sonderman*

menced in 1946 when Anderson purchased the property and built the first units. It was completed in 1954. That year the *AAA Western Accommodations Directory* noted that this was a modern complex, "nicely situated back from the highway. Attractively furnished rooms have central heat and tiled shower or combination baths; radios and TV available." In 2011, Prakash Silveri, the third owner of the historic motel, initiated a complete renovation of the property. The roadside motel appears much as it did in 1954, but the property is in need of renovation.

Lexington

In the mid-1940s, the state of Illinois, in partnership with the federal government, initiated an innovate series of highway improvements that included construction of four-lane bypasses on Route 66 to alleviate congestion in urban centers and facilitate a steady flow of traffic. In 1946, Jack Rittenhouse noted, "the new freeway, by skirting these smaller towns, is affecting the portion of their income derived from tourists."

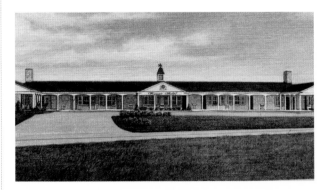

The **Manor Motel** was built in **Joliet** between 1946 and 1954. *Mike Ward*

To combat the resultant economic decline, many communities initiated a variety of promotional endeavors to ensure at least a modicum of traffic flowing into town. In Lexington, this effort was manifested as a simple large red sign with white letters and an arrow accentuated in neon that read "Lexington" along the new highway alignment. Recent refurbishment of landmarks in the community included restoration of this sign.

Lincoln

The Lincoln City Hall, located at 700 Broadway Street, dates to 1895 and serves as an integral component of the downtown National Historic Registered District. On the roof is a phone booth that was installed for use by weather spotters.

The Railsplitter Covered Wagon sculpture, featuring Abraham Lincoln as the driver, is recognized by the Guinness Book of World Records as the "World's Largest Covered Wagon." *Reader's Digest* proclaimed it a top roadside attraction.

Litchfield

The original Ariston Café was opened by Pete Adam in Carlinville, Illinois, in 1924 on the courthouse square. With realignment of Route 66 in late 1930, Adam relocated to Litchfield. Construction of the current restaurant commenced in late 1934 directly across the street from the first incarnation of the Ariston Café in Litchfield. With the exception of a banquet room and modern front doors with awnings, the building's interior and exterior appear as they did on opening day on July 5, 1935. The neon signage on the rear exterior wall of the restaurant dates to 1940. Realignment of Route 66 as a four-lane highway to the rear of the restaurant prompted the addition. Listed on the National Register of Historic Places in May 2006, the restaurant is a popular destination for Route 66 enthusiasts. Pete Adam's son, Nick Adam, is the current manager.

A second property of note in Litchfield is the Belvidere Café and Motel, located at 817 Old Route 66. Established by Albina and Vincenzo Cerolla, European immigrants, in 1929, the facility began as a simple wood-framed service station with a single visible register pump. By 1937, a series of expansions had transformed

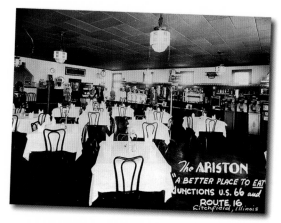

The **Ariston Café** in **Litchfield** appears unchanged from this early postcard view. *Joe Sonderman*

the property into a larger complex consisting of a brick service station, a four-unit motel complex, and the Belvidere Café. Further expansion during the 1940s included the addition of a dance hall. In the 1950s, Albina and Vincenzo's daughter Edith and her husband, Lester Kranich, assumed control of the complex. Expansion during this period included a new home and the construction of additional units for the motel. It remained a prosperous and viable business enterprise until completion of the I-55 bypass in the early 1970s. It was added to the National Register of Historic Places in 2007.

The Sky View Drive In Theater that opened in 1951 is another Litchfield landmark. It remains as the last original drive-in theater in operation on Route 66 in the state of Illinois.

Originally established in Mt. Olive in 1922, Jubelt's Bakery opened at 303 North Old Route 66 in 1952. It retains many original attributes and still serves regional specialties as it has since its inception.

Opened in 2013, the Litchfield History Museum & Route 66 Welcome Center at 334 Historic Old Route 66 is located in the former site of Vic Suhling's service station. A key attribute is the restored original service station sign from the 1950s.

McCook

Built of locally quarried limestone, Snuffy's Restaurant at 8408 Joliet Road opened in 1926. When the restaurant closed in 2010, the building was refurbished, and it reopened as a Steak 'n' Egger, a local chain established in 1955.

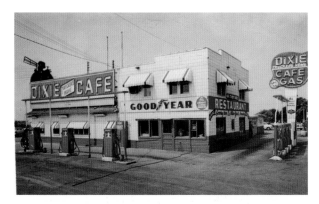

The **Dixie Truckers Home** in **McLean** is the oldest continuously operated truck stop on Route 66.
Steve Rider

McLean

The modern Dixie Travel Plaza on I-55 began as the Dixie Trucker's Home in 1928 at the junction of U.S. 66 and U.S. 138. Established by J. P. Walters and his son-in-law, John Geske, it evolved in direct correlation with the increasing flow of traffic on Route 66 and the postwar trucking industry. Initially the complex consisted of a gas station and a six-stool diner. By 1938, near-continuous expansion had transformed it into a full restaurant with seating for sixty customers, six cabins, and fuel islands on both sides of the building. In 1965, fire destroyed the restaurant and service station. As the gasoline pumps remained usable, the complex reopened the following day, with one of the cabins serving as the service station office. Until completion of a new and modern facility in 1967, another cabin served as a small café. The current name dates to completion of the new facility. Since that date, the complex consistently rates among the top ten truck stops in America.

A modern landmark is located at 107 South Hamilton Street. America's Playable Arcade Museum is housed in a late nineteenth-century storefront and replicates an arcade from the mid-1980s with games from that period.

Mitchell

The Economy Inn at 3228 West Chain of Rocks Road opened in 1957 as the six-unit Chain of Rocks Motel. The following year, expansion transformed it into a twelve-unit complex. Expansion of the property continued through 1977, first with the addition of eleven units in 1960 and then with construction of another fifteen in 1977. The towering sign installed in 1960 remained in place and operational until 2006.

The Luna Café at 201 East Chain of Rocks Road (Route 66) opened in 1929 and remains in operation, little changed from that period. According to folklore, Al Capone was a regular customer here. Urban legend also claims that the café was a house of ill repute that operated when the neon red cherry in the martini glass sign was lit, and that a casino operated in the basement. Recent renovations preserved the historic integrity of the building. The famous neon signage with its red cherry underwent complete restoration, and in the fall of 2011, with great fanfare, was relit.

Mt. Olive

The son of an Irish immigrant, Henry Soulsby worked in area coal mines until injury forced him to seek other employment. Utilizing his savings, he purchased two lots at the corner of 1st Street (Route 66) and built a small cottage-type service station with canopy in 1926.

Henry's son, Russell, assisted in the station's construction and operation before his service in the Pacific Theater during World War II. Upon his return, he utilized skills learned in the military to establish a radio and, later, television repair facility at the station to supplement income. After Henry's retirement, Russell and his sister Ola continued selling gasoline until 1991 and then closed the station in 1993. The station was sold to Mike Dragovich, a neighbor, in 1997.

With establishment of the Soulsby Preservation Society in 2003, Dragovich initiated restoration of the historic facility. Grants provided by the National Park Service Route 66 Corridor Preservation program enabled funding of the project.

Listed on the National Register of Historic Places in 2004, the Soulsby Service Station is a tangible link to the infancy of Route 66. It is also a common photo stop for fans of the "Mother Road."

Nilwood

Immediately south of Nilwood is a segment of concrete roadway that served as the course for Route 66 from 1926 to 1930 and for that highway's predecessor, State Highway 4, after 1920. The short piece of roadway is a surprisingly

popular landmark among Route 66 enthusiasts for the turkey tracks in the road surface that date to the time of its construction.

Normal

As of 2013, the building at 1219 South Main Street in Normal is home to a pizza parlor, but the building dates back to 1934 when it served as the original Steak 'n Shake.

Gus Belt operated a service station at this location in 1932. Using the profits from the sale of gasoline and oil, he added a small restaurant that offered basic fare such as fried chicken, coleslaw, beer, and French fries. By 1934, the restaurant proved to be more profitable than the service station, and so Belt obtained a loan and built a new facility, which opened under the Steak 'n Shake name, a reference to the T-bone and sirloin steak he used for his steak burger sandwich. From its inception, Belt employed several revolutionary concepts in his new restaurant. To establish the restaurant's reputation for cleanliness, he utilized black and white décor and stainless steel, and he designed the kitchen in a manner that allowed customers to watch food preparation. Precise ratios of fat to meat ensured sandwich consistency. Next, he initiated curb service to allow for maximum utilization of the facility.

The formula proved so successful he opened a second location in Bloomington, Illinois, in 1936. Three years later, he had eight restaurants, and in 1943, he became a pioneer in the selling of franchises for the restaurant. The Steak 'n Shake enterprise remained a family-owned company until 1969. Company franchises are still popular along the Route 66 corridor in the Midwest.

Odell

In 1932, Patrick O'Donnell, a local contractor, purchased a parcel of land on Route 66 at the south side of Odell, and utilizing standardized 1916 plans provided by Standard Oil of Ohio, he built a gas station. O'Donnell added a two-bay garage to the station in about 1940 in an effort to remain competitive with the nine stations operating along the short segment of Route 66 that coursed through Odell during this period.

Robert Close leased the property in 1952 and

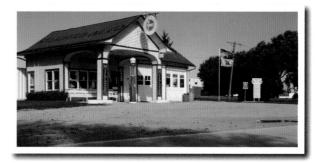

The pride of **Odell** is this 1932 **Standard Oil station.**

then purchased it from the estate of Patrick O'Donnell in 1967. Shortly after leasing the station, Close bought the café next door (a building that burned in 1970) and converted it into a home for his family. Close made other changes to the historic station as well. During the early years of his management, he initiated the sale of Sinclair products. He also transformed the garage into a body shop, a business that continued until the Village of Odell purchased the property in 1999.

The Route 66 Association of Illinois Preservation Committee undertook measures to preserve the station in 1995. On November 9, 1997, the facility received recognition with placement on the National Register of Historic Places, thanks to those efforts.

Author John Weiss and his wife, Lenore, spearheaded an innovative collaboration among the Village of Odell, the Illinois Route 66 Association, Illinois State Historic Preservation Office, Hampton Inn Landmarks, and the National Park Service Route 66 Corridor Preservation Program that led to the station's restoration. In 2002, the National Historic Route 66 Federation recognized the efforts by bestowing the project with the Cyrus Avery Award for most outstanding preservation project.

The old station currently serves as the welcome center for the Village of Odell.

Pontiac

The District Six Illinois State Police building was constructed in 1941 in an Art Moderne architectural style, featuring use of curved corners and glass bricks. Perhaps the most intriguing aspect of the building's design is that from the air it resembles a pistol. The design incorporated two primary

wings, one for administration and a second that served as a garage for vehicle maintenance. Architects made use of built-in cupboards, plaster walls, and terrazzo floors throughout the interior to present a smooth utilitarian look. The Illinois State Police continued to use the facility until 2003. Listed in the National Register of Historic Places in 2007, the building is the centerpiece of a park proposed by Livingston County.

The Log Cabin Restaurant established in 1924 originally faced State Highway 4, Route 66 after 1926, along the railroad tracks. With completion of the four-lane bypass alignment of Route 66 at the rear of the restaurant in the 1940s, the owner lifted the building from its foundation and spun it to face the new roadway.

The Pontiac city hall and firehouse building that dates to 1900 now houses two museums of note. One is the Livingston County War Museum; the second is the Route 66 Hall of Fame Museum. The Route 66 museum displays a virtual cornucopia of Route 66 artifacts that together present a complete tapestry of the highway's evolution. Attractions of particular interest are the Volkswagen camper van that belonged to acclaimed artist Bob Waldmire—a vehicle that inspired the character Fillmore in the animated film *Cars*—and the handcrafted motor home that he built on a 1966 Chevrolet bus chassis.

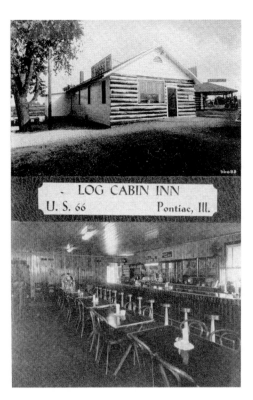

The **Log Cabin Restaurant** in **Pontiac** opened in 1924. *Joe Sonderman*

Springfield

Every aspect of the now-legendary Cozy Dog Drive-In at 2936 South 6th Street (Route 66) in Springfield ensures it will always have a place in Route 66 history. Surprisingly, the current incarnation of the drive-in dates to only 1996.

Founder Edwin "Ed" Waldmire Jr. created the then one-of-a-kind batter-dipped and fried hot dog on a stick at the PX of the Amarillo Army Airfield during World War II. He perfected the batter during his off-duty hours when he sold batches of the "Crusty Curs" to cafes, diners, bars, and restaurants along Route 66 in the Texas Panhandle.

Upon his return to civilian life, Waldmire introduced his hot dog creation at the Illinois State Fair in 1946. He followed this with a stand at the Lake Springfield Beach House. With gentle input from his wife, Virginia, the name became Cozy Dog, and Waldmire used this on signs for his second stand, which he opened at the corner of Ash and MacArthur in Springfield. In 1950, he consolidated operations in a building shared with a Dairy Queen franchise.

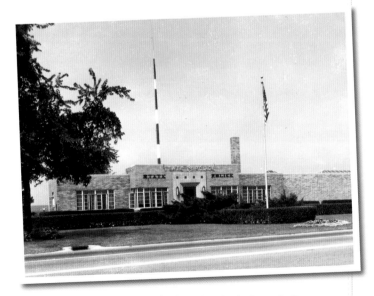

The uniquely styled **District Six Illinois State Police** building dates to 1941. *Joe Sonderman*

The popularity of the Cozy Dog allowed Waldmire to open three stores in Springfield. Still, in the late 1950s, he decided to focus on development of one location, the store on Route 66. The Cozy Dog relocated to its current site formerly occupied by the A. Lincoln Motel in 1996. Sue Waldmire, Edwin Waldmire's daughter-in-law, and her family currently manage the restaurant.

Another Route 66 landmark in Springfield is Shea's Gas Station Museum located on Peoria Road (Route 66) south of the Illinois State Fairgrounds. Bill Shea, a World War II and D-Day veteran, originally opened this facility as a Marathon station in 1955. Before that, he operated a Texaco station at 2001 Peoria Road in a partnership with Maurice Dupuy beginning immediately after World War II and managed it until 1955. As a station owner with more than four decades of service between the two locations in Springfield, Shea collected Route 66 memorabilia, gasoline pumps, and a wide array of vintage service station promotional materials. After his retirement, he transformed the station into Shea's Gas Station Museum, a facility operated until 2013 by Bill Shea Sr. and Bill Shea Jr.

The Route 66 Hotel & Conference Center at 625 East St. Joseph Street opened in 1957 as the first Holiday Inn on Route 66 in the state of Illinois. Fully refurbished and remodeled, the hotel décor includes an extensive collection of historical photographs and memorabilia, as well as vintage automobiles.

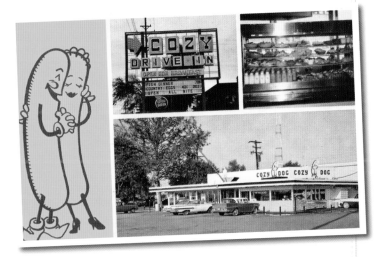

Springfield's Cozy Dog Drive-In is a treasured landmark.

Staunton

Henry's Rabbit Ranch & Route 66 Emporium near Madison Street on the post-1930 alignment of Route 66 exemplifies the quirky attractions associated with the highway's roadside during the 1950s. The eclectic collection centers on rabbits of all types: live ones, cars built by Volkswagen, and large fiberglass models. However, there are also vintage neon signs awaiting restoration, antique cars and trucks, and other roadside relics. Henry's also houses materials associated with Campbell's 66 Express, including original tractor trailer units adorned with the trademark Snortin' Norton camel and the company's slogan, Humpin' to Please.

Willowbrook

Dell Rhea's Chicken Basket, as with many Route 66 landmarks, is a survivor as a result of the resurgent interest in the road, and it is a business that evolved with the highway. It shares another similarity with much of the development of Route 66 in that diversity born of necessity was a foundational component in its growth.

Irv Kolarik, the founder, added a small café to his garage and service station in about 1940 as a means to coax more profitability from his enterprise. According to Kolarik, the limited menu of coffee, pie, and cold sandwiches expanded to include fried chicken after two women who owned a local chicken farm offered to provide a special recipe if he agreed to purchase all the poultry from them.

The chicken proved to be a hit for travelers as well as locals, which led Kolarik to convert the garage into a dining room promoted as Club Roundup. In June 1946, he built a new restaurant on the adjoining property (the current site). To ensure his restaurant received adequate word of mouth promotion, Kolarik began honing his promotional talents with catchy stunts, such as creating an ice skating rink on the roof. Even though the restaurant proved to be a profitable business, the realignment of Route 66 led to a precipitous decline, culminating in bankruptcy and closure in the early 1960s.

In 1963, Dell Rhea and his wife, Grace, purchased the defunct restaurant and reopened under the Dell Rhea's Chicken Basket name. The

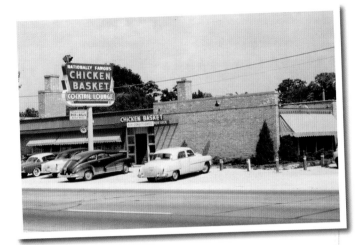

The origins of **Dell Rhea's Chicken Basket** in **Willowbrook** date to the mid-1940s. *Joe Sonderman*

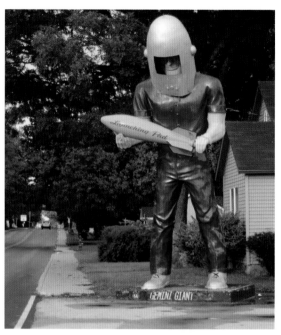

The Gemini Giant at the **Launching Pad Café** in **Wilmington** is a roadside landmark dating to 1965.

restaurant remained in operation as a family-run business into the modern era and was inducted into the Illinois Route 66 Hall of Fame in 1992 and listed on the National Register of Historic Places in 2006.

Patrick Rhea, the son of Dell and Grace, currently owns and manages the restaurant. Excellent food as well as preserved features from the 1950s and 1960s, including the refurbished 1956 neon sign, led the National Historic Route 66 Federation to designate it a "very special must stop" in the *Route 66 Dining & Lodging Guide* (15th edition).

Wilmington

The Launching Pad Drive In at 121 South Main Street (Route 66) opened in 1960 as a Dari-Delight franchise restaurant. By 1963, expansion transformed the property into a full-service restaurant.

John and Bernice Korelec, proprietors at that time, were in attendance of the National Restaurant Association when a display by the International Fiberglass Company provided inspiration for a novel promotional idea. For the sum of $3,500, they purchased an oversized astronaut figure with helmet and rocket, placed it in front of their building along Route 66, and changed the name of the restaurant to Launching Pad Drive In.

The statue remains a favorite photo stop for Route 66 fans. The restaurant is still in operation during the tourism season.

Parks

Bloomington

Located at 1020 South Morris Avenue just off Route 66, the Miller Park and Zoo is a rare blending of a modern zoological and botanical park with a historic early twentieth-century community park. In addition to the lake lined with shade-dappled trails along the shore, the park also features a restored 1906 pavilion, memorials to wars and the veterans who fought in them, and indoor tropical rainforest exhibit. A prized exhibit is the Nickel Plate Railroad. The display preserves railroad history with a steam-powered locomotive, coal tender, caboose, and informative kiosks.

Chicago

At the intersection of Jackson Avenue and Michigan Avenue is the now famous "End Historic Route 66" sign and Grant Park, the largest park,

and one of the oldest, in Chicago. The park's origins are in an effort by business leaders and citizens in 1835 to preserve a tract of land along the shore of Lake Michigan. The official dedication of Lake Park occurred on April 29, 1844. The current name for the park dates to celebrations on October 9, 1901, commemorating President Ulysses S. Grant.

In 1871, during the period of rebuilding after the Great Chicago Fire, debris dumped into Lake Michigan at the site resulted in expansion to the park's current 319 acres. At its inception, the park had prohibitions against building within its boundaries, but in 1892, an initiative spearheaded by Aaron Montgomery Ward resulted in the issuance of an exemption and the construction of the Art Institute of Chicago.

With the precedent set, exemptions in the years that followed led to the construction of such features as Buckingham Fountain—which was modeled after the Latona Fountain in Versailles, France—in 1927, the Shedd Aquarium, the Field Museum of Natural History, and expansion of the park that allowed for creation of Millennium Park to the north.

Millennium Park, to the north of Grant Park, is a major attraction for Route 66 enthusiasts and tourists of all sorts. *Joe Sonderman*

The park served as the venue for the 1893 World Exposition. Running from May to October, the exposition attracted numbers of visitors equal to half of the United States population at that time. The exposition also served as a catalyst for the park's transition into the city's civic and cultural centerpiece. As a historic footnote, the exposition also introduced numerous firsts including the Ferris wheel, Cracker Jacks, and Pabst beer.

Funks Grove

Located just west of Route 66, Sugar Grove Nature Center preserves one thousand acres of woodlands and the largest intact prairie grove in the state of Illinois. It is also designated a National Natural Landmark by the U.S. Department of the Interior. In addition to interpretive kiosks and exhibits, the nature center features more than five miles of trails and is a destination for bird watchers and wildlife photographers.

Godley

The K Mine Park at Godley is a masterpiece of land reclamation. Utilizing lands devastated by decades of mining, the park features shaded picnic areas, hiking trails, a ballpark, and a gazebo for summer festivities

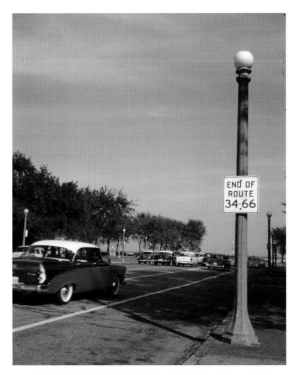

The **eastern terminus** of Route 66 is a landmark destination for enthusiasts. *Joe Sonderman*

Route 66 Park is a favored stop in Joliet. *Steve Rider*

Joliet

Route 66 Park at 920 North Broadway Street in Joliet provides a scenic overlook of the city's historic prison and features an eclectic collection representing the area's rich and diverse arts community. Informational kiosks highlight various Route 66 attractions surrounding the park.

Another park of note is the Billie Limacher Bicentennial Park at 201 West Jefferson Street. Opened in 1976 to celebrate the nation's bicentennial, the park utilized land along the river that had served as the city's first street. Central features are the promenade and a lighted fountain affectionately named Frannie. From the promenade, there are expansive views of the city's historic bridges, as well as various modern art sculptures.

Lexington

Lexington's Route 66 Park is located at the intersection of the original alignment of Route 66 and the bypass alignment built during the 1940s. A section of original Route 66 roadway preserved as a bicycle and pedestrian path is designated Route 66 Memory Lane and connects the park with Lexington one mile to the southwest.

Lincoln

Located directly south of Lincoln and bisected by Route 66 is the Edward R. Madigan State Fish and Wildlife Area. Created in 1971, the 974-acre park was initially called Railsplitter Park and received its current designation in 1995 in honor of Edward R. Madigan, a former Secretary of Agriculture and member of the United States Congress.

Operated by the Illinois Department of Natural Resources, the park serves as a primary hatchery for pheasant. As Salt Creek flows through the park, fishing, canoeing, and kayaking are popular attractions. Mainly a forest preserve, the park contains large stands of hardwoods such as white oak (the state tree) and hickory. Stands of ash, hackberry, black walnut, and American sycamore are also found here.

Mazonia

The Mazonia State Fish and Wildlife Area, consisting of 1,017 acres of parklands, is located three miles southeast of Braidwood on Illinois Route 53 (Route 66) at the former townsite of Mazonia and on reclaimed mining properties. The park's most unique features are the more than 200 water impoundments that range from less than an acre in size to more than thirty acres. The depth of these impoundments varies greatly, as some are flooded quarry or mine pits.

Managed by the Department of Natural Resources, the area serves as a haven for migratory birds and game species and provides sportsmen with fishing opportunities from the banks or from a boat. Additionally, the area is world-famous for the discovery of Pennsylvanian age fossils and is a favored location for fossil hunters.

Romeoville

Isle a la Cache, located one half mile east of Romeoville, is a complex consisting of a museum, trails along the Des Plaines River, picnic areas, and river access for canoeing. The park is used for the annual Island Rendezvous each June, a celebration of life on the island in the eighteenth century. The centerpiece of the park is the Isle a la Cache Museum (discussed under "Pre-1926 Historic Sites") housed in the old Murphy's Restaurant building.

Towanda

The Geographical Journey Parkway preserves a 1.6-mile section of the four-lane alignment of Route 66, built in 1956, as an educational bicycle and pedestrian corridor. Created by volunteers, and by teachers and students from the Normal Community High School, kiosks lining the corridor provide information about each of the eight states through which Route 66 passes. Attesting to the international popularity of the attraction and of Route 66 is the fact that the informational fliers are published in several languages.

Wilmington

Historic Route 66 (State Highway 53) bisects the Midewin Tallgrass Prairie, which was created from eighteen thousand acres of reclaimed and restored lands from the former Joliet Army Ammunition Plant. It remains the largest example of tall grass prairie restoration in North America and the largest tract of land representing the pre-European colonization era in the state of Illinois.

Military

Elwood

The Kankakee Ordnance Works and the Elwood Ordnance Plant were established in 1940 near Elwood, south of Joliet. They were combined as the Joliet Arsenal in 1945 and then deactivated later that year with the end of World War II. With the advent of the Korean War, the plants reopened in 1952 as the Joliet Army Ammunition Plant.

The federal government originally acquired the property for the plants through the process of eminent domain. The government-owned, contractor-operated facilities were the first of sixty munitions manufacturing plants established by the end of 1942. The complex's massive size meant that the owners of 450 farms were ordered to vacate their properties, and ten existing farmhouses were relocated. The facility's contractor maintained the six cemeteries on the land.

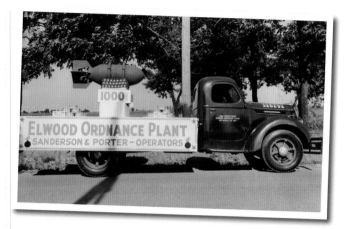

"Swords to plowshares" describes the transformation of the **Elwood** munitions factory complex into the **Midewin National Tall Grass Prairie**. *Joe Sonderman*

The New York based company Sanderson and Porter began construction of the Elwood facility in November 1940, and production of artillery shells, mines, munitions, and bombs at the plant was underway by July 12, 1941. Construction on the Kankakee unit was initiated by the Stone & Webster Engineering Corporation of New York in September 1940, and facility was producing explosives for use in other capacities the following September.

In June 1942, an explosion at the assembly line in the Elwood facility left sixty-eight men dead, missing, or wounded. Reports indicate the explosion was felt more than one hundred miles away.

With reactivation in 1952, the plants manufactured TNT and various ordnances under the control of United States Rubber Company. The Kankakee facility closed in 1957, and the Elwood facility closed in 1965.

The transformation of the **Midewin National Tall Grass Prairie**. *Joe Sonderman*

The facility reopened again shortly after initiation of the conflict in Vietnam, as the Joliet Army Ammunition Plant. Refurbished by the Army Corps of Engineers, the Kankakee unit opened first, in 1965, followed by the Elwood unit a year later.

Production continued until 1976, and site cleanup and transformation commenced several years later. Redevelopment of the site included the creation of two light industrial parks, a landfill, the Abraham Lincoln National Cemetery, a Burlington Northern Santa Fe Railway facility, a Walmart distribution facility, and the Midewin National Tall Grass Prairie.

Crime and Disaster

Benld

On March 29, 1938, a meteorite passed through the roof of a garage belonging to Edward McCain in Benld. It also ripped through the roof of his 1928 Pontiac coupe, the passenger seat cushion, the floorboard, and the muffler. A neighbor, Carl Crum, was standing 50 feet away and witnessed the incident. At the time, the meteorite strike created a sensation. Portions of the car, including the seat cushion and the meteorite, are now on display at the Museum of Natural History in Chicago.

In March 2009, the Benld Elementary School was damaged extensively when the collapse of an abandoned coal mine caused substantial subsidence. Even though the building was only seven years old, the damages necessitated condemnation of the school structure.

Berwyn

On August 13, 1929, Chicago police captured Willie "Baby Face" Doody without incident in front of the apartment building where he resided on West Jackson Boulevard (Route 66). His arrest marked the end of a reign of terror that had commenced in early May of that year.

It began when Doody and an unknown accomplice shot and wounded a postal inspector during a robbery at a Chicago hotel. Three weeks later, he was involved in an armed robbery of a store on Ogden Avenue (Route 66) in Berwyn and the theft of an automobile for a getaway car.

Several days later, Berwyn police officers led by Chief of Police Charles Levy located the stolen car on 21st Street. As the officers approached the vehicle, Doody and his accomplice opened fire, mortally wounding Levy.

On June 18, Doody shot and killed a pharmacist in Oak Park during a robbery. Two nights later, a restaurant owner on the South Side of Chicago died during another robbery orchestrated by Doody.

Doody eventually received the death sentence on October 25, 1929, for the murder of Police Chief Charles Levy. Appeals to the state supreme court resulted in a second trial on April 8, 1931. On June 26, 1931, Doody received a commuted sentence of life in prison. He died in prison on September 29, 1955.

Braidwood

The late nineteenth century was a tumultuous period in mining towns such as Braidwood. Media coverage of several violent incidents brought the community an unsavory reputation.

In April 1876, the election of city officials quickly moved from libelous words and accusations to violence. Fights broke out at the polls. A ballot counter was severely beaten, an angry mob disarmed the town marshal, and a crowd stormed city hall and stole records.

In 1877, miners went on strike demanding better working conditions and higher wages. Mine owners responded by recruiting African American miners from Alabama and Tennessee. As violence and incidents of sabotage increased, the governor sent in troops to restore order and keep the peace.

Two years later, a devastating fire swept through the town's business district. Destroyed in the conflagration were the hotel, several saloons, a gristmill, the railroad depot, a blacksmith shop, and numerous homes.

The cave-in at the Diamond Mine owned by the Wilmington Coal Mining & Manufacturing Company on February 16, 1883, ignited national

sentiment for the institution of child labor laws. Counted among the forty-nine miners killed (forty-six bodies were never recovered) were two boys, thirteen and fourteen years old.

Chicago

Edwin C. Shanahan was the first FBI agent killed in the line of duty. He died in a garage on Ogden Avenue between Adams Street and Jackson Boulevard during an attempt to arrest Martin Durkin on October 11, 1925. Shanahan had received a tip from an informant that Durkin, wanted in several states for automobile theft, would be arriving at the garage with a stolen vehicle.

In addition to automobile theft, Durkin had outstanding warrants for murder and attempted murder in several states. A few months prior, he had shot and wounded three Chicago police officers in an incident on Jackson Boulevard, and before this, he had wounded another police officer in Los Angeles.

Several weeks after the murder of Shanahan, Chicago police acting on a tip attempted to arrest Durkin at the home of his girlfriend's family. In the ensuing gun battle, one officer was left dead and another had life-threatening injuries. Durkin escaped unharmed.

He fled to California after the shooting and resumed his method of operation. Durkin would respond to advertisements for the sale of expensive automobiles, leaving a deposit with the promise to return the following day, and then returning at night to steal the vehicle.

FBI agents finally caught up with Durkin and arrested him in St. Louis on January 20, 1926. He was extradited to Chicago for trial and convicted for the murder of agent Shanahan; he received a sentence of thirty five years.

Between 1970 and 1973, a series of murders occurred in Grant Park at the eastern terminus of Route 66, capping a nearly three-decade-long crime spree. The trial was a media sensation because of the brutality displayed in the murders, including cannibalism, and because of the litany of judicial oversights.

In 1945, twenty-two-year-old Lester Harrison received a sentence of five to ten years for the armed robbery of a Chicago service station. In November of 1951, he murdered his cellmate Norman Kimme, a convicted murderer. The mur-

der led to Harrison's incarceration in the state hospital and a ruling that he was incompetent to stand trial. Incredibly, Harrison received parole at his first hearing.

Between the time of his parole and his arrest for robbery in March 1972, Harrison had eight convictions ranging from larceny and indecent exposure to attempted armed robbery and assault. In addition, he was incarcerated in the state hospital twice and jumped bail upon release.

Harrison received a sentence of eighteen months for the 1972 robbery, but a judge released him based on time served during the psychiatric evaluations. At the time, no one suspected him of being involved in a series of murders that had taken place in Grant Park, beginning with the killing of Agnes Lehman in the bandshell on July 19, 1970.

Three weeks after his release for time served, Harrison was arrested and charged with assaulting Cozetta Gladys in a Chicago alley, but a $5,000 bond secured his release. In July 1973, while the assault trial was still pending, Harrison stabbed Irene Koutros to death in the Grant Park underground garage.

In August of that year, Lee Wilson died of stab wounds in the park, and Judith Ott was stabbed to death in a park restroom. As Harrison fled the scene of the Ott attack, the victim's husband, David, gave chase and tackled him.

After confessing to four of the park murders, Harrison received a sentence of life imprisonment. He was denied an appeal for release based on debilitating medical conditions in May 1986.

Collinsville

Mining disasters and related labor issues plagued Collinsville in the closing years of the nineteenth century and the first decades of the twentieth. Some of the incidents had ramifications far beyond the Illinois village.

The Lumaghi Coal Company's Mine No. 2 was the scene of several disasters. On March 26, 1912, Louis Albie, a seventy-year-old laborer, died after a ceiling of slate collapsed. A similar accident claimed the life of Samuel Alex on October 13, 1917. In January 1916, Carl Althardt died in this mine after an accident involving a loaded pit car. Another pit car accident on October 29, 1923, claimed the life of seventeen-year-old Robert Bertalero.

During the late 1910s, tensions between mine owners, miners, and the United Mine Workers were fueled by anti-German sentiments stemming from the outbreak of World War I and eventually boiled over in an incident that remains a black mark on the American legal system.

The incident began when Robert Prager, an immigrant from Dresden, Germany, applied for membership in the United Mine Workers union at Marysville. He was denied membership because of his ethnicity and the fact that he was "unmarried, stubbornly argumentative, given to Socialist doctrines, blind in one eye, and looked like a spy to the miners."

On April 4, 1918, a group of miners confronted Prager and hinted that his safety was in jeopardy if he chose to stay in Marysville. Fearing for his safety, UMW members Moses Johnson and James Fornero asked the Collinsville police to place him in protective custody, but they refused.

Prager returned to Marysville and prepared a document attacking Fornero and the UMW, which he distributed around town. A mob formed with intent to remove Prager from the area by force.

A Collinsville policeman, Fred Fost, intervened and put Prager into protective custody. Mayor John H. Siegel calmed the crowd and then issued an order for all saloons to close early. However, a new rumor that Prager was in fact a German spy whipped the mob into a frenzy so intense that they stormed the jail, dragged Prager to Mauer Heights, and hanged him.

On April 25, a grand jury indicted eleven men for the murder, and the trial commenced on May 13. The concluding statements of the defense noted that the lynching was justified by "unwritten law." After a forty-five-minute deliberation, the jury returned a verdict of not guilty.

Incredibly, the outcome was received with a number of positive editorials at the time. The *Washington Post* noted that, "In spite of the excesses such as lynching, it is a healthful and wholesome awakening in the interior of the country." J. O. Monroe, editor at the *Collinsville Herald*, also published an editorial praising the verdict: "Outside a few persons who may still harbor Germanic inclinations, the whole city is glad that the eleven men indicted for the hanging of Robert P. Prager were acquitted. The city

does not miss him. The lesson of his death has had a wholesome effect on the Germanists of Collinsville and the rest of the nation."

In March 1923, a heinous murder again placed Collinsville on the front pages of newspapers throughout the nation. The *Lawrence Daily Journal-World* of Lawrence, Kansas reported on the incident:

Piilk Saknwic, 42 years old, this afternoon confessed according to police that shortly before last midnight he shot and killed Joe Pachtorias, dismembered his legs, head, and arms, put the parcels in sacks, and threw them into a creek half a mile from the house in which they lived. The killing followed a quarrel, police quote Saknwic as saying.

Pachtorias' brains were found on the floor of the house, and two human legs found in a sack in the creek were identified as Pachtorias through a scar. Two knives Saknwic is alleged to have used in dismembering the body were found in a cistern.

The creek, which is rain swollen, is being dragged for the rest of the body.

Edwardsville

On June 8, 1961, George York, age eighteen, and James Latham, nineteen, robbed a service station along Route 66 on the west side of Edwardsville and killed the attendant, Martin Drenovac. York and Latham had initiated a cross-country killing spree after going AWOL from Fort Hood, Texas, in May 1961.

Arrested in Tooele County, Utah, on June 10, the two men confessed to the murder of nine people. However, investigators determined that two of their victims had survived.

Charged with robbery, murder, and sexual assault in Florida, Illinois, Tennessee, Colorado, Missouri, and convicted of murder in Kansas, the two men were imprisoned in the Lansing, Kansas, correctional facility and then were executed by hanging on June 22, 1965. As an historical footnote, while on death row, both men associated with Richard Hickock and Perry Smith, the murderers profiled in Truman Capote's book *In Cold Blood*.

Elwood

At 2:45 a.m. on June 5, 1942, the assembly line at the Elwood facility of the Joliet Army Ammunition Plant was obliterated in a blinding explosion. United Press International reported, "Explosion shattered buildings of one of the units of the $30,000,000 Elwood Ordnance plant [and] gave up the bodies of 21 workers Friday. Army officials said 36 more were missing from the blast that could be felt for a radius of 100 miles. Another 41 were injured, five of them critically, from the explosion that leveled a building. Not one of the 68 men inside the shipping unit when the blast occurred escaped death or injury."

Joliet

The viewpoint at Kicks on 66 Park (920 North Broadway) is an excellent place from which to view the famous Joliet Correctional Center. Originally known as the Joliet Prison, the facility has the distinction of having served its original purpose longer than any other correctional facility in the United States. The first inmates incarcerated here arrived in May 1858. The complex closed in 2002.

The original buildings were built with convict labor leased by the state to contractor Lorenzo P. Sanger. Warden Samuel K. Casey utilized limestone quarried on site by prisoners. Large sections of the complex built between this period and 1870 retain their original façades.

During the American Civil War, the prison housed criminals as well as prisoners of war. In this period Joseph Clark became the first officer

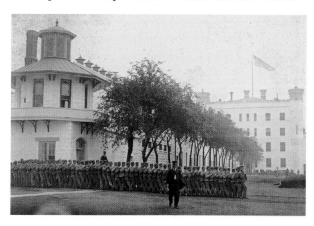

The historic prison in **Joliet** housed some of America's most famous and notorious criminals during its nearly 150-year history. *Steve Rider*

killed in the line of duty at the complex. By 1872, the complex housed 1,239 prisoners and was the largest of its kind in the country. The largest number of prisoners incarcerated here was 1,300 in 1990.

Even though Alcatraz in San Francisco is usually associated with the most famous criminals of the early twentieth century, the prison at Joliet housed a number of infamous individuals. During the 1920s, the most famous duo incarcerated here were Nathan Leopold and Richard Loeb.

Modernization came slowly to the complex. For example, before World War I there were no toilets or running water in the cells. As early as 1917, as construction commenced on the Statesville Correctional Center, there were plans to close the Joliet facility.

A women's facility opened in 1896 directly across the road from the main gate. After closure in 1932, this facility served as a secondary annex for the main prison and as a processing center for northern Illinois prisoners.

Lincoln

The *News Palladium*, Benton Harbor, Michigan, Monday, October 22, 1956:

Two Illinois state policemen were shot early today and one was reported in critical condition after engaging in a gun battle with four heavily armed men.

Officer Glen Nichols, about 35, was shot three times and critically hurt and officer Robert Golightly was wounded once in the roadside gunfight on U.S. Route 66 bypass.

Sheriff William Keys of Logan County said two Joliet, Illinois men were captured, but the two others involved in the fracas eluded police. Keys identified the prisoners as William O. Wilfong, 31, of 351 Western Avenue, Joliet, and Arvid Jopp, 24, of the Edgewater Hotel, Joliet.

Keys said the officers chased an auto carrying the four men after it went through a red light near Lincoln, a central Illinois community. The car stopped near a restaurant and the other four suspects opened fire as the officers drove up, Keys related.

The policemen returned the gunfire but Keys said he did not know if the two who

escaped on foot in opposite directions were wounded. Neither of the captured two were struck by bullets, he said.

Litchfield

In 1867, a large portion of the Litchfield business district burned, and in 1871, a similar fire burned five buildings in the same area. A primary employer, the McPherson Mill burned in a spectacular fire in 1870, and three years later Boxberger Mill burned. In 1893, the Planet Mill, one of the largest flourmills in the country, exploded and burned.

All of these disasters paled in comparison to the one that occurred in 1904. *Moberly Evening Democrat* (Moberly, Missouri) dateline July 5, 1904: "Rushing along at 39 miles per hour, the Exposition Limited on the Wabash due in St. Louis at 7:03 Sunday night, plunged into an open switch one mile from the Litchfield, Illinois station at 5:25 Sunday night and in an instant almost its entire train was completely demolished. Twenty-two persons are known to be killed and thirty-seven injured."

With establishment of Route 66, crime of a transient nature became an issue within the community. *Alton Evening Telegraph*, August 20, 1943, dateline Edwardsville, Illinois: "Stolen early Thursday morning by burglars who broke into a service station adjoining Rut's Corner tavern at Litchfield, Montgomery County, a

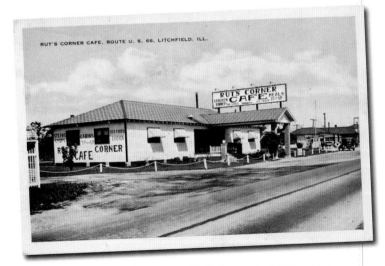

A late-night burglary at **Rut's Corner** in 1943 netted the thieves an almost empty safe. *Steve Rider*

300-pound steel safe was recovered later in the day on a farm east of here, off Route 43, where it had been blasted open and abandoned. Approximately $700 worth of liquor, stored in the service station, was hauled away by the thieves, whose only reward for transporting the safe thirty miles and blasting it open was a meager $45 in cash the strongbox contained."

Normal

On Friday, April 7, 1933, Deputy Charles Adams of the McLean County Sheriff's Department arrived at the grocery store located at 1410 South Main Street (Route 66) to execute an arrest warrant for charges of contributing to the delinquency of a minor, as well as to question a suspect about a robbery in Clinton. The seventeen-year-old suspect had eloped with the storeowner's sixteen-year-old daughter to Indiana. After her father brought her back home, the young man had attempted to visit the girl, resulting in the issuance of the warrant.

A scuffle ensued as a back-up deputy attempted to place the juvenile suspect in handcuffs after disarming him. The assailant produced a second revolver hidden in his sleeve and shot Deputy Adams in the back and leg, and the storeowner in the hand.

Transported to St. Joseph Hospital in Bloomington, Deputy Adams succumbed to his wounds nine days later. The juvenile assailant received a sentence of life in prison without parole after his conviction of first-degree murder.

Pontiac

On August 20, 2013, the *Bloomington Pantagraph* reported, "Police were called Tuesday morning to check the well-being of the occupants of room 239 at the motel, which now serves as a long-term rooming complex on Pontiac's west side. . . . The hotel, 213 S. Ladd Street [Route 66], is next to the Fraher Ford dealership. Employees at the shop said they did not hear or see anything unusual until police and rescue personnel arrived about 11:00 a.m."

The double homicide of a mother and son, and the wounding of another son, rattled the community of Pontiac. In interviews, the police chief worked to allay fears by noting this was a rare and isolated incident.

The faded **Palamar Motel** in **Pontiac** became the scene of a murder in 2013. *Joe Sonderman*

The crime scene was the Palamar Motel, which opened in 1968. At the time of its opening the motel and adjoining supper club where popular bands played attracted weekend customers from Chicago and Springfield.

Romeoville

The museum at Isle a la Cache is located in the former Murphy's Restaurant, which according to historian and author John Weiss, was a frequent hangout for the Al Capone gang. The restaurant opened in the mid-1920s.

Springfield

On August 14, 1908, racial tensions exploded into violence and rioting followed by the alleged rape of a white woman by an African American man, and the murder of an engineer by another African American. Marauding gangs of youth and laborers swept through the largely African American enclaves of the Levee and Badlands district, burning buildings and shooting indiscriminately. Two African American men died by hanging, and several people on both sides of the fracas were killed or wounded from gunfire. To quell the violence and restore order, the governor ordered 3,700 militiamen into the city.

On Sunday, September 25, 1932, tensions between striking coal miners and the coal companies exploded into vicious rioting on the streets of Springfield. While attempting to disarm a rioting miner in front of the Leland Hotel at the corner of 6th and Capitol Streets (Route 66), Detective Sergeant Porter Williams was mortally wounded by a single gunshot to the back. An intense investigation, including a coroner's report that noted the assailant was a very short man, led to the arrest of twenty-five miners. There was never a positive identification of the perpetrator or a conviction made for the murder.

On Monday, July 31, 1933, Detective Ernest Purgatoria responded to a report of a young girl imprisoned in a room at the St. Nicholas Hotel. The report filed by the girl's father indicated that the incident was a kidnapping. When Purgatoria knocked on the hotel room door, the suspect threatened to shoot the first person who came through the door. The accompanying detective returned to the police station, obtained tear gas, and returned to the scene. When Purgatoria kicked in the door, the suspect fired one shot with a high-powered rifle, striking the detective in the chest and killing him instantly. The suspect then escaped using a rope ladder and eluded police officers for several weeks in spite of an intense manhunt.

The castle-styled Illinois State Arsenal, built over a two-year period from 1901 to 1903, dominated the corner of 2nd Street (Route 66 from 1926 to 1930) and Monroe Street. The huge facility served as a venue for a wide array of exhibitions, most notably automobile shows during the 1920s. In 1934, at an estimated loss of $900,000, the arsenal burned. Investigators determined the cause was arson and apprehended ten-year-old Cecil Kiper, who confessed to the crime.

On March 12, 2006, a pair of F2 tornadoes swept through the fringe of the city, causing an estimated $150 million in damages. Thirty-four people were injured but there were no fatalities.

Staunton

In 1917, numerous communities expressed open opposition to America's involvement in the ongoing conflict in Europe. The central part of the country was so vocal in its opposition that President Woodrow Wilson once quipped about the "apparent apathy in the Middle West."

In early 1918, members of the United Mine Workers union decided the time had come to "Americanize" the community of Staunton. The vigilante mob swept through town, stopping at

homes whose owners had publicly voiced opposition to the war and forcing the head of the household to kiss the American flag and sign loyalty pledge cards.

The *Staunton Star Times* reported that "the members of Local Union 755 were to be heartily congratulated on what they accomplished." The *Mount Olive Herald* printed an editorial that congratulated the "super patriots" and warned "in the future anyone with pro-German tendencies will do well to keep their mouths shut."

Virden

A series of memorials in the central park on Virden's town square honor notable events from the town's history. One honors the veterans of World War I, another is dedicated to Officer Mike, a dog, and another commemorates the 1898 Battle of Virden, a pivotal moment in the development of the organized labor movement, dedicated in 2006.

The strike began largely through the activities of Alexander Bradley, who had been involved in the organization of Coxley's Army, a march of unemployed workers down Pennsylvania Avenue in Washington, D.C., in 1894. He assumed the role of primary organizer for the United Mine Workers in central Illinois shortly afterward and initiated a series of meetings in the woods nearby to organize area miners in a nationwide strike that was to commence on July 4, 1897. As a result, when the strike commenced, the coal industry in central Illinois came to a virtual standstill.

Coal companies responded by recruiting African American miners from the South in the late summer of 1898. When striking miners learned of this and the mine companies' plan to reopen the mines on October 5, an estimated 2,000 union miners descended on Virden to prevent the mines from reopening. To protect their property, mine owners had hired former Chicago police officers, veterans, and, according to rumors, armed thugs.

Fearing violence, Sheriff Davenport petitioned Governor John Riley Tanner for troops to help keep the peace. The governor refused and ordered the sheriff to move the strikers to the outskirts of town and then disarm them.

The train carrying miners from Alabama arrived in Virden shortly after noon on October 12. In ad-

dition to guards hired by the mining companies, approximately forty heavily armed Pinkerton detectives were also on the train.

Vandalism that damaged a switch in the rail yard negated orders issued by railroad executives to continue on to Bloomington rather than stop in Virden. As the train slowed, the striking miners descended on the yard, and gunshots fired by an unknown party initiated a pitched battle. The battle intensified as the train reached the mine, and a number of guards in the tower above the mine pit opened fire on the striking miners and their supporters.

Conflicting reports went out over telegraph lines and by telephone. Fueling rumors and conjectures were requests for Springfield,

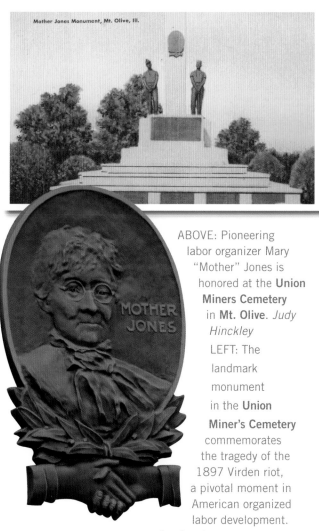

ABOVE: Pioneering labor organizer Mary "Mother" Jones is honored at the **Union Miners Cemetery** in **Mt. Olive**. *Judy Hinckley*

LEFT: The landmark monument in the **Union Miner's Cemetery** commemorates the tragedy of the 1897 Virden riot, a pivotal moment in American organized labor development. *Joe Sonderman*

Mt. Olive, and other communities to send physicians, and for the governor to send in the state militia.

The governor immediately complied, and the first troops arrived the following evening. On October 13, Governor Tanner placed Virden under martial law. Investigators worked to sort myth from rumor, conjecture from fact. Initial reports of eleven killed were confirmed. These included railroad detectives, miners, and a store superintendent. The wounded numbered in the dozens.

It would be early November before the coroner's inquest was complete. Martial law was lifted, and the troops departed, on November 12, 1898. The Virden incident resulted in the creation of the Union Miners Cemetery in nearby Mt. Olive, elevated labor organizer Mother Jones to national prominence, and today is regarded as a pivotal moment in the American labor movement.

Film and Celebrity

Atlanta

Located at 110 Southwest Arch Street, the Palms Grill Café originally opened in 1934 with James Adams as the proprietor. Named for a restaurant Adams enjoyed in Los Angeles, California, the locals referred to it as the "the Grill." After being restored to its original appearance, the café reopened in 2009. The café and its famous pies garnered international attention with the first installment of Billy Connolly's *Route 66* series that debuted in 2011.

Bloomington

The list of celebrities born in Bloomington includes actors, writers, directors, and politicians. Among these are writer Rachel Crothers; director Edward Griffith; actor Patrick Hancock (*Blades of Glory*, *The Cutting Edge*); Cleo Madison, a vaudeville and silent movie star from the

1910s and 1920s; producer K. Gordon Murray; and Forest Taylor, a character actor known for his roles in "B" movies from the 1930s to the early 1960s.

The David Davis Museum State Historic Site, preserved and maintained by the Illinois Historic Preservation Agency, is located at Clover Lawn. The home was built for U.S. Supreme Court Justice David Davis at 100 Monroe Drive. Before serving on the bench of the highest court in the nation, Davis rode the circuit as a judge and attorney often in accompaniment of Abraham Lincoln.

Braidwood

The Braidwood Inn at 140 South Hickory, operating as the Sun Motel as of 2012, was featured prominently in the 1987 film *Planes, Trains, and Automobiles*. In this film, Neal Page, played by Steve Martin, and Del Griffith, played by John Candy, share a motel room in Wichita after a delayed and rerouted flight.

Carlinville

In the late 1850s, Carlinville garnered national headlines when two of the nation's leading orators spoke here. In August 1858, Abraham Lincoln delivered a speech here during his campaign for U.S. Senate. The speech given by his opponent in the senate race, Stephen A. Douglas, made headlines for reasons unrelated to his oratory skills. During the speech, the politically charged atmosphere ignited and several fistfights erupted, one of which resulted in John Duff losing an eye.

Charles Robertson, a highly acclaimed entomologist, was born in Carlinville. He published *Flowers and Insects* in 1928, a seminal work on bee species in the United States.

Novelist Mary Hunter Austin is also a native.

Chicago

The Buckingham Fountain in Grant Park appears in the opening credits of the television comedy *Married . . . with Children*. South of the fountains is the ball diamond where Rob Lowe and James Belushi played softball in the movie *About Last Night*.

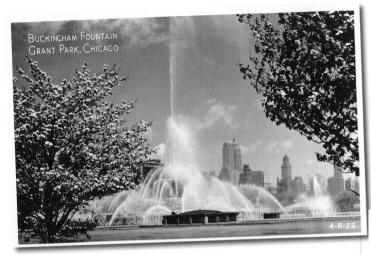

Grant Park and its historic fountain are associated with everything from the television show *Married . . . with Children* to murder. *Joe Sonderman*

Collinsville

Collinsville is the hometown of a number of sports celebrities. Art Fletcher, born here in January of 1885, signed with the New York Giants baseball team in 1909. As the team's regular shortstop he played in four World Series (1911, 1912, 1913, and 1917). His claim to fame was as the Giants' leader for being hit by pitches, rather than his career batting average of .277. Traded to the Philadelphia Phillies in 1920, he remained with this team until his retirement after the 1922 season. He then accepted the position as the Phillies' manager in 1923, a role he held until 1926. The following year he commenced a nineteeen-year stint as a coach with the New York Yankees. After Fletcher's death from a heart attack in 1950, the Collinsville High School field was renamed Arthur Fletcher Field in his honor. It is also the home field for the town's American Legion team.

Kevin Stallings, head coach of the Vanderbilt University men's basketball team since 1999, was also born in Collinsville. He graduated from Collinsville High School in 1978, where he played guard for four years that included three conference championships. Before assuming his position at Vanderbilt, Stallings served as an assistant coach at Purdue University and Kansas University and as head coach at Illinois State University.

Dwight

The Pioneer Gothic Church at 201 North Franklin Street, one block south of the Route 66 corridor on East Waupansie Street, dates to 1858. The future King Edward VII of England, then the Prince of Wales, attended services here while on a hunting trip to the area in 1860.

In 2007, the Association of Illinois Architects named this church as one of the state's top 150 architectural treasures. It is also listed on the National Register of Historic Places.

East St. Louis, Illinois, has a surprisingly lengthy celebrity association. *Steve Rider*

East St. Louis

East St. Louis has a lengthy association with celebrities, sports figures, artists, and politicians who were born or raised here. The list includes jazz musician Miles Davis, who spent his childhood in the city; Richard Durbin, a U.S. Senator from Illinois; poet Robert Wrigley; choreographer and dancer William Dollar; anthropologist Katherine Dunham; musician Russell Gunn; and Walter Boyne, director of the National Air and Space Museum.

Edwardsville

The Wildey Theater at 250-254 North Main Street initially opened as an Independent Order of Oddfellows (IOOF) hall and theater on April 12, 1909. Named for Thomas Wildey, a founder of the IOOF, the three-story masonry structure was designed by the architectural firm of G. H. Kennerly of St. Louis and built at a cost of $30,000. It

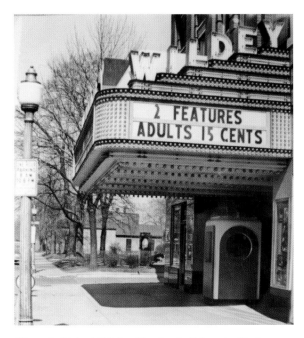

The refurbished **Wildey Theater** in **Edwardsville** is a cornerstone of the area's renaissance. *Joe Sonderman*

originally featured a formal meeting room on the third floor, a small theater on the second floor, and a large auditorium at ground level.

The Wildey Theater served as the primary venue for vaudeville productions and as a community center. The list of celebrities that performed here includes Al Jolson, Douglas Fairbanks Jr., and Eddie Cantor.

Shortly after its opening, the auditorium underwent remodeling that included the addition of a movable screen and projection booth. In 1927, the theater was upgraded to allow the showing of "talking pictures" with the first feature being Al Jolson's *The Jazz Singer*.

In 1937, extensive remodeling replaced the Victorian décor with art deco styling. The theater continued in operation until 1984. In 1999, the city bought the property and initiated fundraising efforts for the theater's restoration. The Wildey Theater became a performing arts center utilized for a variety of live performances.

Elkhart

The Elkhart Cemetery is widely known for its unique headstones, historic markers, and the beautiful Gillett Memorial Chapel built of locally quarried stone. The cemetery is also the final

resting place for two nineteenth-century celebrities. Richard Oglehurst, a close friend of Abraham Lincoln and the only governor of Illinois elected three times, is buried here, as is Captain Adam Bogardous, an original member of the Buffalo Bill Cody Wild West Show and a trap-shooting world champion.

Joliet

The historic Joliet Correctional Center that closed in 2002 served as a location for the filming of several movies and television programs. The most famous of these is 1980's *The Blues Brothers* starring John Belushi and Dan Aykroyd. Other films shot here include *Charley Varrick* (1973), *Red Heat* (1988) starring Arnold Schwarzenegger and James Belushi, *Natural Born Killers* (1994), and *Derailed* (2005). The film *The Babe* (1992) features the ornate lobby of the historic Rialto Theater at 102 N. Chicago Road (Route 66) in a

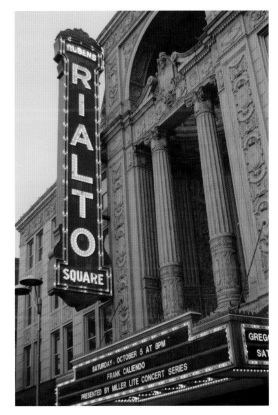

The historic **Rialto Theater** in **Joliet** is a distinctive landmark that has appeared in numerous movies.

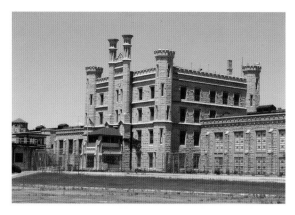

In addition to its role in the criminal justice system, **Joliet Prison** has served as a set for the filming of several movies and television programs.

In **Pontiac**, a colorful mural commemorates the city's association with the **Chautauqua Assemblies**.

scene that shows Babe Ruth getting a first taste of life on the road as a major league baseball player.

Television programs that utilized the prison as a filming location include *Get Smart* (season 2, episode 14 in 1966); the first season of *Prison Break*; *Bones* (season 2, episode 12); and 2006's *Let's Go to Prison*.

The prison also has musical connections. The first recorded song about the prison was "Joliet Bound" by Memphis Minnie in 1932. Other musical references can be found in Steve Goodman's "Lincoln Park Pirates" and Bob Dylan's "Percy's Song."

The list of celebrities born in Joliet includes professional football player Michael Alsott; actors Anthony Repp, Mike Sorenson, and Vince Vieluf; and Mercedes McCambridge, a radio celebrity who did the memorable voiceover for the demon child in *The Exorcist*.

Pontiac

Chautauqua Park is named for the Chautauqua Assemblies, which were first celebrated in Pontiac in 1898. Initially the Chautauqua movement, which began on the shores of Lake Chautauqua in New York in 1874, was a religious movement, but it quickly morphed into a multifaceted event that included educational as well as entertainment programs.

A. C. Folsom spearheaded the development of the movement in Pontiac and in conjunction with civic leaders in the city organized the first assembly at Buck's Pasture. Using funds derived

the sale of stock in the event, he purchased the property, built a pavilion, and cleared brush.

Numerous celebrities participated in the Chautauqua Assemblies during the course of its thirty-two-year history in Pontiac. Among them were William Jennings Bryan, Samuel Gompers, Booker T. Washington, and evangelist Billy Sunday.

In addition to informative lectures, the events would include stage plays, pageants with more than 300 performers, and displays from leading businesses and manufacturers. Indicative of the event's popularity, a pavilion was built on the site to accommodate 2,000 people and was expanded to 4,500 seats within a few years. At its peak, estimates are that 65,000 people attended during a season.

With the advent of motion pictures and radio, the popularity of the two-week event began to fade. By 1930, organizers for the event deemed it no longer feasible nor profitable.

The refurbished park is an integral component in the city's revitalization. A colorful mural in the historic district just off Route 66 commemorates the Pontiac Chautauqua Assembly.

Riverside

Riverside's celebrity and film associations are both lengthy and obscure. Though actually filmed in Vancouver, the 2004 film *Christmas with the Kranks* is set in Riverside. A home on Riverside Road, the former Henniger's Pharmacy,

and the railroad depot appear in scenes from *The Lake House* (2006), and the community served as the primary filming location for the made-for-TV movie *In the Company of Darkness* (1993).

Riverside is also the hometown for a number of celebrities, including gangsters Frank Nitti and Claude Maddox, championship bowler Harry Lippe, former Illinois State Treasurer Judy Topinka, and Johnny Kerr of the Chicago Bulls.

Sherman

Located at 10875 Prairie Home Lane is the former home of Lafayette Funk, cofounder and director of the Chicago Union Stockyards, and an Illinois State Senator. Built in 1864, the refurbished home preserves Funk family memorabilia, antiques associated with the family, and one of the earliest extant examples of an electric kitchen.

The actor Christopher Stapleton was born in Sherman on February 18, 1971. He has appeared in numerous films, the most notable of which was *The Bucket List*, as well as on television.

Springfield

The most notable person associated with the city of Springfield is Abraham Lincoln, as evidenced by the many related sites, including his home, presidential library, and tomb.

An additional presidential link with the city occurred on February 10, 2007, when then-Senator Barack Obama announced his candidacy for president while standing on the grounds of the Old State Capitol. On August 23, 2008, with the Old State Capitol again as his backdrop, he announced that Senator Joe Biden would be his running mate.

The list of film, stage, and music celebrities associated with Springfield includes minor as well as major stars, directors, and musicians. Among them are Brad Booker, visual effects master for such films as *The Lord of the Rings: The Two Towers*; June Christy, the singer who replaced Anita O'Day in the Stan Kenton Band in 1945; actress Leslie Farrell of *Snow White and the Three Stooges*; and actress Dianne Travis, who is also an acclaimed western rider and horsewoman. Authors John Clifford, Arik Martin, Brendon Small, and Stephen Verona are also from Springfield.

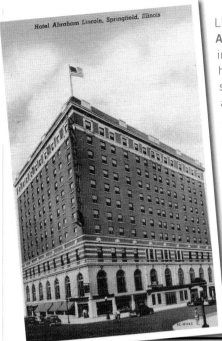

LEFT: The **Hotel Abraham Lincoln** in **Springfield** has hosted movie stars, presidents, and royalty. *Joe Sonderman*

BELOW: **Springfield** has associations with everything from presidents to obscure movies.

Artist Bob Waldmire was born in St. Louis in 1945 but his family relocated to Springfield shortly after his birth. His father, Edwin, invented a breaded and deep-fried hot dog on a stick dubbed the Cozy Dog, and established a small and now-iconic drive-in in the city from which to sell them.

Bob Waldmire was a prolific and gifted artist known for intricate pen and ink drawings as well as colorful murals. Beginning in the early 1980s, Waldmire began creating postcards and posters depicting Route 66 locations and business, and in the process helped spark renewed interest in the highway and its history. In 2004, Waldmire received the John Steinbeck Award in

recognition of contributions to the preservation and promotion of Route 66. He died of pancreatic cancer on December 16, 2009.

A cursory nod to Waldmire's role in developing the modern era on Route 66 is in the Pixar movie *Cars*. Waldmire, who traveled extensively in a 1972 Volkswagen bus, served as the inspiration for the Fillmore character.

Transitional Sites

Auburn

Two historically significant segments of pre-1931 Route 66 (now State Highway 4) can be found immediately to the north of Auburn. One is a

This 1.5-mile section of brick-overlay roadway near **Auburn** served Route 66 until 1932.

1,277-foot section of 16-foot wide roadway of Portland cement that dates to 1921, and the second, a 1.5-mile section of this roadway that was overlaid with red brick in 1932. These segments originally served as part of the roadway for State Route 4 and were incorporated into the course for U.S. 66 with certification of that highway in 1926. This section of highway also features two original single-span concrete bridges built in 1920.

Carlinville

Approximately three miles southeast of Carlinville along Deerfield Road (Route 4 and Deerfield Road) remains an early alignment of state highway that also served as the initial course for Route 66. Dating to 1920, the primary point of interest is a bridge over Honey Creek, currently closed to vehicular traffic.

Cayuga to Chenoa

The 18-mile segment of highway from Cayuga to Chenoa reflects a broad illustration of Route 66 engineering and development through the years. The original pre-1926 roadway that initially served as the course for Route 66 also served as the foundation for the construction of a modern limited-access four-lane highway in 1943 and 1944. This roadway remained in use as U.S. 66 until the advent of the interstate highway and the resultant bypass. A rare component of this stretch of roadway is the retention of six historic bridges.

Cotton Hill

Remnants from every era of Route 66 development as well as predecessor highways and trails can be found southwest of Springfield. The creation of Lake Springfield in 1933 necessitated realignment or abandonment of these segments.

One of the earliest alignments currently signed as Cotton Hill Road is a residential and rural roadway that dead ends on the lake shore. Originally, this alignment passed through the historic community of Cotton Hill.

Girard to Nilwood

Built in 1920 as part of State Route 4, this segment, surfaced with Portland cement, carried Route 66 traffic until 1930. The roadway retains its historical integrity with five original concrete box culverts and a single-span concrete bridge built in 1920.

Joliet to Wilmington

Currently designated Illinois Route 53, the 15.9-mile segment of roadway between Joliet and Wilmington originally dates to the period 1920 to 1922, when it served as the course for state highway 4. With establishment of the Kankakee and Elwood ordnance plants, the roadway was upgraded with funding through the Defensive Highway Act of 1941, legislation that would serve as an evolutionary component in the development of the interstate highway system in the 1950s.

These upgrades included construction of a limited-access four-lane divided highway. Added to the original roadway were a foundation of gravel and stone, and then, a 10-inch thick Portland cement slab.

In the postwar years, this segment of roadway served as Alternate Route 66, a bypass of the main alignment that ran through the congested

The **Ruby Street Bridge** in **Joliet** served as the primary Route 66 river crossing until 1933. *Steve Rider*

center of Joliet. It continued in use as such until the completion of I-55 and the resultant bypass in 1957, but the general character of the road from the 1940s remains intact.

Lexington

In Lexington, an original alignment of Route 66 is preserved as Memory Lane, a walking and bicycle corridor adorned with reproduction billboards. The one-mile path connects with the 1940s era four-lane bypass segment at a small park. Vintage billboards present the corridor as it would have appeared in the 1940s.

Litchfield to Mt. Olive

As with the segments between Cayuga and Chenoa and between Joliet and Wilmington, this portion of the highway has origins in the pre-1926 State Route 4 roadway. Likewise, it also underwent a major transformation during the early 1940s. The resultant four-lane, limited-access highway that utilized the newly constructed roadway for northbound lanes and the modified older roadway for southbound lanes underwent further modification in 1954 and 1955. This portion of the highway remained open until completion of the interstate highway in 1957.

Springfield

Dating to 1922 and in use until 1936, a quarter-mile segment of highway in Carpenter Park initially served as the course for Route 4 before its incorporation into the U.S. highway system as Route 66. As a result of its early abandonment as a roadway, it retains most of its original engineering features. These include a 16-foot roadbed paved with a mix of cement and gravel. In addition, there are 4-inch curbs and the abutments for the Sangamon River Bridge, which was dismantled in 1936.

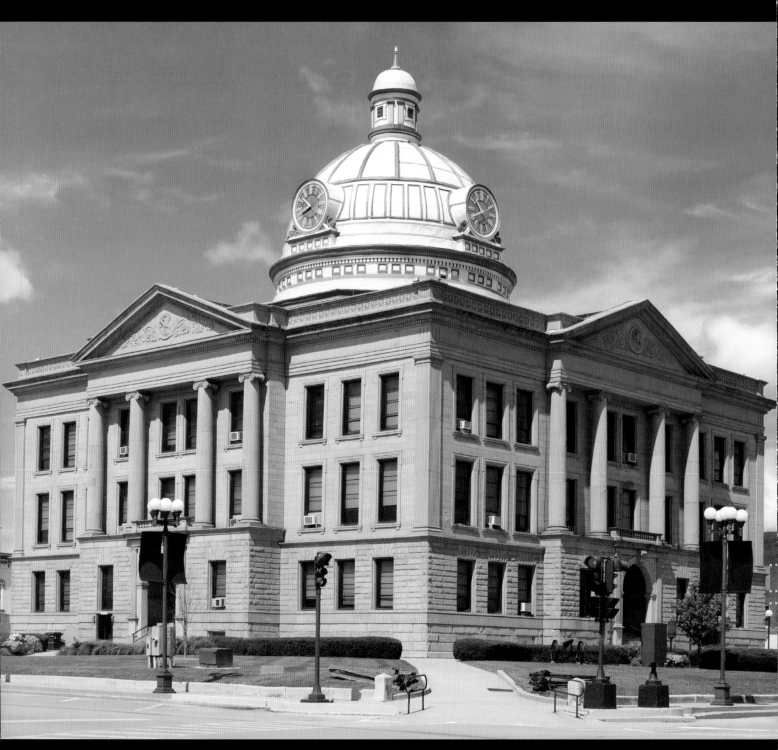

Logan County Courthouse in **Lincoln.** © *iStock.com/ghornephoto*

ILLINOIS

- Crime and Disaster
- Film and Celebrity
- Transitional Sites

Springfield, home to Leslie Farrell of *Snow White and the Three Stooges,* among others. *Page 41*

The **Chautauqua Assemblies mural** in **Pontiac.** *Page 40*

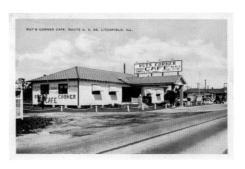

Rut's Corner in **Litchfield.** *Page 34*

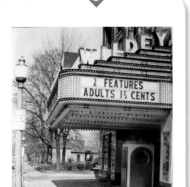

Wildey Theater in **Edwardsville.** *Page 39*

74
Normal
Shirley
Bloom
Atlanta
155
Lawndale
Broadwell
Lincoln
Williamsville
Elkhart
Sherman
66
Springfield
Chatham
Glenarm
Divernon
Farmersville
Waggoner
Litchfield
55
Mt. Olive
Staunton

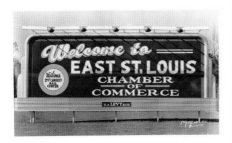

East St. Louis, where many celebrities have been born or raised. *Page 38*

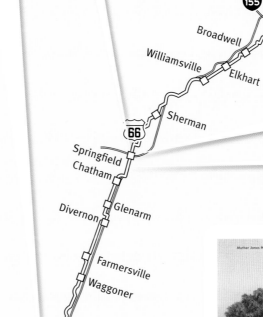

Union Miner's Cemetery in **Mt. Olive.** *Page 36*

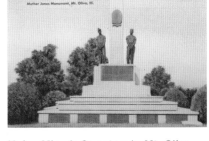
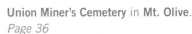

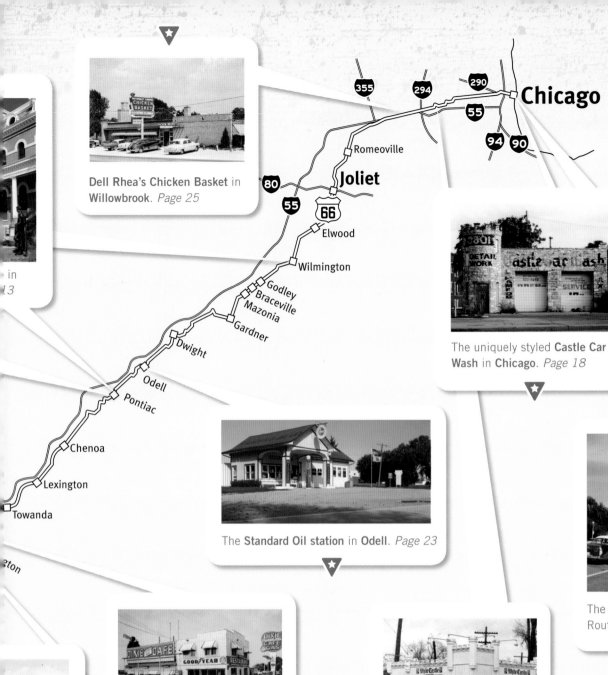

Chicago

355 294 290 55 94 90

Romeoville

Joliet

80 55 66

Elwood

Wilmington

Godley
Braceville
Mazonia
Gardner

Dwight

Odell

Pontiac

Chenoa

Lexington

Towanda

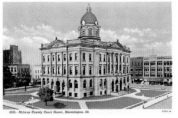

Dell Rhea's Chicken Basket in **Willowbrook**. *Page 25*

in
13

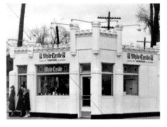

The uniquely styled **Castle Car Wash** in **Chicago**. *Page 18*

The **eastern terminus** of Route 66. *Page 26*

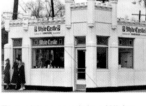

The **Standard Oil station** in **Odell**. *Page 23*

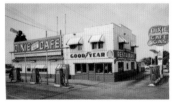

The **Dixie Truckers Home** in **McLean**. *Page 22*

The oldest surviving **White Castle** in **Berwyn**. *Page 16*

ounty
n. *Page 12*

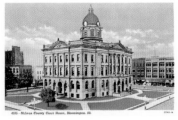

The **McLean County Courthouse** in **Bloomington**. *Page 8*

ILLINOIS

Pre-1926 Historic Sites

Landmarks

Parks

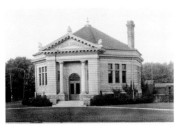
The **octagonal library** in **Atlanta**. *Page 8*

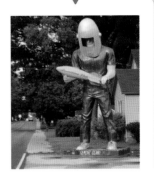
The **Gemini Giant** in **Wilmington**. *Page 26*

The **courthous** **Pontiac**. *Page*

The **Cozy Dog Drive-In** in **Springfield**. *Page 24*

The **Log Cabin Restaurant** in **Pontiac**. *Page 24*

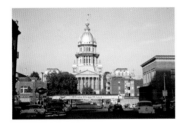
The **Old Illinois State Capitol** building in **Springfield**. *Page 15*

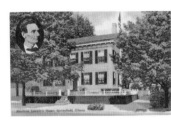
Abraham Lincoln's home in **Springfield**. *Page 15*

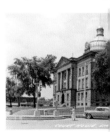
The historic **Logan C** **Courthouse** in **Linco**

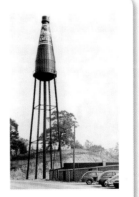
The **water tower** in **Collinsville**. *Page 19*

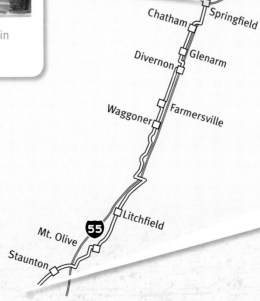

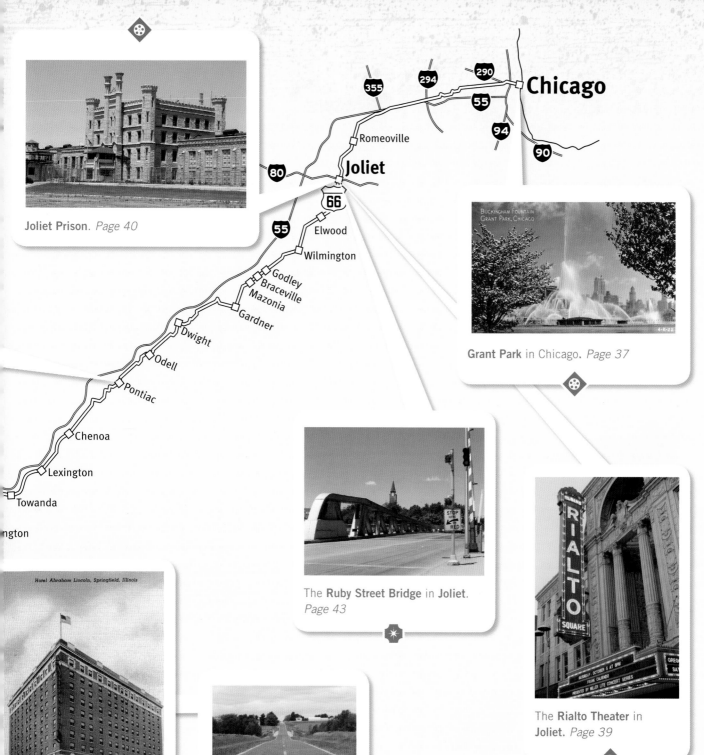

Joliet Prison. *Page 40*

Grant Park in Chicago. *Page 37*

Chicago

Romeoville

Joliet

Elwood

Wilmington

Godley
Braceville
Mazonia

Gardner

Dwight

Odell

Pontiac

Chenoa

Lexington

Towanda

...ngton

The **Ruby Street Bridge** in **Joliet**.
Page 43

The **Rialto Theater** in
Joliet. *Page 39*

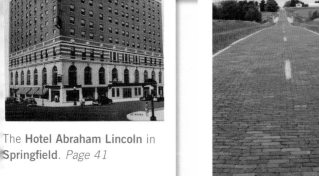

The **Hotel Abraham Lincoln** in
Springfield. *Page 41*

A segment of pre-1931
Route 66 near **Auburn**.
Page 42

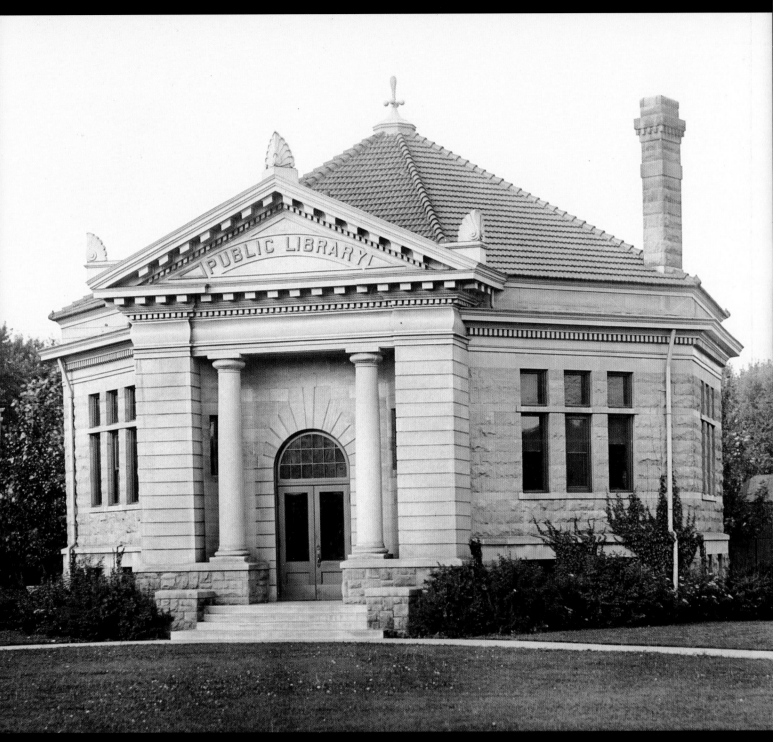

The unusual octagonal library in **Atlanta** dates to 1908. *Joe Sonderman*

InsatiableWanderlust/Shutterstock

ROUTE 66

Missouri

Pre-1926 Historic Sites

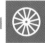

Bridgeton

As the site of a ferry crossing by 1842, and later a bridge, on the Missouri River, the community of Bridgeton on the post-1936 alignment of Route 66 prospered. The community's history, however, has taken several interesting turns. The town site was first platted during the time of French occupation in 1794. The settlement was initially called Marais de Liards. During the brief period of Spanish association, it became Vila a Robert. After acquisition by the United States, it was originally called Owen's Station, a reference to the river ferry.

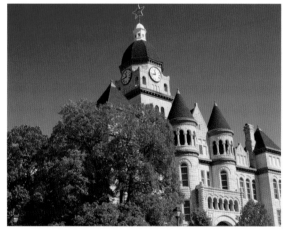

The **Jasper County Courthouse** in **Carthage** is an architectural masterpiece built in 1895.

Carthage

Built in 1895, the stunning Jasper County Courthouse in Carthage dominates a town square listed on the National Register of Historic Places. It was designed in a Romanesque Revival style by acclaimed architect Maximilian Orlopp Jr. and constructed using locally quarried limestone and marble. The courthouse is the second-most photographed man-made site in the state of Missouri.

The **Old Courthouse** in **St. Louis** is a distinctive structure and was the site of the infamous Dred Scott case in 1847.

St. Louis

Construction of the Old Courthouse commenced in 1839, but the structure was not fully completed until 1862. In 1847, the first of three trials in the landmark Dred Scott case took place here. The courthouse has a distinctive dome and was once the tallest building in the city.

Completed in 1834, the Basilica of St. Louis received the basilica designation with a proclamation by Pope John XXII in 1961. The structure survived two city improvement projects that had called for demolition: the Jefferson National Expansion Memorial and construction of the 3rd Street Expressway.

The courthouse and the basilica were the only two historic buildings in the city's originally platted district that were spared demolition during construction of the Jefferson National Expansion Memorial. As part of the memorial, a greenway between Market and Chestnut Streets connects the courthouse with the center green under the Gateway Arch.

The official opening ceremony for the Eads Bridge spanning the Mississippi River at Laclede Landing took place on July 4, 1874. Because the structure was the largest arch bridge ever constructed at the time, and as it marked the first use of structural alloy steel in a bridge project, there

The **Basilica** of **St. Louis** was completed in 1834.
Joe Sonderman

was a great deal of public apprehension about the road/railway bridge's safety. To alleviate concerns, John Robinson led a circus elephant across the bridge on June 14, 1874. This stunt and the opening ceremony filled the front pages of papers throughout the world. After extensive refurbishment, the bridge remains an important river crossing. It also serves as a crossing for the metro air rail line.

The 1904 World's Fair was the catalyst for construction of the Jefferson Hotel at the corner of Twelfth and Locust Streets. It was at this eight-hundred-room hotel in 1925 that federal and state representatives met and assigned numbers to the new federal highway system roadways, including U.S. 60 for the highway connecting Chicago with Los Angeles, a road later signed as U.S. 66. The hotel remained in business until 1975. After a period of abandonment, it was refurbished and reopened as a retirement community.

Built for the 1904 World's Fair, the **Jefferson Hotel** is a historic landmark in **St. Louis**.

Landmarks

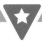

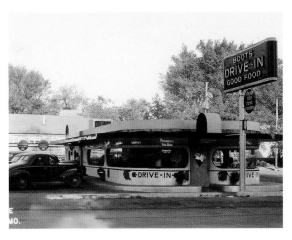

An often-overlooked landmark is the former **Boots Café** in **Carthage**. *Joe Sonderman*

Carthage

Arthur Boots built the recently refurbished Boots Court that dates to 1939 at the intersection of U.S. 66 and State Highway 71. Initially the property also included a service station at the front, but the station was removed in 1948 to allow for expansion of the complex. Shortly thereafter, a gabled roof replaced the original flat roof in an effort to present a more modern appearance. A renovation commenced in 2012, and the following year additional restoration projects were underway on the original roofline and the neon sign.

Established by F. Naramore and W. D. Bradfield, the 66 Drive In Theater opened on September 22, 1949, with the showing of *Two Guys from Texas*. The theater remained in operation until 1985. After its closure, a salvage yard opened on the site. The property was later acquired and refurbished by Mark Goodman, and the theater reopened on April 3, 1997. During the 2013 Route 66 International Festival in Joplin, Missouri, the drive-in hosted a special showing of the animated classic *Cars* and an appearance by Michael Wallis, the voice of the sheriff in that film. Tickets for the event sold out within eight hours of announcement.

Cuba

The Wagon Wheel Motel was built in 1936 as a motel, service station, and café complex by master stonemason Leo Friesenhan, and it remains as a unique and popular Route 66 stop. Added to the National Register of Historic Places in 2003, the motel complex underwent extensive renovation and restoration after it was purchased by Connie Echols in 2009. The refurbished motel and café that now houses Connie's Shoppe exemplify the modern era on Route 66. The complex is also a foundational component in the city of Cuba's redevelopment, indicating the famous highway's role as an economic catalyst for communities along its path.

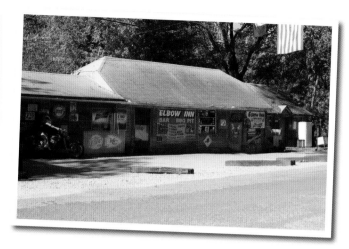

This roadhouse in **Devils Elbow** began as the Munger Moss restaurant in 1936.

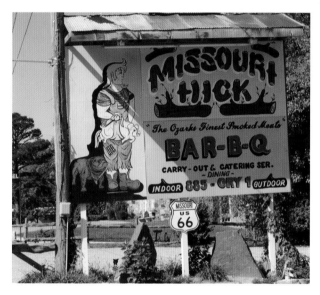

Missouri Hick in **Cuba** is a landmark of the modern era on Route 66.

Devils Elbow

Devils Elbow, including the 1923 steel truss bridge over the Big Piney River, received inclusion in the state planning commission's listing of Seven Beauty Spots in Missouri in 1941. This segment of pre-1943 Route 66—with the vintage bridge still intact, and with the Elbow Inn and BBQ that initially opened in 1936 immediately to the east—remains one of the most beautiful segments of this highway in the state.

Another Route 66 landmark located here is Miller's Market, established in 1954 and also housing the post office. Miller's took the place of the large two-story store (building still standing) built by Charles McCoy in 1941. In addition to selling fishing tackle and sporting goods, McCoy's was also a dry goods store. Six small rooms were available for rent on the second floor.

Fanning

Mary and Serafino Vitali established the original Fanning store on Route 66 in 1930. By the end of the decade, the complex had expanded to include the Fanning Social Club, and the Speedway Garage established by Mary's brother, Joe. The store remained in business until 1972 and was demolished in 1982.

The Fanning Outpost General Store was built on the site shortly thereafter. Featuring an indoor archery range, a display of products from area wineries, and a gift shop, the quirky store encapsulates the essence of the classic Route 66 roadside attraction. Enhancing that feel is the 44-foot tall rocking chair in front of the store. The giant rocking chair is now a popular photo stop and was featured in several films, including a Route 66 video series starring comedian Billy Connolly. It also figures prominently in a popular fundraising program. In 2008, civic leaders in nearby Cuba, Missouri, initiated the Route 66 Race to the Rocker to raise money for children's charities, including Backpacks for Kids, scholarships, and development of the Rails to Trails program.

Joplin

In August 2013, the city of **Joplin** unveiled a series of new murals. *Judy Hinckley*

Kirkwood

William Spencer and his wife, Irene, opened Spencer's Grill on Route 66 in Kirkwood on October 14, 1947. Thanks to the busy traffic on Route 66, business was brisk enough to warrant a twenty-four-hour-a-day operation. In 1948, the café was remodeled and expanded. Many of its current features, including many fixtures and the neon sign with clock, are originals from this period.

Spencer's Grill in **Kirkwood** opened on October 14, 1947. *Joe Sonderman*

Lebanon

With the bypass of the Devils Elbow segment of Route 66 in 1943, Jesse and Pete Hudson sold the Munger Moss Sandwich Shop and relocated to Lebanon, Missouri. In 1946, they built the fourteen-unit Munger Moss Motel, which evolved and expanded as profits allowed.

The **Street Car Diner** in **Lebanon** was a favored stop for travelers. *Steve Rider*

The ruins of **John's Modern Cabins** near **Rolla** are a popular photo stop.

In 1971, Bob and Ramona Lehman bought the complex, then consisting of fifty-eight rooms. Under their ownership, the well-maintained rooms and recently refurbished neon signage, which dates to 1955, further ensure that the Munger Moss remains popular among Route 66 enthusiasts.

Pacific

James and Bill Smith built the Red Cedar Inn along Route 66 in 1933 from logs cut on the family farm. It was the third of three taverns with restaurants the brothers built, with the other two

The **Red Cedar Inn** in **Pacific** opened in 1934.
Joe Sonderman

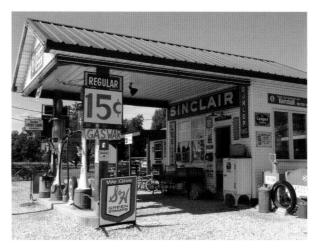

Gay Parita at **Paris Springs Junction** is a recreated time capsule. *Judy Hinckley*

located in Fenton and Eureka. The business in Pacific was so successful that the inn was expanded in 1935. It remained active as a family-run operation until 1972.

After its closure in 1972, the property remained vacant until 1987 when James Smith III, grandson of James Smith, reopened the business. In April 2003, its historical significance garnered inclusion in the National Register of Historic Places. The restaurant building has served a variety of purposes in the past decade, including as an office for a used car dealership. As of this writing, the dormant facility is listed for sale.

Paris Springs Junction

For almost a century, travelers, and even cartographers, have confused Paris Springs with Paris Springs Junction. The town of Paris Springs was established in 1870 and was located approximately one half mile to the north of the junction. By 1926, the once-prosperous community that included a chair factory and sawmill, and wool mill, had declined precipitously. When the establishment of Route 66 bypassed the community, it was completely abandoned; Paris Springs is now a complete ghost town.

A few entrepreneurial and visionary businessmen established enterprises at the junction, which gave rise to Paris Springs Junction. Fred Mason and his wife, Gay, established a cobblestone garage and service station, as well as a fieldstone home, there in 1930. Dubbed Gay Parita by Fred, the business remained a profit-

able partnership until 1953, the year Gay died. In 1955, the service station burned to the ground and Fred retired.

Route 66 aficionados Gary and Lena Turner purchased the property, refurbished the original garage into a quasi-museum, and re-created the old Sinclair station into a circa-1930 time capsule. Turner's infectious enthusiasm and friendly demeanor, as well as the attention to detail in the property's refurbishment, make the modern incarnation of Gay Parita popular among Route 66 enthusiasts.

Rolla

Located eight miles west of Rolla, the tumbledown complex overgrown by the encroaching forest and signed as John's Modern Cabins seems an unlikely landmark. However, these picturesque ruins are a favored stop for travelers on the historic 66.

Established by Bill and Beatrice "Bessie" Bayless in 1931 as a complex consisting of a roadhouse and six cabins under the name Bessie's Place, it proved a profitable enterprise. In late 1950, John Dausch purchased the property, renovated the cabins, and operated the business as John's Modern Cabins. With the establishment of more modern motels in the immediate area, the rustic facility began to decline in popularity in about 1960. After Dausch's death in 1971, the cabins were abandoned and left at the mercy of vandals and the elements.

Spencer

Having learned of plans for a new highway, Sidney Casey bought the entire town of Spencer, which consisted of a vacant store and two acres of land, for a reported $400 in 1925. The town itself dated to the establishment of Johnson's Mill on Turnback Creek in about 1866. A picturesque pony truss bridge built in 1923 currently spans this waterway immediately to the east of modern Spencer.

With the flow of traffic on Route 66, Casey's enterprise consisting of a service station, café, barbershop, and garage flourished. However, the realignment of U.S. 66 in 1961 to bypass the narrow bridge wholly eliminated business. The Francis Ryan family acquired the property in 2011 and refurbished the façades to their 1930s appearance. There are plans to restore the small complex of buildings.

Springfield

Shortly after Hillary and Mary Brightwell purchased Richard Chapman's service station in 1947, they established the Rest Haven Court on the property. In 1952, construction of ten additional cottages brought the number of units to fourteen. With completion of ten more cottages in 1955, and the relocation of the service station building to the rear of the property to serve as a storage facility, the motel assumed its current configuration. Enclosure of the garages completed the transition. The 1954 edition of the *Western Accommodations Directory* published by AAA noted that this was a "very nice court." Amenities mentioned included attractive landscaped grounds, thermostatically controlled floor furnaces, television, gift shop, and tiled shower combination baths. The Rest Haven Court sign was designed by Hillary Brightwell in 1953 and is the inspiration for a similar sign erected by Pete Hudson at his Munger Moss motel in Lebanon. Exceptional care as well as recent renovations and upgrades to the complex make Rest Haven Court a special treat.

Another Route 66 landmark motel in Springfield, the Best Western Rail Haven Motel, evolved in direct correlation with the highway. Established by Lawrence and Elwyn Lippman in 1938 as the Rail Haven Cottage Camp, the complex initially consisted of eight stone cabins surrounded

The **Best Western Route 66 Rail Haven** in **Springfield** opened in 1938 as Rail Haven Cottage Camp.

by a picturesque rail fence. The *Directory of Motor Courts and Cottages* published by AAA in 1940 indicates that almost from its inception the complex was in a state of flux. "Rail Haven Cottages on U.S. 65 and City Route 66 and 66, corner of St. Louis Street and Glenstone Boulevard . . . 16 thoroughly modern stone cottages, all with showers; nicely furnished; automatic safety controlled gas heat; well ventilated, insulated against heat and cold. Very good beds. Rates $2.50 to $4.00 per person. Porter and maid service. Night watchman. Laundry facilities. Children's playground. Catering to select clientele."

The complex remained relevant as well as profitable with such improvements as the construction of additional cabins, the linking of the cabins

John Woodruff, first president of the U.S. Highway 66 Association, established the **Kentwood Arms** in **Springfield** in 1926. *Joe Sonderman*

with garages, the enclosure of the garages, and the addition of motel rooms, a service station, and a restaurant. It became the Rail Haven Motel in 1954. After buying the property in 1994, Gordon Elliot demolished the long-closed restaurant and service station and made renovations to the motel, ensuring that the facility would survive as a profitable enterprise that blended modern amenities with historical ambiance and architecture.

The Kentwood Hall Dormitory on the Missouri State University campus is the former Kentwood Arms Hotel. Built by John T. Woodruff, a property developer and the first president of the U.S. Highway 66 Association in 1926, the hundred-room hotel featured an array of amenities as well as spacious landscaped grounds and an eighteen-hole golf course. It remained the city's premier hotel for more than two decades. After the property's acquisition by Southwest Missouri State, now Missouri State University, in 1984, the hotel was transformed into a dorm hall.

The Woodruff Building in Springfield was the site of a series of meetings held in John Woodruff's office. On April 30, 1926, a proposal was made to number the new federal highway connecting Chicago with Los Angeles as U.S. 66.

Springfield's **Woodruff Building** was the site of a key decision to name the highway from Chicago to Los Angeles U.S. 66. *Joe Sonderman*

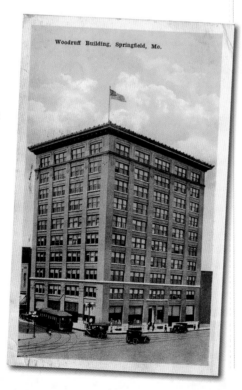

Woodruff Building, Springfield, Mo.

Staunton

Barns promoting **Meramec Caverns** were once a common sight along Route 66. *Joe Sonderman*

St. Louis

The Ted Drewes Frozen Custard store at 6726 Chippewa (Route 66) opened in 1941. It was the third frozen custard store opened by Ted Drewes in the St. Louis area.

Drewes, an award winning tennis player in the 1920s, opened his first ice cream store in Florida in 1929. Anemic sales prompted him to sell the business and relocate to St. Louis, where he opened a frozen custard store on Natural Bridge Road. Profits derived from the sale of this property allowed him to build a larger establishment on South Grand. The success of that enterprise led Drewes to open a second store, the one that is now a popular attraction on old Route 66. It remains a family-owned business. The current proprietor is Ted Drewes Jr.

Waynesville

The Pulaski County Courthouse in Waynesville was built in 1903 as a replacement for the original building that predated the Civil War. In 1990, it figured prominently in a Route 66 event as the location where Missouri Governor John Ashcroft signed the bill designating Route 66 as a historic highway within the state. The building, which remained in use as a courthouse until 1993, currently houses a museum.

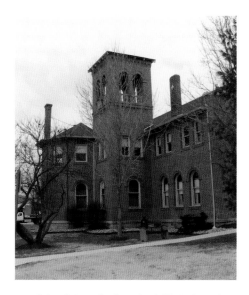

Governor John Ashcroft signed a bill designating Route 66 as a historic highway at **Waynesville's Pulaski County Courthouse** in 1990. *Joe Sonderman*

Wildwood

The Big Chief Hotel opened in 1929 in Pond, now Wildwood, with promotion listing it as a cabin hotel. The complex consisted of sixty-two cabins with attached garages, a service station, a small grocery store, playground, and a restaurant. Envisioned as the modern equivalent of the Harvey House chain that transformed passenger rail service, Henry K. Pierce of Pierce Petroleum proposed to build a series of full-service establishments at 125-mile intervals along major highways in Missouri and Oklahoma, commencing

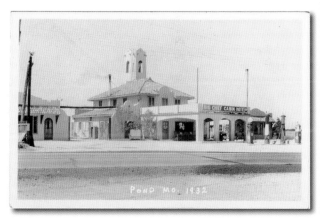

The **Big Chief Roadhouse** in **Pond** is housed in the former Pierce Pennant terminal complex. *Joe Sonderman*

The first **Pierce Petroleum** terminal opened in **Springfield** on July 16, 1928. *Joe Sonderman*

with the Route 66 corridor. The Big Chief Hotel was part of that vision.

The realignment of Route 66 in 1932 bypassed the complex and Pond, initiating a period of decline stemmed only briefly by World War II and the resultant housing shortage caused by expansion of companies such as the nearby Weldon Spring Ordnance Works. That facility closed in 1949.

The first stage in the property's transformation came following its acquisition by new owners in 1954, whose extensive renovation included razing the cabins, removing the false bell tower, and removing the gasoline pumps. As a restaurant, the Big Chief continued on.

In 1993, another major renovation modernized the facility, and it reopened as Big Chief Dakota, a restaurant that specialized in meats such as bison and elk. Listed in the National Register of Historic Places in 2003, it currently operates as the Big Chief Roadhouse.

Parks

Pacific

Named for Peter Lars Jensen, founder of the Henry Shaw Gardenway Association, Jensen Point Park on the bluffs overlooking Pacific opened in 1939. It was constructed under the auspices of

Jensen Point Park in **Pacific** opened in 1939.
Joe Sonderman

the Civilian Conservation Corps and was a showpiece of the Route 66 corridor west of St. Louis. With renovations, much of the park's stonework has been restored to its 1940s appearance. Additionally, information kiosks and a replica Civil War–era cannon provide a multidimensional history of the Battle of Pacific.

The former **Bridge Head Inn** now serves as the visitor center for Route 66 State Park and is the last remnant of Times Beach, the site of an ecological disaster.
Steve Rider

Route 66 State Park

The centerpiece of the 419-acre Route 66 State Park on the Meramec River, established in 1999, is the former Bridge Head Inn, which now serves as the park's visitor center. Shortly after opening in 1935, the inn developed an unsavory reputation for illicit activities, but after being purchased by

Edward Steinberg in 1947, it became a fashionable resort. In the early 1980s, the former inn served as the project headquarters for the Environmental Protection Agency during the land reclamation and dioxin cleanup at Times Beach. In addition to the visitor center, the Bridge Head Inn also houses an excellent museum, bookstore, and gift shop.

Viewed from the roof of the Old Courthouse in **St. Louis**, the world-famous **Gateway Arch** dominates the park at the Jefferson National Expansion Memorial.
Library of Congress

St. Louis

Maintained by the National Park Service, the Jefferson National Expansion Memorial consists of a ninety-one-acre park on a hill above the St. Louis levee on the Mississippi River, the Old Courthouse, the Museum of Westward Expansion, and the Gateway Arch.

Luther Ely Smith, a leading citizen in the city of St. Louis, first proposed the concept for a memorial park at this location in 1933. He said the idea first came to him from discussions about creating a memorial for Thomas Jefferson, and from Smith's experience working on the George Rogers Clark National Historic Park in Indiana. The concept morphed into a plan when he returned to St. Louis and noticed from his rail car window the blighted condition of the city along the river.

On December 15, 1933, Smith outlined his idea to Mayor Bernard Dickman and a group of community and business leaders at the Jefferson Hotel.

A committee submitted a petition to President Franklin D. Roosevelt for the creation of a national park. The project would evolve into the Jefferson National Expansion Memorial Association.

The location selected for the park was in the district that comprised the original city plat. As this was the site of the Spanish capital of New Spain, an area encompassed by most of the Louisiana Purchase, it seemed an ideal setting for a monument to President Jefferson.

Additionally, this was the site of the Battle of St. Louis, the only battle of the Revolutionary War fought west of the Mississippi River. It was also the site of the ceremony in which Spain turned Louisiana over to France on the day before the United States took claim to the Louisiana Purchase in 1804. Initial estimates placed the cost of the monument's construction, the purchase of lands, and demolition at $30 million.

Acquiring sufficient funds was just one of several obstacles facing the committee. In addition, many in the city of St. Louis bitterly contested the clearing of forty city blocks. Still, on September 10, 1935, voters approved the initial $7.5 million bond issue.

President Roosevelt, accompanied by Senator Harry Truman, toured the site while visiting the city for the dedication ceremony for the St. Louis Soldiers Memorial on October 14, 1936. Despite such highly publicized support, the project progressed at glacial speed.

Shortly after the end of World War II, a contest was launched for the design of the monument.

Forest Park in **St. Louis** was the site of the 1904 World's Fair. *Joe Sonderman*

Architect Eero Saarinen won the contest with his plans for a 590-foot-tall catenary arch on the banks of the Mississippi River. Over the course of the following fifteen years, the plans were gradually modified to produce the current configuration.

The site's groundbreaking ceremony was held on June 10, 1950, with President Harry S. Truman officiating. However, due to various delays, excavation for construction of the arch did not begin until February 11, 1961, less than eight months before Saarinen died.

Two years later, on February 12, 1963, the first stainless steel section was set in place. The arch was completed on October 28, 1965, but the official dedication ceremony did not occur until May 25, 1968, with Vice President Hubert Humphrey and Secretary of the Interior Stewart Udall in attendance.

Before completion of the Jefferson National Expansion Memorial and the Gateway Arch, Forest Park was the city's most famous attraction. After more than a decade of debates and planning, this park in the western part of St. Louis opened on June 24, 1876, with more than 50,000 people attending the opening ceremonies. The park continued to evolve and expand with land acquisition through the end of the century.

By the early 1890s, streetcar lines enabled an estimated three million annual visitors to enjoy the 1,371-acre enclave, which included the relocated city zoo. In 1901, an announcement that Forest Park had been selected as the site for the 1904 World's Fair, to be held from April 30 to December 1 of that year, inspired the city to proclaim it to be the Louisiana Purchase Exhibition.

Architect Eero Saarinen poses with a scale model of the **Jefferson National Expansion Memorial**, featuring the arch he designed. *Library of Congress*

Preparation for the fair and the fair itself transformed the park. In addition, the park served as the setting for the swimming, water polo, and diving events of the 1904 Summer Olympics.

Numerous buildings and landscape enhancements remain from the 1904 World's Fair, among them the Apotheosis of St. Louis, a statue of King Louis IX, the St. Louis Art Museum, the Bird Cage, and the Pavilion.

The fair's landscape architect, George Kessler, resolved numerous issues that had plagued the park since its inception. In the western quadrant of the park, he drained swamps and transformed the area into a series of five connected lakes. The installation of a network of sewer and water lines at this time was to serve as foundational components in the park's future infrastructure development. Additionally, thousands of trees were planted between 1904 and 1913, the year the Missouri History Museum building was completed.

At the time of the park's dedication, the de Peres River ran openly through the park. Concerns about sanitary conditions during the World's Fair resulted in rerouting of portions of the river through underground box culverts. Expansion of this project occurred in the 1930s.

At the turn of the twenty-first century, a $100 million dollar renovation of the park commenced. This has included the restoration of wetlands and prairie areas to control flooding as well as create wildlife habitats.

The park remains the city's largest attraction, with an estimated twelve million visitors annually. This surpasses the number of visitors to the city's second most popular attraction, Jefferson National Expansion Memorial.

Five of the area's major cultural institutions are located in the park. These are the Missouri History Museum, Muny Amphitheater, St. Louis Art Museum, St. Louis Science Center, and St. Louis Zoo. In addition, the park has numerous recreational facilities including fields for softball, baseball, soccer, and archery, a tennis center, skating rink, restaurant, and country club. Clayton Avenue, an early alignment of Route 66, is utilized for outbound traffic from the park while Wells Drive, another segment of early Route 66, is used for inbound.

Military

Avilla

With issuance of a decree by Governor Claiborne Jackson that declared Missouri as the twelfth state to join the Confederate States of America on October 28, 1861, citizens of Avilla displayed their defiance by flying the American flag in the city park. Then, to defend their homes, farms, and the town, Dr. J. M. Stemmons organized a militia company.

When William T. "Bloody Bill" Anderson moved on Avilla with a contingent of Confederate raiders on March 8, 1862, the militia engaged in its first military skirmish. In the ensuring action, Dr. Stemmons, his three sons, and two other Avilla men died.

In the late summer of 1862, the Union Army established headquarters in Avilla in an effort to gain control of the western segment of the vital Wire Road. The local militia served as patrol units in neighboring counties.

Bellefontaine Neighbors

Located on the post-1936 alignment of Route 66 and City 66 that connected with the Chain of Rocks Bridge, Bellefontaine Neighbors is a suburb of St. Louis. The original community developed around Bellefontaine Springs on Coldwater Creek, the mouth of which was the site for Fort Bellefontaine, a military facility that operated from 1806 to 1826. This served as the first United States military facility in the Louisiana Territory. Initially it operated as a Spanish military outpost.

After the Louisiana Purchase, Fort Bellefontaine operated as an official fur-trading center, commencing on November 3, 1804. It was established as an American military encampment in 1806, and as such, it served as the headquarters for the Department of Louisiana until 1815 and as regional United States Army Headquarters during the War of 1812.

TOP: Established in 1940, **Fort Leonard Wood** remains a vital military facility. *Joe Sonderman*

ABOVE: Construction of the fort transformed the Route 66 roadside. *Joe Sonderman*

Fort Leonard Wood

Established in December 1940, Fort Leonard Wood was named in honor of Major General Leonard E. Wood, a veteran of the campaigns against Geronimo and of the Spanish-American War as well as a Medal of Honor recipient and the chief of staff for the U.S. Army from 1910 to 1914. During World War II, the fort served primarily as a basic training and doctrine-command training base. Its secondary use was as a POW camp for German and Italian troops captured in North Africa and during the campaigns in the Mediterranean. The fort was deactivated in 1946 and then reactivated in 1950. It continues to serve its original purpose as a training center, and as of 2012, more than three million personnel have trained at the facility.

A replica gun battery at **Jensen Point** commemorates American Civil War battles fought here.

Pacific

Due to its location on a primary railroad corridor and the Wire Road, the bluffs overlooking the community of Pacific and the valley to the south became crucial military assets during the American Civil War. In October 1864, after a pitched battle with Union forces, Confederate troops swept into Pacific, burned a large segment of the community, and destroyed bridges and railroad infrastructure.

Springfield

On August 10, 1861, the first major battle in the American Civil War west of the Mississippi River commenced at Wilson's Creek just south of Springfield. Heavily outnumbered by 12,000 Confederate troops, the 5,400 Union troops under the command of General Nathaniel Lyon retreated to the east along the Wire Road, first to Lebanon and then Rolla, during a near continuous battle. With fresh provisions and reinforcements, Union troops pushed west to Springfield. However, Confederate troops had withdrawn to Arkansas, a move that led to the pivotal battle of Pea Ridge in 1862.

In the two years that followed the Battle of Wilson's Creek, numerous skirmishes to gain control of Springfield ensued. In January 1863, Confederate forces under the command of General John S. Marmaduke overwhelmed the Union garrison and advanced to the town square before being repelled.

Union forces prevailed. This marked the last attempt by Confederate forces to gain control of the city. General Lyon was among the heavy Union casualties. He became the first Union general killed in combat during the Civil War.

The Springfield National Cemetery was established two years after the end of the war. Interred here are both Union and Confederate casualties of Wilson's Creek and the battles for Springfield.

In 1960, the National Park Service designated the 1,750-acre site at Wilson's Creek a National Battlefield. It is recognized as one of the most pristine Civil War battlefields in the nation.

Crime and Disaster

Carthage

On Saturday, December 13, 1930, Eli Othel Bray, a jailer with the Carthage Police Department, was overwhelmed during an escape attempt and killed with his own service revolver. Under the pretense of visiting a prisoner, 18-year-old Wilbur Hensen and his 20-year-old wife attacked Bray during an aborted jailbreak.

After Bray's shooting, the young couple fled west on U.S. 66 but were arrested after a traffic stop in Chelsea, Oklahoma. Convicted of Bray's murder, Hensen received a death sentence that later was commuted to fifty years.

He escaped from the Missouri State Penitentiary in December of 1954 and remained at large for almost four years. Captured during a burglary in Los Angeles, California, on November 14, 1958, he served four years in San Quentin before returning to Missouri to serve out the remainder of his sentence.

After a lengthy court battle, a jury handed down a verdict of second-degree murder for his wife's role in the death of officer Bray. She received a sentence of ten years.

Eureka

In September 1931, a tornado devastated **Eureka**.
Joe Sonderman

Joplin

In August 1926, Jesse Laster, Joplin Chief of Detectives, was returning from Galena with his family when he stopped to investigate an armed man on the roadside. When Laster identified himself, the unknown assailant opened fire, mortally wounding the officer.

Herbert Farmer, an itinerant gambler and pickpocket born in 1890, settled in Webb City, Missouri, a community on the eastern edge of the tri-state lead and zinc mining boom, in 1910. In 1916, an altercation resulted in Farmer receiving a five-year sentence for assault with intent to kill. Upon his early release after serving only two years, he turned his attentions to the West, as indicated by arrest records in Colorado, California, Utah, and Texas for a wide array of criminal activity including assault, larceny, fraud, and swindling. In 1927, Herbert "Deafy" Farmer returned to Missouri with his wife, Esther, and purchased a small farm near Joplin. Farming, however, was not his intent, and instead he developed the property as a safe house for fugitives and criminals.

A particularly infamous incident occurred in January 1951, when Police Chief Carl Nutt and Detective Walter Gamble initiated an investigation of abandoned mines in the area of 2nd Street (Route 66) and Oliver Street after receiving laboratory test results on mud found in the

Main Street, Joplin, Missouri

The 1978 demolition of **Joplin's Hotel Connor**, seen here in a vintage postcard view, resulted in several deaths. *Joe Sonderman*

car belonging to Carl Mosser. William E. Cook Jr., a young man from the Joplin area, had stolen the Mosser car, a 1949 Chevrolet sedan discovered near Tulsa on January 3 with a blood-stained interior.

One of the largest manhunts in U.S. history to that point in time commenced with the discovery of all five members of the Mosser family in a flooded mine shaft by Nutt and Gamble. At its peak, more than 2,000 law enforcement officers were involved.

Born in Joplin in 1929, Cook was one of eight children. His father, an alcoholic miner, moved his family into an abandoned mine shaft after the death of his wife until state welfare workers placed the children in foster homes. At an early age, Cook became involved in petty theft at stores in the Joplin area, and then as a teenager, robbed a cab driver of $11. Sentenced to five years in the state reform school, Cook was soon transferred to the state penitentiary because of his violent temper.

After a brief visit with his father in Joplin, Cook hitchhiked to El Paso, Texas, where he worked at odd jobs and purchased a .32-caliber pistol. The pattern of drifting and odd jobs took Cook to California and then back to Texas.

On December 28, 1950, Lee Archer picked up Cook who was hitchhiking near Lubbock. The next morning, near Luther, Oklahoma (on Route 66), William Cook overpowered Archer and locked

him in the trunk. Shortly after, Cook became stuck in a ditch and flagged down another car, Mosser's blue 1949 Chevrolet. As Cook had left his duffle bag in the Archer car, police soon had a complete description as well as his prison records.

For the next several days, Cook forced Mosser to drive him through Texas, western New Mexico, and Oklahoma before returning to Joplin. Early on the morning of January 2, he shot all five members of the family, left their bodies in the mineshaft, and drove west on U.S. 66.

After the Mosser car broke down near Tulsa, Cook continued west on Route 66 by bus as well as hitchhiking. Turning south at Needles, California, he kidnapped a deputy sheriff near Blythe, California, stole his patrol car, and used it to pull over Robert Dewey. Cook then killed Dewey, and drove his car to Mexico where he kidnapped two Americans, James Burke and Forrest Damron. On January 15, Mexican police arrested Cook and extradited him to Oklahoma for trial on federal kidnapping charges.

After Cook was sentenced to serve 300 years in prison, the U.S. Justice Department intervened and allowed the state of California to try Cook for the Imperial County murder. Found guilty of murder, he was executed on December 12, 1952, in the San Quentin gas chamber.

On November 11, 1978, national attention again focused on the city of Joplin when during demolition of the Hotel Connor, built in 1908 on Main Street, a section of the building collapsed killing two workers. A third worker remained trapped for eighty-two hours.

On Sunday, May 22, 2011, a catastrophic EF5 tornado swept through the city of Joplin. Damage estimates exceeded $2.2 billion, and the death toll exceeded 160. It was the seventh deadliest tornado in U.S. history, and the costliest.

In 1883, a tornado estimated to be of similar size had followed close to the path of the 2011 trail of destruction. Nine years later, another tornado swept through the city and caused extensive damage.

Rolla

Henry Newton Brown, a relatively obscure nineteenth century outlaw who also served as a law enforcement officer, spent the first seventeen years of his life in Rolla. In his brief career on

A murder at **Bessie's Place** in 1935 led to closure of the Rolla roadhouse.

both sides of the law, Brown fought alongside Billy the Kid as one of the Regulators during the Lincoln County War, rustled horses in the Texas Panhandle, accepted the position of deputy sheriff for Oldham County in Vega, Texas, and worked on various ranches in Oklahoma and Kansas.

As city marshal in Caldwell, Kansas, Brown developed a reputation for dispensing swift and lethal justice. The citizens were so appreciative of his services that they presented him with a new, engraved Winchester rifle on New Year's Day 1883, a rifle he used in an attempted robbery of the bank in Medicine Lodge, Kansas, in 1884. As a result of the failed robbery attempt in which two men were killed, Brown was arrested. Before the trial commenced, a mob stormed the jail, and in the ensuing melee, Brown was shot and killed.

In 1931, Bill and Beatrice "Bessie" Bayless built a roadhouse and six small log cabins along Route 66 about eight miles west of Rolla near the crest of the hill above Arlington. Bessie's Place remained a profitable and popular establishment until a fall evening in 1935. Billie, the estranged wife of Eugene Duncan, had been frequenting the roadhouse and local rumor had it that she was quite popular. Late one October evening, Duncan walked into Bessie's Place and shot his wife to death on the dance floor.

Springfield

Route 66 initially followed St. Louis Street from the east to access Springfield's Park Central Square. On July 21, 1865, on the south side of the square, J. B. "Wild Bill" Hickok confronted Davis K. Tutt, reportedly over outstanding gambling debts. Later that evening, at 6:00 p.m., the men again met at the square and at a distance of about 75 yards assumed a dueling position. According to reports, both men fired simultaneously but Tutt missed. Hickock's bullet passed through Tutt's chest, a mortal wound. A historical marker embedded at the site of the shooting commemorates the event.

On January 2, 1932, an investigation into the attempted sale of stolen cars, one from Avilla and the other from Halltown, led to a gunfight that left six officers from the Greene County Sheriff's Department and Springfield Police Department dead. The shootout remains one of the deadliest encounters between law enforcement officers and criminals in the state of Missouri.

On June 2, 1929, Harry Young shot and killed Mark S. Noe, the town marshal of Republic, Missouri, when the officer attempted to arrest him for drunk driving. Young had mistakenly assumed the officer was arresting him for his involvement in area burglaries, crimes not yet linked to him.

With Young identified as the assailant, issuance of a warrant led to a fruitless manhunt even though the family owned a farm near Brookline, southwest of Springfield. Apparently, this did little to deter Harry, or his brother Jennings, from

"Wild Bill" Hickok shot and killed Davis Tutt Jr. at this site in **Springfield** in 1865. *Joe Sonderman*

engaging in other criminal activities such as stealing automobiles from towns near Springfield.

In late December 1931, an automobile dealer in Springfield contacted police and provided information pertaining to the attempted sale of a stolen vehicle. The woman who attempted to sell the vehicle and the woman who had attempted to sell another stolen vehicle a few days prior under similar circumstances were sisters to the Young brothers.

This information and an anonymous tip that the Young brothers were hiding on the family farm prompted Greene County Sheriff Marcel Hendrix to make another investigative trip to Brookline. Taking no chances, he was accompanied by deputies Wiley Mashburn and Ollie Crosswhite, Chief Detective Tony Oliver of the Springfield Police Department, and Ben Bilyeu, Owen Brown, Charlie Houser, Virgil Johnson, Sid Meadows, and Frank Pike, also from the Springfield Police department.

The officers armed themselves with only service revolvers and a tear gas gun. The arsenal for the Young brothers included a Winchester 12-gauge semi-automatic shotgun, a Remington rifle, and hundreds of rounds of ammunition

Upon arrival at the Young farm, Sheriff Hendrix and his two deputies initiated an investigation to determine occupancy of the house and then fired a tear gas canister through a front window. They then went to the back door and forced entry into the kitchen where the Young brothers were waiting in ambush.

Sheriff Hendrix died instantly from a shotgun blast to the face. Deputy Mashburn died where he fell while Pike, severely wounded, and Owen Brown managed a retreat while under constant fire.

The Young brothers immediately turned their attention to the remaining officers. With chilling accuracy they killed Meadows, Crosswhite, and Houser with single shots to the head. Oliver died from two chest wounds.

Johnson and Bilyeu managed to escape the melee and drove into Springfield for assistance. Even though Brookline was a short distance from the city, it took time to coordinate an armed force that included National Guard troops.

Upon arrival, they found the farm abandoned. Immediately radio, newspapers, and police nationwide received reports with full details.

Several weeks later, acting on an anonymous tip, Houston, Texas, police surrounded a boarding house and fired tear gas into an upstairs apartment. Two shots rang out; the Young brothers were dead from self-inflicted gunshot wounds.

St. Louis

The dawn of the twentieth century witnessed the rise of gangs and crime syndicates in many American cities. In St. Louis the most predominate during this period was a group known as "Egan's Rats," formed by Tom Egan and Thomas "Snake" Kinney.

From 1890 to 1924, this crime syndicate dominated bootlegging, robbery, voter intimidation, election fraud, and other crime in the city. In addition, it served as a school for many criminals who were later associated with some of the most infamous crimes in the country.

Kinney and Egan were street toughs living in a seedy district known as the Kerry Patch on the riverfront when they began recruiting others in the neighborhood to assist with burglary, armed robberies, and pickpocketing. The gang's rise to prominence commenced with voter intimidation intended to assist the corrupt Democratic Party machine that dominated area politics.

Kinney used connections made during this stage of the gang's development to become the Fourth Ward's delegate to the Missouri House of Delegates and, later, to win a seat in the Missouri State Senate. Meanwhile, Egan remained on the streets solidifying his position of power in the criminal syndicate.

Indicative of the gangs' power, reach, and immunity was the murder of Fred Hesse, a mechanic suspected of providing evidence against them during an investigation into a $15,000 railroad swindle. In broad daylight on November 7, 1913, in front of dozens of eyewitnesses, Deputy Constable Harry Levin shot and killed Hesse at 2647 Olive Street.

The sensationalized trial that followed featured numerous witnesses and evidence that Levin was on Egan's payroll. Still, he was acquitted of all charges.

Anticipating the passage of the Volstead Act, Egan moved to establish an interstate liquor-smuggling cooperative and to consolidate control in St. Louis by eliminating rival gangs. The resul-

tant warfare led to a number of murders, including innocent bystanders caught in the crossfire.

Upon Tom Egan's death after a debilitating illness in 1919, his brother Willie assumed control. In the ensuing struggle for dominance, members of the gang with low seniority known as "hot shots" launched an independent crime wave that included interstate truck hijacking along the Route 66 corridor, contract murder, and bank robbery.

Internal strife and attacks by rival gangs unleashed a level of warfare never before witnessed on American city streets. As the body count of gangsters and bystanders climbed, and public outrage mounted, the St. Louis police was forced to respond aggressively.

By late 1923, the remnants of Egan's Rats had shifted their focus to armed robbery and bank robbery in rural Missouri and across the Mississippi River in Illinois. A conservative estimate of cash and property stolen by the gang in a five-year period between 1919 and 1924 is $4.5 million. This includes major robberies in cities soon to be associated with Route 66, including a robbery on February 26, 1924, from the Bank of Maplewood, Missouri, that netted $8,500. The robbery of the Granite City National Bank in Granite City, Illinois, on April 25, 1924, brought in an additional $63,000.

With the arrest, conviction, and subsequent co-operation of Ray Renard after a Staunton, Illinois,

In February 1924, gangsters associated with the Egan's Rats gang robbed the bank in **Maplewood**. *Joe Sonderman*

mail robbery in 1923, members of the gang scattered to other cities, where they wreaked havoc and leant their talents to other criminal syndicates.

By 1940, most of the imprisoned gang members who had been arrested in the 1920s were returning to the streets of St. Louis. Efforts by a few to reclaim territories were often met with violent ends, including the death by machine gun in St. Louis on February 17, 1943, of William Colbeck, the leader of Egan's Rats after the murder of Willie Egan.

Gang violence was not the only criminal scourge in the city. On March 3, 1936, Sergeant William Cullen was shot and killed at the intersection of Warne Street and West Florissant Street (Route 66). While Cullen was waiting in his patrol car for a partner who was picking up medicine at the drugstore, an unknown assailant walked up to the vehicle and fired two shots into Cullen, who died the following morning. An investigation failed to find motive or suspect for the murder. The case remains unsolved.

Even though his crimes never reached the level of those of Egan's Rats, the man whom the press labeled the "Killing Dentist," Dr. Glennon E. Engleman, left a trail of murder along Route 66 for nearly a quarter of a century, ending with his conviction in 1980. The exact number of victims is unknown, but indications are that his crime spree, which involved seducing female patients and then murdering their husbands for insurance claims, may have commenced as early as 1958.

Though directly linked to the murder of Peter Haim of Kirkwood, who was killed by a sniper in Pacific, Missouri, in 1976, Engleman received an initial sentence of thirty years for conspiracy and fraud rather than for the charge of murder. At a subsequent trial focused on the murder, he was sentenced to fifty years without parole.

The murder trial of Sophie Barrera, who died in a car bombing, ended in a hung jury. Barrera was the owner of a dental lab who had filed suit against Engleman in order to collect on outstanding debts.

In 1985, Engleman pleaded guilty to murdering Ronald Gusewell of Glen Carbon, Illinois, and his parents, Arthur and Vernita, at their farmhouse near Edwardsville, Illinois. Over the course of his various trials, evidence coupled with his confessions led investigators to link him with numerous unsolved murders and fraud cases. These included

the murder of James Bullock in 1958 near the St. Louis Art Museum. At the time of the shooting, Bullock was married to Engleman's ex-wife.

The Engleman case also led to the reopening of an investigation that had initially ended in a verdict of accidental death. On September 23, 1963, Eric Frey, a partner of Engleman's in Pacific Drag Strip along Route 66 at Pacific, Missouri, died in a premature dynamite explosion as he was clearing a well. In the subsequent investigation in 1981, John Newton Carter, also a partner in the drag strip, and Frey's widow, Sondra, testified that Engleman had murdered Frey for the insurance money.

The numerous convictions resulted in five life sentences plus sixty years. Engelman died in prison on March 3, 1999.

Natural disasters are another calamity that has plagued the city of St. Louis. On September 29, 1927, two tornados swept through north St. Louis from Fountain Park to Hyde Park, with the epicenter in the area west of Grand Avenue between Delmar Boulevard and St. Louis Avenue (Delmar Boulevard and Grand Avenue served as Route 66 corridors). The first of the tornados touched down in the Manchester factory district, the second in Forest Park at Laclede Street.

Another tornado struck the city in 1959. In addition to extensive property damage, the death toll surpassed twenty.

Erased from the Route 66 roadside in 1995, the stylish Coral Court Motel on Watson Road west of St. Louis figured prominently in a crime that stunned the nation in the 1950s.

The heinous crime began on September 28, 1953, when Bonnie Emily Heady executed a clever ruse and kidnapped Bobby Greenlease, the six-year-old son of wealthy automotive dealer Robert Cosgrove Greenlease, from the Notre Dame di Sion School in Kansas City, Missouri. Masterminded by her paramour Carl Austin Hall, the plan was to extract a ransom of $600,000 (the largest ransom in U.S. history to date) from the boy's parents.

However, from the plan's inception, the couple never intended to provide a safe return of the boy in exchange for the ransom. After picking up Bobby, they bought him ice cream, drove him to an isolated farm in Kansas, and executed him.

In the week that followed, the Greenlease family received fifteen phone calls and numerous ransom notes in what was actually little more

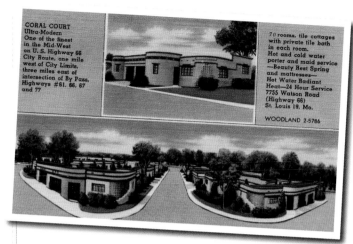

The **Coral Court Motel** was central to one of the biggest kidnapping cases in history. The motel's demolition spawned an intense preservation movement along Route 66. *Joe Sonderman*

than a goose chase. On October 5, the couple collected the ransom, broke off communication with the family, and drove from St. Joseph, Missouri, to St. Louis.

After they rented an apartment, their scheme quickly unraveled. The couple, both severe alcoholics, began drinking heavily, and one evening after Heady passed out, Hall put $2,000 in her purse, called a cab, picked up a prostitute and some whiskey, and checked into the Coral Court Motel.

The cab driver notified police and the following morning police arrested Hall at the motel. Resultant of his testimony, they arrested Heady later that evening.

Confessions and accusations led to the recovery of Bobby's body, and the irrefutable evidence resulted in a guilty verdict and the issuance of the death penalty. On December 18, 1953, Heady and Hall died in the gas chamber at the state prison.

The story does not end there. As only half of the ransom money was recovered, rumors, evidence, and speculation connected mob boss Joe Costello to the case and led to the cab driver, the prostitute, and the arresting officers being suspected of involvement with the money's disappearance.

Persistent local legend claimed that the money remained hidden at the Coral Court Motel. Demolition of the motel failed to find any trace of the missing ransom.

Times Beach

Located seventeen miles west of St. Louis, on the banks of the Meramec River, Route 66 State Park is the site of a modern ecological disaster that resulted in the erasure of the community of Times Beach and a subsequent land reclamation project. Only the Bridge Head Inn and a steel truss bridge that carried Route 66 across the river remain as tangible links to that community.

The origins of Times Beach are rather unique. In 1925, the owners of the *St. Louis Star Times* purchased 480 acres on the Meramec River and launched an innovative promotional campaign. For $67.50, a customer could purchase a 20-by-100-foot lot for the construction of a summer cottage and receive a six-month subscription to the newspaper. The catch was that building a home on the property would require the purchase of an additional lot.

By 1930, the resort of Times Beach was morphing into an actual community with full-time residents and businesses. Fueling business development was the traffic that flowed on Route 66.

In 1970, the population exceeded 1,200 people and there was an active movement within the community to move beyond the image of low-income housing. One aspect of this transition was the decision by city management to address the 16.3 miles of unpaved streets.

With insufficient funds to meet the cost of paving, administrators instead chose to oil the roads to control dust. Contracted for the project was Russell Bliss, owner of a small cartage company that specialized in hauling waste oils and similar materials. Counted among those other materials were waste products from the Northeastern Pharmaceutical and Chemical Company of Verona, Missouri, a major producer of Agent Orange during the Vietnam War. As a result, the oils sprayed on the streets of Times Beach contained deadly dioxins.

An investigative reporter turned his attentions on Times Beach after establishing a link between Bliss's company and the death of horses at stables that had been sprayed with waste oil to control flies and dust in 1982. His report prompted a more in-depth investigation by the Environmental Protection Agency.

Following extensive flooding of the Meramec River, almost the entire town was evacuated on December 5, 1982. Eighteen days later, the EPA notified city management and residents that, "if you are in town it is advisable for you to leave, and if you are out of town do not return."

Soon the small rural community of Times Beach was garnering international headlines as a symbol of manmade environmental catastrophe. By 1985 the mandatory evacuation was complete, negotiated buyouts were well underway, and the site was under full quarantine.

Throughout 1996 and 1997, a special incinerator built at the site burned 265,000 tons of contaminated soils and materials. Upon completion, with certification that the site was clean, land reclamation by the state of Missouri commenced and the site reopened as Route 66 State Park in 1999.

Film and Celebrity

The **Boots Court** in **Carthage** is a landmark motel that hosted Clark Gable and, according to local legend, Gene Autry.

Carthage

Established by Arthur Boots in 1939, Boots Court (later Boots Motel) is a nondescript location with a surprising number of celebrity connections. In the 1940s, Clark Gable stayed at this motel on two separate occasions. On his first stay, it was in room number six, and shortly after construction of the rear section of the complex in 1946, he stayed in room No. 12. Reportedly, Smiley Burnett and Gene

Autry were also guests at the Boots Motel. Local legend has it that Autry's horse, Champion, grazed on the lawn at the rear of the motel. The motel has survived into the modern era.

Doolittle

Pre-1946 maps list the cluster of service facilities that was located at the junction of U.S. 66 and State Highway T as Centerville. A guidebook published that year indicates a population of 208 and businesses "loosely strung along about two miles of highway." This was also the year that the community's name was changed to honor General "Jimmy" Doolittle, the World War II Medal of Honor recipient who led the raid on Tokyo in 1942. The celebration included many dignitaries including General Doolittle.

Joplin

Mickey Mantle grew up in Commerce, Oklahoma, and played ball for the Baxter Springs Whiz Kids in Baxter Springs, Kansas, two nearby communities that were part of the tri-state lead mining district. During the 1950 season, he played shortstop for the Joplin Miners.

Lebanon

Perhaps the most famous people associated with Lebanon, Missouri, are Walter Reed, namesake for Walter Reed Hospital, and author Harold Bell Wright. Wright served as the pastor for the First Christian Church from 1905 to 1907, and he later published *The Calling of Dan Mathews*, a fictionalized account about his tenure that portrayed the community in an unfavorable light.

Phil Donnelly is another native of Lebanon. Donnelly served as the governor of Missouri on two separate occasions, from 1945 to 1949 and from 1953 to 1957. Richard Parks Bland, the district's congressional representative from 1872 to 1899, also called Lebanon home.

Marshfield

In 1948, President Harry S. Truman made a campaign stop in Marshfield. As the community proclaims to host the oldest Fourth of July parade west of the Mississippi River, President George

The **Webster County Court House** in **Marshfield** contains a scale model of the telescope developed by native son Edwin Hubble. *Joe Sonderman*

H. W. Bush attended the festivities during a campaign stop in 1991.

In 2006, the ceremony announcing the National First Families Library and Museum included the largest gathering of presidential families in one place in history. The ceremony was attended by representatives from the families of eight presidents.

Marshfield is the hometown of renowned astronomer Edwin Hubble, namesake for the Hubble Telescope. Route 66 utilizes Hubble Drive through the town, and a quarter-scale replica of the telescope is located on the grounds of the historic courthouse.

Other celebrities associated with Marshfield include Joseph Sterling Bridwell, a philanthropist who attended school here in the late nineteenth century; swing-era bandleader Joe Haymes, born here in 1907; and musician Darren King.

Springfield

Actress Kathleen Turner, née Mary Kathleen Turner, was born in Springfield on June 19, 1954. Her long list of film credits includes *Body Heat*, *Peggy Sue Got Married*, *Prizzi's Honor*, *Romancing the Stone*, *Serial Mom*, and *The War of the Roses*.

A Springfield landmark with considerable celebrity association is the Abou Ben Adhem Shrine Mosque just off East St. Louis Street, an early alignment of Route 66. The massive complex, promoted as the largest auditorium west of the Mississippi River, opened on November 3, 1923. Elvis Presley performed here in 1956, and

The **Abou Ben Adhem Shrine Mosque** in **Springfield** has hosted presidents and celebrities. *Joe Sonderman*

Franklin D. Roosevelt, Harry Truman, and Ronald Reagan all made appearances at the auditorium.

The Colonial Hotel, built in 1907, was the first steel-framed multistory building in the city of Springfield. It stood on the southwest corner of St. Louis Street (Route 66) and Jefferson Avenue until it was demolished in 1998 after being closed for twenty years. Among the hotel's esteemed guests during its history were Elvis Presley, Harry Truman, and John F. Kennedy.

Another landmark with an Elvis Presley connection is the historic Gillioz Theater one block north of Route 66. M. E. Gillioz had planned for his theater to front the new federal highway U.S. 66, but the cost of property on St. Louis Street was prohibitive. Instead, he purchased property to the north and leased a frontage corridor on St. Louis Street to provide access to the theater. Built in 1926 and deemed an architectural masterpiece, the Spanish Colonial Revival styled theater featured a terra cotta tile and brick pilaster façade, and a large arched window above the marquee featured the letter "G" in blue glass. Interior trim and accoutrements were even more lavish. They included plaster friezes, wrought iron details, and murals.

The 1,100-seat theater—where Elvis Presley watched a film before his performance at the nearby Abou Ben Adhem Shrine Mosque in 1956—remained in operation until 1980. After a decade of abandonment, a structural evaluation determined that the cost of demolition would exceed the cost of renovation. The Springfield Landmarks Preservation Trust initiated restoration of the property with a focus on preserving the original architectural details. The facility reopened in 2006.

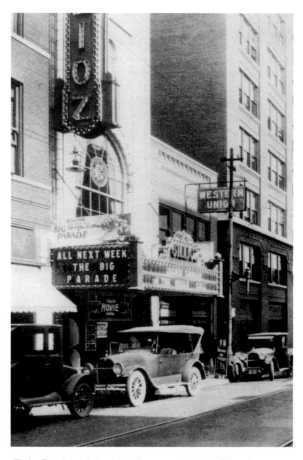

Elvis Presley claimed to have watched a film at **Springfield's Gillioz Theater** in 1956. *Joe Sonderman*

In 1955, ABC broadcast the first nationwide country music program for television from Springfield. Brenda Lee, Slim Wilson, and Porter Wagoner were among the performers.

On June 4, 1993, Harold Lloyd Jenkins, better known as Conway Twitty, became ill during a performance in Branson, Missouri. Rushed to Cox South Hospital at 3801 South National Street, he died from an abdominal aortic aneurysm the following day.

St. Louis

In 1893, Nikola Tesla conducted the first public demonstration of radio communication here. His choice to make this demonstration in St. Louis was inspired in part by the fact that on July 1, 1859, the first mail ever carried by air left on a balloon launched from City Hall Square.

Located at 3701 Lindell Boulevard (Route 66 from 1926 to 1932), the Coronado Hotel opened in 1925 and remained in operation until 1965. After standing vacant for many years, a $40 million renovation in 2003 restored the property to its original elegance. As a premier property in St. Louis for more than two decades, the hotel has had a lengthy list of celebrity guests, including Queen Marie of Romania, Charles Lindbergh, Rudolph Valentino, and Harry Truman.

Michael Wallis was born in St. Louis in 1945. He is a prolific author, journalist, historian, and lecturer. He has written more than seventeen books, including *Route 66: The Mother Road*. Instrumental in the resurgent interest in Route 66, this book was re-released in 2001 for an updated seventy-fifth anniversary edition and continues to be a best seller among Route 66 enthusiasts. Wallis is also a cofounder of the Route 66 Alliance, a nonprofit organization that works with numerous organizations and communities to develop promotional, educational, and restoration projects on Route 66. He also provided the voice of the Sheriff in the 2006 Pixar animated film *Cars*.

Stratford

Stratford, Missouri, is featured in *Ripley's Believe It or Not* as the only town in the United States with two main streets but no alleys. The road on the north side served as the original main street as well as an early alignment of Route 66. With realignment of the highway that resulted in Route 66 running behind the buildings along the railroad tracks, business owners converted the rear of the stores into second fronts.

Transitional Sites

Arlington

The history of Route 66 at Arlington, now severed by I-44, is one of transition. This is the site of the original crossing of the Big Piney River by that highway. Additionally, the last segment of Route 66 paved in the state of Missouri was at Arlington. A celebration to mark the momentous occasion occurred on January 5, 1931. The event concluded with highway workers tossing coins in the wet concrete.

Chain of Rocks Bridge

Built in 1929 as a Mississippi River toll bridge, the Chain of Rocks Bridge is of the cantilever truss type with a 5,353-foot span and a unique 22-degree bend at mid river, purportedly the result of issues with the bedrock anchors for the piers. In 1936, the tolls were suspended and the bridge became the U.S. 66 beltline alternative route for travelers wishing to bypass the constrictions of city traffic in St. Louis.

The bridge continued in this capacity until 1955. From this date to 1965, it served as Bypass 66. With completion of the I-270 bridge immediately to the north in September 1966, the Chain of Rocks Bridge saw little usage. It was closed in 1970 and soon fell into disrepair. Only the high cost of demolition prevented its removal. Leasing by the innovative Gateway Trailnet system resulted in refurbishment and inclusion in the expansive biking and hiking trail system in June 1999.

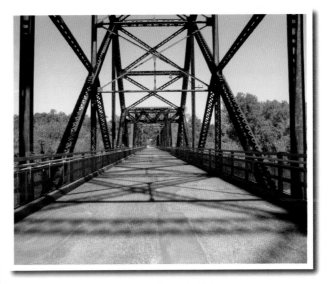

Built in 1929, the **Chain of Rocks Bridge** was incorporated into Route 66 in 1936. It currently serves as a Trailnet river crossing. *Judy Hinckley*

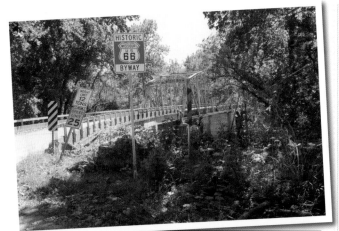

TOP: Built in 1923, this bridge in **Devils Elbow** carried Route 66 until 1945.

ABOVE: **Hooker Cut** was the first and last four-lane section of Route 66 in Missouri. *Joe Sonderman*

Hooker Cut

The evolutionary history of Route 66 as well as its prehistory are encapsulated within the area of Hooker Cut and the Devils Elbow via Teardrop Road, formerly U.S. 66.

The Devils Elbow moniker is derived from a bend in the Big Piney River so severe that log-jams were a constant issue during the era of logging in the area. The steel truss bridge spanning the river here opened in 1923 as a part of the Ozark Trail system, one of the named roads that predated the U.S. federal highway system.

Incorporated into Route 66 in 1926, the bridge served as that highway's river crossing until completion of Hooker Cut in 1943. Necessitated by construction of Fort Leonard Wood,

Lebanon was the first community bypassed with the construction of the interstate highway system. *Joe Sonderman*

the 90-foot deep Hooker Cut that bypassed the Devils Elbow was only the second four-lane segment of Route 66 in the state, and it was the last segment of Route 66 bypassed by I-44 in the early 1980s.

Lebanon

On August 8, 1957, a 4.6-mile section of modern four-lane highway signed as U.S. 66/Interstate 44 opened in Laclede County, Missouri. Bypassing Lebanon, this roadway has the distinction of being the first section of highway completed under the Interstate Highway Act.

Rolla

Paving for U.S. 66 in the state of Missouri was completed with the 65-mile section between Rolla and Lebanon in 1930. To commemorate the momentous occasion, the U.S. Highway 66 Association sponsored a celebration in Rolla on St. Patrick's Day, 1931. The event included speeches by Cyrus Avery and by Missouri Governor Henry Caulfield, who used the opportunity to call for the creation of a state highway patrol. There were also dances, dinners, a formal dedication ceremony, and a parade.

St. Louis

The Mississippi River crossings utilized by Route 66 at St. Louis are numerous. Many of the bridges predate the highway.

Named for Congressman William B. McKinley, the McKinley Bridge was built in 1910 and served as the initial river crossing for Route 66 in 1926. The bridge reopened in 2007 after six years of restoration with the inclusion of a bicycle and pedestrian path.

The Municipal Bridge opened as the first non-toll bridge over the Mississippi River at St. Louis in 1916. Renamed in honor of General Douglas MacArthur in 1942, the bridge served as a Route 66 river crossing from 1929 to 1935 and carried City 66 traffic from 1936 to 1955.

Construction of the Veteran's Memorial Bridge commenced in 1948, and it opened on January 13, 1951. It served as Route 66's primary St. Louis river crossing from 1955 to 1967. At a ceremony in 1972, it was renamed for Dr. Martin Luther King Jr.

The last river crossing for Route 66 is the Bernard Dickman Bridge, also referred to as the Poplar Street Bridge, which currently is utilized by Interstate Highways 55, 70, and 64. It carried Route 66 traffic from November 9, 1967, until decertification in 1977.

RIGHT: The **McKinley Bridge**, which opened in 1910, served as the original Route 66 Mississippi River crossing. *Joe Sonderman*

The **Municipal Bridge** in **St. Louis** carried Route 66 from 1929 to 1935 and City 66 from 1936 to 1955. *Joe Sonderman*

The **Chain of Rocks Bridge** on the north end of **St. Louis.** © iStock.com/Gim42

MISSOURI

Hooker Cut. *Page 70*

The **Gillioz Theater** in **Springfield**. *Page 68*

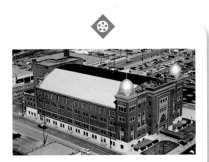

The **Abou Ben Adhem Shrine Mosque** in **Springfield**. *Page 67*

Park Central Square in **Springfield**, where "Wild Bill" Hickok shot and killed Davis Tutt Jr. *Page 62*

The site of the **Hotel Connor** in **Joplin**. *Page 61*

The **Boots Court** in **Carthage**. *Page 66*

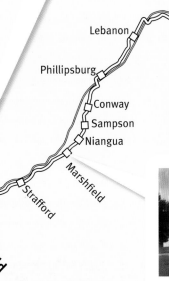

The **W**...
in **Ma**...

Lebanon

Phillipsburg

Conway

Sampson

Niangua

Marshfield

Strafford

Halltown

Paris Springs

Heatonville

Phelps

Spencer

Albatross

Carthage

Carterville

Maxville

66

71

44

Springfield

MISSOURI
KANSAS

Riverton

Galena

Joplin

44

Baxter

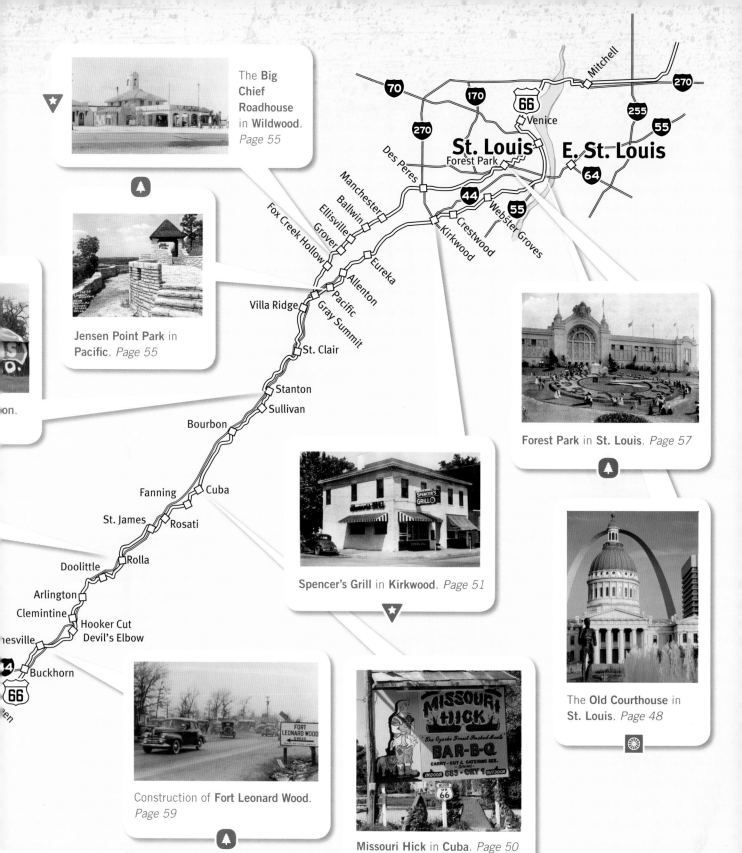

The **Big Chief Roadhouse** in **Wildwood**. *Page 55*

Jensen Point Park in **Pacific**. *Page 55*

Forest Park in **St. Louis**. *Page 57*

Spencer's Grill in **Kirkwood**. *Page 51*

The **Old Courthouse** in **St. Louis**. *Page 48*

Construction of **Fort Leonard Wood**. *Page 59*

Missouri Hick in **Cuba**. *Page 50*

Gay Parita at **Paris Springs Junction**. *Page 52*

MISSOURI

⊕ Pre-1926 Historic Sites

▽ Landmarks

🔔 Parks

△ Military

The **Best Western Route 66 Rail Haven** in **Springfield**. *Page 53*

The former **Boots Café** in **Carthage**. *Page 49*

Meramec Caverns in *Page 54*

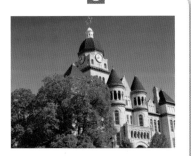

The **Jasper County Courthouse** in **Carthage**. *Page 48*

The **Woodruff Building** in **Springfield**. *Page 54*

The ruins of **John's Modern Cabins** near **Rolla**. *Page 51*

One of the **murals** in **Joplin** unveiled in 2013. *Page 51*

Lebanon

Phillipsburg

Conway

Sampson

Niangua

Marshfield

Springfield

Strafford

Halltown
Paris Springs
Heatonville
Phelps
Albatross
Spencer

Maxville

Carthage

Carterville

Webb City

66

71

44

Riverton

Galena

Joplin

Baxter

44

MISSOURI
KANSAS

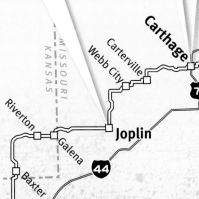

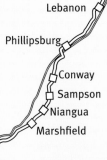

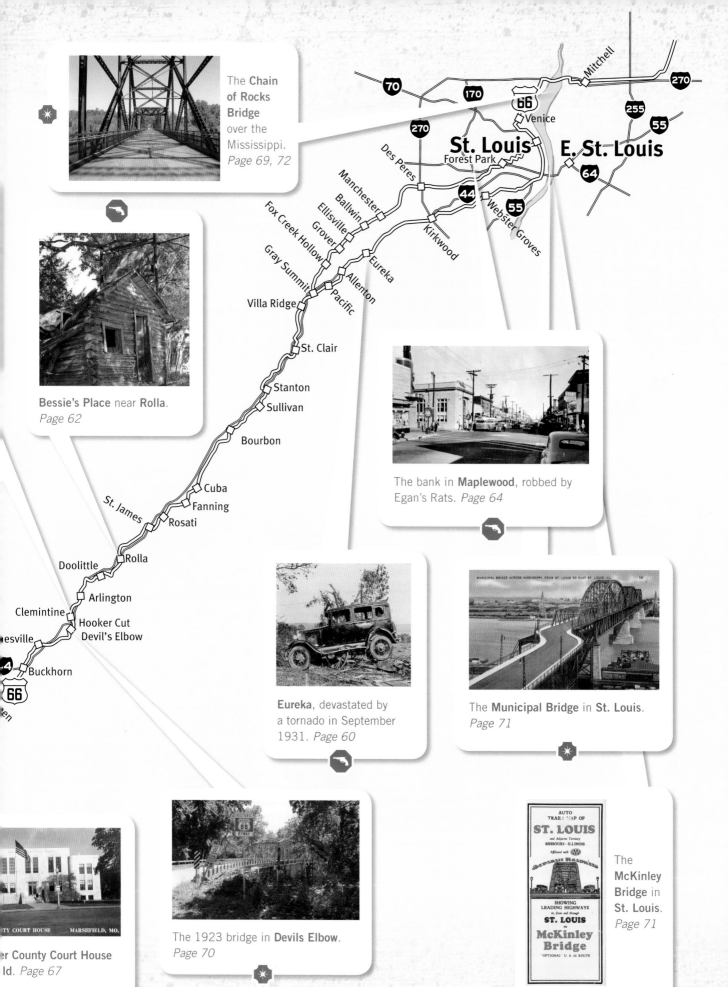

The **Chain of Rocks Bridge** over the Mississippi.
Page 69, 72

Bessie's Place near **Rolla**.
Page 62

The bank in **Maplewood**, robbed by Egan's Rats. *Page 64*

Eureka, devastated by a tornado in September 1931. *Page 60*

The **Municipal Bridge** in **St. Louis**.
Page 71

The **McKinley Bridge** in **St. Louis**.
Page 71

The 1923 bridge in **Devils Elbow**.
Page 70

r County Court House ld. *Page 67*

Mitchell

St. Louis
Forest Park

E. St. Louis

Venice

Des Peres
Manchester
Ballwin
Ellisville
Grover
Fox Creek Hollow
Gray Summit
Villa Ridge
Pacific
Allenton
Eureka
Kirkwood
Webster Groves

St. Clair

Stanton
Sullivan

Bourbon

Cuba
Fanning
St. James
Rosati

Doolittle
Rolla

Arlington

Clemintine
Hooker Cut
Devil's Elbow
esville
Buckhorn

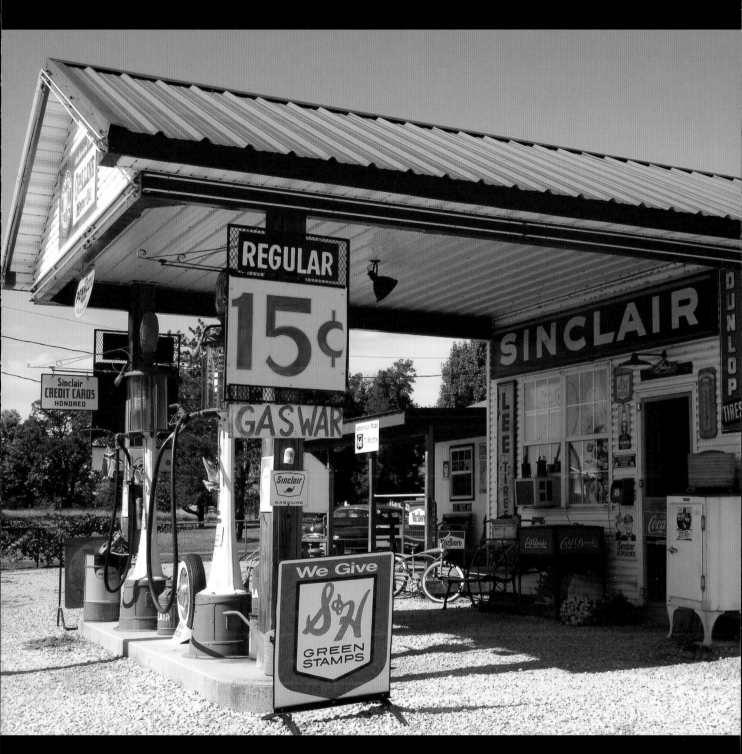

Gay Parita at **Paris Springs Junction** is a recreated time capsule. *Judy Hinckley*

ROUTE 66

Kansas

Pre-1926 Historic Sites

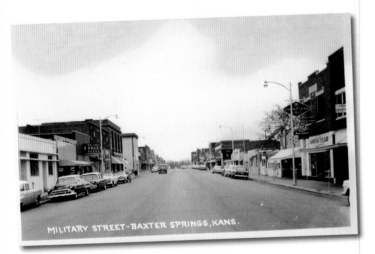

MILITARY STREET-BAXTER SPRINGS, KANS.

Years before the existence of Route 66, Jesse James rode down this street in **Baxter Springs**.
Joe Sonderman

Baxter Springs

In 1876, the brick building at 1101 Military Avenue (Route 66) in Baxter Springs housed a community bank. In the spring of that year, armed citizens repelled Jesse James and Cole Younger's robbery attempt, forcing the legendary outlaws to flee back to Missouri.

Riverton

Though it has received numerous upgrades since it first opened in 1909, the Empire District Electric Company on Spring River along the south side of Route 66 has the distinction of being the oldest continuously operated power plant in the United States. The foundational origins of a generating station at this location are even older, dating to the Spring River Power Company that initiated operations in 1890.

Initial construction work on the current Riverton Generating Station commenced in the summer of 1909 with the installation of one generator.

Dubbed "Old Kate," this first generator originally supplied electrical power for the 1904 St. Louis World's Fair in Forest Park before its purchase and relocation to Riverton.

Landmarks

Baxter Springs

The classically styled Independent Oil & Gas service station building at the north end of the business district dates to 1930. It was listed in the National Register of Historic Places in 2003.

Colorful murals and pocket parks are transforming **Galena**.

Galena

A refurbished Kanex station is the most popular Route 66–related attraction in Galena. Established originally as Four Women on the Route, the gift shop and snack bar is credited as the catalyst for revitalization along the Route 66 corridor in the city.

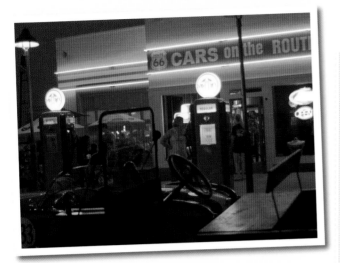

Cars on the Route (originally 4 Women on the Route) in Galena ignited the community's redevelopment. *Judy Hinckley*

Another attraction of note is the former Katy Depot, which was relocated to its current site in 1978. The former depot now houses the Galena Historical Museum.

Riverton

The current Eisler Brothers Old Riverton Store opened on March 20, 1925, as a replacement for the original store that was destroyed by a tornado. In addition to operating it as a traditional general store, the owners, Leo and Lora Williams, built a regulation croquet court adjacent to the property, complete with lighting to allow for nighttime play. With establishment of Route 66 in 1926,

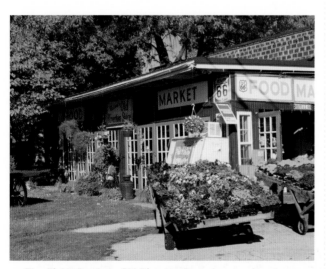

The Eisler Brothers Old Riverton Store is a landmark that dates to 1925.

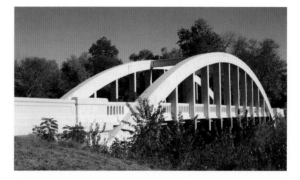

The Brush Creek Bridge is the last Marsh Arch Bridge on Route 66 in Kansas.

business flourished and a parking lot replaced the croquet court. A succession of owners continued operating it as a general store without infringing on the historical architectural detail. The primary exception was transformation of the shaded portico with gasoline pumps into an enclosed room with tables for deli customers.

Parks

Galena

Schermerhorn Park on Shoal Creek, located 1.5 miles south of Route 66 in Galena, served as a haven for scores of weary travelers during the 1930s, 1940s, and 1950s. Edgar Backus Schermerhorn of Galena donated land for the park, including a 2,500-foot cave, in 1922.

Actual development of the site did not begin in earnest until the 1930s as a WPA (Works Progress Administration) project during the Great Depression. Further work on the park followed World War II. The stone terrace walls and the picnic areas with cooking facilities date to this period.

Today the park is the centerpiece of the Southeast Kansas Nature Center. The historic scout cabin serves as an exhibition center for the diverse plant and animal life found within the park. Biologists consider Schermerhorn Cave the most biologically diverse cave in Kansas.

Military

Baxter Springs

In mid-1863, a massacre took place north of town during the Civil War. A cavalry detachment of Confederate guerillas known as Quantrill's Raiders was returning to Texas after sacking Lawrence, Kansas, when they initiated a surprise attack on troops of the Union's 3rd Wisconsin Calvary and 2nd Kansas Colored Infantry at Fort Blair, located next to the inn of John J. Baxter, the namesake for Baxter Springs.

In spite of heavy casualties, the Union forces held the earth-and-timber fortress, forcing Quantrill to regroup and consider calling off the attack. As Quantrill contemplated the next course of action, scouts reported that a Union detachment was approaching from the north, and they seemed unaware of the Confederates' presence.

Utilizing captured Union uniforms, the Confederate raiders surprised General James G. Blunt, commander of the Union forces in Kansas. Blunt was relocating his headquarters from Fort Scott, Kansas, to Fort Smith, Arkansas, and at the time of the attack, most of the one hundred men under his command were staff, clerk, and assorted personnel associated with the quartermaster.

The surprise attack by Quantrill quickly turned into a full rout, as Union troops were scattered. In the ensuing melee, seventy Union troops died, and a dozen suffered severe wounds, but Blunt escaped to Fort Smith. The general was later relieved of his command because of the incident at Baxter Springs.

These sites are now within the confines of the community of Baxter Springs. Many casualties are interned at the national cemetery west of town, and a marker commemorating the massacre was relocated to a site along Route 66 in 1961.

Crime and Disaster

Baxter Springs

During the first years of the twentieth century, Baxter Springs often garnered headlines for bold crimes, violence, and quirky deaths. For example, the *Daily Oklahoman*, reported on May 5, 1910: "Frank Williams, J. H. Green and John Anderson were found guilty here [Columbus, Kansas] of highway robbery and assault with intent to kill in connection with the robbery of a St. Louis & San Francisco Railway company's station and the shooting of Agent Cortland High at Baxter Springs, March 19. Judge McNeill was the recipient this morning of a black hand note in which he was threatened with death before the end of summer if the men on trial were convicted."

A story in the *Kalamazoo Gazette* dated January 18, 1894, detailed a bizarre and gruesome story about the death of a newlywed couple. On their wedding night, the cabin that was built using a bluff as one wall became infested with dozens of snakes as the chimney warmed them out of hibernation. The couple died from numerous snakebites.

By the 1920s, with the area pockmarked with abandoned mines, Baxter Springs often garnered headlines pertaining to the discovery of bodies. A *Baxter Springs Citizen* headline on June 4, 1925, read "Stephens Was Murdered—Coroners Jury Finds."

Harve Stephens, 62 years old, of Oromongo, Missouri was undoubtedly murdered by some unknown person or persons, according to the verdict of the coroner's jury last Monday night. Stephens' body was found dead and floating on 25-feet of water in the Silver Fox Mine south of Baxter Springs on the road to Quapaw [Route 66 after 1926].

G. P. Stephens, brother of the dead man, testified that he had not seen his brother since March 16, at which time he left Afton saying that he intended to go to Commerce, Oklahoma."

By the mid-1930s, the once-raucous mining camp of Baxter Springs had become a prosperous, modern community. Still, crime occasionally placed the town in the national spotlight.

Responding to a domestic disturbance call sparked by an eviction notice, Baxter Springs Police Department Chief John Moyer arrived at the rooming house located just off 3rd Street (Route 66) on the afternoon of Friday, April 21, 1939. Upon arrival, Moyer and the rooming house owner went to the suspect's room. The suspect responded to Moyer's knock on the door with gunfire from a .45-caliber handgun fired through the door. The owner of the rooming house died instantly, and Chief Moyer died seven days later in a Joplin, Missouri, hospital.

In May 2011, the small community again made news with the announcement that the Cherokee County Sheriff's Department planned to reopen a nineteen-year-old cold case. At the time of the incident on May 11, 1992, a nationwide plea for information had provided few clues. The victim, Jennifer Judd, was found in her Baxter Springs duplex apartment dead from multiple stab wounds. She had recently married, a fact that seemed to magnify the scope of the tragedy. Indications were that robbery was not a motive, and despite extensive investigations, there were no leads in the case and it remains unsolved.

A more recent tragedy in Baxter Springs resulted in a court ruling that had national implications. Elizabeth Shirley, the wife of Russell Graham, filed a negligence lawsuit against the owners of Baxter Springs Gun and Pawn Shop, Joe and Patsy George. The suit claimed that the owners were negligent in selling a shotgun to her husband, which he used to murder their son before committing suicide. In the lawsuit, she noted that Russell, as a convicted felon, was unable to purchase the firearm, and his grandmother had purchased the weapon with Russell present.

Galena

The Stafflebeck hostelry that doubled as a brothel was the scene of a series of horrendous murders during the 1890s. The family proprietors would rob and murder clients and dispose of the bodies in abandoned mineshafts. The *Dallas Morning News* on September 8, 1897, reported the story as the trial unfolded with grisly details and confessions. "Ed and George Staffleback, brothers, and their mother, Mrs. George Wilson, are accused of the murder of Frank Galbraith, in June last, at Galena, Kansas. The evidence is so direct that George Staffleback and his mother were speedily found guilty of murder in the first and second degree, and the trial of Ed is still in progress." During the trial, it was determined that the Staffleback family was responsible for an estimated thirty murders. The search for bodies continued into the early years of the twentieth century.

The story is legend in Galena, but it would have remained little more than a local historic footnote were it not for claims made about the history of a nearby property used for promotional purposes in 2011. In that year, a restored property that dated to the late nineteenth century and is located along Route 66 was promoted as being the "murder bordello." Historians and researchers, however, debunked the claim. The resultant investigations for "haunted" activity resulting from the murders and the denunciation by historians placed Galena, the Staffleback murders, and the refurbished home, which is now a bed and breakfast, in the national news.

This refurbished historic home was linked to an infamous nineteenth-century crime in **Galena**.

The Staffleback murders mirrored the community's growing reputation for lawlessness, mayhem, and violence. When reporting on a murder near the Frisco Depot, the *Galena Evening News* on July 24, 1900, opened the story with, "Another killing has been added to Galena's calendar of crime. Chas Payne, a hack driver, was shot and almost instantly killed about 3:30 this afternoon by Jack Sanders."

Additional headline-grabbing violence in Galena stemmed from labor strife and unionization efforts between the late 1910s and the 1940s. In May 1935, John L. Lewis, president of the United Mine Workers, called a labor strike against the Eagle Picher Company, a smelter located at the east side of Galena near the Missouri state line. Approximately a thousand miners of the 5,000-man workforce in the area responded to the call.

The company responded by hiring non-union workers from Missouri, Oklahoma, and Kansas. As the strike continued into the summer, angry miners barricaded Route 66 in an effort to deny access to workers coming from Missouri, which forced the sheriff to reroute traffic.

By late summer, increasing violence prompted Governor Landon, the Republican candidate for president in 1936, to call out the National Guard. In spite of the military presence, which included a checkpoint on Route 66, and resolution of the initial strike, the violence escalated.

For a brief period, it looked as though the worst of the strife was over, and the National Guard's involvement was suspended. Then, on April 11, 1937, during a parade of solidarity with members of the Tri-State Metal and Mine Workers Union, gunmen opened fire, wounding nine people including a fifteen-year-old boy, Lee Dixon.

Later that same day, an estimated 4,000 men armed with pick handles attacked the headquarters of the International Mine, Mill, and Smelter Workers Union to protest organization efforts at area mines and smelters. Gunfire dispersed the confrontation but not before the shooting of nine men.

The labor strife continued into the 1940s. However, after the incident at the union office, the violence was minimal compared to earlier protests and confrontations.

![Photograph of a line of 1930s automobiles on a road with a uniformed National Guardsman standing beside them]

In **Galena**, labor violence led to military intervention in 1935. *Steve Rider*

Film and Celebrity

Baxter Springs

Baseball Hall of Famer Mickey Mantle launched his professional baseball career in Baxter Springs. It was while playing for the Baxter Springs Whiz Kids, a minor league team, that he first received payment for playing ball.

Joe Don Rooney, lead guitarist and harmony singer in the band Rascal Flatts, was born in Baxter Springs on September 13, 1975. Raised in nearby Picher, Oklahoma, he formed his first band, Rascal's, in Miami, Oklahoma, a few miles south of Baxter Springs.

Galena

In the closing years of the nineteenth century, Harry Houdini was eking out a living working for a traveling show managed by a "Dr. Hill." Looking for ways to boost attendance, Hill decided to capitalize on the popularity of mediums by offering a séance as part of the program bill. Hou-

George Grantham, born in Galena, played for the Pittsburgh Pirates from 1925 to 1931.
Library of Congress

Riverton

The historic Marsh Arch Bridge over Brush Creek two miles west of Riverton figured prominently in the Learning Channel special *Route 66: Main Street of America*, which aired in 2000. It was on this bridge that Brad Paisley performed the song "Route 66" for the program.

Transitional Sites

Baxter Springs

Three and one half miles north of Baxter Springs, the narrow Brush Creek Bridge that dates to 1923 and its modern replacement span Brush Creek. The historic bridge, listed in the National Register of Historic Places in 1983, is the last of three bridges of this type utilized by U.S. 66 in its 13-mile course through Kansas.

The graceful arched bridge utilizes a patented concrete-and-steel design devised by James Barney Marsh in 1912. It remained in service until completion of the modern bridge immediately to the east in 1992. The Historic Route 66 Association of Kansas intervened and successfully halted plans to demolish the bridge. Fundraising efforts spearheaded by this association, as well as receipt of funds from the Cherokee County Commission and cost-share grants through the National Park Service Route 66 Corridor Preservation Program, enabled the complete refurbishment of the bridge by 2005.

The modern bridge remains the primary crossing of Brush Creek, while the historic bridge accommodates pedestrian and one-way traffic, providing Route 66 enthusiasts with a unique experience as well as photo stop.

dini made his debut as a "spiritualist" on January 8, 1898, at a theater in Galena. To prepare for his performance he studied old newspapers and memorized dates and names on headstones in the local cemetery. Contemporary accounts indicate the performance was rather mediocre until he spelled out the name of a victim in an unsolved murder. According to reports, several people fled from the theater.

George Grantham, who played infield for the Chicago Cubs, Pittsburgh Pirates, and Cincinnati Reds during the 1920s and early 1930s, was born in Galena on May 20, 1900. He had a .302 career batting average over thirteen major-league seasons.

In Galena, labor violence led to military intervention in 1935. *Steve Rider*

Marcin Wichary

The so-called **"murder bordello"** in **Galena**. *Page 79*

Colorful murals in **Galena**. *Page 76*

Galena

MISSOURI
KANSAS

Cars on the Route (formerly **4 Women on the Route**) in **Galena**. *Page 77, 83*

S
MA

Labor violence in **Galena**. *Page 80, 82*

KANSAS

 Pre-1926 Historic Sites

 Landmarks

 Crime and Disaster

The **Eisler Brothers Old Riverton Store**. *Page 77*

The **Brush Creek Bridge** in **Baxter Springs**.
Page 77, 81

Riverton

Baxter
Springs

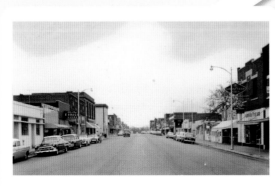

Military Street in **Baxter Springs**. *Page 76*

The onetime Four Women on the Route in **Galena**, now known as **Cars on the Route**. *Judy Hinckley*

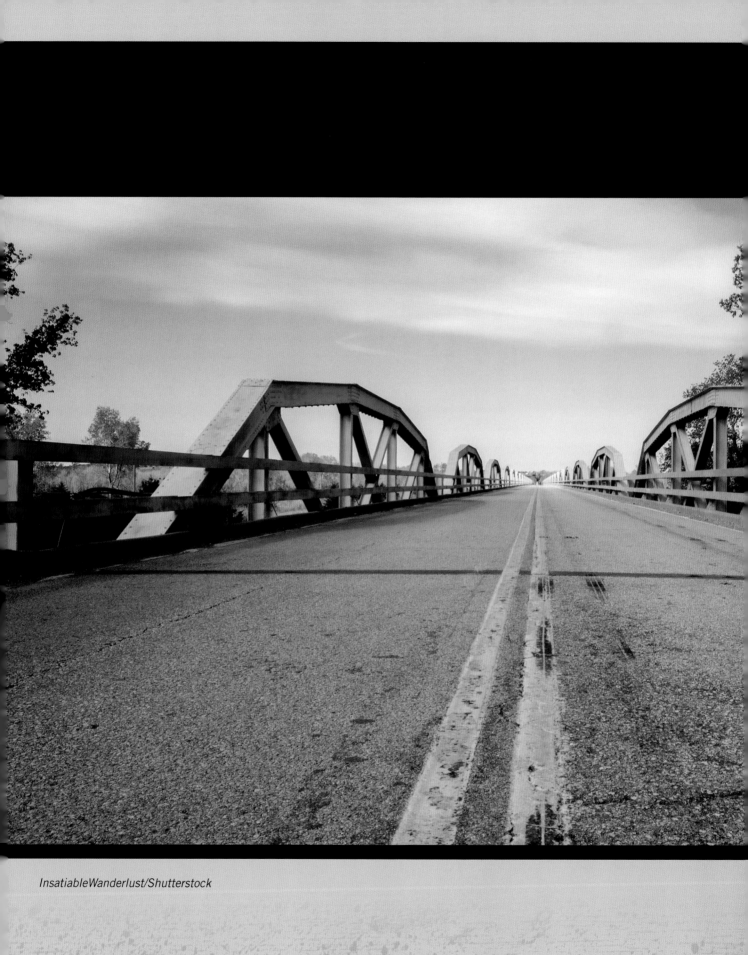

ROUTE 66

Oklahoma

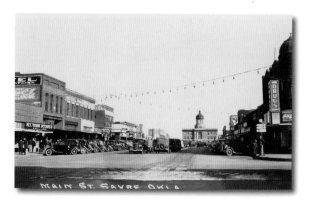

The **Beckham County Courthouse**, visible at the end of Main Street in this historic photo, is the tallest building in **Sayre**. *Joe Sonderman*

Pre-1926 Historic Sites

Erick

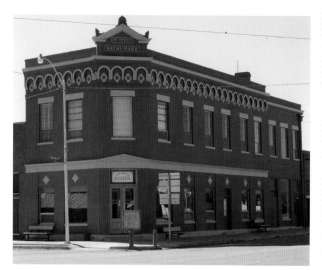

The **100th Meridian Museum** in **Erick** is housed in a former bank.

El Reno

El Reno, Oklahoma, is located on the site where the western fork of the historic Chisholm Trail crossed the North Canadian River. The river ford at this location also served as the point of crossing for the Chicago, Kansas & Nebraska Railroad, owned and operated by the Chicago, Rock Island & Pacific Railroad after 1891.

As the community and county is divided by the 98th Meridian, the eastern section opened to settlement in the famous Land Run of 1889, and the western section was included in the run of April 1892. Additionally, the town was the site of one of two land district offices for the 1901 land lottery drawings.

There are numerous historically significant buildings in El Reno. These include the El Reno Hotel, built in 1892; the Carnegie Library, 1904; the Canadian County Jail and Stable, 1906; and the Southern Hotel, 1909.

Sayre

Built in 1911, the Beckham County Courthouse in Sayre is the tallest building in the community and one of the few courthouses in the state topped with a dome. Designed in a neoclassical style utilizing Doric-type columns by the architectural firm of Layton, Smith, and Hawk, the building features brick and locally quarried stone in its construction. The distinctive design led to much critical acclaim upon the courthouse's completion. It was added to the National Register of Historic Places in 1984.

Tulsa

The towering Creek Council Oak overlooking the Arkansas River served as the initial meeting place for the Lockapoka Creek Indians, led by Chief Achee Yahola, after being forcibly relocated to the site by the federal government in 1834. It is listed on the National Register of Historic Places.

Landmarks

Afton

Afton Station, a small automotive museum and eclectic collection of local and Route 66-related memorabilia, is a landmark that epitomizes the

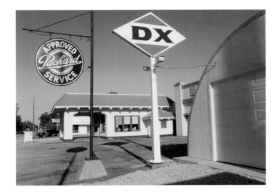

Afton Station in is a popular attraction. *Judy Hinckley*

revitalized interest in Route 66. As such, it is a destination for Route 66 buffs from most every country.

The building that houses Afton Station dates to 1930. Purportedly this DX station was the first to operate twenty-four hours a day in the community of Afton. It continued to serve as a gasoline station until the mid-1980s, after which point a succession of owners used the building for various businesses, including a Western Auto Store, a flower shop, and a beauty shop. Restoration commenced following acquisition of the property by David and Laurel Kane in 2000. They reopened it as Afton Station and Route 66 Packards, indicative of the owners' interest in automobiles manufactured by the Packard Company. In 2009, Afton Station was selected the best new business on Route 66.

Arcadia

Arcadia is unique among Route 66 communities in that it has one landmark representing the area's pre-Route 66 history located almost directly across the road from a landmark of the modern fascination with that highway.

The famous Arcadia round barn was built by William F. Odor in 1898. The 60-foot diameter barn with a 43-foot interior height was rescued from collapse through efforts by community activists led by Luke Robison in the 1980s. It currently serves as a location for special functions and houses the offices of the Arcadia Historical and Preservation Society

The second landmark, Pops, perfectly blends the classic malt shop and service station with the modern era through the use of glass and

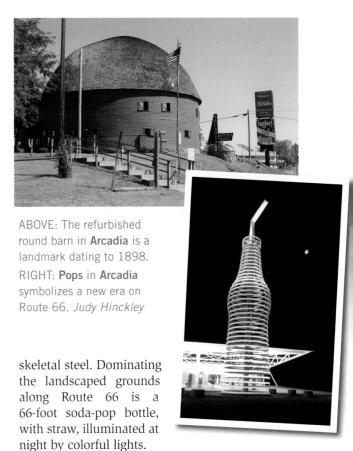

ABOVE: The refurbished round barn in **Arcadia** is a landmark dating to 1898.
RIGHT: **Pops** in **Arcadia** symbolizes a new era on Route 66. *Judy Hinckley*

skeletal steel. Dominating the landscaped grounds along Route 66 is a 66-foot soda-pop bottle, with straw, illuminated at night by colorful lights.

Bristow

The Bristow Motor Company building, which dates to 1923, boasts a well-preserved façade that includes original plaster reliefs. The 1946 publication *A Guide Book to Highway 66* recommended it as an available service facility. It is on the National Register of Historic Places.

The building, which currently houses Bolin Ford, appears much as it did in the 1920s thanks to extensive restoration following a fire in December 2008. In the process of renovating the building, several modern features were incorporated into the original design, including transformation of the Bolin Ford sign into a four-kilowatt wind turbine.

Built in 1930 and listed on the National Register of Historic Places, the Bristow Firestone Service Station building at 321 North Main Street underwent restoration and renovation in 2007. Funding for the project included a $25,000 cost-share grant from the Route 66 Corridor Preservation Program.

The **Blue Whale** in **Catoosa** has become an internationally recognized landmark. *Steve Rider*

Catoosa

Although the Blue Whale in Catoosa is a relatively late addition to the Route 66 roadside, it is nevertheless a popular landmark and is often cited as an example of renovation and preservation spurred by the resurgent interest in Route 66. The unique structure dates to 1972.

The Blue Whale was one of the final additions to a park and small zoo established by Hugh Davis and his wife, Zelta, in the late 1960s. The entire complex centered on a small pond, and it met local recreational needs and provided a refreshing stop for travelers for almost two decades.

After its closure in 1988, a decade of abandonment and vandalism led to discussions about demolition. An informal group of concerned citizens and local businessmen interceded and initiated refurbishment in 1997, and renovations of the grounds continue as of this writing.

As commemoration of the Blue Whale's refurbishment, a community Christmas celebration included the addition of strings of lights in 2010.

Chandler

The Chandler Route 66 Interpretive Center and the Ben T. Walkingstick Conference Center and Exhibition Hall are housed in the historic Chandler Armory building that dates to the mid-1930s. It is discussed in greater detail under the military sites section later in the chapter.

The gallery of internationally acclaimed artist Jerry McClanahan is housed in an unassuming building several blocks north of Route 66 at 306 Manvel Avenue in Chandler. As McClanahan is also the author of the *EZ 66 Guide for Travelers*, arguably the most popular guidebook to Route 66 in the world, the gallery is a common destination for enthusiasts.

Claremore

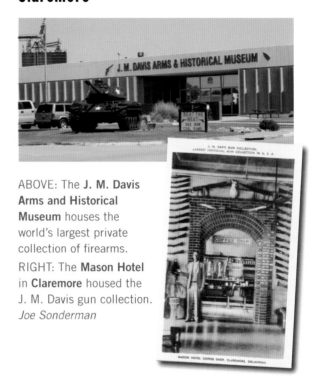

ABOVE: The **J. M. Davis Arms and Historical Museum** houses the world's largest private collection of firearms.

RIGHT: The **Mason Hotel** in **Claremore** housed the J. M. Davis gun collection. *Joe Sonderman*

Clinton

The Oklahoma Route 66 Museum at 2229 West Gary Boulevard in Clinton blends traditional static exhibits with state-of-the-art audio and visual presentations to tell the story of Route 66 in the Sooner State. A centerpiece of the museum is an audio tour written and narrated by award-winning author Michael Wallis. Additional exhibits of note at the only state-operated Route 66 museum include a small theater with video presentations and a refurbished diner on the grounds.

At the Y-shaped intersection of 10th Street (formerly U.S. 66) and U.S. 183 stands the Y Service Station and Café. The complex was built in 1937 in a blending of Mission Revival and Streamline Moderne styling, and it originally included the

The **Oklahoma Route 66 Museum** in **Clinton** is a destination for thousands of enthusiasts. *Judy Hinckley*

The **National Route 66 Museum** in **Elk City** is part of a museum complex.

Y Modern Cabins, which have since been demolished. The facility thrived into the 1950s, but with realignment of Route 66 in 1956, the business entered a period of precipitous decline. In the years since the closure of the café and service station, the building has been used for a variety of purposes, most recently as an automotive dealership.

Elk City

Located at the intersection of Pioneer and 3rd Street (Route 66), the National Route 66 Museum is part of Elk City's award-winning Old Town Museum complex. Additional components include the National Transportation Museum, Farm & Ranch Museum, and Blacksmith Museum.

The Route 66 museum features a variety of displays ranging from photographs to detailed dioramas featuring real vintage automobiles, as well as a gift shop. A pair of towering kachina from the Queenan Trading Post dominate the parking lot.

The Queenan Trading Post was established at the junction of Oklahoma Highway 6 and U.S. 66 in 1948 by Reese and Wanda Queenan, and it remained an attraction in the Elk City area until its closure in 1980. To ensure their trading post garnered attention, the owners had the colorful kachina built from discarded drums and pipe.

Erick

Housed in the former city meat market, the Sandhills Curiosity Shop is an internationally famous attraction. In addition to the shop's eclectic collection of vintage signage and other artifacts that chronicle almost a full century of American roadside evolution, owners Harley and Annabelle entertain visitors with a bawdy version of redneck vaudeville, as the Mediocre Melody Makers. The shop is located on Sheb Wooley Avenue a few blocks south of Roger Miller Boulevard (Route 66).

Hydro

The Provine Station, built near Hydro in 1929, is one of the most photographed locations in Oklahoma. Better known as Lucille's in reference to Lucille Hamons, who served as the proprietor from 1941 to the early 1990s, the facility is an unaltered example of the pre-1930 service station, complete with overhead living quarters.

Carl Ditmore built the facility at the busy intersection of Provine Road and U.S. 66 a few miles

Elk City hosted the 1931 U.S. Highway 66 Association convention. *Steve Rider*

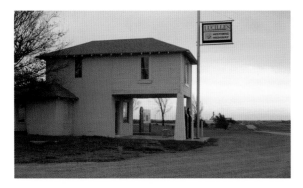

Lucille's in **Hydro** is an exceptional example of roadside service architecture.

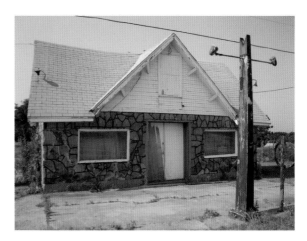

The **Threatt service station** in **Luther** is listed on the National Register of Historic Places.

east of Hydro. In 1941, Carl and Lucille Hamons purchased the facility, which at that time also included a small store and a motel.

The motel closed in 1962, largely because the completion of I-40 bypassed this segment of Route 66. Shortly after Lucille Hamons's death in 1999, the original Hamons Court sign was donated to the Smithsonian Institute for inclusion in an exhibit that chronicled the evolution of Route 66 and its role in American society during the twentieth century.

Although exterior renovations are complete, the facility remains closed as of this writing. However, the current owners built a replica restaurant, Lucille's Roadhouse, at exit 84 on I-40.

Luther

The distinctive Bungalow-Craftsman styled Threatt Filling Station, located at the intersection of Historic Route 66 and North Pottawatomie Road,

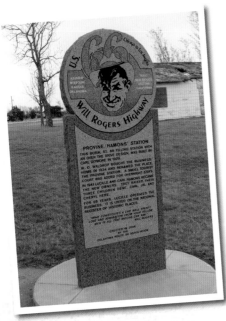

Throughout **Oklahoma**, Route 66 landmarks are commemorated with a Will Rogers–adorned marker.

approximately three miles east of Luther, was built of locally quarried sandstone in about 1915. The station is relatively unmodified in its size and configuration with the exception of a small addition at the rear built in the early 1960s.

The Threatt family immigrated to the Luther area with other former slaves in 1899 and began homesteading after establishment of the federal system of land allotment for the Oklahoma Territory. In addition to farming, the Threatt family also quarried sandstone on their property. The Threatts established the service station with the creation of State Highway 7 (later U.S. 66) along the property's northern boundary in about 1915, and it remained operational through the late 1950s.

Its history as an African American–owned business and the building's preserved state were factors that led to the property's listing in the National Register of Historic Places in 1995. The building most recently served as a private residence.

Miami

Located on Miami's Main Street (Route 66), the fully refurbished Spanish Colonial styled Coleman Theater was built in 1929 at a cost of $590,000 by zinc mining magnate George L. Coleman Sr. The ornate theater was designed by the Boller Brothers, an architectural firm based in Kansas City, Missouri, and it presents a tangible link to the period of prosperity during the area's mining boom that bracketed World War I. The elaborate exte-

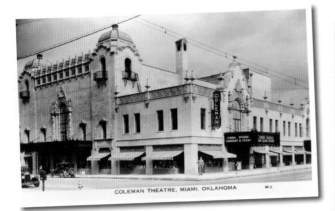

COLEMAN THEATRE, MIAMI, OKLAHOMA M-2

The ornate **Coleman Theater** in **Miami** continues to host performances and events more than eighty-five years after it opened. *Joe Sonderman*

rior incorporates towers, minarets, hand-carved gargoyles, and stucco and terra cotta trim and cornices on the façade. The interior is equally opulent, with gold-leaf-accented trim, carved mahogany moldings and railings, and stained glass windows.

The theater is again the centerpiece of this community's historic district. In addition to special film showings, it also serves as a venue for special events. The theater was listed on the National Register of Historic Places in 1983 and was donated by the Coleman family to the city of Miami in 1989.

Waylan's Ku-Ku is a restaurant that has specialized in simple, traditional American fare such as hamburgers and French fries since 1965. In addition to the excellent food and service, the vintage neon signage ensures that the restaurant continues to be a primary Route 66 destination.

Waylan's Ku Ku in **Miami** retains its original 1965 signage.

The Miami Marathon Oil Company Station dates to 1929, and the Neoclassical Revival style of its design is unique for the period. Located at 331 South Main Street, it was listed on the National Register of Historic Places in 1995. Fully refurbished with the exception of reinstallation of gasoline pumps, the building has housed a variety of businesses in recent years, most recently a beauty parlor.

The triangular **"Milk Bottle Building"** is a unique **Oklahoma City** landmark. *Joe Sonderman*

Oklahoma City

Built in 1930 and listed on the National Register of Historic Places, the uniquely designed 392-square-foot triangular "Milk Bottle Building" on Classen Street (Route 66 from 1926 to 1930) mirrors the geometry of the lot formed by the rails for the Belle Isle streetcar line and Northwest 23rd Street. The building initially housed the Triangle Grocery and Market, which also served as a stop for the streetcar line. The building's descriptor stems from the placement of an 8-foot-wide, 11-foot-high, milk-bottle-shaped metal sign on the roof in 1948 to promote a local dairy. The building has housed an array of businesses since its construction, the most recent of which is a Vietnamese restaurant.

Frontier City, U.S.A., is an unusual roadside attraction in that it remained relevant and popular into the twenty-first century. Established in 1958 on a radical business model developed by Jimmy Burge, the park continues to serve as a primary

Frontier City, U.S.A., in Oklahoma City has evolved with changing times since opening in 1958.
Joe Sonderman

entertainment venue for Oklahoma City.

Burge was associated with various elements in the film and entertainment industries for many years, running the gamut from usher at the Criterion Theater in Oklahoma City to being a press agent for Joan Crawford and Robert Taylor at MGM Studios. In 1957, Burge returned to Oklahoma City from California and assumed the director's position for the state of Oklahoma's semi-centennial celebration.

After studying Walt Disney's and Walter Knott's process for creating amusement parks, Burge initiated construction of a replica Oklahoma boomtown from circa 1907. He then purchased numerous components of this replica community upon the fair's closure, acquired a sizable property along the westbound lanes of U.S. 66, and with assistance from Russell Pearson, a designer with the state celebratory project, initiated plans for the Frontier City, U.S.A., amusement park.

"The Gold Dome," located at 1112 Northwest 23rd Street (an alignment of Route 66), was built in 1958 as the fifth building in the world to use the patented geodesic designs of futuristic architect Buckminster Fuller, and it was the first to utilize gold anodized aluminum. The building is listed on the National Register of Historic Places.

Neighboring the Gold Dome is the twenty-one-story, hexagon-shaped Classen Building. The 1966 structure features extensive use of glass, aluminum, and marble.

The Tower Theater at 425 Northwest 23rd Street dates to 1937. Renovated into an office complex, the 1,500-seat theater was the largest in Oklahoma City at the time of construction.

Stroud

Originally opened in August 1939 and added to the National Register of Historic Places in 2001, the Rock Café epitomizes the era of renewed fascination in Route 66. Its origins reflect the entrepreneurial opportunities offered by Route 66.

Roy Rives built the café over a three-year period as constraints of time and finances allowed. Shortly after its opening, the café began to double as a stop for the Greyhound bus lines, which resulted in such a dramatic increase in business that Rives initiated a twenty-four-hour schedule.

The café remained in continuous operation through 1993. At that time the café's new owners initiated a complete restoration and renovation, funded in part with money from the National Park Service Route 66 Corridor Preservation Program.

The café was restored to its 1939 appearance by using original floor plans in the renovation. However, shortly after the filming of an episode for the Food Network's *Diners, Drive-Ins & Dives*, a devastating fire in 2008 gutted the structure, leaving only the outer stone walls standing as a shell.

With funding assistance from the National Trust Southwest Office and the National Park Service, proprietor Dawn Welch again rebuilt the café to its original appearance. It reopened in 2009 and remains a favored stop for Route 66 enthusiasts.

As a side note, Welch served as the inspiration for the character Sally Carrera in the 2006 animated film *Cars*.

Tulsa

The designation of 2nd Street and other streets in Tulsa as the course for Route 66, with certification of that highway in 1926, served to transform the entire corridor. In late 1930, the Phillips Petroleum Company purchased property at the corner of 6th and Elgin streets, razed the two-story home on that site, and built a service station utilizing the then-popular Cotswald Cottage design.

The Cotswald design incorporated a uniform floor plan that included a chimney, a steeply pitched roof, and a standard paint scheme of dark green with orange and blue trim to facilitate customer recognition as well as to allow the facility to blend into residential settings. The Vickery Station, as it is known today, appears as it did in 1930 with the exception of a matching brick-

THE BLUE DOME, "BEST IN WEST", 2ND AND ELGIN, TULSA, OKLA.

The **Blue Dome** in **Tulsa** is now the centerpiece of a thriving arts district. *Steve Rider*

constructed four-bay garage that was built as a separate building a short time after.

The complex remained in operation as a service station and garage until 1973. Since then, it has housed a variety of business. Between 2006 and 2008, after its listing in the National Register of Historic Places in 2004, a new owner fully renovated the property to an original appearance utilizing cost-share grant assistance from the National Park Service Route 66 Corridor Preservation Programs and tax credits for historical preservation. It currently serves as a rental car facility.

Located at the corner of 2nd Street (pre-1932 Route 66) and Elgin, the Blue Dome Station is now the centerpiece for Tulsa's Blue Dome District, the venue for the Blue Dome Arts Festival. Built by T. J. Chastain in 1925 for the diversification of Chastain Oil Company into retail sales, the Blue Dome Station represented a dramatic step in the development of service stations. Living quarters for the manager originally dominated the top floor under the distinctive blue dome, and this was one of the first stations in Oklahoma to offer a carwash service and pressurized air. It was listed on the National Register of Historic Places in December 2011.

The Desert Hills Motel at 5220 East 11th Street in Tulsa, a Route 66 alignment since 1933, succumbed to changing times in the early 1970s. As a low-rent weekly or monthly apartment complex, the motel deteriorated before its acquisition by Jack Patel in 1996. A full and complete restoration and renovation commenced. With the exception of the removed swimming pool, the motel appears as it did in the late 1950s, including the original neon sign from 1953.

Dating to the mid-1930s, the towering illuminated Meadow Gold sign that originally stood atop the Beatrice Foods building at the intersection of 11th Street (Route 66) and Lewis Street is now a symbol of Tulsa's endeavors to preserve its rich Route 66 related heritage. Scheduled for demolition in 2004, the two 20-by-40-foot panels became a rallying point for area preservationists. Thanks to an unprecedented coalition of the City of Tulsa, the Tulsa Foundation for Architecture, the Oklahoma Route 66 Association, the state historic preservation office, and the National Park Service, the panels were removed, restored, and then relocated to the roof of a small brick pavilion and information kiosk at the intersection of 11th Street and Quaker. The restored sign, including functioning neon, was rededicated on May 22, 2009.

The **Warehouse Building** in **Tulsa** is a landmark dating to 1929. *Joe Sonderman*

The refurbished **Meadow Gold Sign** and its kiosk mount is a landmark in **Tulsa**. *Judy Hinckley*

The restored **Campbell Hotel** is a landmark of Route 66's renaissance in **Tulsa**.

Built in 1927 by Max Campbell, the thirty-six-room Casa Loma Hotel in the Max Campbell Building at 2636 East 11th Street did not survive the economic collapse of the 1930s. After closure, the building underwent a major

TOP: **Cyrus Avery Plaza**, near the foot of the Cyrus Avery Route 66 Memorial Bridge, honors the man considered to be the father of Route 66. The centerpiece sculpture, entitled "East Meets West," depicts Avery's Ford automobile encountering a horse-drawn carriage.

ABOVE: **Tally's Café** in **Tulsa** is a landmark on the post-1932 alignment.

renovation, resulting in its transformation into a series of storefronts on the ground floor and offices on the second. Group M Investment of Tulsa acquired the building in 2008 and initiated a detailed restoration to the hotel's original appearance—a daunting task, as the roof was gone in numerous places and many windows were broken. Listed in the National Register of Historic Places, the restored Campbell Hotel has twenty-six guest rooms on the second floor and a 4,000-square-foot event center on the first, and it is a showpiece of the Route 66 corridor in the city of Tulsa.

Clanton's Café in **Vinita** has been owned by the same family since it opened in 1927. *Judy Hinckley*

Vinita

Clanton's Café is housed in a rather nondescript building but is recognized for its excellent traditional American food and the simple sign outside that reads, "Eats." Featured on *Diners, Drive-Ins & Dives* (season 2, episode 4), this café has the distinction of being the longest continuously operated family-owned restaurant on Route 66 in the state of Oklahoma. It originally opened in 1927.

Warwick

Seaba Station was built in 1921 by John Seaba along State Highway 7, a part of the Ozark Trail network that was incorporated into the U.S. highway system as Route 66 in 1926. The building was originally a service station and garage. A series of expansions in the 1930s led to the creation of a

full-service facility that included Seaba's Engine Rebuilding & Machine Shop, a diversification that enabled the business to survive the Great Depression. With many government contracts to repair military equipment and with a decline in the gasoline business due to rationing during World War II, Seaba incorporated the service station into the more profitable machine shop. It remained in business through 1994

In 2005, receipt of a National Park Service Route 66 Corridor Preservation Cost-Share Grant served as a foundation for the funding of a complete restoration of the distinctive brick building. In the late summer of 2010, the building reopened as a motorcycle museum.

The ruins of the restrooms at the rear of the building are a unique attraction at Seaba Station. Built from stone and a variety of discarded materials, the buildings house a rare toilet that consists of a fluted cast-iron base, a wooden seat, and a valve system that is operated by pressure on the seat, rather than the traditional water reservoir tank.

Yukon

The recently refurbished **Yukon's Best Flour** sign in **Yukon** is a treasured landmark.

Parks

This distinctive gateway stands at the entrance to **Clinton's McLain Rogers Park**, established in the mid-1930s.

Clinton

Built as a joint project of the Federal Emergency Aid Relief Administration, the Works Progress Administration, and the Civil Works Administration between 1934 and 1937, the twelve-acre McLain Rogers Park, named for the Clinton mayor at that time, retains numerous unique architectural elements. The most notable of these is the impressive Art Deco styled gateway fronting Route 66, which utilizes brick supports and neon lit trim, a feature that helped the park achieve listing in the National Register of Historic Places in 2004.

Mature hardwoods and conifers now shade many original buildings and features, resultant of well-planned landscaping at the time of construction. These original structures include an amphitheater, bandstand, pavilion, bathhouse, and tennis court. In 1941, the Oklahoma Highway Patrol established a dispatch center at the entrance of the park, the last major construction within the park.

Foyil

Located 3.5 miles from Route 66 in Foyil, Ed Galloway's Totem Pole Park remains as the largest and oldest folk art collection in the state of Oklahoma. Built by Galloway between 1937 and 1961, the park features many highly decorative creations as well as a picnic area.

Totem Pole Park at **Foyil** is the largest folk art centered park along Route 66. *Judy Hinckley*

Galloway, one of the state's premier folk artists, built the decorated totem poles, fanciful trees, and his woodworking shop from stone, reinforced concrete, and wood. The largest of these is the 90-foot main totem pole that features bas-relief designs and what appears to be a massive turtle as the foundation. In addition to the park features—including fanciful picnic tables, a totem pole barbecue-fireplace, and intricate gateway—Galloway also built a Craftsman styled home and smokehouse at the site. The eleven-sided workshop, or Fiddle House, is where Galloway created his ornately carved furniture and fiddles, some of which remain on display.

After years of abandonment, Ed Galloway's Totem Pole Park was renovated between 1988 and 1998. Spearheading refurbishment of the expansive grounds and examples of Galloway's artistic genius were the Rogers County Historical Society and the Kansas Grassroots Arts Association.

Oklahoma City

Numerous parks line the Route 66 corridor on the shores of Lake Overholser in **Oklahoma City**.

Military

Chandler

Built by the Works Progress Administration (WPA) in two sections between 1935 and 1937, the Chandler Armory was designed by Major Bryan W. Nolan of the Oklahoma National Guard. The original facility included offices, a full-service garage, an ammunition vault, classrooms, locker rooms, and an auditorium that doubled as a drill hall. Beneath the auditorium's elevated stage was a long, narrow rifle range.

The armory's construction served as a template for other WPA projects designed to boost local economies by utilizing local labor and resources. The sandstone for the armory was supplied by a local quarry that employed more than 250 men, and the auditorium displays exceptional local artisanship in its wooden floor, which consists of more than 156,000 wood blocks that were cut on site and installed by hand. Completion of the armory complex in March 1937 was greeted with a communitywide celebration that included a parade, bands, and a banquet.

The facility served as the headquarters for Battery F, Second Battalion of the 106th Field Artillery of the Oklahoma National Guard 45th Infantry Division, a unit that served with meritorious distinction in North Africa, Sicily, and Italy during World War II. The complex remained in use through 1971.

Following long periods of abandonment, spotty maintenance, and modification to meet varying

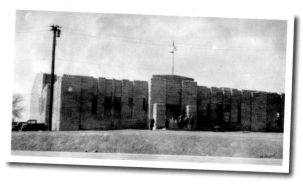

The historic armory in **Chandler** now houses a Route 66 interpretive center.

purposes, discussions were underway in the 1990s to demolish the building. A volunteer organization, the Old Armory Restorers, was formed in 1998 to generate support for saving the armory, and community fundraising efforts as well as monies from grants, matching-funds grants, and endowments allowed for renovation of the historic property.

It was listed on the National Register of Historic Places in 1992, and it is currently used as the Chandler Route 66 Interpretive Center and the Ben T. Walkingstick Conference Center and Exhibition Hall.

Claremore

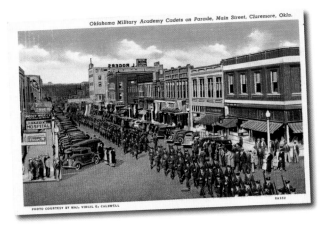

Deemed the "West Point of the Southwest" the **Oklahoma Military Academy** in **Claremore** operated from 1919 to 1971. *Joe Sonderman*

Fort Reno

Fort Reno was named for Major General Jesse L. Reno, a casualty of the Battle of Antietam during the American Civil War. Commissioned in 1874, it initially served as a protective fort for the Darlington Indian Agency during the Cheyenne uprising and as a staging area for campaigns against bands of Northern Cheyenne that would not submit to relocation to reservations.

Troops stationed at the fort served as law enforcement and peacekeepers during the "land rush" lotteries of 1889, 1892, and 1894. In a similar capacity, troops supervised the establishment of farms and ranches, and a post office operated at the fort from February 1877 to May 1909.

Dating to 1874, **Fort Reno** remained an important military installation through World War II.

With the exception of a brief period of closure in 1908, Fort Reno was an active military base through 1949. For most of this forty-year period, it was one of the few military installations utilized for the training of mules and horses.

During World War II, the fort served as a POW camp for German and Italian soldiers captured during the battles in Sicily and North Africa. At its peak, the camp housed 1,300 enemy prisoners of war, and the cemetery serves as a final resting place for seventy German and Italian prisoners who died while imprisoned in Oklahoma and Texas. In addition, with its location on Route 66, the fort served as a transit base for U.S. troops traveling to disembarkation points for either the European or Pacific theaters of operations.

In 1947, Fort Reno hosted the Department of Agriculture Research Laboratory, a facility still in operation at the fort. The fort also hosts special events and educational programs, and a visitor center and museum utilizes former military buildings at the site.

In 1970, the National Park Service listed the facility on the National Register of Historic Places. In the same year, Historic Fort Reno Inc. was established to preserve, promote, and maintain the site.

Foss

For a short two-year period in the early 1950s, an air force facility operated at Burns Flat near Foss. Traffic on Route 66 sustained the community's economy after the closure of the base.

A military base at **Burns Flat** did little to stem the slide in **Foss** that came with realignment of Route 66.

During World War II, **Will Rogers Field** in **Oklahoma City** served as a major training center. *Joe Sonderman*

Miami

On June 17, 1941, under contract from the United States Army Air Corps, the Spartan Aircraft Company leased land near the current Miami Airport and initiated construction of what would become the Spartan School of Aeronautics. Officially designated British Training School No. 3, it opened on July 13, 1941, and served as a primary and advanced training center for pilots and aircrews of the Royal Air Force.

The school remained in operation until mid-1945. During its period of operation, several British flyers died in training accidents. Burial took place in the G.A.R. Cemetery at 2801 North Main Street.

Records indicate that 2,000 pilots received training at the facility. In 1995, several of the RAF pilots that trained in Miami endowed an annual scholarship for the city high school.

Oklahoma City

Will Rogers Field, now Will Rogers World Airport, officially opened in June 1941. This was the first major military facility established in Oklahoma since statehood. The primary function for the Army Air Corps facility was as a training school. Initially only bomber crews received secondary training here, but within a few months, it began offering classes for photo reconnaissance.

In July 1941, construction began on another air base, Tinker Field, southeast of Oklahoma City near Midwest City. The Army Air Corps field, which opened in October 1942, was named for Major General Clarence Tinker, an Oklahoma native of Osage ancestry who was killed in attacks on Wake Island. The facility remains operational as Tinker Air Force Base.

Tulsa

On August 1, 1939, the Spartan School of Aeronautics at the Tulsa Municipal Airport was transformed into a training center under contract from the United States Army Air Corps. As one of the first contract schools for the Army Air Corps, it initially served as a training center for civilian pilots and later for Royal Air Force pilots and crews. The facility operated through August 1944.

Only one RAF pilot died at the facility. He was interned in the American Legion section of the Tulsa Memorial Park Cemetery.

Crime and Disaster

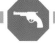

Bristow

A routine traffic stop in Bristow on June 29, 1926, resulted in the arrest of Mathew Kimes, who with his brother George was wanted for numerous crimes, including bank robbery. They escaped the next day with assistance from an unknown accomplice.

Catoosa

Early on the morning of September 1, 1978, Police Chief J. B. Hamby responded to a call of an armed robbery in progress at Catoosa Tag Agency, located on the corner of Highway 66 and Pine Street. As the police chief entered the building, Jackie Ray Young, twenty-nine, and David Gordon Smith, twenty-five, opened fire.

In the ensuing gun battle, Young was shot in the leg and suffered a fatal gunshot to the temple. Smith escaped but sought medical attention for gunshot wounds in the hand, groin, and leg and was later arrested and charged with murder.

Hamby received a gunshot wound to the leg and a fatal wound in the chest. Before succumbing to his injuries, the chief retreated to a laundromat next door, reloaded his weapon, and fired at Smith as he fled the scene.

Claremore

On Sunday, July 11, 1954, Claremore City Police Officer Joseph C. Hause accompanied the chief of police to the Page Hotel to investigate the theft of a shotgun from a local gun store. As the officers climbed the stairs from the lobby, the suspect opened fire from the landing, shooting Hause in the chest. As the police chief returned fire and retreated from the building, he dragged Hause's body to safety. Hause died on the scene. The suspect died from a self-inflicted wound to the head after officers stormed the hotel.

Clinton

Robert "Big Bob" Brady launched his criminal career at age fifteen in 1919 with larceny that resulted in his arrest and a prison sentence of five years. Upon his release from the Oklahoma state penitentiary in 1931 after serving additional time for forgery and an attempted armed robbery, Brady joined Clarence "Buck" Adams in a series of bank robberies, as well as a service station robbery in Vinita that ended with his arrest and incarceration in December 1932.

On May 30, 1933, Brady escaped from the state penitentiary in Lansing, Kansas, where he was serving a life sentence. Accompanying him in the escape were Harvey Bailey, Wilbur Underhill, Jim Clark, and seven other inmates.

Brady, Underhill, Bailey, and Clark quickly formed a new gang and resumed robbing banks. On July 3 of that year, the gang struck the bank in Clinton and made off with $11,000. This would be the gang's last criminal activity in Oklahoma.

On Friday, June 26, 1953, following leads in a burglary investigation, Patrolman Otto Thomas went to Bell's Tavern in the Lincoln neighborhood that bordered U.S. 66. After arresting three suspects without incident, an unknown assailant shot Thomas four times in the chest at point blank range with a .32 caliber handgun.

Commerce

On Easter Sunday, April 1, 1934, Bonnie Parker and Clyde Barrow—the famed Bonnie and Clyde—and accomplice Henry Methvin parked their stolen 1934 Ford sedan six miles west of Grapevine, Texas, on Dove Lane for a few hours of rest. While Bonnie and Clyde slept in the car, Methvin served as the lookout.

At some point in the evening, two Texas state patrolmen pulled up next to the car and were immediately fired upon by Methvin. One died instantly, and the second suffered fatal wounds.

To escape, the trio drove north into Oklahoma utilizing county and farm roads to avoid major highways, but deep mud caused numerous delays. An attempt to flag down assistance after they got stuck near Route 66 resulted in a motorist notifying the police in Commerce, Oklahoma.

The trio opened fire on Police Chief Percy Boyd and Constable Cal Campbell when they arrived to investigate or render assistance. Campbell was killed in the melee, while the wounded police chief was taken hostage and the gangsters drove east to Missouri; Boyd was later released near Fort Scott, Kansas.

A monument commemorating Constable Cal Campbell stands in a small park at 3rd and Main Street (Route 66) in Commerce.

Depew

On May 30, 1909, the *Billings Daily Gazette* reported that, "Depew was destroyed by a double twister that formed from that striking Key West and another coming from due east. The tornado wiped out Depew and then pushed northeast."

By the summer of 1926, the Kimes brothers, George and Mathew, had established a lengthy

criminal record that also included escape from prison. On June 30, the brothers added a bank robbery in Depew to their resume.

On February 8, 1960, an armed robber stole $5,000 from the State National Bank. An alert police officer, Glen Alt, captured the suspect less than an hour later in Bristow, Oklahoma.

Edmond

Police were relatively quick to identify a nude body with several bullet holes found along a farm road just off U.S. 66 at Edmond, Oklahoma. It was Lucille Comer, the second wife of Chester Comer.

Identification, however, did little to prevent the string of murders that culminated with Comer's death during a shootout with police near Blanchard, Oklahoma. Nor was it any assistance in preventing the murder of his first wife, Elizabeth, whose bullet-riddled and badly decomposed corpse was found near Kansas City, Missouri, in the fall of 1935.

No motive or reason was ever determined for Comer's rampage, and there was no record of serious altercation or legal troubles previously. Apparently, he simply went "amuck," as one newspaper account claimed.

After killing his ex-wife Elizabeth and disposing of the body, he drove south to Tulsa before turning onto U.S. 66 toward Edmond, where he murdered his second wife. He then proceeded to drive in a random manner, selecting targets without reason.

At Shawnee, Oklahoma, he abducted and murdered Ray Evans, a civic and community leader. He then stripped Evans naked and left the body in a field outside of town.

As Comer drove west, his next two victims were L. A. Simpson, a farmer, and his fourteen-year-old son, Warren. Robbery may have been a motive, but Comer simply shot the pair execution style, left them in the field where they had been working, and continued west to Blanchard in Simpson's car.

When Marshal Oscar Morgan stopped Comer near Blanchard, a gunfight ensued. Comer died from gunshot wounds shortly thereafter.

Erick

On July 14, 1930, simmering racial tensions exploded into a night of violence in Erick. As the *Frederick (Maryland) Post* published, "Reports received here [Shamrock, Texas] by Sheriff W. K. McLemore, Wheeler County, said negroes were driven out of Erick, Oklahoma, last night, and from Texola, Oklahoma, today by a mob seeking reprisal for the death of Mrs. Harry Vaughn, wife of a farmer in a nearby county in Texas, who was beaten to death Friday by a Negro."

Foss

In September 2013, an Oklahoma Highway Patrol training exercise utilizing a new sonar device discovered two vehicles at the bottom of Foss Lake, a short distance north of the Route 66 community of Foss, Oklahoma. The officers initially believed that the cars, a 1969 Chevrolet Camaro and a 1952 Chevrolet sedan, were stolen vehicles.

A near-record drought that left the lake almost thirteen feet below normal levels played a role in the vehicles' discovery. The position of the cars—side by side with the Camaro, all windows down, facing backward in the lake and the Chevrolet sedan facing into the lake with the driver-side door open—provided no indication that the initial speculation was incorrect.

After recovering the vehicles, police discovered the skeletal remains of six people, three in each vehicle, which initiated a crime-scene investigation. As of this writing, the bodies have not been positively identified, and the investigation was ongoing.

However, the 1969 Camaro matched the description of a vehicle belonging to Jimmy Allen Williams, who went missing from Sayre, Oklahoma, on November 20, 1970. That day, the sixteen-year-old Williams left his job at the 7th Street Grocery early, leaving his paycheck at the store, and picked up two friends, Leah Johnson and Thomas Rio.

Initial reports were that the trio intended to go to a football game in Elk City, a community on Route 66 to the east of Sayre. Investigators later learned that they instead had decided to go hunting along Turkey Creek Road.

Coincidently, several days after Williams's disappearance, the sheriff's department received a call to investigate a crime on Turkey Creek Road. Upon arrival, they found the remains of a burned Chevrolet Corvette that had been reported stolen in California.

An intense search for the missing teenagers and the Camaro yielded no leads. The families never gave up hope, and as late as 2009, Jimmy's brother, Gary, was offering a $10,000 reward for information. Still, no leads materialized, and Jimmy's social security number indicates no usage after 1970.

The second vehicle recovered in Foss Lake matched the description of a car owned by John Alva Porter, a former rodeo champion who was last seen in Canute, a Route 66 community west of Foss, on April 8, 1969. Porter, Cleburn Hamnock, and Nora Marie Duncan had indicated they were driving to Foss Lake.

As with the Williams case, despite intense investigation, the car was never located. Additionally, the bank accounts of Porter, Duncan, and Hamnock indicated no activity after this date until intervention by the family months later.

Foyil

On February 18, 1919, the American Railway Express Company of Kansas City, Missouri, issued a wanted poster: "$200.00 Reward—Paul Eugene Stufflebeam, formerly an employee of the American Railway Express Company at Foyil, Oklahoma, who absconded from that point with company funds."

Hydro

The *Daily Capital News* of Jefferson City, Missouri, reported on June 25, 1948: "All the deaths so far are at Hydro, in the west central section, where Deer Creek rose in a flash flood Tuesday night and sprang a 5-mile death trap along U.S. 66 transcontinental highway. A Greyhound bus and more than fifty cars and trucks were trapped in a wall of water that rose swiftly to 12 feet where the creek winds across the highway four times."

The article concluded with succinct details about the recovery of six bodies and seven destroyed vehicles without occupants, and a search for three missing truck drivers.

Miami

In the early morning hours of Tuesday, June 12, 1934, city police officers S. Dunaway, I. W. Ellis, and S. J. Johnson responded to a call regarding three suspicious men in a new Model A Ford sedan on Main Street (Route 66) at the Northeast Oklahoma Freight Depot. As the officers approached the car, the three suspects—Frank Shinn, twenty-one, Leroy Dennison, nineteen, and Jess Howard, twenty-five—opened fire.

Officer Dunaway, thirty-three, was shot in the left leg and died from blood loss before arriving at the hospital. Howard, an escaped murderer from Missouri, also died of his wounds shortly after arriving at the hospital. Dennison died on the scene from a gunshot to the head. Shinn escaped the melee unscathed, only to be snared by a highway roadblock a short time later.

Oklahoma City

Oklahoma City Justice of the Peace Joseph W. Wood was at the state fairgrounds on Sunday, July 14, 1935, when he responded to a call for assistance from a sheriff's deputy who had arrested a man carrying a gun. In the ensuing struggle, the suspect gained control of the deputy's revolver as he was being placed in the patrol car. Struck in the chest by a single bullet, Wood died on the scene.

On Sunday, July 12, 1942, Oklahoma Highway Patrolman James A. Long responded to a call about a woman screaming at Winans Park, located south of Route 66. As Long entered the park on foot, an unknown assailant opened fire with a shotgun, striking the officer in the chest. The patrolman died on the scene. Intense investigation failed to identify the assailant.

On the morning of Wednesday, January 12, 1949, Postal Inspector Harkins stopped to check his post office box at the city's main post office on Dean A. McGee Avenue. Without provocation Joseph Donnelly, sixty-nine, walked up behind Harkins and shot him once in the head. Donnelly then calmly waited for the police to arrive. Upon his arrest, he admitted guilt, but blamed Harkins for the loss of two twenty-dollar postal money orders.

Oklahoma Highway Patrolman Johnnie Whittle responded to a suspicious persons call on Monday, September 14, 1953, on Broadway (Route 66) near Edmonds. Upon arriving at police headquarters in Oklahoma City, one of the suspects pulled a gun that had been overlooked by Whittle and fired one shot to the back of the head. Whittle died instantly.

Sapulpa

On January 10, 1927, the remnants of the Ray Terrill Gang, consisting of Terrill and Herman Barker, joined with Mathew Kimes, one half of a pair of brothers that had been involved in a wide array of crimes in Oklahoma throughout the 1920s. In the first of a series of robberies, the gang stormed the bank in Sapulpa, Oklahoma, and absconded with an estimated $42,000.

On February 3, 1934, the extensive manhunt for Aussie Elliott, a bandit who had robbed banks in Sallisaw and Henryetta, Oklahoma, and later escaped from the Oklahoma State Penitentiary in McAlster, culminated in a gun battle outside of Sapulpa. Elliott, along with accomplices Raymond Moore and Eldon Wilson, was cornered by Sapulpa police officers on Route 66. Rather than surrender, the men chose to fight their way out. The ensuing gun battle lasted for almost an hour before the three criminals were subdued. In addition to Elliott, Moore, and Wilson, the casualties included Sapulpa Police Chief Tom Brumley and officer Charles Lloyd.

Stroud

A daring raid on two banks in Stroud, Oklahoma, on March 27, 1915, garnered national headlines. The primary catalyst for the media coverage was more the perpetrator than the crime itself, as Henry Starr was a famous outlaw from the frontier era.

For reasons unknown, while hitchhiking across Texas in 1958, James Donald French kidnapped one of the motorists who gave him a ride. Near Stroud, he murdered the driver and dumped the

Henry Starr robbed two banks in **Stroud** on March 27, 1915. *Steve Rider*

body along Route 66. Arrested shortly after and convicted of kidnapping and murder, French began serving his life sentence in the state penitentiary at McAlester in 1959. He received the death penalty after murdering cellmate Eddie Lee Shelton on October 17, 1961. Before his death by electrocution in the electric chair in August 1966, French purportedly quipped, "How's this for a headline? 'French Fries.'"

Texola

Crime and fire plagued the community of Texola between 1901 and 1910, the first decade of the community's existence. The first major conflagration occurred in October 1905.

The *Galveston Daily News* reported on October 25 that "a fire at Texola destroyed two business blocks, making a clean sweep from the Boxley & Company's grocery store down Main

TOP: Fire, bank robbery, and racial strife plagued early **Texola**. This is an abandoned service station in the town.

ABOVE: A violent bank robbery at **Texola** in 1908 garnered national headlines.

Street. The Terrill hardware store, Boxley grocery, Howard drug store, a saloon, racket store, confectionary store, and butcher shop were burned as were also several unoccupied buildings."

On April 29, 1908, the *Muskogee Times Democrat* reported that "four buildings on the main street of this town have been destroyed by fire and the total loss of buildings and stocks is placed at $20,000. The fire is believed to have been of incendiary origin. The losses are as follows: Kukendall Bros. dry goods and groceries, $10,000, insurance, $5,000, W. T. Smith, vacant building, $1,000, Howard's Drug Store, $3,000, insurance, $3,000."

Texola and its neighboring communities were also beset by a string of robberies in the first decade of the twentieth century. A particularly violent robbery in 1908 garnered national headlines. The *Washington Post* of January 19, 1908, reported: "After a hand to hand fight with Assistant Cashier Jones, two masked men tonight robbed the First National Bank of Texola of about $4,000. Jones was found bound, gagged, and insensible from a blow to the head."

Tulsa

In post–World War I Tulsa, racial tensions began manifesting as violent confrontations. In 1920, a mob of outraged citizens stormed the jail, removed an African American teenager accused of murder, and lynched him. Investigations that determined possible complicity by the Tulsa Police Department sparked outrage in Tulsa and nationally.

On May 30, 1921, Dick Rowland, an African American, and Sarah Page, a white elevator operator, had an altercation that later investigation determined to be relatively minor. However, the atmosphere of racial tension fueled by the lynching in 1920 added credibility to rumors, innuendos, and accusations, and Rowland was arrested following the incident with Page.

Rowland's arrest only added to the growing tensions, and on the evening of his arrest, an armed contingent of white citizens descended on the jail at the Tulsa County Courthouse to demand the release, to them, of Rowland. The sheriff refused, and the crowd grew larger and more hostile. Into this volatile scene arrived approximately twenty-five heavily armed African American veterans of World War I to lend support to the sheriff.

The sheriff declined the offer of service, but the mere presence of the armed men enraged the mob, which then proceeded to the National Guard Armory with the intent of obtaining guns. Armed guardsman turned the mob away from the armory, but this did nothing to quell the rumor that a mob was forming to descend on the Greenwood District, a prosperous African American enclave in the city.

To counter the perceived threat, a large contingent of African American men gathered in the hope of protecting their homes and businesses. When the police attempted to disarm them, a riot ensued.

By the time the violence was over, more than forty African Americans were killed, including A. C. Jackson, a surgeon of international renown. Additionally, fire decimated thirty-six blocks of the Greenwood residential and business district.

Film and Celebrity

Afton

The inauguration parade for President Kennedy included a buffalo from the **Buffalo Ranch** in **Afton**. *Joe Sonderman*

Canute

Canute is the hometown of Colonel Norman Lamb. Lamb served in the United States Army for thirty-three years, first at Fort Bliss working on air defense systems. He later served as a West Point Liaison.

Lamb served in the Oklahoma State Senate from 1971 to 1988. He also acted as chair of the Republican State Convention in 1976, the same year he was voted one of the Top Ten Most Effective Senators by Peers and one of the Top Ten Most Popular Senators by Peers.

In 1995, Governor Frank Keating appointed Colonel Lamb to the position of Secretary of Veteran Affairs. He continued to serve in this position following the election of Brad Henry in 2002.

Chandler

The Oak Park Cemetery in Chandler is the final resting place of legendary law enforcement officer William Mathew Tilghman Jr. His career spanned an astounding fifty-four years.

Before accepting the appointment as deputy sheriff in Ford County, Kansas, in 1877, Tilghman had been a successful buffalo hunter and had served as a scout for the United States Army. His next appointment was as city marshal in the notoriously violent town of Dodge City, Kansas, in 1884.

Before the turn of the century, Tilghman would be involved in a series of successful business endeavors, including ranching and saloons. He also developed a reputation for honesty, tenacity, and a skill with guns while working as the sheriff of Perry, Oklahoma, and as a Deputy U.S. Marshal.

Further fueling his reputation were incidents such as the single-handed tracking and arrest of infamous outlaw Bill Doolin. He was also instrumental in the capture of "Little Dick" Raidler.

He started the new century in the position of Lincoln County Sheriff, followed by election to the state senate in 1910, and in 1911, he accepted the position of Police Chief in Oklahoma City. During this period, he also worked in the motion picture industry and played an important role in the development of *The Passing of the Oklahoma Outlaws*, a film released in 1915.

In August 1924, at age seventy, Tilghman accepted the position of city marshal at Cromwell, Oklahoma, a booming and raucous oil town. On November 1 of that year, he arrested Wiley Lynn, a federal prohibition agent, for public intoxication and disturbing the peace. As he was being escorted to jail, the federal agent pulled a hidden handgun and shot Tilghman three times. The subsequent trial received much media attention due to Tilghman's reputation and Lynn's eventual acquittal.

For Route 66 enthusiasts the most famous celebrity in Chandler is Jerry McClanahan, an internationally acclaimed artist and mural painter and the author of the *EZ 66 Guide for Travelers*, the most popular guidebook to the highway yet written. McJerry's Route 66 Gallery at 306 Manvel Avenue, a few blocks north of Route 66, serves as his studio and showroom and is a destination for travelers from throughout the world who stop to have their guidebook signed.

Gene Autry initiated his music career while living in **Chelsea**. *Steve Rider*

Chelsea

Gene Autry resided in Chelsea for a brief time while working for the Frisco Railroad. Chelsea was also the residence of Will Rogers's sister, Sallie McSpadden.

Claremore

Even though it has been more than seventy-five years since Will Rogers and famed aviator Wiley Post died in a plane crash in the territory of Alaska, the community of Claremore still maintains a proud association with Rogers. A museum and memorial to Rogers is located at 1720 West Will Rogers Boulevard.

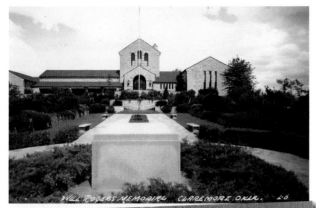

TOP: Monuments and commemorations to Will Rogers abound in **Claremore**, including this memorial. *Joe Sonderman*

ABOVE: The landmark **Will Rogers Hotel** in **Claremore** opened in 1930. *Joe Sonderman*

The Will Rogers Hotel on J. M. Davis Boulevard (the pre-1958 alignment of Route 66) opened on February 7, 1930, established by Louis Abraham, Walter Krumrei, and Morton Harrison. Rogers said of the hotel that he "was more proud to see his name in electric lights in my old home town and on an institution built for service to the public than I ever was on the biggest theatre on Broadway."

The hotel initially boasted radium baths on the top floor. It closed in 1991, and after refurbishment in 1997, it now serves as an apartment complex for seniors.

Claremore is also the hometown of legendary crooner Patti Page, and playwright Rollie Lynn Riggs. The play *Green Grow the Lilacs*, which served as the basis for the musical *Oklahoma*, is Riggs's most memorable work.

Elvis Presley was one of the illustrious guests of the **Trade Winds Motor Hotel** in **Clinton**. *Joe Sonderman*

Clinton

The Trade Winds Courtyard Inn's claim to fame is that an occasional guest in the 1960s was a musician by the name of Elvis Presley. The inn is located on West Gary Boulevard, across from the Oklahoma Route 66 Museum.

Commerce

Indicative of the community's most famous citizen, the latter alignment of Route 66 is signed as Mickey Mantle Boulevard. His boyhood home, now a private residence, is located at 319 South Quincy. Mutt Mantle Field is named in honor of his father, and it was here that "the Mick" began his baseball career by playing for the Commerce Comet team.

El Reno

Demolished in 2005, the Big 8 Motel that opened in 1940 as the Beacon Motel & Café at 1705 East Highway 66 served as a film location for the 1988 movie *Rain Man* starring Tom Cruise and Dustin Hoffman. Before its demolition, the owner noted that thousands of visitors asked to see or stay in room 117 because of the film.

Altered to read "Amarillo's Finest" for the film, the Big 8 Motel sign was purchased by a private collector in 1999. Before its demolition, the motel operated as the DeLuxe Inn.

Erick

Erick's celebrity associations are evident in the commemorative signage for the Route 66 corridor through town: Roger Miller Boulevard and the original Main Street designated as Shelby "Sheb" Wooley Avenue.

Born in Erick on April 10, 1921, Shelby Wooley formed his first band, the Plainview Melody Boys, when he was just fifteen years old. Through the connections of his father, who was an acclaimed fiddle player, the band played on radio station KASA in Elk City.

In 1940, Sheb married Melva Miller, who was a cousin of singer Roger Miller. A few years later, Wooley traveled to Nashville, where his music attracted the attention of Ernest Tubb, a star of the Grand Ole Opry, and shortly before Christmas in 1945, he recorded his first song for the Bullet label. In addition, he was writing music for several other performers.

Though his music gained in popularity from recordings and tours, Wooley traveled to Hollywood, California, in 1950 in the hope of becoming an actor. After a successful screen test with Warner Brothers, he appeared in a variety of films while continuing to write music for stars such as Hank Snow and Theresa Brewer.

In 1958, Wooley accepted a contract to play the character Pete Nolan on a new television program called *Rawhide*. That same year, he recorded the smash hit *Purple People Eater*.

Wooley's career would include appearances in more than eight movies and a role as an original cast member of the television show *Hee Haw*, a program for which he wrote the theme song. In 1962, he began regarding novelty songs under the name Ben Colder.

Foyil

C. C. Pyle, a sports promoter and entrepreneur, devised an epic cross-country foot race that he believed would gain international media attention and be a profitable venture. As the course of the race was to follow Route 66 east from Los Angeles before connecting with other highways that led to Madison Square Gardens in New York City, the U.S. Highway 66 Association became an early sponsor and promoter of the race.

The International Trans-Continental Foot Race, dubbed the Bunion Derby by sportswriters, commenced at the Los Angeles Ascot Speedway on March 4, 1928. With a first-place prize of $25,000, the race attracted more than 200 entries, including professional marathon and long-distance runners, and Andrew Payne, a nineteen-year-old Cherokee from Foyil, Oklahoma.

Payne, an unknown amateur, began dominating headlines shortly after assuming the lead near the Oklahoma state line at Texola. With this, Foyil garnered media attention around the world.

Only fifty-five competitors crossed the finish line on May 26, 1928. Payne was the winner, and he used his winnings to pay off the family farm and purchase a farm of his own.

Route 66 in Foyil is designated Andy Payne Boulevard. At the west entrance to town, a statue of Payne dominates the small park, and a Bunion Derby marker is in a park on the east side of town.

The **Coleman Theater** in **Miami** is listed on the National Register of Historic Places.

Miami

The McPherson Post Number 48 of the Grand Army of the Republic spearheaded establishment of the G.A.R. Cemetery at 2801 N. Main Street in 1892. The cemetery serves as the final resting place for numerous veterans of the American Civil War, as well as for many Ottawa County pioneers.

It is also the final resting place of Samuel Thomas Privett Jr., known as Booger Red after a premature gunpowder explosion as a child resulted in permanent facial scarring. An inductee into the Cowboy Hall of Fame, Privett was an internationally acclaimed bronco rider whose internment at the cemetery in 1924 received considerable media coverage.

Because of Privett's skills as a rider and showman, Buffalo Bill Cody offered to hire him for his Wild West Show. Instead, Privett established his own show and performed at the 1904 World's Fair in St. Louis.

Surprisingly, his grave remained unmarked until June 17, 2011, when a celebration in his honor culminated with the placement of a grave marker that had been paid for with local donations. The stone contains a quote attributed as the last words spoken by Privett: "Always be honest, for it pays in the long run. Have all the fun you can while you live for when you are dead you are a long time dead."

The Coleman Theater on Main Street (Route 66) opened on April 18, 1929, to a sold-out crowd. During this late vaudeville period, a number of celebrities performed here, including Sally Rand, the infamous fan dancer, and Will Rogers.

Joe Don Rooney, lead guitarist and harmony singer for the country band Rascal Flatts, initiated his music career with a band named Rascal's, formed in Miami. Band members included Boone Pickens and Fred Samuels.

The list of celebrities associated with Miami includes Mickey Mantle, Jim Thorpe, and Steve Owens, the 1969 Heisman Trophy winner. Charles Banks Wilson, the artist who painted the murals in the dome of the Oklahoma State Capitol, spent his childhood in Miami before enrolling at the Art Institute of Chicago. Cinematographer Lucien Ballard, a Miami native, collaborated with Sam Peckinpah on various projects, including *The Wild Bunch*.

Faubion Bowers, also born in Miami, trained as a concert pianist and received critical international acclaim. However, in 1940 he initiated a career as a teacher at Hosei University in Tokyo, Japan, and a lecturer at schools in Java. With the United States' entry into World War II after the attack on Pearl Harbor, Bowers returned to America. Throughout the war, his mastery of the Japanese language enabled him to make vital contributions to the U.S. Army Military Intelligence Division.

Sapulpa

In *Oklahoma's Yodeling Cowboy*, Gene Autry noted that, "My folks moved to Ravia, Oklahoma, when I was about 15, and that's where I finished high school. During off hours I worked around the Frisco Railroad station, doing odd jobs. In return for this, the stationmaster taught me telegraphy.

"I went to work for the Frisco, as a telegrapher, after graduating from high school. When the wires weren't too busy, I'd play my guitar and sing.

"In Sapulpa, Oklahoma, I met another railroad man who liked to sing, and we formed a team. We played at dances and parties around Sapulpa, and wrote a lot of songs together."

Sayre

Sayre's historic Beckham County Courthouse, built in 1911, appears for about thirty seconds in the 1940 film *The Grapes of Wrath*.

The **Admiral Twin Drive-In Theater** in **Tulsa** appears in *The Outsiders. Joe Sonderman*

Tulsa

Listed on the National Register of Historic Places, the Mayo Hotel built by John and Cass Mayo opened in 1925 as the showpiece for the city of Tulsa. Before closure in 1981, the hotel register listed a number of celebrities and political figures as guests, including John F. Kennedy, Char-

les Lindbergh, Elvis Presley, and Harry Truman. It also served as the Tulsa home of John Paul Getty.

After two decades of abandonment, followed by a $40 million renovation, the hotel reopened in 2009. The hotel consistently receives recommendation from leading travel organizations and in *The Route 66 Dining & Lodging Guide* published by the National Historic Route 66 Federation.

The Modernaire Drive-In Theater opened on May 24, 1951, with the showing of *Oh Susanna* starring Forest Tucker. With the addition of a second screen and acquisition by new owners in 1952, the theater was renamed the Admiral Twin Theater. The theater served as a set for the filming of 1983's *The Outsiders*. The property was restored after a fire destroyed one screen in 2010.

Architect William Henry Ryan claimed that inspiration for the design of the Rose Bowl Lanes came from domed bomb shelters he had seen in Germany during World War II. The bowling alley, which opened in 1962 and then closed in 2005 before reopening as the Rose Bowl Event Center in 2007, appears in several scenes of the movie *UHF*.

The list of movies and television programs with scenes filmed in Tulsa is lengthy. They include: *Tex* (1982); *Rumble Fish* (1983); *Friends* ("The One with the Birth Mother," 1994); *Raw Target* (1995); *The Frighteners* (1996); *Every Hidden Thing* (2008); *Treasure Blind* (2008); *The Killer Inside Me* (2010); and *Dead Girls Don't Cry* (2013).

Vinita

The namesake for this community is Lavinia "Vinnie" Ream, a renowned sculptor in the late nineteenth and early twentieth centuries. Her best-known work is the life-sized sculpture of Abraham Lincoln, created when she was only eighteen, that stands in the rotunda of the capitol building in Washington, D.C.

Phillip Calvin McGraw was born in Vinita on September 1, 1950. McGraw graduated from Midwestern State University in 1975 with a Bachelor of Arts in Psychology. He advanced his studies at the University of North Texas and obtained a Doctor of Philosophy in clinical psychology in 1979.

In 1995, Oprah Winfrey hired McGraw's legal consulting firm, CSI, to prepare her for the Amarillo, Texas, beef slander trial. Winfrey was so

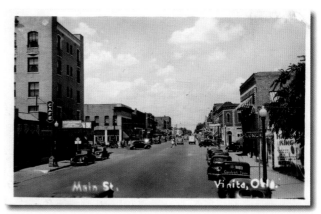

The namesake for **Vinita** is sculptor Vinita Ream.
Joe Sonderman

impressed with McGraw that she offered him a weekly segment on her program.

In September 2002, McGraw formed Peteski Productions and launched a syndicated television program, *Dr. Phil*. Winfrey's studios produced the program.

Weatherford is the hometown of astronaut Thomas Stafford.

Weatherford

Weatherford is the hometown of astronaut Thomas Stafford. The airport bears his name, as does the aeronautical museum.

Yukon

Yukon is the hometown of country and western singer Garth Brooks. A former access road for Route 66, a commercial corridor in town is signed Garth Brooks Boulevard.

Transitional Sites

Completion of the **Canadian River Bridge** allowed for the bypassing of **Bridgeport**.

Arcadia

Built in 1922 as an unpaved section of State Highway 7, the remaining 1.3-mile roadway located east of Arcadia at Hiwasassee Road was significantly transformed after it was incorporated into U.S. Highway 66 in 1926. This portion of Route 66 is included in the National Register of Historic Places thanks to efforts spearheaded by author and historian Jim Ross.

Preserved here are two distinctive federally aided paving projects that represent a transitional point in highway engineering. At the east end, the 1928 paving project utilized a Bates Type surface of Portland concrete. The west end, paved in 1929, utilized a Modified Bates Type surface consisting of a 2-inch asphalt layer on a base of 5-inch thick concrete. Additionally, this segment retains concrete curbing.

To commemorate the importance of the project, a 3-foot high Federal Aid Project monument with brass shield descriptors was built at the point where the two segments intersect. The monument remains a tangible link to this pivotal point in highway engineering.

Bypassed by a multi-lane alignment immediately to the north, this segment of Route 66 remained in use until 1952.

Bridgeport

The community of Bridgeport originated as a work camp for the Rock Island Railroad and as a primary crossing of the South Canadian River. The postal road built through town in 1905 became a primary roadway for motorists in the 1910s and part of the Ozark Trail system in 1917.

George Key, a partner in the Postal Bridge Company in Oklahoma City and chair of the state Democratic Party, negotiated a contract for construction of a bridge at this point in 1920. The toll bridge opened in 1921.

With certification of U.S. 66 in 1926, the bridge served as the river crossing for that highway. It continued as such until completion of the bypass in 1934.

Canute

Named for the King of Denmark, Canute's association with Route 66 spanned the years from 1926 until 1970, when the I-40 bypass opened. As a result, numerous transitional segments of that highway are located here.

A park built by the WPA during the Great Depression is located immediately to the east of town, at the approach to the older, original two-lane alignment that also contains a segment of the later four-lane alignment. The four-lane segments at each end of town served as the course of Route 66 between 1956 and 1970.

Depew was the first community bypassed with realignment of Route 66.

Depew

Depew has the dubious distinction of being the first community on Route 66 to be bypassed by the highway's realignment. From 1926 to 1928, U.S. 66 looped through town utilizing Ladd, Main, and Flynn Streets. After October 1928, the road followed its current course immediately to the north of town. A section of the first alignment on Main Street retains its original concrete surface.

Hydro

An 18-mile segment of Route 66 between Bridgeport Hill and Hydro that was used between 1934 and 1962 presents a picture of highway engineering evolution during the Great Depression. It also preserves a key component in the history of highway development in the state of Oklahoma.

Initially referred to as the El Reno cutoff, the project funded by the Oklahoma Highway Department and federal monies created a direct path between El Reno and Hydro, replacing the early alignment of U.S. 66 that utilized sections of old postal roads and which was also the course of the Ozark Trail. This early alignment had looped north through Calumet, past Geary, and on to the Canadian River toll bridge at Bridgeport.

This section of U.S. 66 utilized the then-new formula of a 20-foot roadbed instead of the previous standard of 18 feet. Additionally, the parabolic-curved roadway with concrete lips and gutters to facilitate drainage is also preserved here.

A primary obstacle in the building of this replacement for the earlier alignment was the Canadian River. The resultant nearly one-mile long Canadian River Bridge, consisting of thirty-eight graceful pony truss spans, was an engineering marvel and is today a favored photo stop for Route 66 travelers.

Miami

Between Miami and Afton, a very rare segment of road represents early highway engineering that resulted in a paved roadway a mere 9 feet wide. Known loosely as the "sidewalk highway," this three-mile segment dates to the period between 1919 and 1921. Speculation abounds as to the reason for its narrow width, but to date, there is no confirmed justification for the design. The roadway initially met the needs of motorists traveling State Highway 7, which was also part of the Ozark Trail network. This segment later served as the course for Route 66 until 1937. A monument commemorating the highway's historic significance was dedicated near Afton in November 2011.

On September 13, 1937, Oklahoma Governor Ernest W. Marland cut the ribbon at the opening ceremony for the Neosho River Bridge southwest of Miami, which led to the bypassing of the "sidewalk highway." The bridge represented another milestone in the state, as this section was the last paved portion of U.S. 66 in Oklahoma.

The **Lake Overholser Bridge** at **Oklahoma City** dates to 1924.

Oklahoma City

Built in 1924 as part of the State Highway Commission's initiative to create a statewide highway system, the Lake Overholser Bridge opened in August 1925 to replace the ferry crossing on the Canadian River. It was also a key component in the development of state Highway 3, which traversed Oklahoma from Texola in the west to the Arkansas state line. With the certification of U.S. 66 in November 1926 incorporating various state highways, portions of highway 3, including the bridge, became a part of the Route 66 corridor in the Oklahoma City area.

The 748-foot span utilized a unique blending of Parker through truss and pony truss designs. At the time of its completion, the bridge served as an engineering design study in numerous schools.

With the postwar increase in traffic and the expansion of Oklahoma City suburbs, the bridge became a bottleneck for Route 66 traffic. Still, until completion of the four-lane interstate highway bridge immediately to the north in 1958, the Lake Overholser Bridge served as the river crossing for this highway.

Even after the completion of the interstate highway bridge, the Lake Overholser Bridge continued to meet local needs, first as a highway river crossing and then, when it was deemed structurally unsound for vehicular traffic, as a pedestrian and bicycle river crossing. Listed on the National Register of Historical Places in 2004 and extensively refurbished in 2010, the bridge reopened to automobile traffic in 2011.

Sapulpa

A 3.3-mile section of pre-1953 Route 66 immediately to the west of Sapulpa dates to 1924. It predates the U.S. highway system as it initially served as part of the Ozark Trail system. This segment of roadway was originally built of Portland cement and is now covered by a layer of asphalt.

Numerous features on this section of Route 66 remain as tangible links to the early period of highway engineering. These include concrete guardrails, an 18-foot-wide roadbed, retaining walls, and the Rock Creek Bridge (currently closed) with red brick decking.

This obelisk west of Stroud marks the course of the Ozark Trails Highway. *Joe Sonderman*

Stroud

A series of roads south and west of Stroud (State Highway 99, Central, Elm, N3540 Road, and E0890 Road) constitute a 1.3-mile segment of pre-1930 Route 66 that originally was a part of the Ozark Trail system. From the date of construction in 1915 to the present, this stretch has remained a graded gravel roadway, with the exception of the highway 99 portion. Numerous original components of the roadway survive intact, including a towering obelisk originally used to mark intersections on the Ozark Trail system, and two culverts, dated 1909 and 1917.

Tulsa

The 11th Street Bridge spanning the Arkansas River in Tulsa was an important consideration in determining the original course followed by Route 66 through the city. Built by the Missouri Valley Bridge & Iron Company in 1916 and 1917

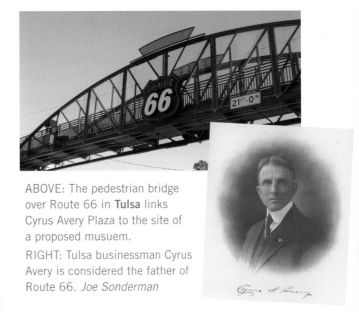

ABOVE: The pedestrian bridge over Route 66 in **Tulsa** links Cyrus Avery Plaza to the site of a proposed musuem.

RIGHT: Tulsa businessman Cyrus Avery is considered the father of Route 66. *Joe Sonderman*

at a cost of $180,000, the bridge originally supported a railroad line, two lanes for vehicular traffic, and a sidewalk on each side.

Increased traffic flow first necessitated renovations in 1929. Five years later, a major upgrade transformed it into a 52-foot-wide vehicular bridge (widened from 34 feet) to accommodate four lanes of traffic. It remained in service until 1980.

Listed on the National Register of Historic Places in 1996, the bridge played a central role in the city's Vision 2025 initiative launched in 2003 to increase economic development in the city. The following year the bridge was renamed the Cyrus Avery Route 66 Memorial Bridge to be a cornerstone for a proposed visitor center and establishment of Cyrus Avery Plaza.

Shadowing the bridge is both the replacement for the historic bridge and a new structure that is utilized by I-44. Together the three bridges represent nearly a full century of highway engineering.

The opening of the **Turner Turnpike** bypassed Route 66 in eastern Oklahoma. *Joe Sonderman*

The replica opera house at the **Old Town Museum Complex** in **Elk City.**
The complex also houses the National Route 66 Museum. © *iStock.com*

OKLAHOMA

Crime and Disaster

Film and Celebrity

Transitional Sites

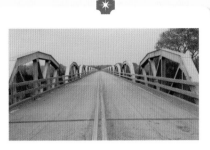

The **Canadian River Bridge** between **Bridgeport** and **Hydro**. *Page 109*

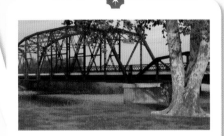

The **Turner Tur**
Oklahoma City a

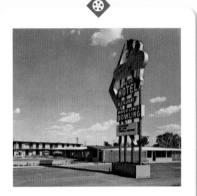

Trade Winds Motor Hotel in **Clinton**. *Page 105*

The **Lake Overholser Bridge** in **Oklahoma City**. *Page 110*

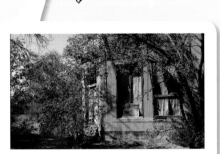

Texola, plagued by crime and fire between 1901 and 1910. *Page 102*

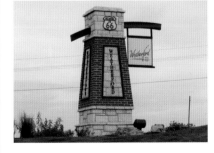

Weatherford, home of astronaut Thomas Strafford. *Page 108*

The **Blue Dome** in **Tulsa**. *Page 93*

Afton Station. *Page 86*

Quapaw

Commerce

Miami

Narcissa

White Oak

Vinta

Afton

44

Chelsea

Bushyhead

66

Foyil

44

Sequoya

Claremore

The relocated **Meadow Gold sign** in **Tulsa**. *Page 93*

Verdigris

Waylan's Ku Ku in Miami. *Page 91*

Tulsa

75 **169** **US**

412

Catoosa

84

Red Fork

Oakhurst

44

Bowden

75

Bellvue

Kellyville

Bristow

177

Wellston

Depew

44

Stroud

Davenport

Luther

Chandler

Warwick

dia

Totem Pole Park in **Foyil**. *Page 95*

oma City

The **Blue Whale** in **Catoosa**. *Page 88*

The **Milk Bottle Building** in **Oklahoma City**. *Page 91*

The **Campbell Hotel** in **Tulsa**. *Page 94*

OKLAHOMA

▼ *Landmarks*

🌲 *Parks*

One of many **Will Rogers Highway** markers in Oklahoma. *Page 90*

Lucille's in **Hydro**. *Page 89*

Pops in **A**...
Page 87

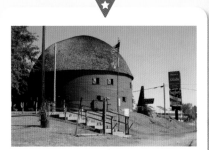

The round barn in **Arcadia**. *Page 87*

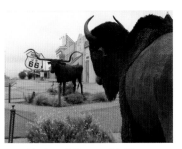

The **National Route 66 Museum** in **Elk City**. *Page 89*

Clinton

🛡️ 66

281
270
81
Yukon
Bethany
Edmond

35

Weatherford
Hydro
Bridgeport
Fort Reno
El Reno

Elk City
Canute
Foss

40

183

Sayre
Hext
Erick
Texola

81

40

240

35

McLain Rogers Park in **Clinton**. *Page 95*

🌲

The **Oklahoma Route 66 Museum** in **Clinton**. *Page 88*

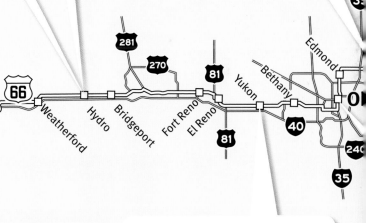

The refurbished **Yukon's Best Flour** sign. *Page 95*

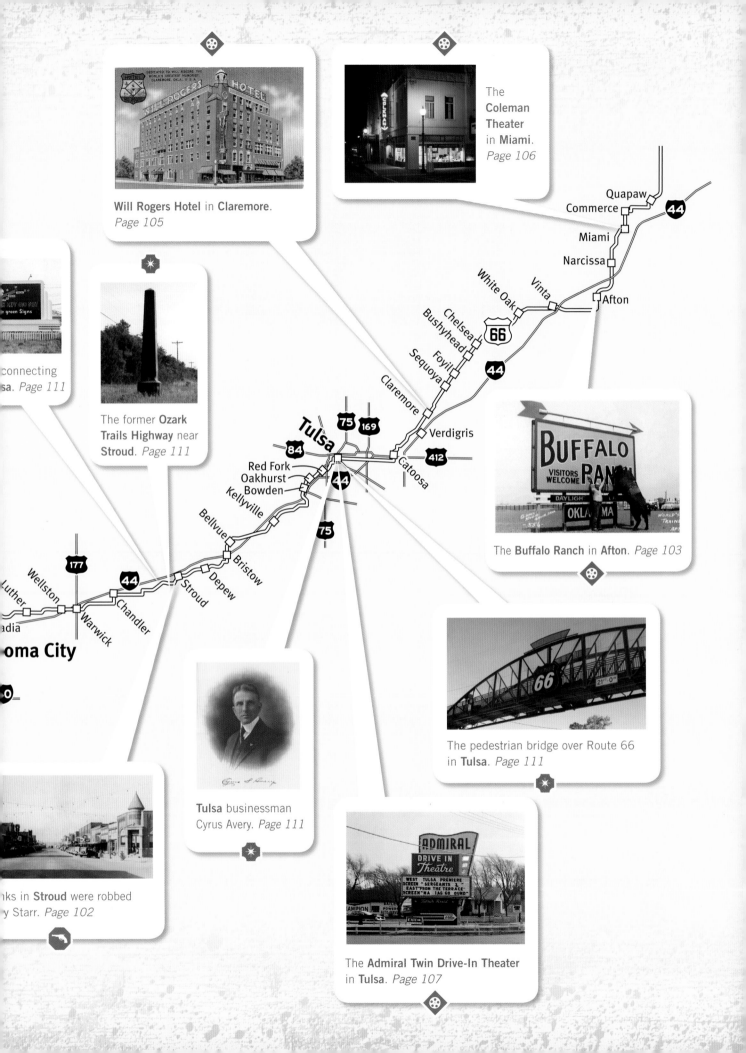

Will Rogers Hotel in **Claremore**. *Page 105*

The **Coleman Theater** in **Miami**. *Page 106*

...connecting ...sa. *Page 111*

The former **Ozark Trails Highway** near **Stroud**. *Page 111*

The **Buffalo Ranch** in **Afton**. *Page 103*

The pedestrian bridge over Route 66 in **Tulsa**. *Page 111*

Tulsa businessman Cyrus Avery. *Page 111*

...nks in **Stroud** were robbed ...y Starr. *Page 102*

The **Admiral Twin Drive-In Theater** in **Tulsa**. *Page 107*

Quapaw

Commerce

Miami

Narcissa

Afton

Vinta

White Oak

Chelsea

Bushyhead

Foyil

Sequoya

Claremore

Verdigris

Catoosa

Tulsa

Red Fork

Oakhurst

Bowden

Kellyville

Bellvue

Bristow

Depew

Stroud

Chandler

Warwick

Wellston

Luther

...adia

...oma City

The historic **Rock Café** in **Stroud.** *InsatiableWanderlust/Shutterstock*

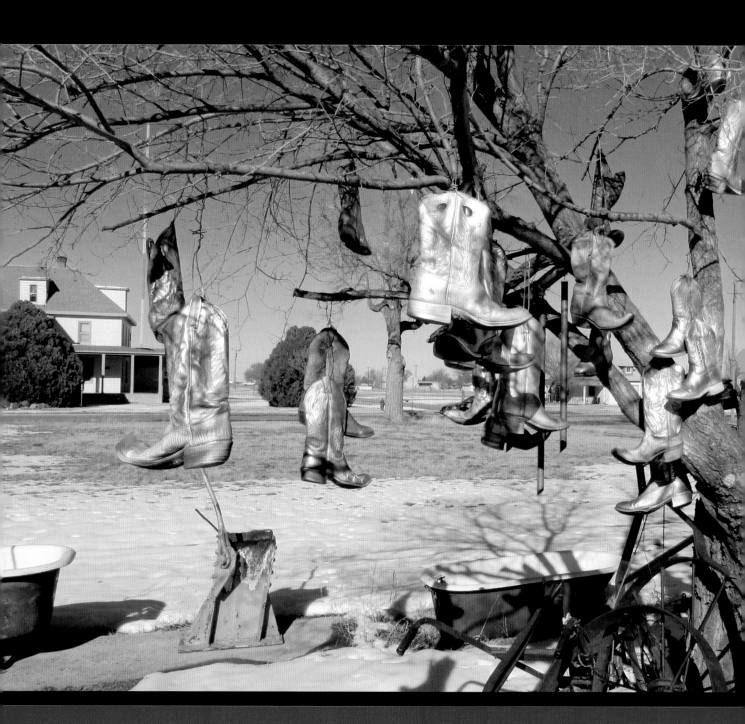

ROUTE 66

Texas

Landmarks

★

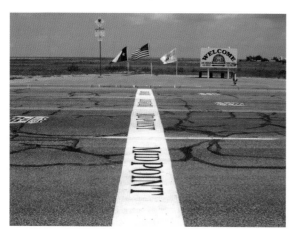

The **Midpoint Park** in **Adrian** is a favored photo stop for enthusiasts.

Adrian

The Midpoint Café, and the famous sign across the road that proclaims this the midpoint of Route 66, are major attractions along the storied highway in Texas. While the sign is a relatively recent addition to the Route 66 roadside, the café dates to 1956.

The café, the inspiration for Flo's V8 Café in Pixar's animated film *Cars*, opened as a partnership between Dub Edmonds and Jesse Fincher. They opened the café in a refurbished building of unknown origin, and Jesse's Café, as it was known then, underwent several expansions and renovations during the 1960s, including adding an A-framed second story.

The venture proved to be so profitable that the partners established a second Jesse's Café in nearby Wildorado. In the ensuing years, the original café in Adrian was damaged in two fires, resulting in its remodeling to the current configuration.

Alanreed

Recently refurbished as a period time capsule, the 66 Super Service Station was built in 1932 utilizing a Spanish Mission style of architecture. The

The **66 Super Service Station** in **Alanreed** dates to 1932. *Judy Hinckley*

dual-canopied pump islands and adjacent two-bay garage retain the original design alignments and configuration.

Amarillo

Amarillo's Cadillac Ranch is an icon of the resurgent interest in Route 66, but it is not even located on that highway. Route 66 serves as a frontage road on the north side of I-40 at this location, but the Cadillac Ranch is located on the south side of the interstate highway at exit 62.

The one-of-a-kind roadside sculpture consists of ten vintage Cadillacs buried to their windshields at the same angle as that of the Great Pyramid of Giza in Egypt and utilized as an international graffiti artists studio. It was the brainchild of eccentric oil industry heir Stanley Marsh III. The idea was conceived following conversations between Marsh and members of the Ant Farm, a three-member group of experimental architects that operated in San Francisco from 1968 to 1977.

Marsh donated the land along I-40 on the western edge of Amarillo and allocated $3,000 for the project, which launched on May 28, 1974. The Cadillac Ranch has since morphed into a Route 66 landmark with thousands of enthusiasts making the pilgrimage to the sculpture every year to sign their names. The site has also served as a location for weddings and innumerable commercial photo shoots.

Another landmark of note in Amarillo is the Big Texan Steak Ranch. Although the restaurant has its origins on Route 66, it has not been located on that highway since the early 1970s. Never-

Cadillac Ranch near Amarillo is an unlikely but popular landmark located not far from Route 66.

theless, the restaurant, and now an accompanying motel, has survived as a Route 66 landmark despite its relocation and a devastating fire in 1976, and it remains a primary attraction in the Amarillo area for fans of the old highway.

R. J. "Bob" Lee opened the original restaurant in 1960 with the goal of establishing a steakhouse with an ambiance that epitomized the romanticized image of the Old West. The theme was a key component in his promotional campaign, which included a towering sign featuring a lanky cowboy with his hat pushed back on his head, a figure that also appeared on billboards along U.S. 66.

A second major promotion was the offer of a "free 72-ounce steak" to any customer who could eat the steak and accompanying dinner within an hour without leaving the table. This offer was featured in many promotional materials and billboards, and people can now view the free steak dinner challenge anywhere in the world through a live webcam streaming on the restaurant's website.

The Santa Fe Railroad building in Amarillo opened in 1930.

Lining the entire 6th Avenue corridor in Amarillo are landmarks of historical significance or ones that retain unique architectural details. A number of these have a direct association with Route 66.

Established in 1946, the Golden Light Café at 209 West 6th Avenue (Route 66) is the oldest continuously operated café along the highway in Amarillo. It still earns favorable reviews for food quality and service.

The Bussey Buildings, located between 2713 and 2727 West 6th Avenue, were built in the closing years of the 1920s utilizing dark brick and limestone trim and details. The strip of commercial storefronts has housed a variety of businesses. The most notable of these was the San Jacinto Beauty School, recipient of the first beauty-school license in Texas. The school operated at this location from 1941 to 1964.

The Cazzell Buildings occupy opposite sides of the street at 2806 and 2801 West 6th Avenue. W. E. Cazzell established a general store and post office in the building at 2806 West 6th Avenue after purchasing it in 1918. After selling the building in 1922, he hired contractors to build a two-story building across the street.

The one-story Borden's Heap O Cream Building is located at 3120 West 6th Street. Refurbished in 1990 by the San Jacinto Boy Scout Troop and Preservation Amarillo utilizing plans provided by the grandson of the original sign painter, the building remains an excellent example of Art Moderne styling.

The Adkinson-Baker Tire Company Building at 3200 West 6th Avenue opened in 1939 as a Texaco station. It is one of two historic service stations remaining in the district but is the only one to retain all architectural attributes from its original construction.

Between 3313 and 3323 on West 6th Avenue, the Carolina Building is a series of eight storefronts divided by brick piers. Built in 1926 in the Spanish Colonial Revival style, it is one of the earliest standing examples of strip commercial buildings in the city.

Dating to 1932, the Dutch Mill Service Station and Café Building is located at 3401 West 6th Avenue. Until the mid-1950s, the building housed both the service station and café businesses, but extensive remodeling of the café in about 1956 included expansion into the building next door at 3403 West 6th Avenue.

Taylor's Texaco Station, built in 1937 at 3512 West 6th Avenue, is an early example of Walter D. Teague's service-station design utilizing white porcelain panels over a steel frame. The plan of an office, canopy over the pump island, two service bays, and restrooms would become standard for most service stations built in the immediate postwar years.

The San Jacinto Fire Station at 610 South Georgia Street (just off Route 66) is the only extant prewar city building in Amarillo. Built in 1926 in a Spanish Mission Revival style, it remained in service until 1975.

To the east of the 6th Avenue Historic District, the thirteen-story Santa Fe Railroad Building was built between 1928 and 1930 at a cost of $1.5 million. It transformed the skyline of Amarillo at the time and remains a towering example of early Art Deco architecture in Texas.

The motel and café in **Glenrio**, promoted as the last stop in Texas, is an abandoned landmark. *Joe Sonderman*

Glenrio

Glenrio, a ghost town astride the Texas and New Mexico border, is an unlikely landmark but it remains a popular photo stop. The town symbolizes the effect that the advent of the interstate highway system had on communities along U.S. 66. But it also encapsulates Route 66's history and prehistory and is an integral part of the Route 66 experience.

Initially established in 1905 as a farming community serviced by the Chicago, Rock Island & Gulf Railway, Glenrio evolved in direct correlation to the development of the highway system.

The entire business district of **Glenrio** is listed in the National Register of Historic Places.

First came traffic on the Ozark Trail network, one of the named highways utilized before the establishment of the U.S. highway system, which led to the growth of a service industry of gas stations, garages, and similar businesses.

The certification and development of U.S. 66 provided a key economic foundation to the community during the drought and financial crisis of the Great Depression. Additionally, the state of Texas built a welcome center at Glenrio in the 1930s, a location that appears in the 1940 film version of *The Grapes of Wrath*.

The most often photographed site in Glenrio is the Texas Longhorn Motel and Café, famous for a sign that read "First Stop in Texas" on one side and "Last Stop in Texas" on the opposite. The complex established in 1950 by Homer and Margaret Ehresman was the couple's third business enterprise along Route 66 in the Glenrio area.

The majority of remaining structures in the community date to the period between 1930 and 1970. All seventeen of these buildings, which constituted the business district, as well as the four-lane segment of Route 66 that traverses the town before coming to an end near the state line are listed in the National register of Historic Places.

Groom

Groom has two landmarks of note. One is the leaning water tower, built at an angle to promote the long-vanished Britten truck stop complex. The second is the illuminated Cross of Our Savior Jesus Christ. Erected in 1995, the 190-foot structure is proclaimed as the tallest cross in the Northern Hemisphere.

The **Cross of Our Savior Jesus Christ** in **Groom** is the tallest illuminated cross in North America. *Judy Hinckley*

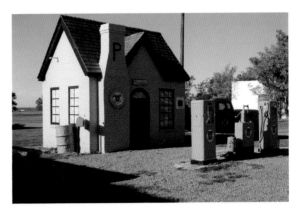

Located in **McLean**, this is the first **Phillips Petroleum station** established in Texas.

Landergin

Established in 1908, the community Landergin never had a population of more than one hundred people. In 1946, Jack Rittenhouse noted that even though it was "listed on many maps as a town," there was little there aside from "a few railroad homes across the railroad tracks, but offering no tourist facilities—not even gas."

From that point, the community entered a period of decline. Still, the community is associated with a key development in Route 66 history. It was here on October 11, 1997, that the National Historic Route 66 Federation hosted the first John Steinbeck Award Banquet. This event is now the cornerstone for the annual International Route 66 Festival.

McLean

West of Main Street on 1st Street (Route 66) in McLean, a former gas station built in the Tudor cottage style of the mid to late 1920s currently serves as a photo stop for Route 66 enthusiasts. Built in 1930, the station was the first one opened in Texas by Phillips Petroleum. It was in

The **Devil's Rope Museum** in **McLean** is a surprisingly fascinating museum. *Judy Hinckley*

operation through 1977 and now remains closed. Painted in its original colors, with period gasoline pumps and a tanker truck of similar vintage on the property, the site appears as a service station from circa 1946.

Shamrock

The U-Drop Inn in Shamrock is one of the most recognizable Route 66 landmarks, in large part because it appears in the mythical town of Radiator Springs in the 2006 animated Pixar film *Cars*. Built in 1936 by J. M. Tindall and R. C. Lewis utilizing plans created by owner John Nunn, the U-Drop Inn initially housed three business: the U-Drop Inn Café, a retail store, and Tower Conoco.

Its location at the intersection of U.S. 66 and U.S. 83 ensured steady business. As a result, shortly after opening, the café was expanded to absorb the retail store.

John Nunn sold the property in the 1940s but repurchased it in 1950. Upon his death in 1957, his wife, Bebe, sold the café to Grace Brunner, who renamed it Tower Café and added a Greyhound Bus station.

In the early 1970s, as a Fina station, the building was painted in a red, white, and blue color scheme. The following decade, John Tindall Jr., son of the original contractor, acquired the property. He had it repainted in subdued tones and reopened the café.

In the 1990s, the First National Bank of Shamrock purchased the property and gifted it to the city. After extensive refurbishment that was funded with a $1.7 million federal grant and included restoration and replacement of original neon trim,

The recently refurbished **U-Drop Inn** in **Shamrock** is a distinctive landmark.

it reopened as the offices of the Shamrock Chamber of Commerce and Visitor Center. Preservation of many original design features, such as glazed tile accents and distinctive architectural elements, led the property to be listed in the National Register of Historic Places in September 1997.

Vega

A now-refurbished Magnolia station that dates to 1924 is located on the original alignment of Route 66 immediately to the south of the Oldham County Courthouse in Vega. Built by J. T. Owen to capitalize on traffic flowing along the Ozark Trail (Route 66 after 1926), the two-story structure featured living quarters on the second floor. It continued to operate as a service station through 1953 even though realignment of Route 66 in 1937 bypassed it. The building housed a barbershop until 1965, and then it sat vacant until it was restored by the town of Vega and the Oldham Chamber of Commerce.

Even though it is no longer an operating business, the refurbished Magnolia station is preserved to its circa-1930s appearance, complete with fuel pumps, advertisements, and merchandise from that period. The only deviation from

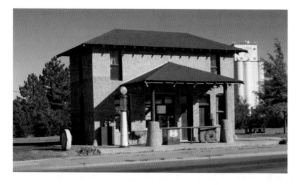

This refurbished **Magnolia station** in **Vega** dates to 1924.

vits original configuration is the shortening of the front portico, an alteration that was necessitated by the widening of the road that infringed on the front of the property.

On the later alignment of Route 66, the Vega Motel is one of the rare architecturally intact Route 66 motels in the Texas Panhandle. Originally established as the Vega Court in 1947, the twelve-unit complex was expanded in 1953 and had cosmetic improvements completed in 1964. First was the construction of an eight-unit east wing. A few of these rooms provided travelers with the additional amenity of kitchenettes. Next were improvements to the façade that utilized Perma-Stone to present a more modern look. Listed in the National Register of Historic Places in 2006, the motel is not currently in operation.

Military

Amarillo

Amarillo's English Field served as the initial training base for the U.S. Army Air Corps until the adjacent Amarillo Army Airfield was completed and activated in April 1942. The first classes were for the training of B-17 aircrews and ground crews. Additional classes added over the course of the duration of World War II included instruction for flight engineers and technicians. With cessation of hostilities, the airfield was designated as part of the Technical Training Command, but postwar budget cuts necessitated its closure in September 1946. At this point, administered by the War Assets Administration, the base became a civilian facility, and numerous structures were razed or relocated.

Reactivated as the Amarillo Air Force Base in March 1951, it became the first military facility utilized for the training of jet mechanics. Under the administration of the Air Training Command, the base evolved until its deactivation in December 1968.

On May 17, 1971, the former base reopened as the Amarillo Air Terminal, now the Rick Husband International Airport. The long runway built by the air force in the 1950s bisected the original

Amarillo Field served as a training center in World War II and is where Edwin Waldmire Jr. introduced the Cozy Dog. *Joe Sonderman*

alignment of Route 66, and as a result, this remains one of the few portions of the original highway not accessible in Texas.

As an interesting footnote, the Amarillo Army Airfield served as the duty station for Edwin Waldmire Jr. during World War II. Waldmire is the father of internationally acclaimed artist and Route 66 icon Bob Waldmire. He also developed the recipe for the deep-fried, breaded hot dog that became the cornerstone of the Route 66 classic Cozy Dog in Springfield, Illinois.

McLean

The McLean Permanent Alien Internment Camp, 1871st Service Command Unit, is located a few miles northwest of McLean. Designed to house 3,000 prisoners of war, the camp saw service as an incarceration center for German soldiers captured during the battle for North Africa. It operated from September 1942 to July 1, 1945.

A Texas State Historical Marker at the site provides a concise history of the encampment, and directions are available at the McLean/Alanreed Area Museum located at 116 Main Street in McLean.

Military police became a familiar site in **McLean** with the establishment of **McLean Permanent Alien Internment Camp** in 1942. *Joe Sonderman*

Crime and Disaster

Alanreed

On July 5, 1927, a front-page story in the *Salt Lake City Tribune* grabbed readers' attention with the headline, "Texas Family Found Slain."

Neighbors, alarmed at not having seen any of the family for several days visited the home of Frank Weatherby, three and a half miles south of Alanreed, and found the badly decomposed bodies of Weatherby, his wife, and his two young children.

Under the bodies of Mrs. Weatherby and the children, a girl of 6 and a boy of 4, lay a crowbar, and a mattress had been thrown over them. The room bore evidence of a struggle. Weatherby's body, with a shot through the head, was found in another room. The weapon with which he had been slain was not found.

An automobile belonging to Mr. Weatherby was tracked to U.S. Route 66 but has not been found and officers were seeking several negroes who worked on the Weatherby place.

In the winter of 1949, a snowstorm stranded several travelers who found refuge at the Standish Court in Alanreed. For reasons unknown, a few of the motel guests accepted alcohol from one of the travelers, believing that antifreeze would be safe to drink if it was strained through bread. Three of the individuals died.

Amarillo

Spawned by an ever-increasing drought on the Great Plains, dust storms became a regular occurrence by the late 1920s and 1930s. On April 14, 1935, a dust storm of unprecedented proportions swept into the panhandles of Oklahoma and Texas, and the event, which became known as "Black Sunday," led to the first media reports that referred to the area as the Dust Bowl. Estimates are that 300,000 tons of topsoil were in the "black blizzard" that shut out the sun, closed roads, and swept into Amarillo at about 7:20 p.m.

The **Black Sunday storm** of 1935 spawned the term "Dust Bowl." *Joe Sonderman*

that evening. Residents reportedly had to "grope for their houses from their front yards" and "cars and trucks sputter[ed] to a stop with carburetors choked by the dust."

On September 26, 1931, Sheriff O. L. Clark arrested Robert Brady and his partner, Clarence "Buck" Adams, in Carlsbad, New Mexico. Wanted for a bank robbery that had taken place in Texhoma, Oklahoma, eleven days prior, they were transferred to the jail in Amarillo, pending extradition. A few days after being incarcerated, Brady overpowered a guard and made a daring escape attempt. In the ensuing melee, he was shot in the head and was transported to Epworth Hospital in Liberal, Kansas. Although he recovered, Brady wore glasses for the remainder of his life and was never able to close his left eyelid completely.

On June 23, 1949, Amarillo again made national headlines with a sensationalized crime and scandal. In this instance, it was the murder of W. A. "Tex" Thornton, an oil-field firefighter with a legendary reputation. The subsequent investigation along Route 66 and the trial became a media and legal circus.

During the 1920s, Thornton had perfected the art of using nitroglycerin and dynamite to snuff out oil-well fires, and by the following decade, he had added rainmaking with explosives, timed charges, and balloons to his résumé. By the mid-1930s, Thornton had become an almost mythical figure in the oil fields and dust bowl towns of the Panhandle. In the immediate postwar years Thornton, who had moved to Amarillo with his wife, Sara, also developed a reputation for wearing large diamonds and carrying large rolls of cash, a fact that investigators considered as the

hunt for the murderers began.

Upon interviewing his wife after the murder, officers learned that Thornton had left Amarillo for a job in Farmington, New Mexico, on June 19, and had planned to be home by June 21. However, on Tuesday, June 21, Thornton had called Frank McCullough of Myers Motor Company in Amarillo to say he had distributor trouble east of Albuquerque on the grade from Moriarty to Clines Corners.

The next day, he picked up a young couple hitchhiking east on Route 66 near Tucumcari. Late that afternoon, Thornton and the couple stopped at a roadhouse along the highway in San Jon managed by Torrance Popejoy, a longtime friend.

Witnesses placed Thornton at Briggs Service Station in Adrian, Texas, two hours later, and at the Park Plaza Motel, at 612 Northeast 8th Street (Route 66) in Amarillo, at 8:20 p.m. The woman paid for a room and filled out the registration card using the name E. O. Johnson of Detroit, Michigan, while the men waited in the car.

The manager, Charlie Thompson, showed them to a two-bedroom cabin, number 18. At around 10:00 p.m., after inquiring about a good local restaurant, the couple asked Thompson and a passing motorist to help them start Thornton's car by pushing it.

Shortly after 9:00 a.m. the following morning, Jessie Mae Walker, the motel maid, discovered Thornton's nude body in the rear bedroom of the cabin. Mere minutes after police arrived, so did Al Dewlen, the city editor of the *Amarillo Times*.

To confirm that the body was Thornton's, the authorities contacted members of the local Will Rogers Range Riders, a group to which he had belonged. Dewlen later described the chaotic scene that would play a crucial role in the outcome of

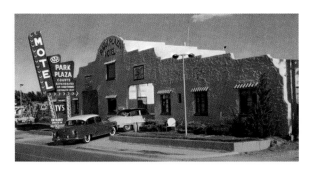

W. A. "Tex" Thornton was murdered at this **Amarillo** motel on June 22, 1949. *Joe Sonderman*

the trial: "Within 15 minutes of when I got there, there must have been 30 people in that room. The Range Riders tramped around and tracked blood everywhere. They had their fingerprints all over everything." He also described the room as containing dirty glasses, empty beer cans, a lipstick-smeared handkerchief, and a blood-stained sink.

Compounding the problems with the bungled investigation, Amarillo Police Chief Sid Harper was out of town on business. As a result, newly elected sheriff Paul Gaither was assigned his first murder case. On Friday morning, twenty-four hours after Thornton's death, a Potter County grand jury returned indictments for the murder against a couple listed as John Doe and Mary Roe.

As the police investigation commenced, a contingent of Will Rogers Range Riders began their own investigation to locate Thornton's car. The trail led east along Route 66 and the group stopped at hundreds of service stations to learn that the couple had stopped in Elk City, El Reno, and Oklahoma City, Oklahoma.

On February 7, 1950, eighteen-year-old Diana Heaney Johnson turned herself into the police in Washington, D.C., and confessed to being an accomplice in the murder of Thornton. Initially police did not believe the rambling, contradictory story she told, but officer Porter Beale remembered that she had confessed to the crime several weeks prior and was admitted to a psychiatric hospital on that occasion because of her ramblings.

On a hunch, Beale sent a telegram to Amarillo Police Chief Sid Harper. It was soon evident that Johnson was indeed one half of the murderous duo.

With her assistance, the second half, her husband, Evald O. Johnson, was arrested in Munising, Michigan. The trial commenced on May 7, 1950, and was soon full of sordid details, courtroom fights between attorneys, and ultimately, a stunning verdict.

Were it not for the sensationalist reports that accompanied the trial, the murder story most likely would have quickly faded into obscurity. As an example, Norton Spayde of the *Amarillo Globe* opened his front-page story with, "Bristling and with eyes blazing, red-haired Evald Johnson testified at his trial for murder that he caught his wife and Thornton in bed naked and that he beat the noted oil well firefighter to death with his own gun."

On May 16, after a deliberation lasting three hours and nineteen minutes, jurors returned a verdict of not guilty in the murder of Tex Thornton. For stealing the automobile and transporting it across state lines, however, Evald was sentenced to four years in a federal prison and Diana received four years' probation.

Shamrock

The *Helena Independent* in Montana, under the headline "Holdup Like Robbery of Stage Coach," reported on June 8, 1931:

> Rivaling in thrills of a stage coach holdup in the wild and wooly days of the Old West, seven unmasked highway men halted a Pickwick Greyhound westbound bus on U.S. 66 nine miles west of Shamrock, Texas early this morning and robbed its passengers of cash and jewelry.

Emulating the chivalry of the old time Wild West robbers, the highwaymen asked each passenger from whom they had taken money where he or she lived and refunded enough change for them to wire home for money and to buy their breakfast.

Wildorado

By the late 1920s, Wildorado's reputation for lawlessness was garnering headlines nationwide. On January 29, 1928, the *Syracuse Herald* in New York profiled the issue with a headline that read, "Wildorado—Texas Town Plundered So Many Times That Six Shooters No Longer Terrorize." According to the article, Wildorado, "the most plundered town in the United States, has an itching trigger finger." The story continued to say that the Wildorado State Bank "has been robbed eight times in the last three years, and the general store next door has been visited by bandits so frequently that the proprietors have lost count of the number of times they have looked down revolver barrels."

It was also noted that "the latest robbery of the bank occurred when the two youths, armed to the teeth, entered the building. Sharp shooting citizens of the town had gathered quickly and captured one of the bandits. They were forced to release him when his partner threatened to kill O'Neal, the bank president."

Details of that robbery hint at the crime that engulfed the community during this period. "One of the men participating in the attempted capture of these bandits was the night watchman who killed one robber and wounded another in a recent gun battle during an attempt to rob the Wildorado Grain and Mercantile Store. Although somewhat discouraged by all these bandit raids, Wildorado is armed and ready."

Four years later, an article in the *San Antonio Light* on May 21, 1933, indicated that the crime wave continued in Wildorado. "Burglars hauled off a 1-ton safe containing more than $500 after breaking into the [Wildorado] State Bank here sometime Friday night, it was learned today. Most of the bank fixtures were torn down by the burglars in getting the heavy safe out the front door."

Film and Celebrity

Amarillo

Located on South Georgia Street immediately to the south of Route 66, the Natorium, affectionately referred to by Amarillo residents as the "Nat," opened in 1922 as a health club with swimming pool. In 1926, the facility was remodeled and converted into a ballroom. Before its closure in the 1960s, the "Nat" served as a performance venue for many leading bands. Counted among these were Tommy Dorsey, Duke Ellington, and Harry James. In 2011, during the International Route 66 Festival, Joe Loesch and his band, the Road Crew, performed there.

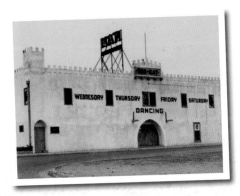

Amarillo's Nat Ballroom has hosted numerous celebrities, including Tommy Dorsey and Harry James. *Joe Sonderman*

Actress Cyd Charisse was born in Amarillo on March 8, 1921. She starred in a variety of movies beginning in the late 1930s. One of her most memorable performances was in the film *Singing in the Rain*, released in 1943.

Other celebrities from Amarillo associated with the film industry include actresses Cynthia Baker and Carolyn Jones, and actor Harry Northup. Acclaimed radio program producer Bradley Dorsey, singer John Rich, and visual-effects specialist Blair Trosper are Amarillo natives.

Groom, Texas, is an unlikely place to be associated with a film star such as Steve Martin.

Groom

The 1992 movie *Leap of Faith* stars Steve Martin as a con artist who pretends to be a faith healer, and the streets of Groom served as the setting for the fictional Rustwater, Kansas. The scenes featuring Martin's oversized revival tent were also filmed in Groom.

Shamrock

In May 1932, the city of Shamrock hosted the annual meeting of the U.S. Highway 66 Association. A parade with the theme "Progress of Transportation" highlighted the importance of Route 66 for area development. The grand marshal for the parade was Major Gordon Lillie, known by his celebrity name, Pawnee Bill. Lillie was a contemporary of Buffalo Bill Cody.

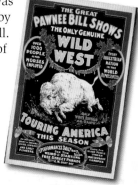

Pawnee Bill served as Grand Marshall of the Progress of Transportation Parade in **Shamrock** in 1932. *Library of Congress*

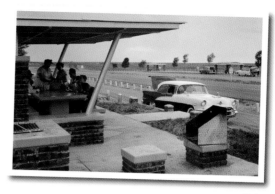

Several Route 66 era parks in west **Texas** are still in use along I-40. *Joe Sonderman*

Vega

Built in the mid-1940s as a standard U-shaped complex with carports between the rooms, the Vega Motel is listed on the National Register of Historic Places. In 1992, country music star Vince Gill filmed the video for his song "I Never Knew Lonely" in room No. 21.

Transitional Sites

The original alignment of Route 66 in **Amarillo** along 6th Avenue is lined with eclectic shops.

Amarillo

In the city of Amarillo, two different alignments of Route 66 reflect the highway's evolution. The earliest alignment snaked through the heart of the city's business district on 8th Avenue (later signed as Amarillo Boulevard), Fillmore Street, 6th Street, and Bushland Avenue. The later alignment bypassed most of the original business district by following Amarillo Boulevard, a four-lane corridor now utilized as the I-40 business loop. The realignment spawned development of tourist courts and other service industry facilities along this roadway.

Glenrio

Indicative of its importance, the four-lane segment of Route 66 in the ghost town of Glenrio was listed in the National Register of Historic Places in 2007. This segment of roadway encapsulates the history of Route 66 and its prehistory, when this was part of the Ozark Trail highway.

Two distinct alignments of Route 66 are present at the Texas–New Mexico state line on the west end of town. The post-1955 alignment sweeps north toward Bard, and the earliest alignment continues southwest toward the ghost town of Endee.

Jericho

The segment of road through Jericho, and the Jericho Gap immediately to the west, served as the course for the Ozark Trail and the first alignment of Route 66. The corridor was notorious for deep mud during the rainy season and ruts during dry weather. In 1928, the Texas Department of Transportation began work on a paved bypass. With completion of the project in late 1931, the entire course of Route 66 in Texas was a paved highway.

McLean

Numerous alignments of Route 66 converge at McLean, including the 1926–1932 alignment, which also served as the path for the Ozark Trail system and is currently highway 273 and county road BB south of town.

Other alignments in McLean are the post-1932 alignment, which followed portions of Railroad Street before proceeding west on a course parallel with the now-abandoned CRI&P rail line, and the postwar four-lane segment that utilized Railroad Street and 1st Street. Additionally, McLean has the distinction of being the last Texas community on Route 66 bypassed with the completion of I-40. This occurred in 1984.

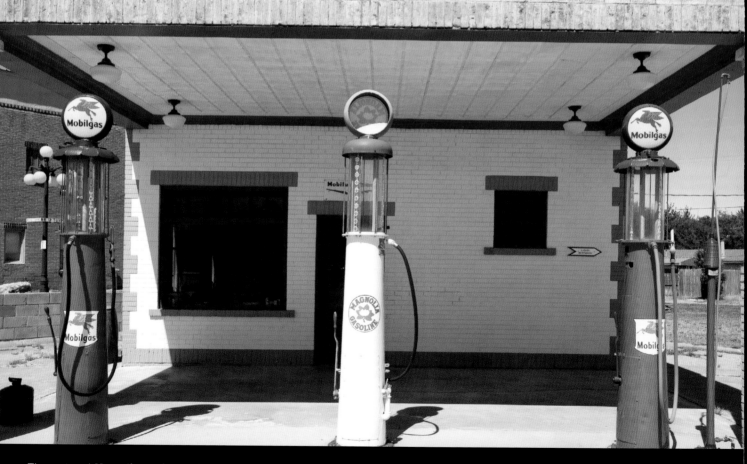

The restored **Magnolia service station** in **Magnolia.** © *iStock.com/Gim42*

TEXAS

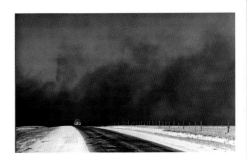

The **Black Sunday storm** in **Amarillo**.
Page 122

Nat Ballroom in **Amarillo.** *Page 124*

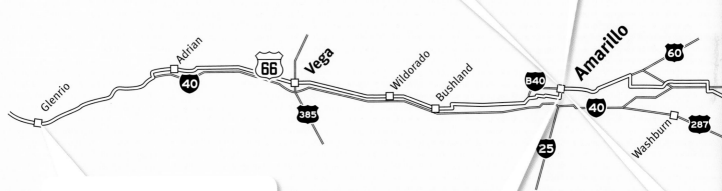

Route 66 era parks in west **Texas**.
Page 125

Eclectic shops in **Amarillo**. *Page 125*

A m
Pag

The **McLean Permanent Alien Internment Camp**. *Page 121*

The **Devil's Rope Museum** in **McLean**. *Page 119*

The **Phillips Petroleum station** in **McLean**. *Page 119*

The **Cross of Our Savior Jesus Christ** in **Groom**. *Page 119*

The **66 Super Service Station** in **Alanreed**. *Page 116*

The **U-Drop Inn** in **Shamrock**. *Page 119*

Conway

Groom

Boydston

Jericho

Alanreed

McLean

Lela

Shamrock

TEXAS

▼ *Landmarks*

⦿ *Military*

The **Midpoint Park** in **Adrian**. *Page 116*

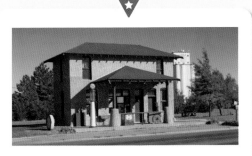

The **Magnolia station** in **Vega**. *Page 120, 126*

Cadillac Ranch near **Amarillo**. *Page 116*

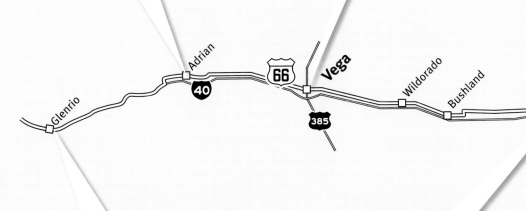

The historic business district of **Glenrio**. *Page 118*

Amarillo Field. *Page 121*

The **Santa Fe Railroad** building **Amarillo**. *Page 117*

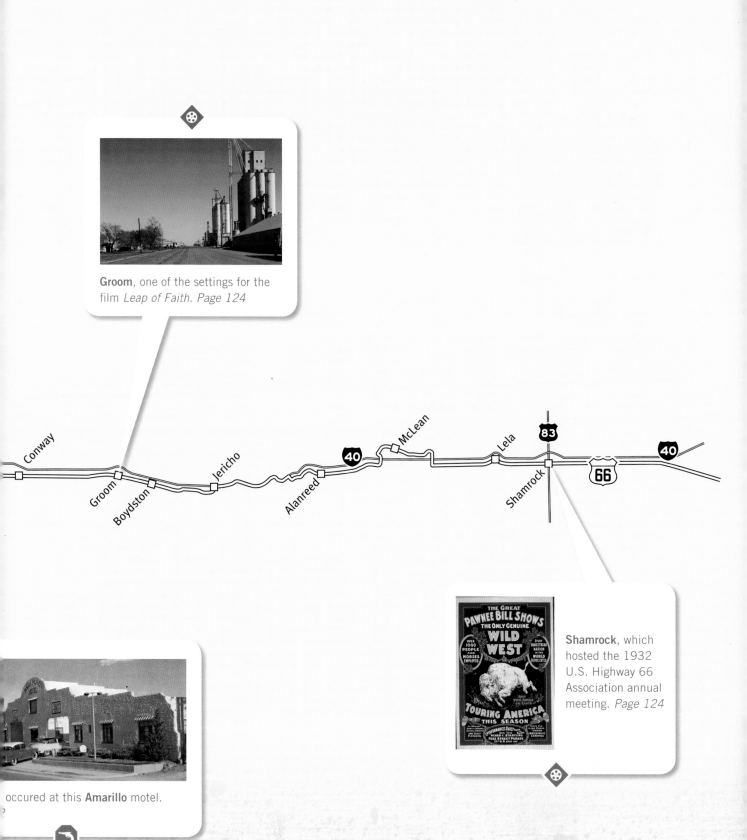

Groom, one of the settings for the film *Leap of Faith*. Page 124

Conway

Groom

Boydston

Jericho

Alanreed

McLean

Lela

Shamrock

Shamrock, which hosted the 1932 U.S. Highway 66 Association annual meeting. *Page 124*

occured at this **Amarillo** motel.

Cadillac Ranch near **Amarillo**. *Andrey Bayda/Shutterstock*

Andrey Bayda/Shutterstock

ROUTE 66 *New Mexico*

Pre-1926 Historic Sites

Acoma is reportedly the oldest continuously inhabited community in America. *Joe Sonderman*

Acoma

Located a short distance south of Route 66 is the village of Acoma. Archeological evidence indicates that the pueblo dates to at least 1100 AD, making it the oldest continuously inhabited community in the United States. Although most Acoma people no longer reside on the mesa, they return for tribal ceremonies. Acoma, dubbed the "sky city" for its location on the summit of a 370-foot mesa, consists of more than 300 structures built of adobe and sandstone.

Acoma is reportedly the oldest continuously inhabited community in America. *Joe Sonderman*

Construction of the stark San Esteban del Rey Mission and Convento began in 1629, but it was not completed until 1640. As its construction required the hauling of materials by hand from the valley below by slave labor, it remains a monument to a dark period of the Acoma people's history.

The World Monument Fund lists Acoma as a "Save America's Treasures" site, and it was recognized by the National Trust for Historic Preservation in 2007.

Alameda

A post office was established at Alameda in 1866, and the ebb and flow of the population resulted in its closure in 1868, and then it was re-established in 1890. In 1960, it became a branch of the Albuquerque post office.

However, settlement at the site predates the period of Americanization by centuries. Notes from the expedition of Francisco Vázquez de Coronado indicate that a well-established Tiwa pueblo existed at the site in 1540.

A Spanish farming community was established here beginning in 1696. It remained a small, rural village into the early twentieth century.

Albuquerque

European settlement in Albuquerque dates to a feasibility study authorized by Spain's governor of New Mexico, Don Francisco Cuervo y Valdea, in 1706, although an earlier expedition in 1540 noted the ruins of a village at the site, and thirty-two families were living at a *rancheria* here in

The plaza in **Old Town Albuquerque** has served as the city's heart for centuries.

1632. The Spanish colonial fortress built here, the third in New Mexico, was named for Don Francisco Fernandez de la Cueva Enriquez, Duke of Alburquerque (anglo cartographers dropped the first "r"), thirty-fourth viceroy of New Spain.

The cornerstone of the historic Old Town, which centers on the original plaza, is the San Filipe de Neri Church, built in 1793 as a replacement for a smaller church located to the west. The church hosts regular services, and other historic buildings in the district house galleries, shops, and restaurants.

The La Placita, a restaurant operated by the family of Elmer and Ross Elliot, is located in a hacienda built in 1706. A second floor was added in 1872. It is the oldest structure in the Old Town district.

Bernallio

Located on the pre-1937 alignment of Route 66, as well as on the Spanish Colonial era El Camino Real, Bernallio stands on the ruins of a Tiwa pueblo that was the site of the Coronado expedition's winter encampment in 1540. The Las Cocinitas district dates to at least 1690 and is one of the oldest continuously inhabited residential districts in the United States.

Carnuel

Archeological investigation indicated that a pueblo with origins that predate by centuries the arrival of Spanish explorers stood at a site near present-day Carnuel. A colonial Spanish outpost, Miguel de Carnue, was established in 1763 near the mouth of Tijeras Canyon but was abandoned in 1771 as a result of the increasing pressures from sporadic raids by Indians. The ruins of this village are located in Singing Arrow Park.

Cubero

Initially the site of a pre-Spanish Colonial era pueblo, the current village of Cubero, located on the pre-1937 alignment of Route 66, dates to at least 1776. A map reference by Bernardo Miera y Pacheco, the cartographer for the Dominguez-Escalante expedition from that year, is the earliest reference to a community named Cubero at the site.

The pre-1937 alignment of Route 66 ran through the old village of **Cubero**.

Cubero served as a garrison town for the Spanish and later for Mexico. It was also the base of operations for military expeditions led by Kit Carson to subdue the Navajo.

Cuervo

Ruins and abandoned buildings in **Cuervo** date to the early twentieth century.

Domingo

Located north of Albuquerque on the pre-1937 alignment of Route 66, Domingo dates to 1883 but has appeared on maps under various names including Wallace, Annville, and Thorton. Three miles to the east, the Santa Domingo Pueblo was established in 1770 from an amalgamation of area pueblos, including the original Santa Domingo Pueblo of 1598.

A landmark here is the Bernalillo Trading Post, established by Fred Thompson as a point of sale for traditional crafts produced by Pueblo Indians, first to tourists traveling on the Atchison, Topeka

son, Topeka & Santa Fe Railroad and later the National Old Trails Highway and Route 66. Damaged by fire in 2011, the trading post is currently undergoing a full restoration.

The **Santo Domingo Trading Post** began operations in the 1880s. *Joe Sonderman*

Glorieta Pass

Before the 1937 realignment of the highway, Glorieta Pass, at 7,500 feet in elevation, was the highest point on Route 66. The pass was named during the Coronado expeditions in 1542 and figures prominently in the history of Spanish colonial development as well as the period of American expansion.

In 1841, the Mexican Army engaged a wagon train of traders from Texas in the shadow of the pass as they journeyed to Santa Fe over the Santa Fe Trail. This incident fueled a dramatic escalation of tensions that culminated in the Mexican-American War. On August 18, 1846, General Stephen H. Kearney routed the armies under the command of General Manuel Armijo at the pass. With this victory, Kearney was able to proclaim New Mexico as American territory.

In July 1861, Confederate President Jefferson Davis authorized Brigadier General Henry Sibley's plan to utilize a contingent of Texans for gaining control of the New Mexico Territory. Learning of the plan, and with only 2,500 troops under his command, Colonel Edward Canby, the Union Commander of the Department of New Mexico, appealed for volunteers in New Mexico and Colorado.

A series of skirmishes and battles throughout 1861 proved indecisive. However, the Battle of

The **Pigeon Ranch** figured prominently in the 1862 Battle of Glorieta Pass. *Judy Hinckley*

Glorieta Pass, which took place between March 26 and 28, 1862, ended all Confederate hopes for domination of the western territories.

Central to the battle was Pigeon Ranch, a hostelry established in the 1850s along the Santa Fe Trail by a French Canadian who spoke "pigeon English." After two days of hard fighting, Union forces fell back to this location on the evening of March 27.

On the morning of March 28, before they could organize, the Union troops came under fire. Battle lines were initially centered on Windmill Hill and the valley floor, but Confederate forces pushed the Union troops back to the ranch.

Dominating the high ground, the Confederates applied steady fire, and as a result, Union forces retreated and formed a second defensive line a half-mile east of the ranch. The Confederate victories were short lived, however, as Major John Chivington had located and destroyed Confederate supply wagons and artillery pieces at a canyon near Johnson's Ranch.

The adobe structure that is now preserved in an arrested state of decay and protected by a guardrail on the pre-1937 alignment of Route 66 served as a field hospital during this pivotal battle. It also served as the centerpiece for a tourist attraction that operated during the era of the National Old Trails Highway and the infancy of Route 66.

The stone well on the south side of the highway was promoted as being used by the Coronado expedition, which added to the site's role as a tourist attraction. The exact date of origin is unknown, but the well was in use during the Battle of Glorieta Pass.

The Mission of **San Augustin de la Isleta**, which originated in the early seventeenth century, is the primary feature at **Isleta Pueblo**.

Isleta Pueblo

The pre-1937 alignment of Route 66 coursed south through the Isleta Pueblo before crossing the Rio Grande at Los Lunas even though the Rio Puerco Bridge, completed in 1933, provided an alternate route. The relatively nondescript Mission of San Augustin de la Isleta at Isleta Pueblo dates to 1612. Following damage incurred in the Pueblo Revolt of 1680, the mission underwent restoration in 1716. It remains the dominant feature of the plaza.

The **San Jose Mission** in **Laguna** dates to 1699.
Judy Hinckley

Laguna

The pueblo of Laguna was established by Keresan-speaking refugees evicted from villages along the Rio Grande by the Spanish in the mid-seventeenth century. The pueblo actually consists of several small villages. The San Jose de Laguna Mission Church, built in 1699, dominates a hill

overlooking Laguna; it is listed as a National Historic Landmark.

Los Lunas

Located south of Albuquerque on the pre-1937 alignment of Route 66 at that highway's crossing point on the Rio Grande, the Los Lunas town site dates to the San Clemente Land Grant awarded to Felix Candelaria in 1716. The initial construction in the village commenced in about 1750. A primary attraction is the Luna Otero Mansion, listed on the National Register of Historic Places. Built in 1881, it currently serves as a restaurant.

Montoya

The town of Montoya derives its name from the Montoya Land Grant. Issued to Pablo Montoya in 1824 by the Mexican government, the land grant was one of the largest issued in what is now eastern New Mexico.

G. W. Richardson opened his first store in Montoya near the Rock Island Railroad depot in 1908. After 1918, he opened a larger, red-sandstone-constructed store to capitalize on the development of the improved highway between Santa Rosa and Tucumcari. This improved road became a part of U.S. 66 in 1926. With the onslaught of the Great Depression, Montoya entered a period of precipitous decline, but Richardson's store, which also served as the post office and began selling gasoline from pumps under its large portico, prospered because of its location.

With completion of I-40 to the south of the store in 1967, business dramatically slumped, even though an interchange provided access. Listed on the National Register of Historic Places by the National Park Service in 1978, the long-closed store is now in a dilapidated state.

Pecos National Historical Park

The Pecos National Historical Park, located along the pre-1937 alignment of Route 66 south of Pecos, preserves remnants of a vast pueblo that predates the arrival of Spanish explorers by centuries, as well as the ruins of a mission church built during the Spanish colonial period.

Archeological evidence indicates that initial

The mission ruins in **Pecos National Historic Park** date to the late seventeenth century.

Romeroville was the western terminus of the **Ozark Trail**.
Joe Sonderman

settlement at this site dates to about 800 AD. By 1100, it was a substantial village of sun-dried adobe bricks. Estimates place the population in excess of 2,000 at the community's peak in about 1450.

The pueblo was a pivotal trade center located between hunting tribes of the plains and between the villages of the Rio Grande River valleys, making it a prosperous and modern community. It was also a fortress with walls of stone five stories high in places.

Spanish expedition notes from 1584 describe the pueblo as sitting on a "high and narrow hill, enclosed on both sides by two streams and many trees. It has the greatest and best buildings of these provinces and is most thickly settled."

The ruins of Kozlowski's Stage Stop can also be found near the ruins of the pueblo. Located on the Santa Fe Trail, this stage stop is where Major John Chivington established Camp Lewis on March 25, 1861, the day before commencement of the battle of Glorieta Pass immediately to the west.

Romeroville

Romeroville, located on the pre-1937 alignment of Route 66, was the northern terminus for the Ozark Trail and that road's junction with the National Old Trails Highway. It also served as an important stop for travelers and merchants traversing the Santa Fe Trail.

The namesake for the community, which began as a ranch, was Don Trinidad Romero. Born in 1835 in Santa Fe, Romero established a profitable freight company that operated on the Santa Fe Trail. He served as a member of the Territory of New Mexico House of Representatives in 1863, as a representative of the Territory of New Mexico to the U.S. Congress from 1877 to 1879, as the probate judge for San Miguel County in 1869, and as U.S. Marshal from 1889 to 1893.

In his $100,000 home, Romero hosted a number of celebrities, dignitaries, and politicians, including President Rutherford B. Hayes and General William Tecumseh Sherman. In the book *Women Tell the Story of the Southwest* by M. L. Wooten, Anna Clark described the home as consisting of "a dozen large, lofty, high ceiling rooms paneled in walnut. The downstairs rooms had sliding doors opening into the spacious ballroom. There was a low, wide, curving stairway."

After serving as a sanatorium for a number of years, the stately manor burned in January 1930. A front-page article in the *Las Vegas Daily Optic* (New Mexico), dated January 24, noted that "crackling flames early today completely destroyed the Thunderbird ranch home, five miles west of Las Vegas, and erased one of the pioneer landmarks of New Mexico." The article continued: "Hardwood floors and oak trimmings provided tinder dry fuel for the fire, and the building collapsed into a smoldering mass, leaving only the adobe part of the house standing as a smoke-blackened skeleton today."

San Felipe

The expedition of Francisco de Coronado noted a pueblo, Katishtya, at the site of the village of San Felipe in 1540. A Spanish colonial garrison was established here in about 1620. Following the Pueblo Revolt of 1680, the garrison and pueblo were abandoned, leaving the village open to

destruction by raiders and the elements. Rebuilding commenced in 1693.

The small village provided basic amenities to travelers on the El Camino Real, the Trail to Sunset, the National Old Trails Highway, and Route 66. The link to U.S. 66 was severed with the highway's realignment in 1937.

The plaza in **Santa Fe** marked the western terminus of the Santa Fe Trail. *Steve Rider*

The **Palace of the Governors** in **Santa Fe** dates to 1680. *Joe Sonderman*

Santa Fe

Santa Fe Plaza dates to the establishment of a presidio—a walled fortress that included residences, a chapel, a prison, the governor's palace, and barracks—on this site by Don Pedro de Peralta in 1610. The historic origins of settlement on this site are much older, however. Peralta laid out a plan for La Villa Real de Santa Fe, including the plaza, atop the pueblo of Ogapoge, which had been abandoned in about 1425.

The plaza in **Santa Fe** marked the western terminus of the Santa Fe Trail before it became a part of Route 66's path through **New Mexico**. *Steve Rider*

Listed on the National Register of Historic Places, Santa Fe Plaza continues to serve as a social and commercial centerpiece in the city. Enclosed within the historic district are monuments, restaurants, art galleries, and various businesses. The Palace of the Governors is among the most notable structures. Built between 1610 and 1612 and then rebuilt after the Pueblo Revolt of 1680, the palace is one of the oldest public buildings in the United States.

An inn, or fonda, has occupied the southeast corner of the plaza since at least 1610. The current La Fonda dates to 1922. Built by the Atchison, Topeka & Santa Fe Railroad, it was leased to the Fred Harvey Company in 1926. Recent renovations preserved the architectural attributes of the original hotel.

Indicative of the plaza's importance to the development of New Mexico is the fact it served as the terminus for numerous historic trails and roads, including El Camino Real, the Santa Fe Trail, and the Old Pecos Trail. Additionally, the National Old Trails Highway and the pre-1931 alignment of Route 66 passed through the plaza.

Nearby, the San Miguel Mission is a Spanish Colonial mission church that dates to the early 1600s. The original building was constructed between 1610 and 1626 utilizing parts of an Indian pueblo predating this by centuries, but the mission building was destroyed during the Pueblo Revolt of 1680. A new structure was built on the site in 1710.

Tecolate

Established in 1824 as a farming village by Salvador Montoya, Tecolate survived for less than five years before it was abandoned as a result of

frequent Indian attacks. Resettlement commenced in the early 1840s, and in August 1846, U.S. Army General Stephen Kearney addressed citizens in the plaza with a proclamation declaring that the area was now under United States jurisdiction.

From 1850 to 1860, the community served as a garrison for the United States Army during campaigns against Indian tribes in the area. William Anderson Thorton, a member of a military expedition in 1855, noted in his diary, "the villages of Vegas and Tecolate made from unburnt clay and in appearances resemble unburnt brick kilns in the States. People poor and dirty. Flocks of sheep, goats, and cattle very numerous. Wheat and Corn raised by irrigation."

Vestiges of and links to the community's early history are numerous. Most notable are a Santa Fe Trail marker and a small adobe church dating to a period before 1870.

Valencia

An expeditionary note from the Chamuscado-Rodriguez exploration party of 1580 indicates the presence of a small Tiwa pueblo, Caxtole, at the site of modern-day Valencia. European settlement at the site dates to at least 1660 with the establishment of a hacienda by Juan de Valencia.

The first records referring to Valencia as the name for this community are from the Vargas expedition of 1692. A U.S. post office operated intermittently here from 1884 to 1939, and for a brief time the village served as the county seat.

Landmarks

Albuquerque

The pre-1937 alignment of Route 66 utilized 4th Street to traverse Albuquerque from north to south. Segments of the predecessor National Old Trails Highway also followed much of this corridor, as evidenced by the Madonna of the Trail monument at the corner of 4th and Marble Streets.

The Red Ball Café opened at 1303 4th Street SW in 1922. It remains as one of the oldest continuously operated restaurants on the Route 66 corridor in the city, and is now listed on the National Register of Historic Places.

The building at 2106 East Central Avenue with the embossed pig façade opened in 1930 as Charley's Pig Stand. It replaced a smaller restaurant first established there in 1924. Since its closure in 1954, the building has housed a variety of businesses. It is on the National Register of Historic Places and the State Register of Historic Places.

At 320 East Central Avenue, the Carothers and Maudlin garage and service station utilized the most modern architectural attributes in its construction in 1938. After the garage closed in 1957, many different businesses set up shop in the building before its purchase by John, Vince, and Mathew Di Gregory in the spring of 2006. The Di Gregory brothers converted it into the Standard Diner. The restaurant receives endorsement from the National Historic Route 66 Association with inclusion in the *Route 66 Dining & Lodging Guide*, and it was featured on the Food Network program *Diners, Drive-ins & Dives*.

The recently renovated El Don Motel at 2222 West Central Avenue is a favored photo location for Route 66 enthusiasts. Established in 1946 by Dan Eitzen, it still boasts its mid-1950s neon sign topped by a cowboy. The fifteen-unit complex received consistent recommendation by AAA through the 1950s.

The El Vado Auto Court opened in 1937 to capitalize on the realignment of Route 66 in Albuquerque. The motel consisted of thirty-two

The **El Vado Court** in **Albuquerque** is one of the best preserved prewar motels in New Mexico. *Mike Ward*

units interspersed with enclosed carports. With the motel's prime location on Central Avenue near the Rio Grande crossing and historic Old Town Albuquerque, Daniel Murphy decided to resign his position as manager of the prestigious Franciscan Hotel and assume that role with this property. A review of the motel in the 1940 *Directory of Motor Courts and Cottages* published by AAA provides further insight into what may have prompted Murphy's decision.

The motel was listed in the National Register of Historic Places in 1993, but a decline in maintenance and clientele led to its closure in late 2005. Still, the motel complex retains such a high degree of authenticity that historian David Kammer described it as "one of the best examples of a largely unaltered pre–World War II tourist court along Route 66 in New Mexico."

This assessment proved to be a key factor in the city's decision to intervene and issue a stay for plans to raze the complex. As of this writing, the motel remains closed.

The Jones Motor Company at 3222 Central Avenue SE (Route 66) opened in 1939 utilizing plans from architect Tom Danahy. The then state-of-the-art facility built by Ralph Jones initially served as a full-service Ford dealership and by the mid-1940s included a Texaco station.

As a proponent of Route 66 promotion and development, Jones held a number of prominent offices in the Albuquerque area. He served as the president of the U.S. Highway 66 Association, president of the Albuquerque Chamber of Commerce, and chairman of the New Mexico State Highway Department in the late 1940s.

The Jones Motor Company complex evolved through the 1950s. A body shop was added to the rear of the property, and an additional showroom was built on the west side to mirror the original showroom and balance the design. After the dealership relocated in 1957, the building housed a variety of businesses, including a moped dealership and army surplus store.

In 1999, Dennis and Janice Bonfantaine acquired the property and initiated restoration with a focus on preserving the Streamline Moderne architectural details and components such as the original garage doors. It was listed on the National Register of Historic Places in 1993.

Today the facility operates as Kelly's Brew Pub. This restaurant is a popular local eatery that

The former **Jones Motor Company** now houses Kelly's Brew Pub. *Joe Sonderman*

consistently receives recommendation in the *Route 66 Dining & Lodging Guide*, published by the National Historic Route 66 Federation.

Directly to the west of Kelly's is the Hiway House, the last remnant of a pioneering motel chain established in 1956 by Del Webb. Webb, the contractor who established Sun City, Arizona, was also an initial investor in the Ramada Inn motels. The Hiway House complex in Albuquerque originally included a restaurant. Other Route 66 locations for this motel chain in the 1950s included Holbrook and Flagstaff, Arizona; Tulsa, Oklahoma; and Arcadia, California.

The ornate KiMo Theater opened on September 19, 1927. Built for Oreste Bachechi at a cost of $150,000, it was designed by architect Carl Boller with a unique blending of Southwestern, Pueblo, and Art Deco styling. It is a steel-framed structure with brickwork façade. The front entrance was updated and modernized in 1952. The interior featured Native American themes, including

The **Hiway House** in **Albuquerque**, the last vestige of a pioneering hotel chain, retains its original signage.

The distinctively styled **KiMo Theater** in **Albuquerque** opened in 1927. *Joe Sonderman*

murals by acclaimed artist Carl von Hassler and vents painted to appear as Navajo rugs. A fire in 1961 destroyed the center stage, and numerous other modifications were made during the period of repair, although the refurbished building initially closed in 1968. Currently utilized as a venue for film festivals, concerts, and theater, restoration to the original appearance was completed in the summer of 2011 with the installation of original and replicated neon signage.

The Maisel Indian Trading Post opened on Central Avenue, one block from the KiMo Theater, in 1939. Maurice Maisel selected the site primarily because of its location on Route 66 in the central business district. Designed by John Meem, Albuquerque's leading proponent of Pueblo Revival styling, the façade featured a deeply recessed entry and display windows floored with glazed terra cotta tiles, creating a Native American themed mosaic. Maisel also hired Olive Rush, a leading Albuquerque artist who specialized in Native American scenes, to design murals depicting various tribal ceremonies and Navajo and Pueblo artists to execute them. In all, Maisel arranged for 300 artists to work on site.

By 1950, this was the largest trading post for authentic Native American handicrafts and artistry on Route 66. The store closed in the early 1960s after Maisel's death. Refurbishment to the store's original appearance commenced in the late 1980s. Shortly after, it reopened with Maurice Maisel's grandson, Skip, as the proprietor. It was listed in the National Register of Historic Places in 1993.

Clines Corner

The initial facility established by Ray Cline in 1934 was located at the junction of New Mexico Route 6 (the Santa Fe bypass) and New Mexico Route 2. With the 1937 realignment of Route 66 that routed traffic directly to Albuquerque from Santa Rosa, bypassing the Santa Fe loop, Cline relocated his business to the junction of U.S. 66 and U.S. 285, its current location.

After its sale in 1939, Clines Corner remained a rudimentary service center into the 1940s. Jack Rittenhouse, author of *A Guide Book to Highway 66*, noted in 1946 that "you reach Cline's Corners. One building here, housing a gas station, and café."

Fueled by the postwar boom in tourism, the facility was expanded to include a large garage, a motel, and a restaurant. During this period, the owners, Lynn and Helen Smith, initiated a petition to have Rand McNally include Cline's Corner on maps and in atlases.

Cline's Corner is rare among Route 66 business in that it has survived and prospered into the modern era, resultant of successful petitioning for an exit on I-40 when that highway supplanted Route 66 in this part of New Mexico in 1973.

The **Clines Corners** complex began with a service station in 1937. *Joe Sonderman*

Gallup

The thirty-four-unit Desert Skies Motel opened at 1703 West Highway 66 in May 1959, with Auro and Nellie Cattaneo as its proprietors. Promotional materials touted its multitude of modern amenities, including "hi-fi music" and 21-inch

The **Richardson Trading Post** in **Gallup** opened more than a decade before Route 66 certification.

televisions. The original signage helps make the motel a popular photo stop.

Earl's Park 'N' Eat at 1400 East Highway 66 opened in 1947. After it was purchased and renovated by Sharon and Maurice Richards in 1974, it reopened as Earl's Family Restaurant. The fifteenth edition of the *Route 66 Dining & Lodging Guide* published by the National Historic Route 66 Federation recommends the restaurant for value, quality, and historical significance.

Established by Dino Ganzerla in the fall of 1954, the forty-unit El Capitan Motel at 1300 East Highway 66 continues to meet the needs of travelers today. Recommendations by AAA in the late 1950s noted a wide array of amenities, including "central heat, tiled combination shower baths, radio, and alarm clocks."

Santa Fe

Currently operating as the El Rey Inn at 1862 Cerillos Road (the pre-1937 alignment of Route 66), the El Rey Auto Court opened in 1936 as a twelve-unit motel. Renovations and upgrades initiated in 1954 included the construction of new units and enclosure of the carports to serve as rooms, as well as installation of a swimming pool.

Built and designed by the company that incorporated Spanish colonial and Pueblo influences in the architecture for this motel as well as the El Vado Motel in Albuquerque, the El Rey

The **El Rey Inn** in **Santa Fe** first opened in 1936.

continued to receive favorable recommendation into the 1950s. The *Western Accommodations Directory* published by AAA in 1954 noted that the motel was a complex of "tastefully furnished one and two room units with central heat and tiled shower or combination baths. Six housekeeping units at small additional costs. Radio and cribs available." A notation that it featured eight carports indicates it was written during the renovation period.

Shortly after acquiring the property in 1973, Terrell and Hanneke White added more rooms, and in 1993 they further transformed the facility with the addition of a two-story, ten-room unit with Spanish styled courtyard. Full refurbishment of the original complex with attention to the preservation of period details maintained the historical ambiance of the property. In 1994, the Whites purchased the adjacent 1950s Alamo Lodge and incorporated it into the El Rey after extensive renovations.

Also during this period, work commenced on transforming the grounds, including a greenhouse for growing shrubs and flowers. In 2003, the property received recognition for its landscaping efforts with the award of Backyard Wildlife Habitat by the National Wildlife Federation.

Santa Rosa

Ira Smith had established numerous successful businesses in Santa Rosa, including the Pecos Theater that opened in 1936, before turning his attention toward capitalizing on the traffic that flowed through town on U.S. 66. In 1950, he established the Tower Courts, a thirty-two-unit complex directly across from Joseph's Café.

Smith sold the property in 1952, and the new owners renamed it Tower Motel. The entry in the 1954 edition of the *Western Accommodations Directory* published by AAA noted that the motel was "air cooled with vented heat and tiled shower or combination bath." Additional amenities included radios upon request. As of summer 2013, the Tower Motel was still in operation.

The **Blue Swallow Motel** in **Tucumcari** opened shortly before World War II. Its iconic neon sign makes the Blue Swallow Motel a popular photo op. *Judy Hinckley*

Tucumcari

The Blue Swallow Motel has survived into the modern day as a near-perfect time capsule representing the pre–World War II auto court. This, in addition to renovations performed with attention to preserving the architectural detail and period amenities—including neon signage, honeycomb bathroom tiles, and hand-sewn curtains—has ensured this motel is highly favored by Route 66 enthusiasts. In addition, it is one of the most photographed locations on this highway.

Construction of the motel at 815 E. Route 66 Boulevard commenced in 1939. Ted Jones, a prominent rancher in eastern New Mexico, purchased the facility in 1942. After the death of Jones and his wife in a 1950 plane crash, Floyd Redman, manager of the Bonanza Motel in Tucumcari, purchased the Blue Swallow Motel. He presented it to his fiancée, Lillian, as an engagement present in 1958.

After her husbands' death, Lillian continued to operate the business until 1998. A succession of owners after that undertook various refurbish-

ment attempts. In July 2011, Nancy and Kevin Mueller purchased the property and initiated a major renovation that included repainting it in its original colors, restoring the neon trim, and upgrading the plumbing with period-correct materials and fixtures.

Located west of the motel on Route 66, the original La Cita restaurant opened in 1940. The building that currently houses the La Cita opened on the opposite side of the highway in 1961. Refurbished in 2006, the restaurant, with its rotating neon trimmed sombrero sign, remains in business as of this writing.

Almost directly across the road from the Blue Swallow Motel, the twenty-three-unit Motel Safari was built by Chester Doer in 1959 and opened as a Best Western franchise property. With the exception of the camel on the sign that replaced the Best Western logo in 1962, and the removal of the swimming pool, the motel remains virtually unchanged. Fully renovated in 2008, it is a popular location for Route 66 aficionados. Enhancing the vintage feel are the refurbished original furnishings and prints made from original postcards portraying businesses along the Route 66 corridor in Tucumcari before 1970, provided by collector Mike Ward.

The current configuration of Tepee Curios, another landmark in Tucumcari, including a faux teepee at the entrance and extensive neon trim and signage, dates to 1960. The facility first opened in 1944 with Leland Haynes as proprietor and operated as a service station, small grocery store, and curio shop. Gasoline sales were discontinued in about 1955. A restoration project,

The **Motel Safari** in **Tucumcari** is a landmark that dates to 1959. *Judy Hinckley*

Tepee Curios in Tucumcari originally opened as a service station in 1944. *Judy Hinckley*

including to the signage and neon, gave the property a 1950s feel and makes it a popular photo stop. It most recently operated as Jene Klaverweiden's Trading Post.

Parks

Albuquerque

In 1909, the National Society Daughters of the American Revolution conceived a plan to mark the course of the Santa Fe Trail in Missouri. By 1911, the plan had morphed into a national committee whose primary task was to establish the Old Trails Road as a National Memorial Highway.

The National Old Trails Highway Association formed in 1912 to assist in that endeavor and to create an ocean-to-ocean highway knit from historic trails and roadways. Creation of this entity and development of the proposed highway resulted in an expanded concept for commemorative memorials. Even though the president of the National Old Trails Highway Association, Harry Truman, had guaranteed funds for the creation and placement of monuments, the transition from the originally proposed cast-iron markers to that of twelve large statues delayed the project until 1924.

The Madonna of the Trail sculptures chosen for the memorial portray a pioneer-era woman with a baby in her arms and a young child clinging to her skirt. The statues stand 10 feet high, on a 6-foot base, mounted on a 2-foot-high foundation with plaques commemorating a locally significant historic event. The first of twelve statues commissioned for placement in the states through which the National Old Trails Highway passed was dedicated on July 4, 1928 in Springfield, Ohio.

Two of these statues, which were designed by sculptor August Leimbach, stand along Route 66. The New Mexico statue is located in a small park at 4th Street (the pre-1937 alignment of Route 66) and Marble Street in Albuquerque. The dedication ceremony was held on September 27, 1928.

Santa Rosa

Listed in the National Register of Historic Places in 1996, Park Lake originated from a Federal Relief Emergency Administration and Works Progress Administration (WPA) project initiated in 1934. The program employed local men to construct a 25-acre municipal park built around the lake.

Completed in 1940, the park became an oasis for Route 66 travelers as well as locals. However, by the mid-1970s, the park had fallen from favor and was suffering from neglect and poor maintenance.

Recently refurbished by residents, the park is again a favored stop for travelers and is a centerpiece in Santa Rosa's redevelopment. It retains much of the original detail, including masonry canals that drain the area into El Rito Creek, retaining walls built of locally quarried stone, and terraces that accentuate the sloping contours of the natural landscape.

Established by the Works Progress Administration, **Park Lake** in **Santa Rosa** is listed on the National Register of Historic Places.

Military

Albuquerque

Established in early 1940, the Albuquerque Army Air Base served as the headquarters for the 19th Bombardment Group. It was designated an Air Forces Advanced Flying School on December 24, 1941.

With the advent of World War II, the Civilian Conservation Corps camp at Rio Grande Park, just north of the present-day Albuquerque Bio Park, was converted into a POW camp. Initially, in October 1943, Camp Albuquerque housed Italian prisoners of war, but from July 1944 to March 1946, the internment of German prisoners became the camp's exclusive function. At its peak, the camp housed 141 prisoners. Throughout its existence, prisoners worked on area farms, as well as farms near Los Lunas.

Santa Fe

Currently the site of the Franklin S. Ortiz Park in the Casa Solana neighborhood north of West Alameda Street (an early alignment of Route 66), a former Civilian Conservation Corps camp here was modified to serve as an internment camp for Americans of Japanese descent during World War II. More than 4,500 prisoners were interned in the camp or housed here while in transit to other concentration camps during the period of operation between 1942 and 1946.

A marker in the park commemorates the camp and its historical significance: "Many of the men held here without due process were religious leaders, fishermen, businessmen, farmers, and others removed from their communities. Yet, many of the internees had relatives who served with distinction in the American armed forces in Europe and the Pacific. This marker is placed here as a reminder that history is a valuable teacher only if we do not forget our past."

Crime and Disaster

Albuquerque

On September 10, 1954, James Larry Upton shot and killed airman Donald Dilley during a robbery and dumped the body off Route 66 west of Carnuel near East Central Avenue in Albuquerque. Upton had been hitchhiking west across Texas when Dilley picked him up near Amarillo.

The crime garnered little attention outside of Albuquerque, but the subsequent trial and Upton's execution became the subject of extensive reporting. After Upton's conviction, there were numerous appeals, including a change in testimony by Upton's psychiatrist that resulted in a sanity hearing before the New Mexico Supreme Court fifteen hours before the time scheduled for execution. That and a telegram sent by his mother to the Court of Appeals served as catalysts for the wide media coverage.

More than one hundred observers attended the execution, on February 12, 1956, many of whom were severely intoxicated. One on-scene reporter described the event as "a circus."

The regulation cap used for executions did not fit Upton, so an improvised version created from a parka hood served as a substitute. Fur in the hood ignited from the voltage. This was the last execution by electrocution in the state of New Mexico.

Razed in 2002, the Canyon Motel at 13001 East Central Avenue most likely would have faded into obscurity after its decline into a weekly or

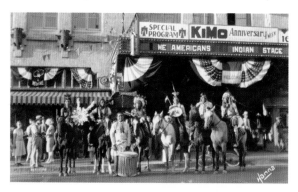

The landmark **KiMo Theater** in **Albuquerque** was the scene of a fatal explosion in 1951. *Joe Sonderman*

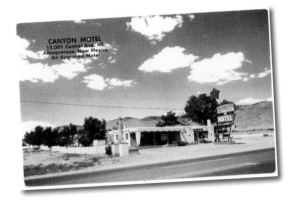

The **Canyon Motel** in **Albuquerque** was the site of the brutal torture of Linda Lee Daniels in 1986.
Mike Davis

monthly rental complex were it not for a brutal murder that took place here in 1986 and rattled the city. Followed by her assailant from a supermarket and kidnapped in her driveway, Linda Lee Daniels was held captive and tortured at this motel before being murdered. The subsequent trial was a sensation that captured the city's attention.

Budville

Budville epitomizes the one-business communities that mushroomed along Route 66 in the pre–interstate highway era. Established in 1928 as an automobile service center by H. N. "Bud" Rice and his wife, Flossie, the town grew to include a trading post, a few houses, and a towing service and impound yard operated by Rice.

By the 1950s, Rice operated the only towing service between the Rio Puerco River west of Albuquerque and Grants. He also served as a justice of the peace and had a well-deserved reputation for levying exorbitant fines.

One evening in November 1967, an unknown assailant shot and killed Rice, and the murder remains unsolved. His wife operated the business until 1979.

On January 10, 1956, the body of Ralph Henderson Rainey was found along Route 66 near Budville with two bullets in his head. Rainey, a 46-year-old butcher from Santa Monica, had been traveling west on Route 66 when he picked up a hitchhiker by the name of David Cooper Nelson near Albuquerque.

Upon recovering Rainey's vehicle, police discovered Nelson's fingerprints and issued an arrest warrant. Arrested in Las Vegas, Nevada, Nelson

Bud Rice met his fate in **Budville** in 1967.
Steve Rider

confessed to the murder but later recanted his confession, to no avail. On August 11, 1960, Nelson was the first person executed in the gas chamber in New Mexico.

Clines Corner

On August 11, 1955, a traffic accident caused by fatigue claimed the lives of six men immediately to the west of Clines Corner, and it sparked an investigation by the National Association for the Advancement of Colored People that garnered headlines through the country. In an article that appeared on August 16 in the *Albuquerque Tribune*, Edward L. Boyd, a special assistant with the NAACP in Albuquerque, said that "it was not surprising" that the men died in the accident. He noted that his investigation determined that "they could not have found a welcome at any of the courts on Route 66 from the Texas border to Albuquerque."

Boyd's investigation also found that less than eight percent of the more than one hundred motels and auto courts along the Route 66 corridor in Albuquerque would accept "Negro tourists." He noted that, when presented with this information, both Don W. Elton of the New Mexico Motor Hotel Association and J. D. Jackson of the Albuquerque Motor Court Association responded with "no comment."

Continental Divide

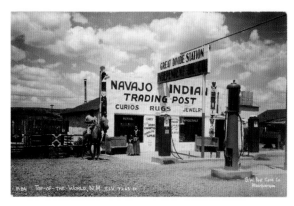

The trading posts at **Continental Divide** had a well-earned nefarious reputation. *Steve Rider*

Endee

In the opening years of the twentieth century, Endee, a town located on the pre-1956 alignment of Route 66 a few miles west of Glenrio, Texas, often garnered national attention for crimes that seemed more fitting in the frontier era.

On May 2, 1906, the *Santa Fe New Mexican* reported:

Two arrests were made just a week ago which it is believed by Captain Fornoff of the mounted police mark the beginning of the end of the cattle rustling that has been going on in the eastern part of the Territory for some time. After a month's chase, including the following of old trails over dangerous mountain passes and lying for hours in wait for the desperados, mounted police arrested John Fife and Tom Darlington, two alleged cattle thieves who are

Now a ghost town, **Endee** was the site of the arrest of a band of cattle rustlers in 1906.

This **Endee** store was linked to the investigation of the murder of T. A. Thornton in 1949. *Steve Rider*

said to be head of a gang of outlaws whose deprecations have cost ranchmen thousands of dollars.

The arrest was made at Endee, forty miles from Tucumcari, a thinly settled country into which the mounted police had never ventured.

Another incident on June 30, 1909, received similar attention. "The anti-saloon campaign at Endee, N.M. territory came to a close last night when a band of masked men, mounted and armed, rode their horses through the doors of a saloon and shot up the place until the mirrors and glassware were completely destroyed. The riders then crashed into a hall where a dance was in progress and wrecked the dance hall and bar."

Gallup

On December 3, 1945, *The Gallup Independent* reported:

A lone gunman locked Gilbert Diaz, the attendant at the Walsh Battery Station, in the coal bin and made off with $160 from the cash drawer and 16 gallons ethyl gas about 12:30 am today to climax a series of events which kept state and city police and the sheriff busy over the weekend.

Gabe Snuello, who is also employed at the Walsh station at 515 West Coal, was there until 11:30 pm, and left Diaz alone when he went off duty.

State policeman Dave Jackson said Route 66 was blocked both east and west of town immediately after the holdup last night but that the gunman was not trapped.

The Traveler's Café on 66 Avenue was burglarized that same evening, and the paper reported that the perpetrator "broke the glass in the rear door to gain entry. The thief got $50 in cash, and $200 in traveler checks."

Glorieta

On December 31, 1916, police in Friday Harbor, California, arrested Elbert W. Blancett for theft and fraud. With the discovery of a badly decomposed corpse, partially eaten by animals, in an arroyo that crossed the National Old Trails Highway (predecessor to Route 66) near Glorieta on January 14, 1917, the additional charge of murder led to Blancett's extradition to New Mexico.

As the case unfolded in court, it became a national media sensation since it featured murder, assumed identity, sexual scandal, and a series of carefully planned robberies. Even after Blancett's execution on July 9, 1920, at Santa Fe, the story continued to be a source of fascination, as there were claims of the governor's interference, and the hanging itself was a gruesome, botched affair.

To the end, Blancett maintained his innocence, claiming that Clyde D. Amour's death had resulted from an alcohol-induced accidental shooting. He had hidden the body in a panic, fearing that as a stranger to the area no one would believe his story.

However, investigators pieced together a very sordid story. Blancett, traveling from Sioux City, Iowa, to Fresno, California, had accepted a ride from Amour on October 22, 1916, and an offer of lodging that night. Drinking between the two men led to a heated and violent argument, the nature of which did not come out until the sentencing phase of the trial.

After killing Amour with a shotgun blast to the back, Blancett robbed Amour and assumed his identity as he continued on to California. Blancett also used information to obtain funds from Amour's friends and associates, and at one point he even obtained money from Amour's mother by sending telegrams alluding to financial problems in California.

Found guilty and incarcerated, Blancett continued to maintain that the shooting was an accident. The governor, citing Blancett's "degeneracy," denied the appeal for a stay of execution until completion of a sanity hearing.

Investigation decades later revealed that the "degeneracy" alluded to was based on evidence that led investigators to believe the argument resulted from a homosexual proposition.

Grants

On April 11, 1952, two brothers from the Gonzalez family sped through Grants on Route 66 at a high rate of speed, running stoplights and weaving through traffic. Investigators later learned that the brothers had been involved with Patrolman Nash Garcia in an earlier altercation and had staged the high-speed pursuit in an effort to lure the patrolman out of town.

Approximately one mile west of town, the brothers turned onto a dirt road where they set up an ambush. As Garcia turned onto the dirt road, they opened fire with a high-powered rifle.

When the patrol car went off the road and stopped, the brothers pulled the mortally wounded officer from the car and beat him with a rifle until the butt broke. They then hid the body and drove the patrol car into a stand of trees. They returned the next day and set fire to the vehicle.

Arrested shortly after the incident, the brothers each received a sentence of twenty years. Garcia, a ten-year veteran, was interred in Calvary Cemetery at Albuquerque, New Mexico.

Isleta Pueblo

The Isleta Pueblo, located on the pre-1937 alignment of Route 66 south of Albuquerque, was the site of a horrendous accident on April 12, 1930. It was deemed the worst accident to occur on Route 66 to that date, and initial reports placed the death toll at nineteen.

Based on survivors' testimonies, an inquiry determined that F. D. Williams, a Pickwick-Greyhound bus driver, was hurrying to make up for time lost due to mud encountered east of Flagstaff, and he misjudged the speed of an approaching Santa Fe, Atchison & Topeka mail train at the grade crossing twelve miles south of Albuquerque. The collision caused the bus to burst into flames.

The *Albuquerque Journal* reported that, "In a twinkling, the luxurious coach was a mass of wreckage twisted about the front of the railroad

engine. Simultaneously with the collision came a terrific blast as gasoline tanks exploded, adding fire to the horror. Bodies of the bus passengers were hurtled through the air, clothes ablaze, or dragged along in the wreckage and distributed along the right of way with debris of the coach. One or two were pinned in the chassis, which were carried along under the cowcatcher of the engine until the screeching brakes brought it to a halt. The bodies were extracted with difficulty."

Attesting to gruesomeness of the accident, the initial coroner's report noted that only seven of the deceased had been identified and that several of the bodies, including two babies, two women, and five men who were "battered or burned beyond recognition," most likely would never be identified.

La Bajada

On March 24, 1928, the *Santa Fe New Mexican* newspaper reported that "Paul Campbell of Fairfield, Missouri, had one ear almost torn off, and Everett Hunter of the same place was stunned and severely bruised when a Ford overturned at the top of Little La Bajada on U.S. Route 66."

According to investigators, Campbell had fallen asleep at the wheel, awoke to oncoming traffic, and subsequently lost control. The article noted that the Ford was "wrecked beyond repair."

The accident magnified concerns that the roadway between Santa Fe and Albuquerque, including La Bajada Hill, was wholly inadequate for the increasing flow of traffic. The following year an-

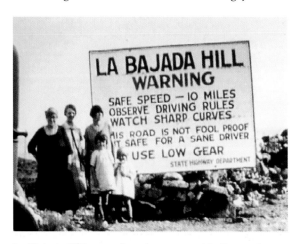

La Bajada Hill was a treacherous road in the early years of Route 66. *Steve Rider*

other accident further fueled those concerns.

On July 23, 1929, a bitterly contested claims case against the estate of H. Duross O'Bryan concluded when District Judge Reed Holloman in Santa Fe ruled in favor of the plaintiff. The case stemmed from an automobile accident on Route 66 at the base of La Bajada Hill in which two men died, two women were seriously injured, and Mary J. O'Bryan died later from injuries sustained in the accident.

The claims included $5,000 to be paid to J. C McCanvery, administrator of the estate of John S. Frazier, one of the fatalities, whose wife suffered from a fractured pelvis. A Los Angeles dentist received $2,650 for treatment of Inez Otero, who suffered a broken jaw in the accident.

The concerted outcry for a bypass of the increasingly congested La Bajada Hill, with its steep grades and sharp curves, and for improvements to highway engineering and construction resulted in initiation of a realignment of Route 66. The bypass was completed in 1931.

Moriarty

In the early morning hours of February 18, 1967, police officer Gilbert Montoya received a call at home from a concerned business owner regarding suspicious activities at a store in the 1000 block of U.S. 66. Montoya arrived and found a car parked in front of the building. While he was questioning the two suspects in the car, a third suspect opened fire from inside the store, shooting Officer Montoya in the back of the head. The three men then stole the officer's gun and fled the scene.

An anonymous tip led to their arrest in Albuquerque two days later. In exchange for testimony, the charges were dropped against one suspect, and a second was acquitted.

The gunman received a sentence of two to ten years for voluntary manslaughter, an additional sentence for breaking and entering, and another sentence for escaping from jail while awaiting trial. Incredibly, he was granted parole in 1974, but on July 1, 1999, he murdered two men in Albuquerque. For this crime, he received a life sentence.

Santa Rosa

On January 28, 1939, a jury handed down a conviction of murder in the first degree in the trial of

Dr. John H. Sanford, for which the judge ruled in favor of the death penalty. April 21 was set as the scheduled date for execution.

As the trial unfolded, lurid details provided fodder for reporters covering the case. Those details and the fact that Sanford had twice served as the mayor of Santa Rosa ensured the trial was the subject of national media attention.

Sanford's wife, an area socialite, had taken ill on July 14, 1938, and was taken to the hospital in Tucumcari. She died nine days later, and the attending physician cited heart failure as the cause of death.

However, persistent rumors circulated that Dr. Sanford had been romantically involved with Hallie Mae Wilson, a waitress at a café along Route 66 in Santa Rosa. These rumors and an anonymous tip from an informant led authorities to exhume Mrs. Sanford's body in September.

The coroner's report indicated the presence of enough poison in her body "to kill fifteen persons," and an arrest warrant was issued for Dr. Sanford. Upon his arrest, he hired an attorney and initiated a methodical campaign to prove that his wife had been suicidal because of discussions pertaining to divorce.

During the trial, damning evidence and testimony led newspapers to refer to Sanford as "an elderly male Borgia" and a "Jekyll and Hyde." Wilson's husband, Walter, testified under oath that the doctor had confessed his love for Hallie Mae after his wife's death. He also produced evidence that Sanford had assumed payments on the couple's car.

After a five-hour deliberation, the jury returned a unanimous guilty verdict. The story did not end with Sanford's sentencing, however.

A series of appeals resulted in commutation of the death sentence. Further legal filings led the case to be brought to the state Supreme Court, where Dr. Sanford was acquitted.

Tucumcari

On April 15, 1907, the *Santa Fe New Mexican* reported:

> This community [Tucumcari] is in a state of feverish excitement as a result of the tragedies here Friday evening coming as a sequel to a family feud. Elmer Horn shot and killed his father-in-law W. W. Horton, and a young man named Williams, who joined the posse pursuing Horn, was also killed.

> According to the meager information obtainable, Horton was returning from town to his ranch a short distance from Tucumcari when he was assassinated by Horn. It is said that bad blood has existed between the two men since Horton's daughter married Horn against her father's wishes and they had threatened to shoot each other on sight.

> Sheriff J. A. Street of Quay County organized a posse and started in pursuit of Horn who, with a companion, had sought to escape before the tragedy was discovered. The pursuing party caught up with the fugitives after a chase of eighteen miles and a pitched battle ensued in which young Williams was mortally wounded and died within a few minutes.

The following day, Horn's companion, John Wilson, died in another confrontation with the posse. Horn, now joined by two more friends, again escaped. Before finally eluding his pursuers near Albuquerque, Horn would engage in three more firefights.

The week of August 22, 1933, was marked by near record rainfall in the area of Tucumcari, and the four inches of rain that fell on the evening of the 28th led to major flooding. At dawn the following morning, the Golden State Limited transcontinental passenger train plunged into a flooded arroyo five miles west of Tucumcari after the west span of a 100-foot steel bridge, built in 1914, collapsed from washed-out moorings.

An article in the *Abilene Daily Reporter* noted that, "The engine is under water at the deepest part of the ravine. The mail car is on top of the engine and the baggage car is at 45-degree angle to the track beside the mail car. The next car, a coach, is crossways of the creek bed partially on top of the baggage car and a Pullman tourist sleeper is crossways of the creek. All of these are on the south side of the fill."

The story continued: "On the north side is a club car in the bed of the creek along with a standard coach which is on its side. The head end of another standard coach, which is on its side. The head end of another standard coach is the only other car off the rails the remaining Pullman coaches remaining on the bridge."

In spite of washouts on Route 66, a flooded airfield at Tucumcari that grounded all flights, and sporadic communication caused by washed-out telegraph and telephone lines, ambulances from as far away as Amarillo were dispatched, and the railroad sent recovery equipment from El Paso and an emergency bridge-building crew from Cloudcroft. Citizens assisted passengers as they climbed from the arroyo, provided blankets and other supplies, and used their cars and trucks as impromptu ambulances.

Initial reports had six people confirmed dead (two more would die later from injuries), forty with severe injuries, forty-five with minor injuries, and an unknown number of people missing. As the dead and injured arrived in Tucumcari, the Randle Hotel served as triage center after the sixteen-bed hospital was overwhelmed. The Dunn Mortuary's owner appealed for embalmers from mortuaries in Las Vegas and Amarillo.

An inquiry later determined that the train had halted approximately one mile east of the bridge. After investigation by P. D. Cook, a bridge inspector for the Southern Pacific Railroad who would die in the accident, the train proceeded at a speed of twenty miles per hour. As the locomotive reached the western span, the weakened structure collapsed.

Film and Celebrity

Albuquerque

The Albuquerque Army Airbase served as a film location for numerous scenes in the 1943 motion picture *Bombardier* starring Pat O'Brian, Robert Ryan, Randolph Scott, and Eddie Albert. Additionally, the actor Jimmy Stewart served as an instructor at the base from mid-1942 until the fall of 1943.

The Desert Sands Motel, formerly the Desert Sands Motor Hotel, opened in October 1954 at 5000 East Central Avenue (Route 66). In the movie *No Country for Old Men*, this motel is shown as a motel in El Paso, Texas.

Demolished in June of 1972, the Franciscan Hotel at 6th Street and Central Avenue (Route 66) opened on December 15, 1923. Many leading bands during the big band era, including Harry James and Benny Goodman, performed in the ballroom. As a premier hotel in Albuquerque, many celebrities stayed here, including Clara Bow and John Wayne.

Established in 1960, the Sundowner Motel was one of dozens of similar properties along the Route 66 corridor (Central Avenue). However, it was here that Bill Gates and Paul Allen wrote a version of the programming language Basic for the Altair 8800 computer invented by MITS, an Albuquerque-based company, in 1975. The motel served as Gates and Allen's base camp during their stay in the city. The programming work served as the cornerstone for establishment of Microsoft. In 2013, the hotel was redeveloped to become the Sundowner Uhuru Apartment Complex for veterans, residents with special needs, and mixed-income residents.

The highly acclaimed AMC series *Breaking Bad* was set in Albuquerque and utilized a wide array of locations in the city for the filming, many along the Route 66 corridors of Central Avenue and 4th Street. A partial list of locations includes Twisters (4257 Isleta Boulevard SW), Denny's (2608 Central Avenue SE), Crossroads Motel (1001 Central Avenue NE), and Loyola's Family Restaurant (4500 Central Avenue SE).

Gallup

R. E. Griffith, a relative of movie mogul D. W. Griffith, established the Hotel El Rancho at 1000

The **El Rancho Motel** in **Gallup** has an extensive association with the film industry.

Among the many movies that have been filmed in the area of **Gallup** is 1965's *The Hallelujah Trail*.

East Highway 66 in the mid-1930s and presided over a gala opening on December 17, 1937. Promoted as the "World's Largest Ranch House," the hotel was built with a western colonial façade and frontier rustic interior. It became a luxurious outpost for film crews and actors in the 1940s, 1950s, and early 1960s during the production of eighteen major motion pictures in the area.

A precipitous decline in business coupled with a corresponding decline in maintenance that commenced in the late 1960s resulted in the property's closure in the 1980s.

Scheduled for demolition, the hotel was sold to Armand Ortega, owner of the largest and oldest Indian trading posts in the area. After extensive renovation, the hotel reopened and is currently a favored stop for Route 66 enthusiasts and movie buffs.

The renovated rooms maintain a period feel through use of authentic fixtures and limited intrusion of modern amenities. The lobby is adorned with autographed movie memorabilia, and the room doors are labeled with names of celebrities who frequented the hotel, including Kirk Douglas, Katherine Hepburn, Betty Hutton, Allan Ladd, Ronald Reagan, John Wayne, and Spencer Tracy.

With streets lined with architectural styles representing nearly a century of development and surrounded by quintessential western landscapes, Gallup and the surrounding area served as a filming location for many motion pictures and television programs. A brief listing includes: *The Great Divide* (1915), *Redskin* (1929), *Billy the Kid* (1930),

The Grapes of Wrath (1940), *Bad Men on Parade* (1941), *The Desert Song* (1943), *Pursued* (1947), *Ambush* (1950), *Rocky Mountain* (1950), *Sundown* (1950), *Ace in the Hole* (1951), *Escape from Fort Bravo* (1953), *Have Gun—Will Travel* (1957), *The Hallelujah Trail* (1965), *Superman* (1978), and *Natural Born Killers* (1994).

Grants

On March 22, 1958, a private twin-engine Lockheed Lodestar named *Lucky Liz* crashed and exploded on impact about twenty miles from Grants. The plane's owner, Mike Todd, producer of the 1956 film *Around the World in Eight Days* was killed in the crash. Also killed were author and screenwriter Art Cohn, pilot Bill Verner, and co-pilot Tom Barclay.

In an odd and fortuitous twist of fate, Todd's wife, Elizabeth Taylor, was scheduled to travel with him but had declined at the last minute due to a severe head cold. Kirk Douglas, a close friend also declined due to a sudden change in plans.

The **Isleta Pueblo** was the setting for an early movie shot by Thomas Edison's film company in 1898. *Joe Sonderman*

Isleta Pueblo

With a copyright date of February 24, 1898, *Indian Day School* is the earliest known film shot in New Mexico. The short feature produced by Thomas Edison contains numerous scenes of Isleta Pueblo and the school located there at that time.

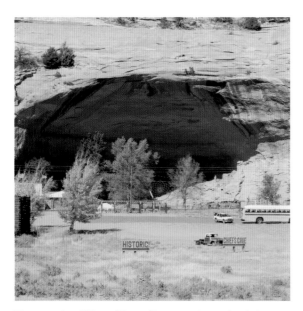

The scenic cliffs at **Manuelito** served as a backdrop for 1951's *Ace in the Hole. Judy Hinckley*

Manuelito

The stunning multi-colored rock walls along Route 66 between Manuelito and the Arizona border served as a backdrop for the movie *Ace in the Hole*, released in 1951. In addition to utilizing the still-existent trading post that is built in a natural pocket in the cliff face, the production company also built the most expansive site ever outside of a war film. Built at a cost of more than $30,000, the set towered 237 feet high and covered a 1,200-foot by 1,600-foot area. After completion of the film, the set, located behind the Lookout Post Trading Post, served as a draw for tourists.

Starring Kirk Douglas and directed by Billy Wilder, the movie debuted to mixed reviews resultant of its scathing portrayal of the media in the time of tragedy. It quickly faded into obscurity but is now a cult classic.

Rowe

Located a few miles from Rowe on the pre-1937 alignment of Route 66, the Forked Lightning Ranch has a colorful history with its connections to John Van Austin, a.k.a. Tex Austin, who established the ranch in 1925 after purchasing sections of the Pecos Pueblo Grant. The historic Kozlowski Stage Stop and Tavern, on the old Santa Fe Trail, was included in the purchase.

Austin, originally from St. Louis, reinvented himself with stories of a childhood on a cattle ranch in Victoria, Texas, working on ranches in New Mexico and Texas, and involvement in the Mexican Revolution.

In the years that followed, he produced the first indoor rodeo in Wichita, Kansas, in 1918; the first rodeo held in Madison Square Garden in New York City in 1922; and the first rodeo in London at Wembley Stadium in 1924.

Shortly after establishing the Forked Lightning Ranch, Austin advertised the property as a dude ranch, promoting it as "the most complete, modern and comfortable ranch house in the West." He initially targeted the East Coast market, and guests arrived at Rowe by train or by automobile on U.S. 66. The dude ranch operated through 1933. Heavily mortgaged and in debt, Austin sold the property and opened the Los Rancheros Restaurant in the historic plaza district of Santa Fe.

In October 1938, Tex committed suicide. He was inducted into the National Cowboy Hall of Fame in 1976.

The ranch changed owners several times in the 1930s before it was acquired by E. E. "Buddy" Fogelson, a Dallas-based oil tycoon and rancher. In 1949, Fogelson married actress Greer Garson, and the ranch house built by Austin became a renowned center for elaborate parties featuring leading businessmen and Hollywood celebrities.

Upon Fogelson's death in 1987, his wife and son divided the Forked Lightning Ranch. In January 1991, Mrs. Fogelson sold her section, including the historic ranch house, to the Conservation Fund, which in turn donated it to the National Park Service for inclusion in the Pecos National Historical Park.

Santa Fe

The Palace of the Governors housed the offices of the governors for the territory of New Mexico. Lew Wallace, governor from 1877 to 1881, penned the now-classic novel *Ben Hur: A Tale of the Christ* here in a room he described as having "the threatening downward curvature of a shipmate's cutlass."

The historic downtown section of the city along the Route 66 corridor appears in numerous scenes in "A Skill for Hunting," episode number 26 of the television program *Route 66*. Episode 25, "The

Newborn," and episode 27, "Trap at Cordova," also contain scenes filmed in Santa Fe.

The historic plaza appears in the 1989 film *Twins* starring Arnold Schwarzenegger and Danny DeVito. In a restaurant on the plaza, Tom Laughlin as Billy Jack, in the movie of the same name produced in 1971, defends Mexican school-children from an attack.

The La Fonda Hotel, located on the southeast corner of the plaza, appears in the 1991 film *White Sands*. The movie starred William Dafoe and Mickey Rourke.

Tucumcari

Tucumcari has served as a setting for or been referred to in numerous films and television programs as well as in many songs.

The television program *Rawhide* (1959–1966), starring Clint Eastwood, featured many onsite locations around Tucumcari and Tucumcari Mountain. Tucumcari-area locations appear in another Eastwood production, Sergio Leone's 1965 film, *For a Few Dollars More*, which utilized some of the same locations as *Rawhide*.

A scene in the classic film *Two Lane Blacktop*, produced in 1971 and starring James Taylor, Dennis Wilson, and Warren Oates, was filmed at a service station on U.S. 54 in Tucumcari. The landmark Tucumcari Mountain appears in the background.

In a scene in the 1967 film version of Truman Capote's *In Cold Blood*, one of the killers asks about the distance to Tucumcari. A similar reference is made in the 1988 film *Rain Man*.

Villa de Cubero

Villa de Cubero near Cubero, New Mexico, is a now-defunct auto court with a still-functioning store that has links to celebrities and, reportedly, to an American literary classic.

The original trading post operated by Wallace and Mary Gunn was located in Cubero along the National Old Trails Highway (Route 66 after 1926). With realignment of the highway in 1937, the Gunns established a new trading post, which included an auto court, at the junction of the old and new alignments west of town.

Stunning landscapes that served as a backdrop for the weathered adobe ruins in ancient Cubero,

VILLA DE CUBERO DE LUXE TOURIST COURTS

57 MILES WEST OF ALBUQUERQUE – 83 MILES EAST OF GALLUP, NEW MEXICO, ON U. S. HIGHWAY 66

Villa de Cubero was a quiet refuge for numerous celebrities. *Mike Ward*

and a peaceful bucolic setting within easy driving distance of Gallup, made Villa de Cubero a destination for a wide array of Hollywood productions, and a favored hideaway during the postwar years. The guest list includes Bruce Cabot, Sylvia Sydney, the Von Trapp family, and J. Robert Oppenheimer, who often came here to relax and escape the pressures of work at Los Alamos.

Actress Vivian Vance, a costar on the television show *I Love Lucy*, owned a ranch nearby, and Desi and Lucy Arnaz were thus also regular guests. Reports are that Lucy Arnaz, nee Ball, used the facility as a haven during her divorce from Desi.

Ernest Hemmingway chose Villa de Cubero as a quiet refuge. Purportedly, he stayed here for two weeks while working on *The Old Man and the Sea*.

Villa de Cubero today provides little to suggest it was a haven for the rich and famous.

Transitional Sites

Albuquerque

At this intersection in **Albuquerque**, the pre- and post-1937 alignments of Route 66 cross. *Judy Hinckley*

Glenrio to Endee

Now a graded gravel county road, this pre-1955 segment of Route 66 parallels the abandoned rail bed of the CRI&P Railroad, as well as the earliest alignment of Route 66 that followed the course of the Ozark Trail network. Four bridges of historical significance on this segment date to 1930. Though they received repairs and upgrades in the years that followed, including the replacement of timber supports in the 1940s, they are among the last creosote-treated bridge spans on Route 66 in the state of New Mexico.

La Bajada Hill

Two alignments of Route 66 scale the escarpment of La Bajada, one utilized for a short period in 1926 that was also the course of the National Old Trails Highway, and a second utilized between 1926 and 1932. Improved for use by automobiles in 1909 and again in 1911, the portion of the National Old Trails Highway included segments of roadway first built in 1640 as the Camino Real de Tierra Adenerto.

A special "Good Roads" section in the *Santa Fe New Mexican* published on January 27, 1911, noted that, "Construction work was begun in November, 1909, and the road built from La Bajada to Algodones, a distance of 19.5 miles. At La Bajada Hill was found the hardest work on the road and for the most part of this distance was solid lava rock. This work was done by a force of convicts from the Penitentiary and by Cochiti Indians. The Good Roads Commission was assisted by the Indian Service to the extent of $1,000.00 used to hire Indians to work on the hill."

The improvements included widening the roadway and building stone curbs at the corners of the twenty-three switchbacks that allowed drivers to make the climb of 800 feet in 1.6 miles. Emily Post, in 1916's *By Motor to the Golden Gate*, wrote, "The best commentary on the road between Santa Fe and Albuquerque is that it took us less than three hours to make the sixty-six miles, whereas the seventy-three from Las Vegas to Santa Fe took us nearly six. The Bajada Hill, which for days Celia and I dreaded so much that we did not dare speak of it for fear of making E.M. nervous, was magnificently built. There is no difficulty in going down it, even in a very long car that has to back and fill at corner; there are low stone curbs at bad elbows and the turns are all well banked so that you feel no tendency to plunge off. A medium car with a good wheel cut under would run down the dread La Bajada as easily as through the driveways of a park!"

The **La Bajada Hill** was a formidable obstacle for early motorists.

The **Rio Puerco Bridge** allowed realignment to bypass the Isleta loop.

Rio Puerco Bridge

The 250-foot Rio Puerco Bridge, located west of Albuquerque at the bottom of Nine Mile Hill, is one of the longest single-span steel truss bridges in New Mexico. Funded largely with federal monies, the bridge was completed in 1934 but wasn't officially designated as part of U.S. 66 until 1937.

Completion of the bridge bypassed the original alignment of the highway and the course of the National Old Trails Highway that had looped south from Albuquerque along the Rio Grande River and through the historic lands of the Isleta Pueblo before turning north following the course of the railroad. It was built as a joint project between the Kansas City Structural Steel Company and F. D. Shufflebarger. The bridge utilized a Parker truss design and had a 25-foot wide deck of concrete and asphalt resting on steel stringers.

In 1957, the bridge underwent extensive modification, including giving higher clearance at the top by using recalibrated strut geometry. Guardrails also were added to protect the supporting truss members. With completion of I-40, the bridge served as the Rio Puerco crossing for a frontage road, Route 66. Bypassed by the New Mexico State Highway and Transportation Department with completion of a new bridge in 1999, the original bridge serves as a pedestrian crossing and is listed on the National Register of Historic Places.

A large mural painted by Doug and Sharon Quarles on the side of **Lowe's Supermarket** in **Tucumcari.** © *iStock.com/NoDerog*

NEW MEXICO

Crime and Disaster

Film and Celebrity

Transitional Sites

Villa de Cubero then (top) and now (bottom). *Page 151*

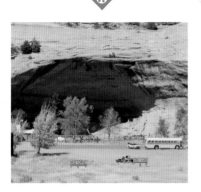

The scenic cliffs at **Manuelito**. *Page 150*

The **El Rancho Motel** in **Gallup**. *Page 148*

The **KiMo Theater** in **Albuque**... site of a fatal explosion. *Page*

491 **66** Iyanbito

Gallup

Defiance
Manuelito
40
Lupton

Coolidge
Thoreau
Prewitt

Blue Water
Milan
Grants
40
Lava
McCartys
San Fidel

Villa de Cubero
Cubero
Paraje
New Laguna
Laguna

Correo
Mesita
Rio Puerco
Sandia

Pre-1937 routing of Route 66

Albuquerque

Bernalillo
66

Carnuel
Tijeras

Armijo
Parajito
Los Padillas

Isleta Pueblo
Bosque Farm
Peralta
Valencia

25

SEE HOW THE WEST WAS *FUN!*

THE MIRISCH CORPORATION presents

BURT LANCASTER LEE REMICK
JIM HUTTON PAMELA TIFFIN

JOHN STURGES'
THE HALLELUJAH TRAIL

DONALD PLEASENCE BRIAN KEITH

Many movies have been filmed in the area of **Gallup**, including *The Hallelujah Trail*. *Page 149*

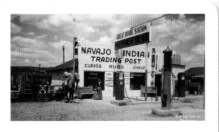

The trading posts at **Continental Divide**. *Page 144*

The **Rio Puerco Bridge**. *Page 153*

Trading Post
e 132

The **El Rey Inn** in **Santa Fe**. *Page 139*

The plaza in **Santa Fe**. *Page 135*

Romeroville. *Page 134*

The **Blue Swallow Motel** in **Tucumcari**. *Page 140*

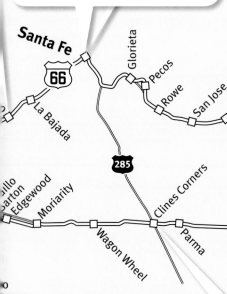

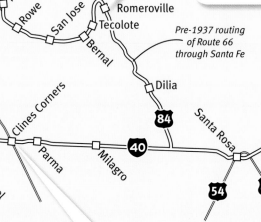

Pre-1937 routing
of Route 66
through Santa Fe

Santa Fe

Tucumcari

Glorieta
Pecos
Rowe
San Jose
Bernal
Tecolote
Romeroville
Dilia
Santa Rosa
Cuervo
Newkirk
Montoya
Palomas
San Jon
Bard
Endee

La Bajada
Edgewood
Moriarity
Clines Corners
Parma
Wagon Wheel
Milagro

25
84
40
54
84
285
54
66

ugustin de la Isleta Mission
ueblo. *Page 133*

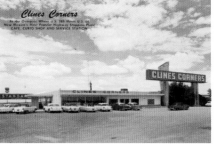

The **Clines Corners** complex. *Page 138*

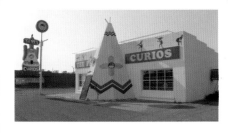

Tepee Curios in **Tucumcari**. *Page 140*

NEW MEXICO

 Pre-1926 Historic Sites

 Landmarks

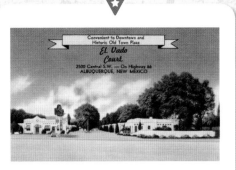

The **El Vado Court** in **Albuquerque**. *Page 136*

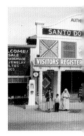

The **Santo Dom** in **Glorieta Pas**

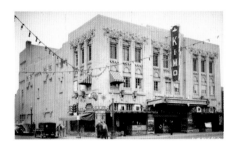

The now-restored **KiMo Theater** in **Albuquerque**. *Page 137*

The **Hiway House** in **Albuquerque**. *Page 137*

 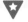

The former **Jones Motor Compan** in **Albuquerque**. *Page 137*

Pre-1937 routing of Route 66

The **Richardson Trading Post** in **Gallup**. *Page 139*

The Village of **Acoma**. *Page 130*

The former garrison town of **Cubero**. *Page 131*

The in

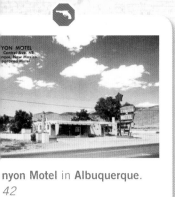

nyon Motel in **Albuquerque**.
42

The treacherous **La Bajada Hill**.
Page 146, 152

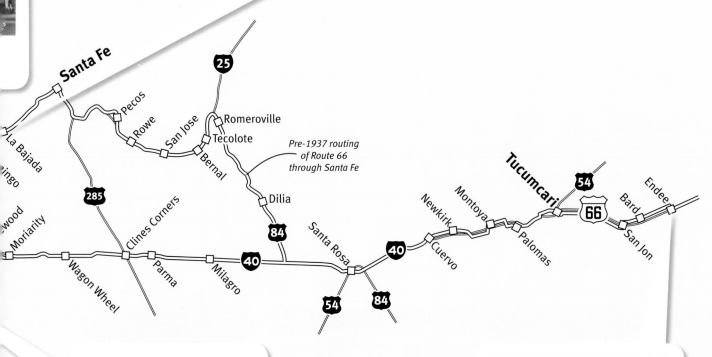

Santa Fe

Pecos
Rowe
San Jose
Romeroville
Tecolote
Bernal

25

Pre-1937 routing of Route 66 through Santa Fe

La Bajada

285

Dilia

84

Clines Corners

Moriarity

Wagon Wheel
Parma
Milagro

40

Santa Rosa

54 **84**

Cuervo

40

Newkirk
Montoya
Palomas

Tucumcari

54

66

Endee
Bard
San Jon

The meeting of the pre- and post-1937 alignments of Route 66 in **Albuquerque**. *Page 152*

One of the locations in **Endee** with links to crime. *Page 144*

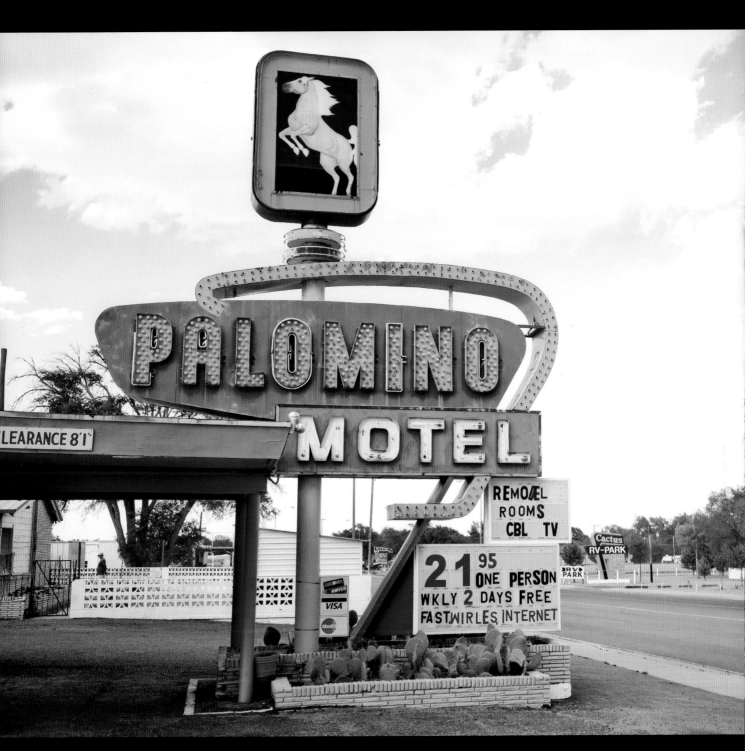

The **Palomino Motel** in **Tucumari** has long been serving travelers along the Mother Road. *Andrey Bayda/Shutterstock*

Expression Photo/Shutterstock

ROUTE 66

Arizona

Pre-1926 Historic Sites

Ash Fork

For Native Americans traversing a trade route that connected the coast of California with Hopi villages and the Zuni Pueblo, Spanish and early American explorers, and survey parties of the Army Corps of Topographical Engineers in the 1850s, the confluence of the three tributaries of Ash Creek served as a key oasis. Establishment of the community of Ash Fork at the site dates to 1882 and the development of a water stop and railroad siding by the Atlantic & Pacific Railroad.

In March 1895, completion of the 136-mile rail line from Ash Fork to Phoenix through Prescott garnered international headlines. Most Arizona historians consider completion of this railroad to be the end of the frontier era in the territory.

In 1897, civil engineer Francis Bainbridge, an employee with the Atchison, Topeka & Santa Fe Railroad, initiated construction of a dam in Johnson Canyon, three miles west of Ash Fork along a roadway that would become the National Old Trails Highway after 1913 and Route 66 between 1926 and 1932. Built in segments by the Wisconsin Bridge and Iron Company, it was the world's first large steel dam, and one of only three built in the United States. The 184-foot-wide, 46-foot-high over-top dam (no spillway) was completed on March 5, 1898. Listed on the National Register of Historic Places in 1976 and named an Arizona Historic Civil Engineering Monument in the same year, this dam remains the last extant example of this type of construction in the United States.

Canyon Diablo

Canyon Diablo, located approximately twenty-five miles west of Winslow, presented a formidable obstacle to initial pioneering and survey expeditions. Lieutenant Whipple bestowed the name on the canyon during his historic 1853 expedition. On December 14 of that year, Whipple arrived at the eastern rim of the canyon and

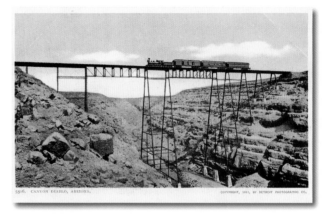

Canyon Diablo presented a major obstacle to railroad engineers in the nineteenth century. *Joe Sonderman*

noted, "we were all surprised to find at our feet, in magnesian limestone, a chasm probably one hundred feet in depth, the sides precipitous, and about three hundred feet across at the top."

Railroad engineers working to bridge the chasm in 1881 discovered that Whipple's estimate of the canyon's depth was off by 150 feet.

The cost of bridging the canyon by the Atlantic & Pacific Railroad nearly bankrupted the company in 1882. However, the bridge proved to be an economic boon for northeastern Arizona and, subsequently, the company.

Crozier Canyon Ranch

With the establishment of a campground at the site on Beale Wagon Road in the 1870s, the Crozier Canyon Ranch remains one of the oldest extant ranches in northwestern Arizona. Named for territorial legislator Sam Crozier, who bought the property in 1880, the main ranch house was built in 1887 of redwood framing and decorated throughout with hickory and red cedar imported from Tennessee by rail.

After 1913, the National Old Trails Highway followed the wagon road that coursed directly in front of the ranch house. To capitalize on the increasing flow of tourist traffic, the owners of the property, the Grounds family, retained Ed Carrow to construct a resort complex in the late 1910s.

A large spring-fed swimming pool with bathhouse and picnic grounds served as the cornerstone of the resort. In addition to providing a respite for travelers, it was a popular Sunday destination for special excursion trains from

With origins that trace back to the 1870s, **Crozier Canyon Ranch** is one of the oldest ranches in the state. The 7-V Ranch Resort attracted travelers here during the 1930s. *Steve Rider*

Kingman by area residents. Actor Andy Devine purportedly worked at the bathhouse.

Shortly after construction commenced, the Grounds family negotiated an arrangement with the railroad. In exchange for the right-of-way for an improved rail line, the family could dismantle abandoned trestles, bridges, and abutments that made extensive use of cut stone. These materials served as the components for the completion of a restaurant, gas station, and garage during the 1920s and early 1930s.

In addition, shortly after certification of U.S. 66 in 1926, eight two-room cabins built on the opposite side of Crozier Creek rounded out the complex promoted as the 7-V Ranch Resort. The resort remained a popular one for travelers, and served as a bus station, until 1937.

In that year, a torrential rainstorm devastated much of the Route 66 infrastructure in the canyon and decimated a large portion of the complex. The resultant realignment of the highway to its current position negated reconstruction of the resort.

Now private property, the Crozier Canyon Ranch retains numerous components of the resort. This includes the cabins that served as bunkhouses into the 1980s, the swimming pool, the ranch house, and a portion of the restaurant and bus station converted into a private residence.

Flagstaff

Located on the grounds of the Museum of Northern Arizona just off Milton Road (Route 66), a two-story log house built by pioneer Thomas F. McMillan in the mid-1880s is the oldest home in Flagstaff. It is now utilized as offices for museum staff.

As a historical footnote, on an 1878 survey, McMillan's homestead here at Old Town Spring appears as Flagstaff Ranch. This is the oldest and first official reference to the Flagstaff name for this community.

In **Hackberry**, the last two-room schoolhouse in Arizona closed in 1990. *Judy Hinckley*

Hackberry

The springs located near the site of the current ghost town of Hackberry served as a rest stop during the expeditions of Father Francisco Garces in 1776. It was given the name Gardiner Springs by Lieutenant Edward Beale during his topographical expeditions in the 1850s. Establishment of a silver mine at the site in the 1870s led to the founding of the town of Hackberry.

Coupled with the development of other mines in the immediate area, the establishment of ranches, and completion of the Atlantic & Pacific Railroad to this site in 1881, the mining camp was transformed into a prosperous community. Indicative of this is the fact that the territorial legislature considered naming Hackberry the Mohave County seat.

The town's decline was hastened by the exhaustion of profitable ore bodies, the financial panic of the 1890s that decimated silver prices, and the establishment of Kingman as a key trading and supply center. Only establishment of the National Old Trails Highway in 1913, Route 66 after 1926, and area ranching provided Hackberry with a sustained if tenuous existence.

Two landmarks of particular historic interest are the cemetery established in the 1870s and the well-preserved mission style schoolhouse. Closed in 1990, this was the last active two-room school in the state of Arizona.

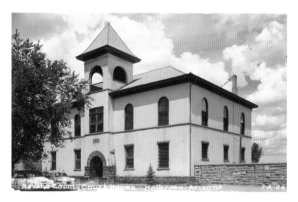

The historic courthouse in **Holbrook** now houses a fascinating museum. *Joe Sonderman*

Holbrook

The old Navajo County Courthouse, built in 1898, now serves as a museum preserving the area's rich history, including its association with Route 66. The courthouse figured prominently in a scandal that led to a reprimand from President William McKinley as well as from Arizona territorial governor Nathan Oakes Murphy.

In 1899, Sheriff Frank Wattron sent an ornate invitation to the hanging of George Smiley on the courthouse grounds: "George Smiley, Murderer. His soul will be swung into eternity on December 8, 1899 at 2 o'clock P.M., sharp. The latest improved methods of scientific strangulation will be employed and everything possible will be done to make the surroundings cheerful and the execution a success."

The outcry over the invitations led the governor to issue a thirty-day stay of execution. With less fanfare, the hanging, as per court order, occurred on January 8, 1900.

Little Meadows

The first European references to the springs at Little Meadows in the Black Mountains of western Arizona dates to the expeditions of Father Francisco Garces in 1776. The springs served

The forlorn ruins of Ed's Camp mark the oasis of **Little Meadows**.

as an important staging area during the years of American exploration in the 1850s and, with establishment of the Beale Wagon Road during the same period, as an oasis. Following establishment of the National Old Trails Highway in 1912, the springs served as a campground for travelers as well as a place for engines and brakes to cool after climbing the steep grades of Sitgreaves Pass.

Shortly before certification of Route 66 in November 1926, Lowell "Ed" Edgerton established a rudimentary tourist camp on this site. With the increase in traffic during the 1930s and establishment of the camp as a stop for the pioneering Pickwick Stages bus company, Edgerton expanded the camp to include a café, cabins, campground, store, and gas station. The 1952 realignment of Route 66 bypassed the Sitgreaves Pass segment and led to the closure of the tourist camp.

Edgerton continued to live on the property until his death in 1978. The trailer camp he established in about 1960 is still operated by his family.

Navajo

Initial settlement at the site of Navajo, Arizona, commenced with the establishment of a railroad siding and trading post utilizing the name Navajo Springs (truncated to Navajo for faster telegraphy) by the Atchison, Topeka & Santa Fe Railroad in 1883. Navajo Springs, located three miles south of the site, played a pivotal role in Arizona history.

A stipulation in the federal designation of the Arizona territory required completion of oaths of office before the end of calendar year 1863 within the territory. As the springs were the first point at

which members of the military escort and territorial government officials were certain of being within the boundaries of the new territory, the inauguration ceremony of Governor John Noble took place here on December 29, 1863.

The hotel on Main Street in **Oatman** is the oldest adobe structure in Mohave County. *Steve Rider*

Oatman

The Durlin Hotel, built in 1902, is the oldest commercial structure remaining in Oatman and the oldest and largest adobe structure in Mohave County. It was listed on the National Register of Historic Places in 1983. The eight-room hotel, with a saloon and barbershop offset from the lobby, operated through 1952. It was also known as the Ox Yoke Inn for a time and was renamed the Oatman Hotel in about 1968.

Legend has it that during the hotel's early history, miners would sign and leave dollars at the bar to ensure they had credit for drinks between paydays. This tradition has continued with tens of thousands of dollars being left by tourists and stapled to the bar's walls and ceiling.

Seligman

An array of historically significant structures remain in Seligman's commercial business district along the Route 66 corridor on Railroad Avenue, Main Street, Chino Street, and Havasu Street. These include the Pitts General Merchandise Store that housed the post office (1903), Pioneer Hall and Theater (1905), Seligman Garage (1905), and Seligman Pool Hall (1923).

The **Aubrey Valley** west of **Seligman** is named after Francois Xavier Aubrey, pioneering explorer.

Sitgreaves Pass

Named for Captain Lorenzo Sitgreaves, who crossed through the Black Mountains during his explorations in 1851, Sitgreaves Pass is located on the pre-1952 alignment of Route 66, also the course of the National Old Trails Highway from 1913 to 1926. Brigadier General Amiel Whipple detailed the pass in a book published about his expedition to the area in 1853, *Explorations and Surveys for a Railroad Route from the Mississippi River to the Pacific Ocean*. Lieutenant Edward Fitzgerald Beale also utilized this pass during the survey expedition to create the Beale Wagon Road in 1857, a venture best remembered for its use of camels.

As a historical footnote, the pass bearing his name was not the one used by Sitgreaves. His expedition actually utilized Union Pass several miles to the north.

The stunning vistas of **Sitgreaves Pass** were seen by several American explorers during the 1850s.

Truxton

The **Beale** expeditions of the 1850s charted the future course of Route 66.

Valentine

The two-story red brick schoolhouse near Valentine, built in 1903, is one of the last surviving structures of the Truxton Canon Training School, an Indian boarding school managed by the United States Office of Indian Affairs, now the Bureau of Indian Affairs. Devised to assimilate Hualapai, and later the Apache, Havasupai, Hopi, Navajo, Pima, Tohono O'odham, and Yavapai tribes, into mainstream American society, the school focused on teaching fundamental Western subjects and industrial arts.

Construction of the complex commenced in 1900 utilizing bricks manufactured on site by students under the tutelage of the industrial teachers. Additional materials arrived by rail, as there was a siding on the main line of the Santa Fe Railroad immediately to the south of the site.

The school was the third building constructed on the site, the first two being a large student dormitory and a teacher's home. As the complex evolved, a superintendent's office, detention house, laundry facility, heating plant, infirmary, cottages for faculty, reservoir, and dairy barn were built utilizing the locally produced red brick or wood framing delivered from mills near Flagstaff.

The school remained in operation through 1937, and most campus buildings, including the dormitory, were razed in 1960, with some of the bricks recycled for the construction of the Mohave Museum of History & Arts in Kingman. The Bureau of Indian Affairs, Truxton Canyon Agency now has offices on this site, located along Route 66. The massive two-story school, listed in the National Register of Historic Places in 2003, is the largest remaining building from the complex. Also remaining are several of the former staff houses, which now house employees of the Bureau of Indian Affairs, and the red brick structure that served as the post office and boarding school offices.

A pre-Columbian time capsule is preserved in **Walnut Canyon** near **Winona**.

Walnut Canyon

Located approximately one mile south of the post-1947 alignment of Route 66 (accessed via exit 204 on I-40), Walnut Canyon National Monument preserves the vast remnants of the Sinagua Indian villages built under the cliffs and in pockets in the walls of Walnut Canyon approximately 850 years ago.

Williams

Scattered throughout the business district on Route 66 in Williams are a number of notable historic structures that predate certification of that highway. The Fray Marcos de Niza opened in 1908 as a Fred Harvey complex, replacing an earlier hotel built in 1901. Its primary function was to serve passengers that traveled to the Grand Canyon on the Santa Fe Railroad spur line. It remained operational until 1954, and after an extensive renovation, it reopened as the depot for the Grand Canyon Railway in 1989.

The Grand Canyon Hotel, located at 145 West Route 66, dates to 1891. It is noted in the classic Route 66 guidebook written by Jack Rittenhouse in 1946 and is listed as recommended lodging in the fifteenth edition of the *Route 66 Dining & Lodging Guide*, published by the National Historic Route 66 Federation.

The Red Garter Bed and Bakery at 137 West Railroad Avenue is housed in a building constructed in 1897 by August Tetzlaff. A tailor shop, saloon, and brothel initially operated in the building. Various businesses operated from the building in the ensuing years, but the saloon remained as a constant enterprise. A liquor-fueled altercation in 1941 ended in murder, however, and the saloon closed shortly thereafter.

COPPER STATE COURT, ASH FORK, ARIZONA X721

The **Copper State Modern Cottages** are among the oldest operating auto courts on Route 66 in Arizona. *Joe Sonderman*

Ash Fork

Established in 1928 by Ezell Nelson, the Copper State Modern Cottages were a family-operated business until 1975. The historic motel retains much of its original architectural integrity, and as of 2013, it served as a weekly rental apartment complex.

Canyon Padre Trading Post

Located to the east of Winona, the Canyon Padre Trading Post opened in late 1948 or early 1949. Initially this complex consisted of a service station, store, and small ten-stool café housed in a prefabricated Valentine Manufacturing Company diner. William and Jean Troxel transformed the property and renamed it Twin Arrows Trading Post after acquiring it in 1954.

The most notable additions were the two giant arrows out front, manufactured from discarded telephone poles. The Twin Arrows Trading Post was one of six trading posts along Route 66 between Winona and Winslow from the 1950s through the 1990s.

It stayed in business until the early 1990s. As of spring 2013, Twin Arrows remained empty and

TOP: The **Fray Marcos Hotel** links railroad and Route 66 history. *Joe Sonderman*

BOTTOM: A bloody murder in the 1940s resulted in closure of the saloon at the **Red Garter**.

The **Canyon Padre Trading Post** opened in the late 1940s as a service station, café, and store.

faced an uncertain future, even though the Hopi tribe announced plans to renovate it and opened the Twin Arrows Casino directly to the north.

Cool Springs

Framed by stunning western landscapes, the Cool Springs Camp was built by N. R. Dunton in 1927 and provided travelers on Route 66 with a wide array of amenities as the complex evolved through the 1940s. Initially the property consisted of simply a gas station and a couple of rustic cabins with water piped from nearby Warm Springs Canyon.

After buying the property in 1936, James and Mary Walker expanded Cool Springs into a full-service facility with restaurant and bar, cabins, garage, and filling station. Business slumped with the realignment of Route 66 in 1952 that bypassed

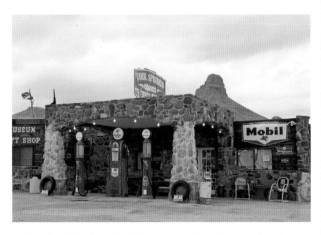

The **Cool Springs** building, located on the pre-1952 alignment of Route 66, is a photographer's paradise.

Cool Springs and the Sitgreaves Pass, but the complex remained open until 1964. Fire gutted the structure in 1966, leaving a stone shell. The ruins served as the framework for a movie set used in the 1991 film *Universal Soldier*.

In 2002, Illinois-based developer Ned Leutchner acquired the property and commenced reconstruction with surviving original stonework. He also introduced a trail to the mesa top that offers stunning views of the property and the Sacramento Valley. With the resurgent interest in Route 66, Cool Springs, now a gift shop and museum, is a destination for enthusiasts of the legendary road from throughout the world.

Flagstaff

Du Beau's Motel Inn was opened by Albert Du Beau in 1929. Purportedly, it was the first motel in Arizona to offer garages as well as steam heat and fresh sheets for each room upon rental. Located at the intersection of Beaver and Phoenix Avenues, the motel received consistent recommendation in AAA travel guides during the 1940s and 1950s. As of 2013, it remained an operational motel under the name Du Beau International Hostel.

The El Pueblo Motor Inn in Flagstaff, now an apartment complex, dates to 1936. The original proprietor, Phillip Johnson, was the son of missionaries to the Navajo Indians who established the Presbyterian Mission at Leuppe, Arizona.

After the attack on Pearl Harbor in December 1941, Johnson contacted Marine Corps Signal Officer Major James E. Jones and proposed developing Native American language speakers for coded combat communications, resulting in the now-legendary Navajo Code Talker program.

Now operating as a Super 8 hotel, the Flamingo Motor Hotel first opened at 602 West Highway 66 in 1954. It was one of several properties along Route 66 in the Flamingo chain.

The restaurant now known as Granny's Closet first opened in 1960 as the Paul Bunyan Café and later became the Lumberjack Café. As a promotional gimmick, the owners of the café purchased an oversized fiberglass lumberjack from International Fiberglass to display in front of the restaurant. International Fiberglass utilized the molds for the lumberjack to make specialty statues for restaurants, oil companies, trading posts,

EL PUEBLO MOTOR COURT, FLAGSTAFF, ARIZONA

The **El Pueblo Motor Court** in **Flagstaff** was founded by Phillip Johnston, who would later develop the Navajo code talkers program. *Mike Ward*

and tire companies. Regardless of the guise, the statues all shared a common characteristic: one palm up and one palm down. Known today by the generic "muffler men" moniker, the statues became a mainstay of roadside promotion during the 1960s. Interestingly, the company offered the statues with a variety of accessories but never mufflers. The Lumberjack Café statue now stands at the Walkup Skydome at Northern Arizona University.

Located at 3406 East Santa Fe Avenue (Route 66), the Starlite Lanes opened on November 9, 1957. It is the longest continuously operated bowling alley on the Route 66 corridor in Arizona.

The Galaxy Diner at 931 West Route 66 was established in 1952 and has survived into the modern era with a blending of classic diner styling and the romanticized image of the 1950s malt shop.

The Museum Club, a classic roadhouse on the east side of Flagstaff along Route 66 (Santa Fe Avenue), opened originally as the home, offices, workshop, and showroom for taxidermist Dean Eldredge on June 20, 1931. After Eldredge's death in 1936, Doc Williams bought the two-story log structure, liquidated most of the collection of animals, removed the Dean Eldredge Museum and Taxidermist signage, and converted it into a bar and dance hall.

In 1960, Don Scott, a former member of the band the Texas Playboys, purchased the facility and transformed it into a honky-tonk. Two years after his wife, Thorna, died from injuries sustained in a fall down the stairs, Scott committed suicide.

Though urban growth has erased the original rural setting, the Museum Club appears almost unchanged from its appearance in postcards from the 1930s. It remains a popular nightspot.

The Western Hills Motel at 1580 East Santa Fe Avenue opened in 1953 with Harold Melville as the proprietor. The current animated neon sign, the oldest in Flagstaff, was installed in 1955 shortly after the facility was acquired by Charles O. Greening.

The 66 Motel, which originally opened as 66 Court at 2100 East Santa Fe Avenue, has links to an obscure chapter in Route 66 history. Myron Wells, the original proprietor, served two terms as president of the Arizona chapter of the Route 66 Association and then formed the No By-Pass Committee to fight the city's bypass with the construction of I-40.

The **Galaxy Diner** in **Flagstaff** has been a roadside mainstay for more than sixty years. *Judy Hinckley*

The **Dean Eldredge Museum and Taxidermist** later became the **Museum Club** and was once owned by Don Scott of the Texas Playboys. *Steve Rider*

Dating to 1953, the **Western Hills Motel** in **Flagstaff** is a highway time capsule. *Mike Ward*

The **Motel Downtowner's sign** has dominated the **Flagstaff** skyline for decades.

The property now occupied by Miz Zip's at 2924 East Santa Fe Avenue has a history that includes a motel, service station, and Trixie's Diner. After purchasing the facility in 1942, Joe and Lila Lockwood, her sons Howard and Bob Leonard, and Bob's wife, Norma, decided to rename the motel and planned to call the café Let's Eat. Bob's uncle reportedly quipped that they needed a zippier name.

Initially promoted as the "Motel with the VIEW," the Wonderland Motel opened in 1956 at 2000 East Santa Fe Avenue with Waldo and Adelyne Spelta as proprietors. As of 2013, it remained in operation.

The twenty-two-unit Skyline Motel was established in 1948 at 1526 East Santa Fe Avenue and

The origins of **Miz Zip's** in **Flagstaff** predate World War II. *Judy Hinckley*

operates today as the Red Rose Inn Motel. Expansion to the current twenty-eight-room complex did not alter most original architectural elements.

Flagstaff's recently refurbished railroad depot dates to 1926, the year of U.S. 66 certification. It currently houses the Flagstaff Visitor Center and serves as an Amtrak station.

The Grand Canyon Café at 110 East Santa Fe Avenue opened in 1938. The original proprietor, Eddie Wong, and his brother, Albert, who joined as a partner in 1940, refurbished and expanded the restaurant in 1950. The restaurant retains most of the architectural changes made during that expansion.

Khatter Joseph Nackard, a leading businessman in Flagstaff, built the Downtowner Auto Court on Beaver Street (the pre-1934 alignment of Route 66) one block south of Santa Fe Avenue in 1929. The motel was expanded in 1933 with the elimination of between-room garages to increase the number of rooms, and the name was changed to Nackard Inn. Further expansion and renovation occurred in 1952.

With upgrades and the acquisition of the property by new owners in 1959, it became the Downtowner Motel. At this time, a towering promotional sign topped with neon lettering ensured travelers on Route 66, Santa Fe Avenue, did not overlook the complex. As of 2013, the facility operated as an apartment complex. The promotional tower of 1959, complete with "$5.00" signage, remained standing.

Grand Canyon Caverns

The Grand Canyon Caverns located east of Peach Springs is a roadside attraction that captures the essence of the Route 66 experience during the 1950s and, as a result, is now a popular destination for enthusiasts. After a period of decline that commenced with the bypass of this segment of Route 66 in 1978, the property now blends the romanticized vision of a classic attraction with modern amenities.

Walter Peck discovered the caverns' entrance in 1927, one year after certification of Route 66. To profit from the flow of tourists passing by on Route 66, he installed a winch and bucket system to lower visitors into the cave, and initiated promotion under the name Yampai Caverns.

A wooden staircase and electric lighting were installed in 1936, and new owners expanded on promotional efforts utilizing the name Coconino Caverns. In the following decade, the primary improvements included the development of an extensive trail system in the caverns.

The immediate postwar years were ones of dramatic transition at the caverns. With increasing tensions and apprehension over the Cold War, the Civil Defense Department designated the caverns a fallout shelter and stocked it with foodstuffs and other materials. Also during this period, installation of an elevator and colorful promotional material developed using the name Dinosaur Caverns, a loose reference to a mummified prehistoric ground sloth discovered during cavern development, fueled a dramatic increase in visitation.

The whimsical **Grand Canyon Caverns** has been a destination for tourists since the 1920s. *Judy Hinckley (photo), Steve Rider (brochure)*

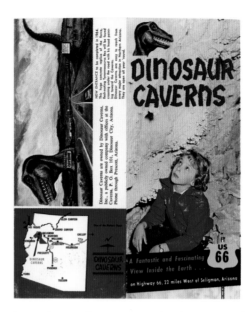

The **Grand Canyon Caverns** attraction has operated under various names during its history. *Steve Rider*

In 1962, the caverns' name changed to Grand Canyon Caverns and the facility underwent an expansion that included a modern café and gift shop at the caverns' entrance, and a motel and service station at the highway junction. Today these amenities are refurbished to present the circa 1962 appearance, and in addition, there is a riding stable, available Jeep tour of the surrounding area, and a unique motel room in the cavern itself.

Hackberry

Construction of the Hackberry General Store dates to realignment of Route 66 in 1937 and the subsequent bypass of Hackberry. The store and service station remained operational until the early 1980s.

Iconic Route 66 artist Bob Waldmire acquired the property a few years later and established a visitor center that included a biodiversity center with nature trails. The current owners, the Pritchard family, have transformed the entire complex to capture the essence of a classic roadside stop.

Currently the Hackberry General Store is one of the most photographed sites on Route 66. Additionally, it has served as a backdrop for a wide array of promotional filming.

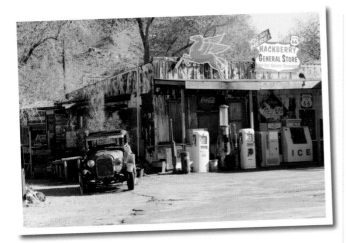

The **Hackberry General Store** as it appeared circa the 1950s.

Holbrook

"Doc" Hatfield established the Geronimo Trading Post along Route 66 five miles west of Holbrook in about 1950. In direct correlation to the increase in traffic flow, he expanded the facility throughout the decade. Carl Kempton acquired it in 1967 and continued operations in the original buildings until 1974, at which time he built a larger, more modern complex. From its inception, the primary attraction was, and is, the "World's Largest Petrified Log," weighing an estimated 89,000 pounds.

The construction of I-40 and subsequent bypass of Route 66 decimated business along this scenic corridor. The Geronimo Trading Post is unique in that it survived into the modern era and is now a landmark for enthusiasts.

The Wigwam Motel at 811 West Hopi Drive is a roadside landmark that has gained in popularity during the era of resurgent interest in Route 66. Chester Lewis opened the motel, Wigwam Village No. 6, on June 1, 1950. Lewis and his family operated the motel into 1974. After closure, it remained vacant until 1988, when, having been renovated by Lewis' children, the motel reopened. It serves as a time capsule of roadside lodging circa 1955.

Frank Redford had plans for various configurations before construction of the first Wigwam Village at Horse Cave, Kentucky. After acquisition of a patent, Redford sold building plans with payment derived through the receipt of monies from pay radios installed in the rooms. Eventually seven Wigwam Village complexes were built, two on Route 66.

Indicative of the iconic status of these motels was their inclusion in the animated film *Cars* released in 2006. In this movie, the motel appears as the Cozy Cone.

Currently operating as the Globetrotter Lodge at 902 West Hopi Drive is the motel that opened in about 1955 as the Whiting Brothers Deluxe Motel, the first diversification from service stations into motels by the Whiting Brothers Oil Company. In the mid-1960s the property sold to Al and Helene Frycek who operated the facility under the Sun N' Sand Motel name until its closure in 2001.

The Sea Shell Motel at 612 West Hopi Drive established in late 1954 was part of a chain that included properties in Lordsburg, New Mexico,

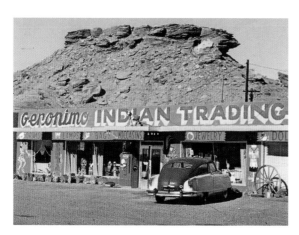

The **Geronimo Trading Post** outside **Holbrook** is a Route 66 time capsule in Arizona. *Joe Sonderman*

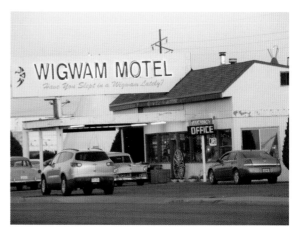

The **Wigwam Motel** in **Holbrook** dates to 1950. *Judy Hinckley*

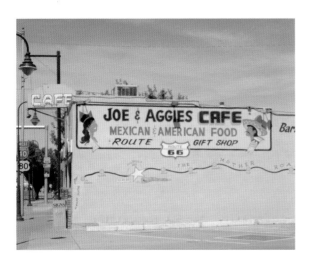

Joe and Aggie Montano relocated their **Holbrook** café to this location in 1965. *Judy Hinckley*

The **Jack Rabbit Trading Post** is a highway survivor dating to 1949. *Joe Sonderman*

The simple but distinctive signage for the **Jack Rabbit Trading Post** has become iconic.

as well as in Safford and Gila Bend, Arizona, and Blythe, California. The Whiting Brothers Oil Company acquired the property in 1958; the motel operated as Whiting Brothers Motor Hotel. Most recently, it was operating as an Economy Inn.

Joseph City

Located just west of Joseph City, the Jack Rabbit Trading Post is an original Route 66 business that has survived into the modern era and is now a revered icon. The date of origination for the trading post is a matter of conjecture, but indications are that in 1948 the Arizona Herpetorium operated in a former Santa Fe Railroad building (the building that now houses the Jack Rabbit Trading Post) at this site. In 1949, Jack Taylor purchased the property, refurbished the building, and then to differentiate his business from others along Route 66 in eastern Arizona, he lined the roof with wooden silhouettes of hopping jack rabbits painted black.

In a partnership with Wayne Troutner, owner of the For Men Only Store in Winslow, Taylor initiated an innovative and highly successful promotional campaign. As far east as Springfield, Missouri, they posted signage and billboards with two simple images, one was the silhouette of a curvaceous cowgirl to promote Troutner's store and the other was that of a jackrabbit.

For Taylor, the final sign located a few hundred yards from the trading post contained the black silhouettes of rabbits along the top, a large black

rabbit against a yellow background, and large red letters that spelled out Here It Is.

The trading post continues to operate as it has for more than sixty years even though the roadside sign campaign was suspended, and a few miles to the west, Route 66 is truncated by I-40.

Kingman

The former Desert Power and Water Company building built in 1907 is the oldest reinforced concrete structure in Arizona. Before completion of Boulder Dam (now Hoover Dam), this pioneering company supplied electrical power for Kingman

and surrounding communities from this location. From the date of its closure in 1938 until 1997, the building served an array of uses, including as a storage facility for Citizens Utilities transformers. It was extensively renovated in 1997, and today the building houses the Kingman Area Chamber of Commerce, the Powerhouse Visitor Center, a Route 66 museum operated by the Mohave Museum of History & Arts, and the gift shop for the Route 66 Association of Arizona.

Mr. D'z Route 66 Diner appears like a caricature, a romanticized image of the classic Route 66 restaurant from the 1950s. In actuality, it is a roadside original.

The Kimo Café opened in late 1938 as one-half of a complex that included a service station. With exception of the enclosed garage and pump island that are now a part of the restaurant, the building appears as it did in photographs from 1940.

The White Rock Court built in 1935 remains as the oldest auto court in Kingman. Built by Conrad Minka, a Russian immigrant and miner, of locally quarried volcanic tufa stone, the complex remains virtually unchanged. A unique attribute of the property's construction is hand-dug tunnels connecting the fifteen-unit complex with the two-story owner's home that served as utility corridors. These tunnels connected to an airshaft with a tank of water at the bottom and burlap sheeting that served as wicks to produce an evaporative cooling effect.

The Arcadia Motel, originally the Arcadia Court, opened in 1938 at the bottom of El Trovatore Hill. Promoted as having the "finest appointments for

The **powerhouse** in **Kingman** now houses an award-winning Route 66 museum. *Judy Hinckley*

The **historic powerhouse** in **Kingman** now houses the chamber of commerce and visitor center. *Judy Hinckley*

the fastidious guest" in a wide array of publications, including the 1940 edition of the *AAA Directory of Motor Courts and Cottages*, the motel offered the latest in modern amenities, such as air conditioning.

A concerted effort by owners to ensure the motel remained relevant and prosperous resulted in numerous transitional developments through the 1960s. These included the addition of a second story that transformed the complex from fifteen units to forty-seven, and the addition of a swimming pool.

The El Trovatore Motel built in 1939 is a Route 66 landmark that is directly associated with the development of Las Vegas, Nevada. John F. Miller, who also built the Nevada Hotel on the corner of Fremont Street and 1st Street in that city in 1906, built the El Trovatore Motel.

At the time of its construction, the El Trovatore Motel and resort complex, built on a rocky bluff that provided expansive views of the Hualapai Mountains, was located in the unincorporated community of El Trovatore immediately to the east of Kingman. The motel provided a wide array of modern amenities including full laundry facilities, a restaurant, and after 1950, a swimming pool.

With the transformation of Route 66 into a four-lane corridor that cut through El Trovatore Hill in the 1950s, elimination of the north side of the enclosed complex occurred. With establishment of newer motels in the 1970s, and the bypass of

The recently restored **El Trovatore tower** is a **Kingman** landmark. *Judy Hinckley*

Route 66 by I-40 in the same decade, the motel became a weekly or monthly apartment complex.

After a brief closure in 2010, it was renovated utilizing many original architectural elements. In March of 2012, the signature 60-foot tower on a rocky knoll at the rear of the complex, with large neon letters spelling out the name of the motel, was relit for the first time in more than fifty years.

In the era of resurgent interest in Route 66, the Hilltop Motel at 1901 East Andy Devine Avenue with its recently refurbished neon signage is

a favored photo stop as well as lodging choice for enthusiasts. The twenty-eight-unit complex opened in 1954 with advertisement that proclaimed "The Best View in Kingman," and today it looks virtually unchanged from postcard photos of the 1950s.

Meteor Crater

As one of the best-preserved meteor craters in the world, Meteor Crater, located along the National Old Trails Highway (later Route 66) west of Winslow, was ideally suited for development of tourism related activities.

Joseph Sharber capitalized on the attraction with the establishment of a service station at the junction of Route 66 and the road to the crater in 1938. With acquisition of the property by Jack Newsum in 1941, a trading post transformed the facility into an attraction.

Promoted as Meteor City, the roadside sign listed a population of one. When Jack married in 1946, the modified sign indicated a population of two.

Jack Rittenhouse, in 1946, noted that Meteor City consisted of "one building, offering gas, groceries, and curios." The trading post remained in operation until 1962 when a fire decimated the complex.

A new Meteor City Trading Post opened on the site in 1979. After a fire destroyed this trading post, a third that utilized a geodesic dome opened on the site. As of 2013, the facility is closed.

In 1938, Henry Locke established the Meteor Crater Observatory, a carefully crafted stone

The **El Trovatore Motel**. *Judy Hinckley*

AERIAL VIEW OF METEOR CRATER

Showing Road to Observation Point on the Crater's Rim

19 miles WWest of Winslow Arizona

E-4200

The largest **meteor-impact crater** on earth is a Route 66 landmark. *Joe Sonderman*

The **Painted Desert Trading Post** ruins are the Holy Grail for Route 66 adventurers. *Steve Rider*

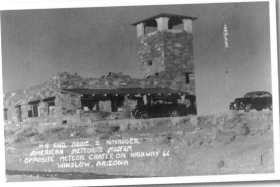

TOP: The original **Meteor City Trading Post** opened in 1938. *Judy Hinckley*

ABOVE: In 1946, Dr. Harvey Nininger transformed the **Meteor Crater Observatory** into a stellar attraction. *Joe Sonderman*

structure that included a three-story observation tower. In addition to a souvenir shop, the building also housed an impressive mineralogical display.

Dr. Harvey Nininger acquired the property in 1946 and opened the American Meteorite Museum on October 19. With a collection of more than 5,000 meteorites, it served as an acclaimed research center that attracted an estimated 33,000 visitors in the first year of operation. It closed in 1953 after realignment of Route 66 in 1949 bypassed the facility. Picturesque ruins atop a rocky red knoll remain to mark the site.

At the crater itself, a museum building that houses a gift shop, snack bar, interactive museum, and observation platform perches on the crater. This facility remains a popular attraction in northern Arizona.

Painted Desert Trading Post

Marooned on a segment of Route 66 bypassed in the 1950s, the picturesque ruins of the Painted Desert Trading Post framed by stunning western landscapes are an unlikely landmark. However, even though they are difficult to reach and are located on private property that requires acquisition of permission from the owners, the ruins rate high on the list of favorite photo locations on Route 66.

Established on a rocky knoll above the Dead River Bridge shortly before American involvement in World War II, the Painted Desert Trading Post remained a remote roadside attraction until its closure in 1957. Indicative of this is the fact the trading post never had a telephone, running water, or electricity, which necessitated the use of battery-operated gasoline pumps.

The trading post's remote but scenic location was a key component in transforming an obscure tragedy into a national news story. In April 1947, Alma Shelnutt was traveling to Pasadena, California, with her husband when she collapsed at the trading post from heart failure, but it was more than an hour before medical help arrived. As a result, she died at the trading post.

Parks

The Parks general store, located on the pre-1941 alignment of Route 66 that also served as the course of the National Old Trails Highway, opened in November 1921 at the junction with the Grand Canyon road. Operating today as Parks in the Pines General Store, it retains aspects of

The store in **Parks** met the needs of travelers on the **National Old Trails Highway**.

The **Querino Canyon Bridge** dates to the bypass of late 1930.

the original building incorporated into the 1940s remodeling.

Peach Springs

Built in 1928 to replace the small wood frame trading post operated by Ancel Taylor and E. H. Carpenter that opened in 1917, the Peach Springs Trading Post, currently used as the office of the Hualapai Tribal Forestry Department, retains most of its original exterior architectural attributes. These include the stone façade with vigas and chimneys.

Listed on the National Register of Historic Places in 2003, the facility continued to serve as a trading post and store selling traditional Hualapai handicrafts until 1972. It also housed the post office until 1965.

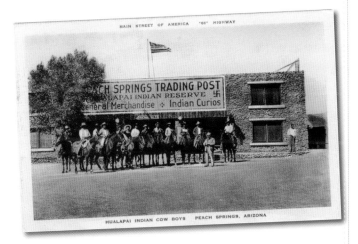

The trading post in **Peach Springs** now houses the tribal forestry offices. *Steve Rider*

Querino Canyon

Before realignment of Route 66 in the early 1950s, Querino Canyon had two points of interest for travelers. One was the Querino Canyon Trading Post that opened in about 1939 but is no longer in existence. The second was the 269-foot Querino Canyon Bridge, built in 1930, with its stunning canyon scenery. The bridge remains accessible on a section of former Route 66, now a gravel road, between exit 346 and exit 341 on I-40.

Seligman

Ethel Rutherford, the former proprietor of the Qumacho Café in Peach Springs and later an Arizona state representative, established the Copper Cart restaurant in Seligman in 1950. The recently refurbished property is where Angel Delgadillo called the formative meeting for the Historic Route 66 Association, the first of its kind after the highway's decertification, in February of 1987.

The Court De Luxe, currently operating as the De Luxe Inn, was built in 1932 and remains as the oldest continuously operated motel in Seligman. The motel has a long history of providing simple, quality lodging, as evidenced by inclusion in AAA guidebooks from 1940, 1946, and 1955, and in the sixteenth edition of the *Route 66 Dining & Lodging Guide* published by the National Historic Route 66 Federation in 2013.

The Seligman Sundries building built in 1904 has housed a wide array of businesses including a theater, trading post, drug store, and dance hall. Extensive renovation, including installation of a vintage soda fountain, has transformed the

TOP: The **Copper Cart** is a cornerstone of the Route 66 renaissance in Seligman. *Joe Sonderman*

ABOVE: The oldest operating motel in **Seligman**, the **Court De Luxe** opened in 1932. *Mike Ward*

business into a popular attraction for travelers on Route 66.

Established in 1952, the Supai Motel at 134 East Chino Avenue (Route 66) takes its name from the Havasupai Indians and the nearby village of Supai that serves as the administration center for the tribal reservation. Recently renovated, including the original neon signage, the motel is popular with Route 66 enthusiasts.

The most famous location in Seligman, and quite possibly anywhere on Route 66, is the barbershop

The **Copper Cart** in **Seligman** is a roadside landmark from the 1950s.

Angel Delgadillo's barbershop in **Seligman** may be the most popular destination on Route 66, and Angel is the most famous person on Route 66. *Judy Hinckley*

of Angel Delgadillo housed in the same building as the Route 66 Gift Shop and Visitors Center. Delgadillo is credited for the birth of the Route 66 renaissance, initiated the establishment of the Historic Route 66 Association of Arizona, and is the highway's most famous spokesman.

Delgadillo established his barbershop in this building along Route 66 in 1972. It consistently receives ratings from Route 66 tour groups and enthusiasts as the number-one destination on this storied highway.

Immediately to the east, in 1953, Angel's brother Juan established the Snow Cap Drive In. Built from materials discarded by the Santa Fe Railroad, the Snow Cap Drive In is an icon among Route 66 enthusiasts. Juan remained as the proprietor until his death in June 2004. His family currently manages the restaurant.

Truxton

Alice Wright established the nine-unit Frontier Motel and adjoining restaurant in Truxton in 1952. The well-maintained complex evokes an earlier time, in part thanks to the refurbishment of the signage with funds and grants from the National Park Service Route 66 Corridor Management Program and the Route 66 Association of Arizona. The Frontier Motel remained in business until 2011, and in the fall of 2013, rally driver Sam Murray of New Zealand purchased the complex. He plans to reopen it as a Route 66 resort.

Two Guns

TOP: **Two Guns** is a landmark with National Old Trails Highway origins. *Steve Rider*

ABOVE: The ruins of **Two Guns** remain a favored photo stop for enthusiasts.

Williams

With its origins as a tent-camp along the National Old Trails Highway, the Del Sue Motel in Williams is the oldest continuously operated motel in this community. Recently renovated, the motel located at 234 East Bill Williams Avenue currently operates under the Grand Motel name.

Operating as an EconoLodge since 2011, the El Coronado Motel opened on Route 66 across from Rod's Steakhouse in the early 1950s. During the mid to late 1950s, the motel owner initiated an innovative promotional campaign offering special day rates for those who planned to cross the western deserts at night.

Rod's Steak House established by Rodney Graves opened on August 23, 1946. Graves, one of the founders of the Bill Williams Mountain Men and organizer of the city's first rodeo, operated the facility through 1967. The restaurant

In Williams, Rod's Steakhouse is a landmark that dates to 1946. *Judy Hinckley*

with its signature neon framed cow is a popular stop for Route 66 enthusiasts.

Numerous vintage motels are in business along Route 66 in Williams. However, few retain original names. An exception would be the El Rancho Motel that opened in 1958.

The complex currently operating as the Mountainside Inn opened in 1957 as the Thunderbird Inn. The motel complex, currently operating as the Rodeway Inn & Suites at 201 East Bill Williams Avenue, opened originally as the Mount Williams Motor Court.

The Royal American Inn at 134 East Bill Williams Avenue opened as the Bethel's Tourist Court. The Historic Route 66 Inn at 128 Bill Williams Inn dates to acquisition and expansion of a cottage camp by D. A. Hosack and Myrtle Smart

Tragedy struck the historic **Highlander Motel** in **Williams** with the suicide of the owners in 2013. *Joe Sonderman*

in 1946, and the opening of Hull's Motel Inn.

Currently operating as the Best Value Inn at 1001 West Highway 66 is the former Norris Motel that opened in 1953. The Westerner Motel, 530 West Bill Williams Avenue, and Highlander Motel, 533 West Route 66, are of similar vintage.

Winona

Immortalized in the now classic song about Route 66 penned by Bobby Troup, Winona is little more than a garage and service station. It is the only community named in the song that is mentioned out of order; all of the others are in sequence as they appear on the highway from east to west.

The origins of the community are as a railroad siding and logging camp named Walnut, established in 1882. The name change to Winona occurred in 1886.

By 1912, the camp had morphed into an actual community with diversified growth fueled by establishment of the National Old Trails Highway in 1913. The establishment of Route 66 kept it vibrant through the early 1930s.

Realignment of Route 66 necessitated relocation of businesses to the current site, and near abandonment of the original community. In

The most recorded song in history, which debuted in 1946, includes reference to the small community of **Winona**, Arizona.

1946, Jack Rittenhouse, author of a now classic guide to Route 66, noted that Winona consisted of a trading post, gas station, grocery store, and a few cabins.

Winslow

Located at 1113 West 3rd Street (Route 66), the Falcon restaurant opened on July 9, 1955. The founders, Jim, George, and Pete Kretsedemas, Greek immigrants, managed the property for forty-three years. The National Historic Route 66 Federation gave the restaurant a favorable recommendation in the sixteenth edition of the *Route 66 Dining & Lodging Guide*.

At the intersection of 2nd Street (Route 66) and Kinsley, the Standin' on the Corner Park rates as one of the most popular photo stops on Route 66. A wall from the former J. C. Penney building is the canvas for a stunning trompe l'oeil mural created by Ron Adamson that serves as the backdrop. The addition of a bronze sculpture by John Pugh, a massive Route 66 shield in the intersection, and a vintage red Ford flatbed truck complete the park that allowed the city of Winslow to capitalize on a line in the song "Take it Easy," recorded by the Eagles in 1973, and to transform the historic district.

The motel currently operating as Earl's Motor Court at 512 East 3rd Street, and promoted with advertising that reads, "Sleeping on the corner in Winslow, Arizona," opened in the late 1940s as the Marble Motel. The motel appears as it did after completion of renovation and expansion in 1952, and remains as the oldest existent Route 66 motel in the city.

Designed by acclaimed architect Mary Colter, the La Posada built in 1929, and listed in the National Register of Historic Places in 1992, reflects the quality and attention to detail that made the Fred Harvey Company "Harvey House" properties legendary. With completion of restoration to original appearances that commenced in 1997, the hotel and restaurant is now a favored location by Route 66 enthusiasts as well as other travelers in northern Arizona.

Originally, to present the illusion that the complex was an aging Spanish colonial estate, Colter used a modified Mission Revival for the façades, and focused on details throughout the building as well as in the landscaping to enhance the

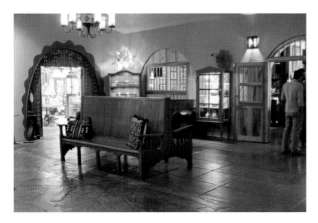

The fully refurbished **La Posada** is a primary attraction in **Winslow**.

perception of antiquity. This included use of red terra cotta tiles for roofing, exposed rough-hewn beams, flagstone floors, stucco and adobe walls, sand-blasted planks for doors and shutters, and wrought iron railings.

Embracing the landscaped gardens were re-created weathered adobe ruins and walls. The utilization of stone for enhancements such as a wishing well completed the picture.

The economic devastation of the Great Depression and the decline in passenger rail travel during the postwar era prevented the property from attaining the profitable status originally envisioned. Still, it remained as the premier luxury hotel in the Winslow area into the 1950s, and warranted

The **La Posada** is a favored stop for railroad enthusiasts. Its courtyard of the La Posada was designed to mimic an historic Spanish ranch.

AAA recommendation in 1954. The AAA's *Western Accommodations Directory* published that year noted that the La Posada was "an attractive Spanish style hotel. Large guest rooms have baths or toilets. Suites with living room, $25. Radios available. Lunchroom and bar."

After closure of the restaurant in 1956, and the hotel in 1959, the Santa Fe Railroad transformed the facility into an office complex. After three decades, the railroad consolidated offices, closed the La Posada, and scheduled it for demolition.

Yucca

In the early 1960s, a group of investors formed a land development corporation and launched Lake Havasu Estates. For promotional purposes, the company placed large colorful billboards along the highway, and built a 40-foot-diameter, 3,400-square-foot geodesic dome on a tubular support that from a distance appeared to be a massive golf ball.

The Dinesphere was to serve as the centerpiece for the planned community. However, construction of the large dome proved to be the only aspect that came to fruition, and the restaurant never opened.

The distinctive dome remained empty until 1981. Hank and Ardell Schimmel who owned numerous business enterprises in Wyoming purchased the structure in 1981, and transformed it into a three-level home with access via the exterior staircase.

A real-estate boondoggle created this landmark along Route 66 in **Yucca**.

Parks

The **Havasu National Wildlife Refuge** area was a welcome oasis for early travelers.

Havasu National Wildlife Refuge

Located along the pre-1952 alignment of Route 66, the Havasu National Wildlife Refuge preserves thirty miles of Colorado River marsh and shoreline. The refuge provides habitat for several hundred species of birds, desert bighorn sheep, fox, and other wildlife. It marks the last remaining natural portion of the lower Colorado River. The expedition journals of Father Garces in 1776 and of Captain Lorenzo Sitgreaves in 1851 contain notations about the marsh and Topock Gorge.

Kingman

The Atchison, Topeka & Santa Fe Railroad engine No. 3759 dominates Locomotive Park, located on the former rodeo grounds that also served as a ballpark across from the Powerhouse Visitor Center. This specially designed "mountain type" locomotive was built by the Baldwin Locomotive Works in 1927. Listed on the National Register of Historic Places, the locomotive is of the 4-8-4 configuration.

Initially built as a coal-fired steam engine, its conversion for use with diesel fuel occurred in 1941. The railroad retired the locomotive from active service in 1953 after having completed more the 2,500,000 miles, and as it was the last

RIGHT: The pre-1952 alignment in **Sitgreaves Pass** provides beautiful views.

BELOW: **Kingman's** association with Route 66 is proclaimed in the park across from the **Powerhouse**.

steam-powered locomotive to travel the line through Kingman, donated it to the city in 1957.

The locomotive became the centerpiece of the newly built park. In 1987, the railroad donated caboose No. 999520 for inclusion in the park.

At the west end of the park, many monuments have been added since the park's inception. One is a veterans' memorial, another commemorates the survey and road construction expeditions of Lt. Edward Beale in the 1850s, and the last celebrates Route 66 and the city's founding in 1882.

Petrified Forest National Park

In addition to preserving the world's largest concentration of petrified wood and preserving the unique Painted Desert ecosystem, Petrified Forest National Park is the only national park to include a segment of historic Route 66. A lodging complex associated with the highway is preserved and utilized as the Painted Desert Visitor Center.

Situated on a knoll that provides panoramic views of the Painted Desert, the Painted Desert

The stunning landscape of the **Painted Desert** adorns **Petrified Forest National Park**, which is also the only national park that contains a segment of Route 66.

Inn predates Route 66 by two years as it opened as the Stone Tree House in 1924. Built by Herbert Lore with extensive use of petrified wood, it was modified to reflect the current Pueblo Revival style after its acquisition by the federal government in 1936.

The Fred Harvey Company managed the hotel and restaurant from 1940 to 1942, and provided hospitality services to travelers on Route 66, to visitors to the Painted Desert, and to tourists traveling on the Santa Fe Railroad. Because of wartime restrictions, the inn closed in 1942.

In 1947, the inn reopened after Fred Harvey's acclaimed architect and interior designer Mary Jane Colter renovated the property. These renovations included the addition of larger windows to capitalize on the stunning views, murals by acclaimed Hopi artist Fred Kabotie, and an

The historic **Painted Desert Inn** now serves as a visitor center and museum in **Petrified Forest National Park**.
Joe Sonderman

enormous skylight consisting of multiple panes of translucent glass hand painted with traditional Hopi designs.

The inn operated, and served as the park's visitor center, through 1963. With completion of a new visitor center, the inn languished until 1975. Public intervention, and inclusion of the property in the National Register of Historic Places in 1976, resulted in a stay of demolition.

The inn reopened in 2006 after being restored to a circa 1949 appearance. It now serves as a museum and bookstore for the park.

Winslow

With completion of the I-40 bypass in 1977, the central business district in Winslow entered a period of precipitous decline. To reverse this trend the nonprofit Standin' On the Corner Foundation formed in 1994.

The initial project was to provide assistance in the acquisition of funds through matching grants and loans for the acquisition and refurbishment of the La Posada, a former hotel and restaurant in the Fred Harvey Company chain. Completion of this project served as a cornerstone for further development.

At a meeting held on May 29, 1997, the board for the foundation met with fourteen business and community leaders to discuss creation and development of a park in the central historic

A song served as the inspiration for transforming this corner in **Winslow**, Arizona.

district. The meeting decided that only items mentioned in the 1973 Eagles song "Take It Easy" would be included in the park.

Winslow architect Loren Sadler joined the committee and drafted plans as well as permit and construction-related documents. Commissioned for the artistic elements of the proposed park were trompe l'oeil artist John Pugh and sculptor Ron Adamson.

Dedicated on September 10, 1999, the Standin' On The Corner Park marked the dawn of a new era in the historic district in Winslow. The park, and the La Posada, is a favorite photo stop for Route 66 enthusiasts.

After World War II, the **Kingman Army Airfield** served as a storage depot.

Military

Bellemont

The Department of Defense selected Bellemont as a suitable site for establishing a munitions storage facility because of its remote location and easy access to the key transportation corridors of Route 66 and the mainline of the Santa Fe Railroad in northern Arizona. During World War II, the Navajo Ordnance Depot was utilized for supplying the Pacific Theater of Operations and was the largest facility of this type in the nation.

Kingman

The former Kingman Army Airfield, now the Kingman airport and industrial park, officially opened on May 27, 1942. However, initial operations had commenced the previous year utilizing the former TAT airfield established in 1929.

Originally designed as an Army Air Force Flexible Gunnery School to train crews of B-17 and B-24 heavy bombers air-to-ground and air-to-air gunnery skills, the training programs were expanded shortly after activation of the first class in August 1942. These included classes for Women Air Service Pilots (WASP).

Through special arrangement with Warner Brothers Studios and the Department of Defense,

Bugs Bunny became the official mascot for the airfield. The base's location along Route 66, as well on a major east–west rail line, and the airport itself, allowed for regular USO tour visits.

On January 7, 1944, a freight train at the airfield entrance struck a bus transporting cadets from night training exercises at the gunnery range located on the north side of Route 66. The death toll of twenty-seven made this the worst bus and train collision in Arizona to date.

Deactivation of the airfield occurred on February 25, 1946. After this date the base, then designated Storage Depot 41, was utilized for the storage and dismantling of aircraft.

By 1947, the facility housed the largest concentration of military aircraft in the world. More than 5,600 aircraft, mostly heavy bombers, were liquidated through the wholesale of complete

Silent remnants from the **Kingman Army Airfield** still line Route 66.

Numerous monuments commemorate the tragedies associated with the former airfield.

units or as scrap metals before closure of the storage depot on July 1, 1948.

Most of the base buildings were dismantled or sold at auction with closure of the facility and transference of the property to Mohave County. A number of these repurposed buildings served a wide array of purposes throughout the area.

As of 2013, two large hangars, a former machine shop that serves as a temporary home for the Kingman Army Airfield Museum, and the control tower that shadows a memorial commemorating the bus and train collision, as well as a midair collision, are the primary tangible remnants from the World War II military facility.

Yucca

The Chrysler and Harley-Davidson test facility and proving grounds in Yucca along the post-1952 alignment initially was an auxiliary field for the Kingman Army Airfield during World War II. In June of 1943, expansion of the facility followed commission as Yucca Army Airfield.

On December 23, 1945, the Army Corps of Engineers assumed control of the base with its closure. Most buildings and other components sold at a series of auctions through 1947.

In late 1954, Ford Motor Company acquired the land and transformed it into a proving ground with the Thunderbird being one of the first vehicles evaluated at the site.

Crime and Disaster

Ash Fork

On December 30, 1921, the *Kingman Daily Miner* detailed the capture and death of Jake Wendell, member of a gang that had robbed several banks in Utah and had killed two Los Angeles police officers during an aborted bank robbery there. Wendell had been the only gang member to escape after that latter incident.

After stealing a second vehicle in Victorville, California, Wendell stopped in Daggett. There, an alert station attendant notified police in Barstow after witnessing Wendell's nervous demeanor and the arsenal in the back of the Ford coupe.

The police department in Barstow then sent telegrams to communities as far east as Flagstaff along the National Old Trails Highway. Upon receipt of such a telegram, Deputy Sheriff Mackey in Oatman notified Mohave County Sheriff Mahoney that a man and car matching the description of Wendell was seen driving east.

Mahoney notified law enforcement in Hackberry, Peach Springs, Seligman, and Ash Fork, as well as officers of the Santa Fe Railway. The following day, after receipt of confirmation that the suspect's vehicle had passed through Peach Springs early that morning, Mahoney boarded the eastbound number two train.

Upon arrival in Seligman, he received notification from the railroad that the Ford coupe was on the National Old Trails Highway near Pinu Veta station about seven miles west of Ash Fork. After securing permission from the railroad to have the train stop as per direction, Mahoney, accompanied by deputy Harris, deputy Plummer, and Santa Fe officer Frohamn, proceeded to the location.

A mile and a half east of the station they saw two men—a section foreman named McNeal and Jake Wendell—walking along the road next to the tracks. As Sheriff Mahoney approached the pair and announced his identity, Wendell darted for the nearby section house.

As the officers surrounded the house, according to testimony, three shots in rapid succession followed by a fourth a few seconds later were heard

from inside. According to the official investigation, the officers discovered Wendell on the floor bleeding profusely from the self-inflicted gunshots.

While awaiting a doctor from Ash Fork, Mahoney inquired about the Los Angles shooting. Wendell detailed the incident, named the gunman responsible, claimed he had been in the backseat of the getaway car at the time of the shooting, and signed a hurriedly written confession.

After administering first aid, the doctor recommended transporting the prisoner to Kingman. Wendell, placed on Santa Fe train number one, died shortly before arriving in Kingman.

Bellemont

On July 31, 1959, Ary J. Best, an elderly man suffering from advanced arthritis, stopped about twelve miles west of Flagstaff near Bellemont to lend assistance to Patrick McGee and Millie Fain, whose vehicle was disabled. Without provocation, McGee and Fain stabbed Best six times and stole his wallet and car.

The murderers proceeded to Williams, where witnesses later reported the couple spent the evening drinking, buying drinks for other bar patrons, and spending lavishly. The next morning McGee and Fain continued to California by train and were arrested shortly after their arrival in Los Angeles.

For her part in the murder, Fain received a life sentence, while McGee received the death penalty. He was executed in the gas chamber on March 8, 1963.

Chambers

In January 1962, a tragedy near Chambers co-incided with ongoing discussions between state and federal agencies about the need for funding to expedite completion of the interstate highway system in Arizona. Ruled a contributing factor in the death of six members of the Eugene Wildenstein family was the antiquated, narrow roadway that lacked a proper shoulder.

The seven-member family from El Centro, California, was returning home from a holiday spent with grandparents in Las Vegas, New Mexico. Only five-year-old Warren Wildenstein survived the head-on collision when a truck coming the other direction crossed the centerline.

Flagstaff

As traffic on Route 66 in Arizona escalated during the late 1920s, *The Arizona Republican* began using oversized boldface type in the body of its articles to indicate the annual number of fatalities when reporting accidents. It was part of the paper's campaign for road improvements within the state.

On October 7, 1930, the paper ran this story on the front page:

Neil Kuhn Dies, 11 injured in Auto Wrecks near Flagstaff – One person was fatally hurt, one was seriously injured, and 10 others were injured in automobile accidents near Flagstaff Sunday.

Neil Kuhn, a Winslow garage mechanic returning home, died in a Flagstaff hospital early today of injuries received last night when his automobile struck a tree while descending a mountain grade. It was the 140th fatality resulting from automobile accidents in Arizona since January 1.

Good Water

On December 1, 1953, Betty Faye Allen, her husband, Raymond Bruce Allen, and their ten-month-old son were relocating from Pennsylvania to California when they pulled their truck and trailer into the Good Water station west of Navajo for dinner at approximately 9:00 p.m. Afterwards they retired to their trailer with plans to continue on to Kingman the following morning.

Carl Folk, a man with a lengthy criminal history that included conviction of attempted rape while armed in 1930 and incarceration in the New Mexico State Insane Asylum in Las Vegas, New Mexico, after his conviction for rape in Albuquerque in 1949, had been following the family since encountering them at Clines Corners in New Mexico.

Several hours after the Allens parked at Good Water, Folk parked his car off the highway on a ranch road about 600 feet from the Allens' trailer and surprised the sleeping family. The armed intruder announced his intention was robbery, proceeded to tie the Allens up ankle to wrist, hitched the trailer to the pickup truck, and drove to the location where he had left his own car.

For the next several hours, Folk raped and

tortured Mrs. Allen and ransacked the trailer in search of money. At some point around 6:00 a.m., Mr. Allen, left in the desert, was able to free his feet, and stopped a truck on the highway.

Despite his extremely swollen hands resulting from loss of circulation, Allen returned to his truck, recovered a gun, and shot Folk as he exited the trailer. He then entered the trailer to find his wife dead from strangulation.

Carl Folk survived his wounds. In a unanimous decision by a jury on the charges of sexual assault and murder, he received the death penalty. His execution in the gas chamber of the Arizona State Penitentiary occurred on March 4, 1955.

Kingman

On October 20, 1926, Tom King, a Chinese immigrant and member of the Hop Sing Tong, was working in the kitchen of the American Kitchen restaurant located next to the Beale Hotel on what is now Andy Devine Avenue (Route 66) in Kingman. Five members of the Bing Kong Tong from California, B. W. L. Sam, Shew Chin, Jew Har, Gee King Long, and Wong Lung, burst through the rear door, opened fire, and killed Tom King instantly.

Mohave County Sheriff Mahoney and several deputies initiated an almost immediate pursuit of the Bing Kong Tong. The ensuing high-speed pursuit over the National Old Trails Highway (which became U.S. 66 after November 1926) culminated with the arrest of all five suspects near Topock.

Concern over Tong activity and retaliation resulted in the prisoners' transfer to Prescott for incarceration in the Yavapai County Jail. It also led Sheriff Mahoney to launch an unconstitutional investigation of Chinese residents in Kingman that included the confiscation of guns and deportation from the county, which in turn resulted in the filing of numerous lawsuits.

The trial that commenced in December of 1926 quickly became a media sensation. Fueling this was claims that more than twenty Chinese businessmen in Prescott belonged to the Hop Sing Tong, as did the disappearance of Don On, the only eyewitness to the Tom King murder.

The trial ended with a unanimous jury verdict of guilty on charges of first-degree murder for all five men and a sentence of death by hanging at the state prison in Florence. Lawyers in the employ of the Bing Kong Tong immediately filed an appeal with the state supreme court.

The Hop Sing Tong responded with a one million dollar retainer to hire attorney J. N. Young of Chicago, who assembled a legal team of Arizona attorneys that included E. Elmo Bollinger, a former judge with the Mohave County Superior Court; W. E. Patterson, Yavapai County Attorney; and John Sweeney, Assistant Yavapai County Attorney.

The Arizona Supreme Court upheld the conviction and death penalty sentencing. Then Frank Craig, a witness at the appeals trial, recanted his testimony, claiming that attorney Young had bribed him.

A flurry of appeals and legal filings with the court as well as the State Board of Pardons and Paroles merely served to postpone enforcement of the death penalty imposed at the original trial. Hours before the scheduled time for execution on June 23, 1928, Wong Lung's sentence was commuted to life imprisonment, since he was seventeen years old at the time of the King murder, but the other assassins were hanged.

On July 5, 1973, on a railroad siding along Route 66, a propane leak in a railroad car was ignited by a spark caused by a slipping wrench. Despite attempts to cool the car, which contained 33,000 gallons of propane, and control the fire, the boiling liquid expanded to cause a vapor explosion that formed a crater more than 10 feet deep, sent debris in a radius of more than 2,000 feet, and sent flames 200 feet into the air.

Three firemen died instantly and seventy people,

These ruins of the **American Kitchen** in **Kingman** are the site of the 1926 Bing Kong Tong assassination of restaurant employee Tom King.

In 1973, a massive propane explosion in **Kingman** closed Route 66 and decimated local infrastructure. *Steve Rider*

including motorists on Route 66, were severely injured. Two storage buildings at the feldspar mill and the offices of Doxol Suburban Gas Company, as well as two service stations, a beer warehouse, and a small supermarket, all vanished from the landscape, and numerous buildings were extensively damaged.

With Mohave County General Hospital overwhelmed, medical helicopters, as well as ones from the state game and fish office, the National Guard, highway patrol, and Nellis Air Force base, airlifted victims to Las Vegas and Phoenix. The Bureau of Land Management utilized slurry bombers to control the resultant range fires, and police rerouted Route 66 through neighborhoods to bypass the conflagration.

Oatman

On March 20, 1936, a kitchen fire quickly spread to neighboring buildings, engulfing in flames

The former lumber company building in **Oatman** remains as one of the few original structures.

an entire block of businesses along Route 66. The resulting closure of the highway created a massive traffic jam that stretched for more than twenty miles in both directions. The local fire department considered using dynamite to stem the spread of the conflagration.

The destruction of the Citizens Utilities Corporation offices and facilities resulted in the severance of telephone communication, and as the fire spread, electrical power was lost as well. Fire departments in Kingman and Needles provided assistance, but almost the entire west side of the Oatman business corridor was burned to the ground.

Padre Canyon

The *Arizona Republican*, October 1, 1930:

A plan to escape from officers resulted in tragedy for Martin Bowman, 20-year old Illinois youth and alleged auto thief. Attempting to escape, Bowman is believed to have caused the accident that may cause his death, physicians at Mercy hospital said tonight.

CANYON PADRE 24 MILES FROM FLAGSTAFF, ARIZ.

Martin Bowman's ill-fated escape attempt on October 1, 1930, occurred here. *Steve Rider*

While handcuffed to Deputy Harry Cagle, Bowman attempted to leap from the car and caused Sheriff H. O. Coldren to crash into the Canyon Padre Bridge, thirty miles east of here [Flagstaff]. Bowman went hurtling through the windshield as the car struck the bridge and is suffering from severe head injuries and loss of blood.

Officers escaped with lesser injuries, although Sheriff Coldren is suffering from two broken ribs and bruises. Bowman was being returned from Daggett, California to Marshall, Illinois to face charges of stealing the auto the officers were returning. He had attempted several previous escape attempts since starting on the journey, officers said.

Peach Springs

Peach Springs has a direct link to a milestone in Arizona crime history: Fleming Parker, the last man hanged on Prescott's courthouse square. Tragically, Parker could have easily avoided the harsh penalty had he awaited trial rather than attempting to escape.

Parker was a cowboy known throughout northern Arizona for his skill with horses, and his fondness for alcohol. After several of his horses were killed by a passenger train, and the railroad offered anemic compensation, Parker retaliated by robbing a train at Peach Springs.

As Yavapai County Sheriff George Ruffner had a long association with Parker, he quickly picked up the outlaw's trail and, in less than a week, had him incarcerated in the jail at Prescott, the Yavapai County seat. Because residents usually were sympathetic to individuals involved in disputes with the railroad, and as Parker was friends with the sheriff, the assumption was that he would receive a light or suspended sentence.

However, as Parker had served a prison sentence in California for burglary, he panicked, overpowered a jailer, escaped, and in the process killed Lee Norris, the deputy district attorney. Additionally, he stole Ruffner's prize gelding to make his escape.

Parker's freedom was short lived; Ruffner arrested him near Flagstaff before the end of the month. Returned to Prescott, Parker was given the death penalty at his trial and was hanged on June 3, 1898.

This crime has an additional connection to the Route 66 corridor. George Ruffner was the first Arizonan admitted into the National Cowboy Hall of Fame, located at 1700 NE 63D in Oklahoma City, a few blocks from the post-1954 alignment of U.S. 66 currently utilized by I-35 and I-44.

Seligman

On Friday, June 9, 1961, Jimmy Welch, twelve; Tommy Welch, eight; Billy Welch, seven; and Johnny Welch, five, flagged down a motorist on Route 66 thirteen miles west of Seligman. The boys, sleeping in pup tents, had awakened to find their father, J. D. Welch, and their mother, Utha Marie, of Spencer, Oklahoma, murdered as they slept in the car.

Robbery was the apparent motive by two unknown assailants. The only leads in the case were those from Glen Hamby and Bill Lawrence of Tulsa, Oklahoma, who reported two young men looking for a ride on Friday morning near where the shooting occurred.

In spite of a multi-state investigation, the crime remains unsolved.

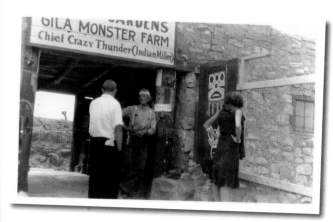

Harry Miller, a.k.a. "Chief Crazy Thunder," linked **Two Guns** to murder.

Two Guns

Hoping to capitalize on the traffic along the National Old Trails Highway that crossed Diablo Canyon on a bridge built in 1915, Earl Cundriff, a veteran of World War I, purchased property on the edge of the chasm in 1924. By 1925, his Canyon Lodge Store complex, which provided

travelers with free campgrounds, firewood, water, and amenities such as small cottages and a post office, was a profitable enterprise and the largest settlement between Winslow and Flagstaff.

In the same year, Harry "Indian" Miller, who proclaimed himself an Apache, leased a portion of the Cundriff property and built a large stone complex on the north side of the canyon. He opened a zoo featuring desert animals, including a mountain lion, and promoted Fort Two Guns with Chief Crazy Thunder as proprietor. Additionally he built fake ruins in the caves where a band of Navajo had trapped and killed a marauding group of Apache warriors in 1878, and he used this as an additional lure for travelers.

Miller's expansive development soon led to disputes over property boundaries. These disputes came to a head on March 3, 1926, when Miller shot Cundriff to death. Even though Cundriff was unarmed, a jury acquitted Miller.

Miller, however, would have another brush with the law resulting from this incident. Enraged by Cundriff's headstone, which included in the epitaph the notation that he had been killed by Indian Miller, Harry Miller destroyed the stone. He was charged with defacing a grave.

After being released from custody, Miller moved to Lupton. Near here, he established the Fort Chief Yellowhorse Trading Post astride the Arizona-New Mexico state line.

An earlier crime at Canyon Diablo near the present site of Two Guns played a pivotal role in the meteoritic rise of frontier-era lawman Bucky O'Neil. On March 20, 1889, four men in the employ of the legendary Hashknife Ranch robbed the express car of a Santa Fe train here.

A posse led by O'Neil, who was then serving as the Yavapai County Sheriff, initiated a dogged pursuit that was also a grueling 600-mile gun battle. Within three weeks, O'Neil had captured all four men and returned them to the jail in Prescott.

Valentine

With permission from the United States Postal Service to apply a unique heart-shaped postmark, Valentine became a world-famous location. A less peaceful claim to fame was achieved in August 1990, when an unknown assailant robbed the post office and the adjoining Union 76 station, and murdered postmaster Jacqueline Ann

Postmaster Jacqueline Ann Grigg was murdered here in **Valentine** in August 1990.

Grigg. The post office and station closed shortly thereafter. It never reopened.

Williams

Mountain Springs Ranch, a rustic establishment offering the barest of amenities and located two miles west of Williams on the National Old Trails Highway (Route 66 after 1926), was the scene of a murder that garnered national attention in 1925.

Granville Johnson, his wife, Hazel, and his infant stepson stopped at the ranch on May 2, 1925, while traveling from Los Angeles to St. Louis. Late that evening, Granville awakened other campers with screams about the murder of his wife.

After a very short investigation, police officers from Williams arrested Granville and charged

Granville Johnson murdered his wife, Hazel, at the rustic **Mountain Spring Ranch** in May 1926. Joe *Sonderman*

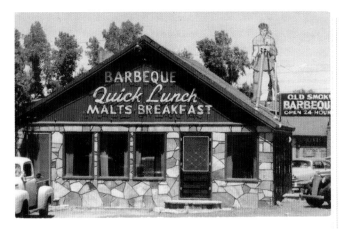

Williams police officer Marshall McDonald was killed in the parking lot at **Old Smoky's Barbeque** in 1947.
Joe Sonderman

him with murder. His alibi of having been in Flagstaff at the time of the murder was proven to be a lie by testimony from other campers. The murder weapon, a hatchet with his name engraved on the handle, was located in the nearby woods.

In the subsequent trial, the judge allowed presentation of evidence of Johnson's lengthy history as a con man to the jury. Additional evidence included several life insurance policies taken out on his wife, a recent widow, shortly before they began the trip east.

Granville was convicted of first-degree murder and received the death penalty, a sentence later commuted to life in prison. He died in the Arizona State Prison at Florence in 1950.

On April 15, 1947, Williams police officers responded to a disturbance call at a parking lot near Old Smoky's, a restaurant on Route 66. When the officers attempted to arrest the suspect, he pulled a revolver, and concerned for a nearby crowd of bus passengers, the officers requested assistance. Marshal McDaniel responded. In the resultant scuffle to subdue the assailant, the gun discharged, mortally wounding McDaniel with a gunshot to the chest.

Film and Celebrity

Ash Fork

The cheap property values in Ash Fork, as well as the fact that the film company was shooting another movie in the area of Kingman to the west, purportedly led to the filming of several scenes for the 1992 movie *Universal Soldier* in the community. These scenes include the destruction of a motel and several houses with explosions.

Scenes from the movie *Easy Rider* were shot in several locations along Route 66. In one such scene, the film's motorcycle-riding characters were turned away from **Bellemont's Pine Breeze Inn**.

Bellemont

The Pine Breeze Inn, located on a dead-end segment of Route 66 approximately two miles east of Bellemont, was used as a location in the filming of the 1969 cult classic, *Easy Rider*.

Cool Springs

Cool Springs, located along the pre-1952 alignment of Route 66 in the Black Mountains of western Arizona, burned in 1966. The town ruins, which are surrounded by stunning western landscapes, served as the framework for a set designed for destruction by explosion in the 1992 movie *Universal Soldier* starring Jean-Claude Van Damme and Dolph Lundgren.

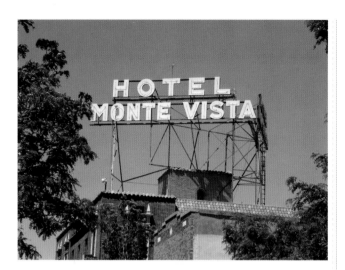

The **Hotel Monte Vista** is a **Flagstaff** landmark that has been attracting the rich and famous since it opened in 1927. *Joe Sonderman (postcard)*

Flagstaff

In 1911, producer Jesse Lasky, traveling with legendary filmmaker Cecil B. DeMille, embarked by train from New York City in search of a suitable site for the relocation of their motion picture company. Upon arriving in Flagstaff, they became enamored with the deep blue skies, the snow-covered San Francisco Peaks, and the towering forest of ponderosa pines. Additionally, the small mountain community was centrally located on a major rail line.

Any plans to move their film company to Flagstaff were short lived, however. An icy drizzle followed by a heavy, deep snow dampened their enthusiasm. When the rails were cleared and the line reopened, DeMille and Lasky boarded a westbound train. Their next stop, in California, proved to be a more suitable location.

The Hotel Monte Vista, located two blocks north of Route 66, opened on January 1, 1927, and since then has hosted many celebrities, including Humphrey Bogart (room 409), Jon Bon Jovi (room 305), Gary Cooper (room 306), Bing Crosby (room 213), Michael J. Fox (room 216), Bob Hope (room 204), Freddy Mercury (room 403), and John Wayne (room 402).

Among the many movies with scenes filmed in Flagstaff are *California* (1947), *A Big Hand for the Little Lady* (1966), *Easy Rider* (1969), *The Other Side of the Wind* (1972), *Vacation* (1983), and *Midnight Run* (1988).

Holbrook

The community of Holbrook has a light association with cinematic history. Filmed along the Route 66 corridor were a few scenes for *Natural Born Killers* (1994) as well as *Bitter Wind* (1963), *Palmer's Pickup* (1999), and *Great American Road Trip* (2009).

Kingman

Kingman has served as a location for or been alluded to in many films and television productions over the years. Additionally, it has been home to and stopover for a number of celebrities. Perhaps the most famous association is mentioned in the song "Route 66" written by Bobby Troup.

Author Louis L'Amour frequented the Nighthawk Saloon in Kingman's Beale Hotel during the period when he worked at the nearby Katherine Mine, and Buster Keaton was known to be a guest at the hotel.

Keaton first stayed at the Beale Hotel while scouting locations for his 1925 film *Go West*. It was here that he allegedly met Tap Duncan, owner of the Diamond Bar Ranch, where several scenes in the film were shot. Keaton later noted in an interview, "We shot the film about sixty miles out of Kingman, Arizona. We were really out in open country."

As reported in the *Kingman Weekly Miner* of May 22, 1925: "Buster Keaton, the noted film comedian, will make a six reel picture in Mohave County starting in a week or so. Mr. Keaton and

The **Hotel Beale** lobby as it appeared in 1925 during Buster Keaton's stay. *Steve Rider*

three of his men were in here this week looking up a location and picked Tap Duncan's Ranch."

Charles Lindbergh was a regular guest at the hotel during construction of the airfield that served his pioneering T.A.T. airline, and Amelia Earhart stayed at the Beale when she participated at the ribbon-cutting ceremony for that airfield in July 1929. The hotel also hosted numerous USO tour events during World War II, including the Three Stooges and the Andrews Sisters.

In a 1955 episode of the television program *This Is Your Life*, Front Street (Route 66) was renamed Andy Devine Avenue in honor of the character actor whose father owned the Beale Hotel during the 1910s and early 1920s. Devine, born in Flagstaff in 1905, grew up in Kingman and developed his trademark gravelly voice from an injury suffered at his father's hotel.

The town's classic Hilltop Motel also has celebrity associations. The owner allowed the band Crosby, Stills, and Nash to use a shower after informing them that the motel had no vacancies.

A dubious form of celebrity association occurred in February 1995. For four days Timothy McVeigh, the Oklahoma City bomber, was a

Charles Lindbergh stayed at the **Hotel Beale** during construction of Port Kingman. *Mohave Museum of History & Arts*

guest at the Hilltop Motel, and during the federal investigation of that incident, the FBI confiscated his registration card as evidence.

Early in the morning of March 29, 1939, Clark Gable and Carole Lombard, accompanied by Gable's MGM publicist Otto Winkler, left Los Angeles and followed Route 66 to Kingman, Arizona. Upon arrival, and after acquiring a marriage license at the Mohave County Courthouse from

Actor Buster Keaton first stayed at **Kingman's Beale Hotel** while scouting locations for his 1925 film *Go West.*

Kingman's Front Street, which ran past the **Hotel Beale**—owned by Andy Devine's father—was renamed Andy Devine Avenue in 1955. *Joe Sonderman*

The boyhood home of Andy Devine is a Kingman landmark. Purportedly, an accident there resulted in his trademark voice. *Joe Sonderman*

clerk Viola Olsen, they retained the services of Methodist Episcopal minister Kenneth Engle for a simple marriage ceremony at the church located at 318 North 5th Street, four blocks north of Route 66. This church now serves as the offices for the public defender. A small inlaid historic marker commemorates the matrimonial occasion.

In 1992, Kingman police escorted Pamela Anderson to the police station for indecent exposure during a *Playboy* photo shoot at the intersection of 4th Street and Andy Devine Avenue.

It was near this intersection that George Taplan "Tap" Duncan died on November 19, 1944, after being struck by an impaired driver. Duncan, a

Timothy McVeigh's name in the register of Kingman's **Hilltop Motel** was included as evidence after the Oklahoma City bombing.

successful pioneer rancher in northwestern Arizona, had moved his family to Arizona from Idaho after an altercation resulted in his killing a man associated with the gang of Butch Cassidy and the "Sundance Kid."

Duncan also had an association with legendary outlaw "Kid" Curry. Curry, after hiding out in Texas near where Duncan's family lived, assumed the identity of Tap Duncan. He was using this name during the botched train robbery that led to Curry's shooting death near Parachute, Colorado.

Lomeli's Garden Arts on Andy Devine Avenue is housed in the Flying A station owned by Allen Bell. Bell is the father of acclaimed author and artist Bob "Boze" Bell, who worked at the station in his youth.

Mr. D'z Route 66 Diner, originally the Kimo Café, which offered its own brand of root beer, served as the film setting for an episode of the *Oprah Winfrey* show in May 2006. Winfrey and her friend Gayle King stopped by the restaurant during their tour along Route 66. Oprah gave the restaurant favorable reviews for its food as well as service. In addition, she ordered seventeen cases of the restaurant's signature root beer as a treat for the studio audience.

Numerous scenes for the 1959 film *Edge of Eternity* starring Cornel Wilde, Jack Elam, and Edgar Buchanan were shot in Kingman and other locations along Route 66 in western Arizona. A pivotal scene utilized the unique cable car across the Grand Canyon that was built as part of a guano mining operation in the early 1950s. The cable car is no longer functional, but this site is now a viewpoint at Grand Canyon West Resort north of Kingman.

In the 1971 cult classic *Two Lane Blacktop* starring Dennis Wilson, Warren Oates, and James Taylor, the canyon at the west side of Kingman, which channels two alignments of Route 66 as well as the National Old Trails Highway, figures prominently in one scene. In addition, during the scene the driver is listening to KAAA, the primary radio station in Kingman during this era.

The 1984 movie *Roadhouse 66* starring Judge Reinhold and William Defoe had several scenes filmed in Kingman along the pre-1937 segment of Route 66 (currently signed as Old Trails Road) and at The Tavern, now the TNT machine shop at 535 East Andy Devine Avenue (Route 66).

Pioneering rancher Tap Duncan died near this intersection in **Kingman** in 1947. *Joe Sonderman*

Red Lake, a dry lake north of Kingman, is the setting for a key scene in 1996's *Mars Attacks* starring Jack Nicholson, Glen Close, Annette Bening, Pierce Brosnan, Danny DeVito, Christina Applegate, and Michael J. Fox. Other locations in the Kingman area also appear.

The Kingman Airport appears in a scene in *Fear and Loathing in Las Vegas*, released in 1998. The airport served as the Kingman Army Airfield during World War II.

On the small screen, in the second episode of the second season of *Prison Break*, L. J. Burrows is sent to an adult correctional facility in Kingman. In the first episode of the sixth season of *The Sopranos*, Tony Soprano mistakenly obtains a driver's license for Kevin Finnerty with an ad-

FRONT
STREET

U.S. Hiwhy 66
Westbound
Through

KINGMAN
ARIZONA

X750

Lengthy celebrity association and murder give this intersection a unique place in Route 66 history. *Joe Sonderman*

dress of Stockton Hill Road in this city.

Kingman also has an association with sports history. On April 1, 1924, the Chicago Cubs stopped in Kingman on their way back to Chicago by rail following spring training in California. The Pittsburgh Pirates baseball team was also passing through en route from California to Pittsburgh. At the urging of Cubs second baseman George Grantham, who had played on a Kingman team as a teenager, an exhibition game between the ball clubs was played at Kingman Ball Park, currently the site of Locomotive Park. On March 28, the *Kingman Daily Miner* reported, "The Cubs and Pirates could have secured other dates, but manager Bill Killefer of the Cubs was anxious to pay a compliment to Kingman. He figures he owes Arizona a lot. The Cubs would have been in bad shape last year had not Grantham come through." Grantham was born in the Route 66 city of Galena, Illinois.

Lupton

The stunning landscapes at **Lupton** made it a destination for travelers and movie companies.

Meteor Crater

Meteor Crater served as a location for the 1977 movie *Damnation Alley* starring Jan-Michael Vincent and George Peppard. The crater and nearby Meteor Crater Trading Post also appear in the 1984 film *Starman* starring Jeff Bridges.

Meteor Crater appears in scenes from the campy 1970s film *Damnation Alley*.

Oatman

The former mining boom town of Oatman, framed by a stunning backdrop of the Black Mountains and unique geological formations, has served as a setting for numerous movies, television programs, and documentaries. Movies with scenes filmed in the area include *Foxfire* (1955), *Edge of Eternity* (1959), *How the West Was Won* (1962), *Roadhouse 66* (1985), *Thunder Run* (1986), and *Killer Holiday* (2013).

Television programs or made-for-television movies shot in Oatman include *Through the Magic Pyramid* (1981); *Glutton for Punishment* ("Egg Fry" episode, 2008); and *Great American Road Trip* ("California or Bust" episode, 2009).

Oatman served as the set for several 1950s films, including *Foxfire*.

Another celebrity connection to Oatman is the persistent legend that Clark Gable and Carole Lombard spent their first night as husband and wife in the town's Durlin Hotel after getting married in Kingman in March 1939. However, there is no historic evidence to support the claim.

Seligman

On the afternoon of Tuesday, November 10, 1914, during the last of the Desert Classic "Cactus derby" automobile races, Louis Chevrolet stopped in Seligman for fuel and oil. An overly excited station attendant accidentally dumped water intended for the radiator into the gas tank.

As Chevrolet and his mechanics worked to rectify the problem, Cliff Durant, son of General Motors founder William Durant, arrived at the station for fuel. As his car had suffered a severely damaged wheel during the crossing of the Colorado River, the Chevrolet team utilized a wheel from Louis's car, and Durant and Chevrolet continued together toward the finish line in Phoenix, leaving the mechanics in Seligman to attend to his car.

Legendary race driver Barney Oldfield shortly before the 1914 **Desert Classic**. *Library of Congress*

Topock

Currently used as a platform to support pipelines crossing the Colorado River, the National Old Trails Bridge was completed in 1916 and served as the river crossing for Route 66 until 1947. In the 1940 film adaptation of John Steinbeck's

The Grapes of Wrath starring Henry Fonda, the Joad family is shown crossing this bridge into California.

The Colorado River Bridge currently utilized by I-40, and originally used by U.S. 66 beginning in 1966, appears in a scene in the 1969 movie *Easy Rider* starring Peter Fonda.

Numerous scenes from 2007's *Into the Wild* were filmed along the Colorado River near Topock, including an area of the Havasu National Wildlife Refuge.

Williams

Scenes for several motion pictures and documentaries were filmed in Williams, including *Sky High* (1922), *Guns of the Timberlands* (1960), *Vanishing Point* (made-for-television movie, 1977), and *Midnight Run* (1988). Documentaries with scenes of Williams include *Route 66: Main Street America* (2000) and *Father, Daughter, Mother Road* (2012).

Winslow

In light of the town's colorful history and its ample structures from the territorial and early statehood periods, it is surprising to learn that very few movies have been shot in Winslow. The most notable films with scenes here are *Starman* (1984), *Natural Born Killers* (1994), and *Savage* (1996).

Transitional Sites

McConico

Bypassed in 1952, the segment of Route 66 through the Black Mountains and over Sitgreaves Pass represents almost a century of American highway evolution. The Beale Wagon Road surveyed in 1857 utilized the pass even though the steep western slope required the use of ropes and winches on wagons for the descent and ascent.

The National Old Trails Highway initially

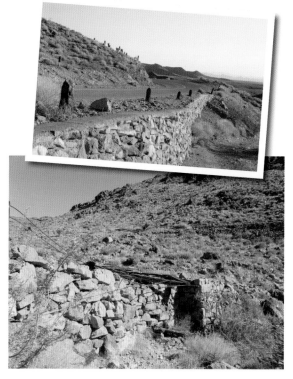

TOP: The pre-1952 alignment of Route 66 through the mountains of western Arizona also served as the **National Old Trails Highway**.

ABOVE: This segment of **National Old Trails Highway** near **Goldroad** has territorial era origins.

followed segments of the Beale Road and a road built in approximately 1909 to traverse the pass from the Goldroad mining camp. A portion of this roadway, complete with original guardrails and stonework bridges, remains just below the course of Route 66 on the west side of the pass.

Another view of the pre-1952 alignment in western Arizona.

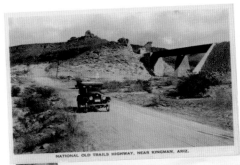

TOP: All aspects of this postcard, including the railroad trestle, remain existent west of **Kingman**. *Steve Rider*

ABOVE: The **National Old Trails Highway** and pre-1937 Route 66 west of **Kingman**.

Route 66 followed the course of the improved National Old Trails Highway before realignment resulted in the highway following the Sacramento Valley, through Yucca, to the Colorado River. This early segment of the highway over Sitgreaves Pass features the sharpest curves and steepest grades found on Route 66.

As an interesting aside, during the era of the National Old Trails Highway (commencing in about 1915), a road from the Colorado River to Kingman through Yucca was designated as an alternate route to avoid the grades and curves of Sitgreaves Pass. The post-1952 alignment of Route 66, and now I-40, follows the course of this secondary route.

Kingman

TOP: More than a century of transportation evolution is preserved in **Kingman Canyon**.

ABOVE: Before 1937, Route 66 entered **Kingman** on 4th Street. *Steve Rider*

Parks

At Parks, tangible links from late-period developments on the National Old Trails Highway through 1939 present a Route 66 time capsule. Behind the town store is a short segment of concrete roadway dating to road improvements made in 1921. To the front of the store are portions of the roadway from the 1931 period. The primary road signed as County Road 146 is the 1939 alignment of Route 66.

Sanders

To the south of I-40, between exit 351 and exit 339, and to the north of that highway between exit 348 and exit 341, two road segments illustrate the evolution of Route 66 from the early 1920s to the late 1930s.

On the southern segment, now Apache County Road 7240, two bridges are the primary remnants of the previous era. At exit 351, immediately south of the railroad grade crossing, stands the now-closed bridge that carried National Old Trails Highway (and Route 66 traffic until 1931) over the Rio Puerco River. A second bridge of similar vintage and accessed from exit 339, also closed, is located near Sanders.

The segment of Route 66 anchored by the two historic bridges was bypassed with completion of the Querino Canyon Bridge and realignment of the highway in late 1930. The Querino Canyon

The 269-foot **Querino Canyon Bridge** dates to the bypass of late 1930 and now carries County Road 7250 traffic.

TOP: The bridge at **Sanders** only carried Route 66 traffic from 1926 to 1931.

ABOVE: The bridge built in 1923 at **Houck** carried Route 66 traffic until 1931.

Bridge and the segment of post-1931 Route 66 between exits 346 and 341 is a unique opportunity to experience wartime-era travel in Arizona. Both alignments are now gravel roads.

Seligman

Encapsulated within the diminutive business district of Seligman is a study in twentieth-century highway engineering. The National Old Trails Highway, after 1913, and Route 66, between 1926 and 1933, followed Seligman's Havasu, Main, and Chino Streets as well as Railroad Avenue.

The last incarnation of Route 66 in town is also the course of the I-40 business loop today. It is a direct east-west corridor along four-lane Chino Street.

Traces of the National Old Trails Highway and the first alignment of Route 66 can be found at the west end of Seligman, under and beside the I-40 access road. This short gravel track, now a private road, includes a stone culvert that dates to the early 1920s.

Topock

Several transitional elements of Route 66 are in evidence at the Colorado River crossing near Topock. Immediately to the south of the bridge currently utilized by I-40, the 800-foot-long National Old Trails Bridge, which carried Route 66 traffic from 1926 until 1947, was the longest arch bridge in the United States at the time of its completion

Dedication of Highway Bridge Over Colorado River at Topock

The **National Old Trails Bridge** carried Route 66 traffic across the Colorado River from 1926 to 1947. *Steve Rider*

in 1916. At 360 tons, it was also the lightest span of such length in the nation.

Supported by sweeping 600-foot-long steel arches, the bridge was deemed an engineering marvel at the time. Engineers used a cantilever-arch system and built the components on the ground. A hoisting mechanism using a ball-and-socket center hinge allowed for completion of the mid-river sections.

Dedicated on February 20, 1916, this was the first bridge designed specifically for automobile traffic to span the Colorado River north of Yuma, Arizona. It replaced the prior river crossing for the National Old Trails Highway, which consisted of a shared-use railroad bridge.

With creation of the U.S. highway system and certification of U.S. 66 in November 1926, the Old Trails Bridge, or Topock Bridge, served as the river crossing for that highway until May 1947. At that

time, the Red Rock Bridge, a railroad bridge built in 1890, reopened after an extensive renovation that included the installation of a highway deck.

The Red Rock Bridge served as the river crossing for Route 66 until 1966 and was demolished shortly after this date. The National Old Trails Bridge, listed on the National Register of Historic Places in 1988, currently serves as a river-crossing support for pipelines of the Pacific Gas & Electric Company.

Two Guns

The bridge at **Two Guns** carried Route 66 and National Old Trails Highway traffic.

Valentine

ALONG HIGHWAY "66" VALENTINE, ARIZ. B-212

The last segment of Route 66 paved was in Truxton Canyon near **Valentine**. *Joe Sonderman*)

BRIDGE ACROSS THE COLORADO U.S. 66

This historic bridge that dates to 1916 appears in *The Grapes of Wrath. Joe Sonderman*

Williams

In 1955, Route 66 in Williams became a divided highway with Bill Williams Avenue, also the course of the National Old Trails Highway, converted into a one-way corridor for eastbound traffic, and Railroad Avenue one block to the north carrying westbound traffic.

The opening ceremony for I-40 north of Williams on October 13, 1984, was a milestone event for the town and in Route 66 history. With that moment, Williams became the last Route 66 community bypassed by the interstate highway.

Winona

The Walnut Canyon Bridge, located on the pre-1947 alignment of Route 66 west of Winona, dates to 1924. Currently closed to vehicular traffic, the bridge served as a crossing over Walnut Creek for motorists on the National Old Trails Highway as well as Route 66.

Initial engineering work commenced in 1922 after receipt of $216,507 in Forest Highway Funds from the Bureau of Public Roads. Actual construction began in December of that year.

Consisting of a single 101-foot span with a 19-foot width, the bridge utilized a Parker through truss design consisting of five panels. The deck retains the original concrete flooring over steel stringers. The bridge was listed in the National Register of Historic Places by the National Park Service in 1988.

Winslow

Route 66 in Winslow was transformed into a four-lane divided highway in 1951. After this date, the original alignment of Route 66 along 2nd Street, which was also the course for the National Old Trails Highway, was designated a one-way corridor for eastbound traffic. Westbound traffic shifted north to 3rd Street.

With completion of this split, Winslow became the first community in Arizona to establish one-way traffic as a means of controlling the escalating flow of motorists along Route 66. The final Route 66 transition in Winslow occurred on October 9, 1979, when the completion of I-40 to the north allowed for the bypass of the community.

Route 66 traffic crossed Walnut Canyon on this bridge near **Winona**. *Judy Hinckley*

Cool Springs. © iStock.com/Gim42

ARIZONA

- Crime and Disaster
- Film and Celebrity
- Transitional Sites

Oatman, the backdrop for several 1950s films. *Page 192*

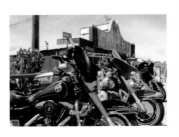

The former lumber company building in **Oatman**. *Page 184*

A segment of **National Old Trails Highway** near **Goldroad**. *Page 193*

Race driver Barney Oldfield shortly before the 1914 **Desert Classic** in **Seligman**. *Page 192*

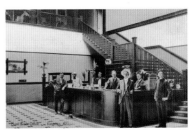

The **Hilltop Motel** in **Kingman**. *Page 190*

The **Hotel Beale** in **Kingman**, whose guests have included many celebrities. *Page 188*

The historic bridge in **Topock**. *Page 196*

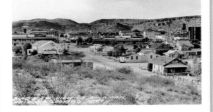

Before 1937, Route 66 entered **Kingman** on 4th Street. *Page 194*

The **Dean Eldredge Museum** and **Taxidermist** in **Flagstaff**. Page 165

The **Canyon Padre Trading Post**.
Page 163

Petrified Forest National Park.
Page 178

The railroad bridge in
Canyon Diablo. Page 158

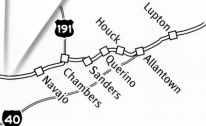

The **Painted Desert Trading Post** ruins. Page 172

The **Motel Downtowner** sign in **Flagstaff**. Page 166

ortalized by
Page 176

Two Guns landmark. Page 175

The Meteor Crater Observatory.
Page 172

Jack Rabbit Trading Post.
Page 169

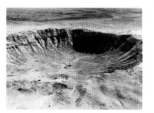

Meteor Crater. Page 171

Winona · Canyon Diablo · Winslow · Jackrabbit · Joseph City · Geronimo · Holbrook · Navajo · Chambers · Sanders · Querino · Houck · Allantown · Lupton · Meteor City

66 · 180 · 89 · 17 · 191 · 40

ARIZONA

- ⊛ *Pre-1926 Historic Sites*
- ▽ *Landmarks*
- ⛺ *Parks*
- ◈ *Military*

The **Grand Canyon Caverns**. *Page 167*

The former trading post in **Peach Springs**. *Page 173*

The **Red Garter** in **Williams**. *Page 163*

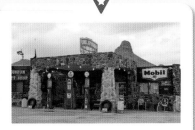

The **Cool Springs** building. *Page 164, 198*

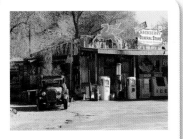

The **Hackberry General Store**. *Page 168*

Vistas of **Sitgreaves Pass**. *Page 161, 199*

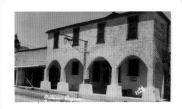

The **Durlin Hotel** in **Oatman**. *Page 161*

Remnants of the **Kingman Army Airfield**. *Page 180*

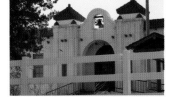

The two-room schoolhouse in **Hackberry**. *Page 159*

"ROU

Winona,
Bobby T

Antares Jct. Truxton Crozier Hackberry Peach Springs Seligman Ash Fork Williams Flag

Cool Springs Goldroad Oatman Old Trails Golden Shores Topock Kingman McConnico Hackberry

93 40 66

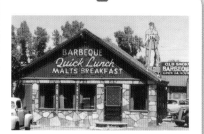

Old Smoky's Barbeque in **Williams**. *Page 186*

The rustic **Mountain Spring Ranch** in **Williams**. *Page 186*

The stunning landscapes at **Lupton**. *Page 191*

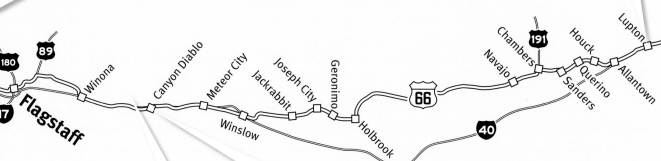

Harry "Indian" Miller linked **Two Guns** to murder. Page 185

The **Pine Breeze Inn** in **Bellemont**, featured in *Easy Rider*. Page 187

Padre Canyon, the site of a 1930 accident. *Page 184*

The stunning vistas of **Sitgreaves Pass** were seen by several American explorers during the 1850s.

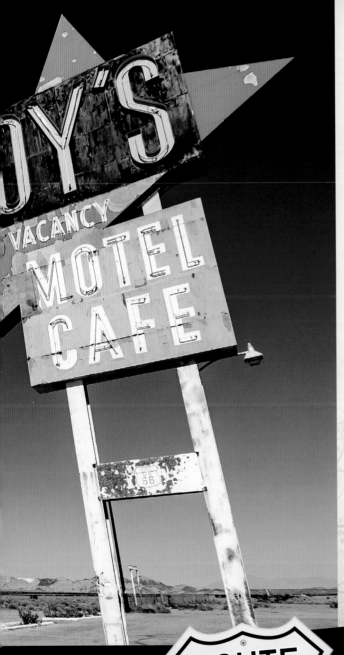

ROUTE 66

California

Pre-1926 Historic Sites

Bagdad

Established as a siding and water supply stop for the Southern Pacific Railroad in 1883, Bagdad became a key supply center and shipping point for mines in the Bristol and Bullion Mountains. One of the first restaurants in the "Harvey House" chain was established here, and another establishment along Route 66 that continued operation until 1973 served as the inspiration for the 1988 motion picture *Bagdad Café*.

According to railroad records, Bagdad holds the unofficial record for lack of precipitation in the continental United States. Between October 3, 1912, and November 8, 1914, measurable rainfall was zero.

Cajon Pass

For centuries, the Cajon Pass has served as a transportation corridor between the San Gabriel Mountains and the San Bernardino Mountains from the Mojave Desert into the coastal valleys now dominated by the Los Angeles metropolitan area. In addition to a thriving Native American trade route in pre-Columbian America, several roads key to European and U.S. settlement in the Southwest also coursed through this pass, including the Mojave Road, Spanish Trail, and Mormon Road.

A monument in **Cajon Pass** commemorates historic roadways such as the Mormon Trail.

Cajon Pass also served as the path of least resistance for railroads and several early automobile highways, including the National Old Trails Highway, Arrowhead Highway, the first alignment of U.S. 66, a four-lane transitional alignment of Route 66, and now, Interstate 15.

The **Desert Market** in **Daggett** first opened as Ryerson's General Store in 1908.

Daggett

The Desert Market in Daggett that stands along Route 66, also the course of the National Old Trails Highway, opened in 1908 as Ryerson's General Store. It has remained in continuous operation since that date.

To the east, the now-shuttered Stone Hotel, with stone and adobe walls two-feet thick, dates to at least 1885. Built originally as a two-story structure, it featured an iron-framed dome over the lobby and a balcony facing the street (the National Old Trails Highway and later Route 66) and railroad depot. The current configuration is the result of its renovation after a fire devastated the upper floors.

A block further east, at the slight curve in the road, stands Alf's Blacksmith Shop. Built in 1894, the building served as a garage for travelers on the Arrowhead Highway, National Old Trails Highway, and Route 66. The shop manufactured specialty wagons designed for heavy loads and the rugged terrain during the borax mining boom in the closing years of the nineteenth century. These wagons, pulled by twenty-mule teams, were immortalized in the television program *Death Valley Days* originally hosted by Ronald Reagan.

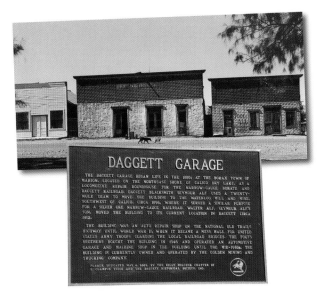

TOP: The **Stone Hotel**, built in the 1880s, is the oldest remaining building in **Daggett**. *Joe Sonderman* ABOVE: The **Daggett Garage** provided service long before Route 66 certification.

Helendale

A unique geological formation and the waters of the Mojave River resulted in the current site of Helendale developing as a desert oasis. The early descriptor on maps for this location was Point of Rocks, a name also used for the first railroad siding and station established in 1882.

As numerous frontier trails utilized the Mojave River corridor, it served as a campsite for several historically significant figures. Explorer and hunter Jedediah Smith established a camp here in 1826, as did Kit Carson in 1844. The Mormon Battalion during the Mexican-American War camped here in late 1846.

Los Angeles

The various alignments of Route 66 in the Los Angeles area course through neighborhoods and over roadways with lengthy histories. The pre-1931 alignment of Route 66 followed Huntington Drive from Pasadena into Los Angeles. As indicated by signage at the western end of this road, this corridor appears on various early maps as Mission Road and Old Adobe Road, direct links to the period between the late seventeenth century and late nineteenth century.

Needles

Named for the intrepid Spanish colonial-era explorer Father Francisco Garces, the El Garces Hotel and depot complex that dates to 1908 was a crown jewel of the Fred Harvey facilities. The expansive and stylish hotel, restaurant, and depot remained in operation until 1949. During World War II, it served as a processing center for troops assigned to the Desert Maneuver Training Center and as an officers' club frequented by General George Patton Jr. and others.

Shortly after the hotel's closure, the Santa Fe Railroad demolished the north wing and converted the remaining structure into offices. Upon the centralization of railroad operations, the entire complex was closed, and intensive lobbying was needed to prevent its demolition.

Renovation commenced in the early twenty-first century but an array of legal and zoning obstacles negated the project. The structure reopened as an office complex and depot in 2014.

The **El Garces Hotel** was a stylish place to stay in **Needles** from 1908 until it closed in 1949. *Steve Rider*

Newberry Springs

The dependable springs near the site of present-day Newberry Springs made this an oasis in the Mojave Desert. Archeological evidence indicates several thousand years of habitation here.

The springs served as an oasis for travelers on a Native American trade route that linked coastal tribes with those in what is now northern Arizona and western New Mexico. This trade route and the springs were used by the expeditions of Father Garces in 1776, as well as those of Jedediah Smith in the 1820s, and travelers on the Mojave Road between the 1850s and 1880s. Much later it served a similar role for automobile travelers on Route 66.

Newberry Springs has served as a desert oasis for visitors for thousands of years, from early Native Americans to Route 66 adventurers staying at establishments like the Cliff House. *Steve Rider*

Rancho Cucamonga

Archeological evidence indicates a Kucamongan village existed at the site of Red Hill by about 1200 AD. It was here that Tubercio Tapia built a fortified ranch house to serve as headquarters for his 13,000-acre Rancho de Cucamonga.

Located at 8318 Foothill Boulevard (Route 66), the Sycamore Inn is purportedly the oldest restaurant on Route 66 in California. It originally opened in 1848 and later served as a stop for the Butterfield Overland Company. The inn was renovated and expanded to its current configuration in 1912, after a major fire, and again in 1939. It is renowned for its fine cuisine and period styling that presents the illusion of an early inn.

The Sycamore Inn is the oldest commercial structure along Route 66 in California. *Steve Rider*

Landmarks

Amboy

The towering Roy's Motel–Café sign has cast a shadow across the gravel parking lot in Amboy since 1959 and is now one of the most widely recognized Route 66 landmarks in the world. The sign, empty café, motel, and service station have served as a backdrop or featured prominently in ads promoting products as diverse as Olympus cameras, Australian insurance, Dodge trucks, and German beer.

Barstow

Designed by internationally acclaimed architect Mary Colter, the Casa Del Desierto opened in February 1911 as a replacement for the Barstow Harvey House that burned in 1908. The expansive complex was built utilizing a blending of Spanish Colonial and Southwest styles. It remains as one of only a few buildings located on the north side of the tracks after rail yard expansion in the early 1920s necessitated razing and relocation of the entire Barstow business district.

The National Old Trails Highway and first alignment of Route 66 ran adjacent to the hotel and provided an additional source for customers aside from the railroad. The hotel remained in business until 1959 and the restaurant until 1970, making this was one of the last Harvey House facilities to close. The complex then sat empty, with the exception of a small section that was used for

Casa del Desierto officially opened for business in Barstow in February 1911.

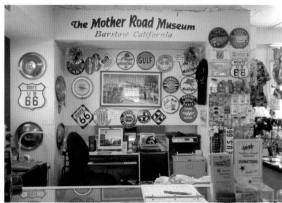

ABOVE: The old **Casa del Desierto** in Barstow now houses the Mother Road Museum. *Judy Hinckley*

RIGHT: Inclusion of the **Casa del Desierto** on the National Register of Historic Places occurred in 1975.

railroad offices, until the mid-1990s, when renovations got underway from local contributions and Federal Transportation Enhancement Funds.

Today, the stunning building houses city offices as well as the Route 66 Mother Road Museum. In addition, a railroad museum on the east end of the property includes a display of railroad rolling stock on the grounds. The complex was listed on the National Register of Historic Places in 1975.

Another Route 66 landmark in Barstow exemplifies the creative thinking and use of recycled materials that could be encountered all along the highway's corridor before 1950. Built almost entirely from discarded railroad ties in 1947 by Cliff Chase, the El Rancho Motel currently serves as a senior housing facility. With the exception of the adjoining restaurant that was destroyed by

The **El Rancho Motel** sign towers above Route 66 in **Barstow**.

fire in 2011, the motel complex appears unchanged. Even the signature signage that towers over the motel remains intact.

Shown here in its heyday, the ruins of **Cadiz Summit** are a favored photo stop for Route 66 enthusiasts today. *Steve Rider*

Cadiz Summit

The graffiti-covered ruins of Cadiz Summit that fronts Route 66 on the east slope of the Marble Mountains is a surprisingly popular landmark. Photographs of the ruins grace a variety of corporate and promotional materials, and the highly acclaimed 2011 book *Route 66 Sightings* by Jerry McClanahan, Jim Ross, and Shellee Graham featured an image of the ruins under stormy skies on the cover.

Cadiz Summit is often confused for Cadiz, the small railroad siding community established three miles to the south in 1883. George and Minnie Tienken operated a small business in that community along the National Old Trails Highway and, after 1926, Route 66.

With realignment of Route 66 to its current location in 1931, the Tienkens relocated their business to the summit of the pass. The complex evolved into a veritable desert oasis consisting of a handful of tourist cabins, a café, and a gas station.

Completion of I-40 and the subsequent bypass of Route 66 in 1973 led to the facility's closure. Vandalism and fire destroyed the entire complex.

Cajon Pass

The first incarnation of the Summit Inn opened at the head of Cajon Pass along Route 66 in 1928. Realignment of the highway necessitated several relocations. The current manifestation of the Summit Inn Cade was built by Burton and Dorothy Riley near the summit of Cajon Pass in 1952. It is

The landmark **Summit Inn** has served celebrities and truckers along Route 66 for decades. *Judy Hinckley*

the only business in the pass to survive the transformation of Route 66 into a four-lane highway and the bypass caused by construction of I-15 in 1970. With the resurgent interest in Route 66, this restaurant remains a thriving business.

Claremont

All alignments of Route 66 entered Los Angeles County at Claremont on Foothill Boulevard. Wolfe's Market first opened in 1917 and relocated to its current spot along Route 66 in 1935. It remains a family-owned business.

Fontana

Bono's Orange, located on Foothill Boulevard (Route 66) in Fontana, is the last of the thematic orange stands that lined this corridor before the postwar boom in urban development decimated the vast orange groves in the area. A related landmark is Bono's Restaurant at 15395 Foothill Boulevard, which opened in 1935.

Helendale

A rather unique institution operated in Helendale during the early 1980s. Jennie Lee, founder of the League of Exotic Dancers, established Exotic World, the only museum dedicated exclusively to preserving artifacts associated with burlesque.

Highland Park

The California Mission styled Highland Theater opened in 1924. The restoration of its towering rooftop signage in 2011 was a pivotal catalyst in the revitalization of the district.

Hollywood

Looming high on the hill above Santa Monica Boulevard (Route 66), the towering letters that spell out Hollywood have been a landmark since before the inception of Route 66. The original sign was built in 1923 at a cost of $21,000 to promote a real estate development called "HollywoodLand."

The original sign utilized 50-foot high letters secured to pipes and telephone poles. Mule teams were used to haul materials to the site on Mt. Lee, and 4,000 20-watt bulbs provided illumination at night.

The real estate development failed to meet profitable expectations. The sign, meanwhile, had become a tourist attraction, but by the 1940s, it had deteriorated to such a point that area residents were circulating petitions for its demolition.

In the mid-1940s, the developers sold the 450-acre tract that included the sign to the City of Los Angeles. After lengthy negotiations, the Hollywood Chamber of Commerce signed a contract with the Los Angeles Department of Parks and Recreation to repair and rebuild the famous sign, but without the inclusion of "land" at the end.

By the 1950s, the sign was an integral part of the Hollywood landscape. Despite its iconic status, it again began to fall into disrepair.

In 1973, the structure was designated a historical landmark by the city's cultural heritage board, and in the same year, acclaimed actress Gloria Swanson sponsored refurbishment of the sign. These proved to be temporary measures, as a complete rebuild was necessary due to termite and arson damage.

The icnonic **Hollywood sign** looms over Route 66 near its western terminus. *Judy Hinckley*

Hugh Hefner, publisher of *Playboy* magazine, initiated an all-star fundraising gala at the Playboy Mansion for the estimated $250,000 needed for the sign's renovation. Contributors for the project included Gene Autry, Alice Cooper, Andy Williams, and John Wayne.

For the first time in more than a half-century, the city was without its trademark sign as demolition of the original sign and its framework commenced in August 1978. In the months that followed, construction workers poured over one hundred tons of concrete as an anchor, installed a massive steel frame, and finally installed corrugated letters with a baked-enamel finish.

In November 1978, the 450-foot long, 480,000-pound sign was unveiled as part of Hollywood's Seventy-Fifth Anniversary Celebration to an estimated television audience of 60 million. Lights returned to the sign in 1984 for the Summer Olympic Games. Today the sign figures prominently in the city's promotional endeavors and statewide political rallies.

The **Aztec Hotel** in **Monrovia** spawned an architectural movement. *Joe Sonderman*

Monrovia

The Aztec Hotel at 311 West Foothill Boulevard (Route 66) in Monrovia opened in 1925 to critical acclaim for its use of modern engineering and construction methods, and for its stunning Mayan-inspired architectural details. As of this writing, renovation is underway that will incorporate modern amenities while preserving the hotel's distinctive attributes and details.

Inspired by a popular archeological work, *Travel in Central America* by John L. Stevens, architect Robert Stacy-Judd drew heavily from Mayan, Toltec, Aztec, and Inca murals, reliefs, and mosaics to create the ornate façade as well as the furniture and fixtures. The hotel's opening received such wide coverage that it launched an entire movement of ancient Mexican–inspired architectural styles.

Though bypassed with the 1931 realignment of Route 66, the hotel remained popular with travelers and celebrities until a lengthy period of decline commenced in the immediate postwar years.

Listed in the National Register of Historic Places in 1978, the latest renovations commenced in 2000 with partial funding from the National Park Service Route 66 Corridor Preservation Program.

The **El Garces** shadowed the earliest alignment of Route 66 in **Needles**. *Joe Sonderman*

Needles

Located at the east end of Needles, the Palms Motel remains as a well-preserved tourist court from the late 1920s. The cottages, now rented as apartments, are a popular photo stop for Route 66 travelers.

Though the surviving cabins of Carty's Camp are now used as storage facilities, the complex opened along the National Old Trails Highway shortly before certification of U.S. 66 in 1926. Owner Bill Carty at first simply copied tent

cabins similar to the ones he had experienced at the Grand Canyon, and added a service station. The complex evolved into the 1940s with the addition of an expanded service station with garage, a campground, and a cottage complex advertised as Havasu Court.

Pasadena

A gastronomical milestone purportedly occurred at 1500 West Colorado Boulevard in Pasadena: the invention of the cheeseburger. Lionel Sternberger purchased the Hinky Dink grill on the west side of Pasadena, and in 1926 he renamed it the Rite Spot, which soon became known throughout the area for the novel grilled sandwich.

The Howard Motor Company opened at 1285 East Colorado Boulevard (Route 66) in 1927 as a Packard automobile dealership. The shape of the front showroom window mimicked that of the company's trademarked grille, and the façade's ornate styling evoked seventeenth-century Spanish baroque architectural elements made popular by the 1915 Panama California Exposition held in San Diego's Balboa Park. Although the building remained empty as of the fall of 2013, the exceptional state of preservation of the intricately detailed façade was a primary factor in the building's listing in the National Register of Historic Places in 1996.

Located along Fair Oaks Avenue, which carried Route 66 from 1926 to 1934, are numerous landmarks of historical significance. The El Centro Market building, listed on the National Register of Historic Places, was a predecessor to the mod-

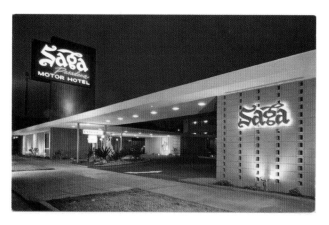

The **Saga** in **Pasadena** remains as a 1950s time capsule. *Joe Sonderman*

ern supermarket and represents an important step in American commercial development.

The Fair Oaks Pharmacy opened in 1915. The recently refurbished facility, including a soda fountain, appears as it did during the Route 66 period.

Listed in the National Register of Historic Places in 1978 and currently under restoration, the Rialto Theater opened in 1925 at 1023 South Fair Oaks (pre-1931 Route 66). It remains one of the few original single-screen theaters in Los Angeles County.

Rancho Cucamonga

The now-iconic Magic Lamp Inn at 8189 Foothill Boulevard opened in 1940 as Lucy and John's Café. A 1955 renovation transformed it to its current appearance after it was purchased by Frank and Edith Penn, who changed the name to the Magic Lamp Inn after a lottery drawing of suggestions provided by the staff. Today, preserved features of the restaurant include the original neon signage, stained glass windows, and Chinese cherry wood beams. The fifteenth edition of the *Route 66 Dining & Lodging Guide*, published by the National Historic Route 66 Federation, calls the Magic Lamp Inn a "must stop."

The Cucamonga service station opened in 1919 and closed in the mid-1980s, and the adjoining garage built in 1910 collapsed in 2011. Suspension of a demolition order for the station served as the catalyst for refurbishment, which commenced with a fundraising initiative in 2013.

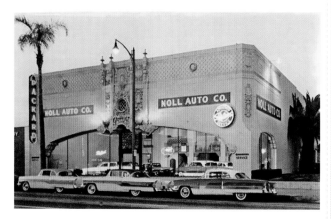

This classically styled **Packard dealership** still fronts Route 66 in **Santa Monica**. *Joe Sonderman*

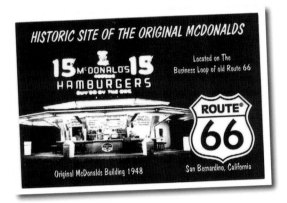

This postcard commemorates establishment of an American classic on Route 66. *Joe Sonderman*

San Bernardino

The Mitla Café opened at 602 North Mount Vernon Avenue (Route 66) in San Bernardino in 1937. Virtually unchanged from that period, the café consistently receives recommendations by Route 66 enthusiasts and in guidebooks.

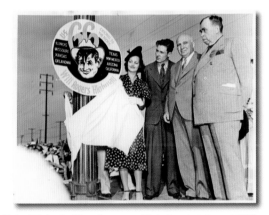

U.S. 66 in California was officially christened **Will Rogers Highway** in 1952. *Steve Rider*

Santa Monica

Palisades Park, overlooking the historic Santa Monica Pier, is located several blocks from the western terminus of Route 66, but it has a direct association with that highway. In January 1936, seven California communities appointed representatives to meet with the Los Angeles County Board of Supervisors to discuss designation of U.S. 66 in the state as the Will Rogers Highway. Shelved until 1952, the idea garnered new support from the U.S. Highway 66 Association, which saw a tremendous promotional opportunity in the release that year of the Warner

Brothers film *The Will Rogers Story* starring Jane Wyman and Will Rogers Jr. (The film premiered in the Route 66 community of Claremore, Oklahoma, the site of the Will Rogers ranch.)

After receiving approval to designate U.S. 66 the Will Rogers Highway, the association organized a caravan, with full press coverage, to drive to Palisades Park in Santa Monica, where a ceremony culminated with the placement of a bronze plaque. The plaque reads: "Will Rogers Highway. Dedicated 1952 to Will Rogers—humorist, world traveler, good neighbor. This Main Street of America, Highway 66, was the first road he traveled in a career that led him straight into the hearts of his countrymen."

Officially, the historic Santa Monica Pier is not on Route 66, because the western terminus for the highway is located several blocks east at the intersection of Lincoln Boulevard and Olympic Boulevard. Nevertheless, for more than seventy years, travelers have traditionally ended their Route 66 adventures at the pier, which dates to the 1909 construction of a replacement for the original pier built in 1893.

A catalyst for the tradition of considering the pier as the highway's terminus was the sign for a movie set that read, "Route 66—End of

TOP: Viewed from **Palisades Park**, the historic **Santa Monica Pier** is considered the traditional, if unofficial, terminus of Route 66. *Joe Sonderman*

ABOVE: **Santa Monica Pier** serves as the traditional western terminus for Route 66.

the Trail" and was placed on the pier in the late 1930s. In 2010, Dan Rice, owner of the 66-to-Cali souvenir shop on the pier, spearheaded an effort to replace that sign.

With its historic carousel, Pacific Palisades Amusement Park, restaurants, street performers, and vendors giving it a festive air, the Santa Monica Pier is almost always part of the travel plans for Route 66 enthusiasts.

Victorville is proud of its Route 66 association. *Judy Hinckley*

Victorville

Emma Jean's Holland Burger Café opened in Victorville in 1947. Located at 17143 D Street (Route 66), it remains, according to the National Historic Route 66 Federation, "a true mom & pop operation" and "a very special must stop."

The New Corral Motel opened in 1953 on 7th Street (Route 66) and immediately received favorable reviews from AAA. The *Westerns Accommodations Directory* published by that organization in 1954 noted that it was "a new motel within easy access to San Bernardino mountain resorts" with amenities that included "individually controlled air coolers; free radios; vented heat; tiled shower baths," all for a rate of six dollar per night. The New Corral's neon signage is a landmark for Route 66 enthusiasts traveling in California.

The signage at the **New Corral Motel** in **Victorville** dates to 1954. *Joe Sonderman*

Parks

Amboy Crater dominates the desert landscape at **Amboy.** For generations, it has inspired Route 66 travelers to explore the desert. *Joe Sonderman*

Amboy

The Bureau of Land Management preserves and maintains the trail system, as well as picnic area along Route 66, at Amboy Crater National Natural Landmark, located 2.5 miles southwest of Amboy. The Amboy Crater, with its 250-foot cinder cone, dominates the desert plain from the park, which also includes a portion of surrounding lava fields. Before the completion of I-40 bypassed this segment of Route 66, the crater was a popular stop for travelers. With the resurgent interest in the highway, the crater is again a favored destination.

Arcadia

Santa Anita Park, on West Huntington Drive (Route 66), opened as a thoroughbred racetrack on December 25, 1934. The art deco styling of the complex is an example of the work produced by acclaimed architect Gordon B. Kaufman.

The very first racetrack here opened at an adjacent site in 1904. The rural location hindered its development as a profitable entity, and it closed in 1909 before burning in 1912.

With the legalization of pari-mutuel wagering in California in 1933, numerous investor groups formed for the purpose of establishing racetracks in the state. A group of San Francisco investors headed by Dr. Charles H. Strub turned their

The **Santa Anita track** at **Arcadia** has extensive celebrity associations. *Joe Sonderman*

focus on the Los Angeles area when a suitable site could not be secured in the Bay Area.

Collaborating with a Los Angles investment group led by movie producer Hal Roach, they formed the Los Angeles Turf Club and established the Santa Anita Park. The first Santa Anita Handicap ran in February 1935 with an unprecedented purse of $100,000.

The stockholder list included such notable celebrities as Bing Crosby, Al Jolson, and Harry Warner. With the track's distinctive architecture, celebrity associations, carefully crafted promotion, and innovations such as starting gates and photo finishes for every race, investors received a 100 percent return on their investment in the first year.

Racing was suspended in 1942 when the park became a temporary relocation center for Japanese Americans awaiting transportation to internment camps. The track reopened in 1945.

Due to encroaching urban expansion, the park was included on the list of America's Most Endangered Historic Places in 2000. Listing on the National Register of Historic Places occurred in 2006.

Mojave National Preserve

The 1,538,015 acre Mojave National Preserve, which borders the pre-1932 alignment of Route 66 on the segment between Goffs and Fenner, encompasses a vast desert wilderness with the refurbished railroad depot at Kelso serving as the park headquarters. Established on October 31, 1994, with the passage of California Desert Protection Act by the U.S. Congress, it is the third largest preserve in the National Park System.

Preserved here are a number of unique natural sites, such as the Keslo Dunes, Cima Dome, and

TOP: The **Mojave National Preserve** borders Route 66 in eastern California.

ABOVE: The former railroad depot in **Kelso** serves as the visitor center for **Mojave National Preserve**. *Judy Hinckley*

other volcanic formations. Also incorporated into the Mojave National Preserve are Mitchell Caverns Natural Preserve and Providence Mountains State Recreation Area.

The historic Mojave Road bisects the preserve. A popular attraction for off-road enthusiasts, this roadway followed an early Native American trade route and was a primary path across the desert from the 1850s to the 1880s.

San Bernardino

The last remnants of a once-famous Route 66 location can be found in San Bernardino's Perris Hill Park (1350 South E Street) and Lytle Creek Park (380 South K Street). The round, cast-concrete picnic tables with steel rims originally graced Camp Cajon in the Cajon Pass along the National Old Trails Highway.

William M. Bristol conceived the idea of Camp Cajon as a picnic area where travelers could rest after attending the dedication of a Pioneers

After a devastating flood, **San Bernardino parks** used remnants of **Camp Cajon**. *Steve Rider*

Monument along the National Old Trails Highway in 1917, near the present intersection of I-15 and State Highway 138. Bristol, an inventor and orange grove owner, returned to the site in 1919 and pitched a tent in an old camping area known as Willow Grove.

His plan to create a roadside oasis quickly morphed into a camp with picnic tables, broilers, grills, and a large building to serve as a shelter and meeting place for groups. His organizational acumen soon garnered support and donations from the Elks and other organizations.

Camp Cajon was dedicated by the Elks on September 11, 1921, the same day that they opened a lodge on the opposite side of the highway. Commemorative plaques recognized everyone who made financial contributions and provided information about neighboring communities.

After certification of Route 66 in 1926, the park became a popular stop for travelers. During the Great Depression, it was a welcome refuge for weary travelers who had crossed the Mojave Desert and traversed the steep grades of the upper Cajon Pass.

Camp Cajon at **Cajon Pass** was an early oasis for motorists. *Joe Sonderman*

In 1937, heavy rains led to a devastating flood that decimated railroad and highway infrastructure in Cajon Pass, and destroyed Camp Cajon. Rather than rebuild the camp, business and community leaders in San Bernardino recovered the tables and plaques and installed them at the current locations in the city.

A monument to **Will Rogers** in **Palisades Park** obscures the real western terminus.

Santa Monica

The 26.4-acre Palisades Park, located along Ocean Avenue, overlooks the Pacific Ocean beaches and Santa Monica Pier. Established by real estate developers Arcadia Bandini Baker and John P. Jones (also a U.S. Senator) and deeded to the city with the stipulation that it forever remain a public park, it initially opened as Linda Vista Park in 1892. It was renamed Palisades Park in 1922.

Though not technically located on Route 66, the scenic **Palisades Park** has long been associated with the historic highway. *Joe Sonderman*

The first transformative improvements to the park occurred in 1913 with the installation of fences along the edges of the bluffs in the interest of public safety. Landscape architect I. G. Le Grande oversaw creation of a formal design that included winding footpaths and the planting of Canary Island date palms, eucalyptus trees, and Mexican fan palms.

Cliffside erosion has erased approximately thirty feet of the park's original acreage. The additions of memorials and statues have also contributed to the altering of its appearance.

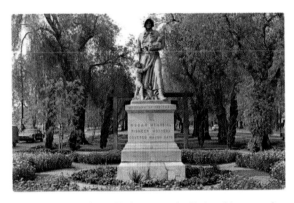

The **Madonna of the Trail** statue in **Upland** is one of two on Route 66. *Joe Sonderman*

Upland

Located in a small park at the intersection of Euclid Avenue and Foothills Boulevard (Route 66) in Upland, the Madonna of the Trail statue designed by sculptor August Leimbach was commissioned by the Daughters of the American Revolution in the early 1920s as one of twelve statues placed in cities along the course of the National Old Trails Highway (predecessor to Route 66) to celebrate that road's origins. The Upland statue is the westernmost of the twelve. An inscription at the base commemorates the expedition led though the area by Jedediah Smith in 1826.

Military

Japanese Americans by the thousands passed through the **Santa Anita** internment camp. *National Archives*

Arcadia

Established on June 3, 1918, Camp Arcadia and Ross Field (named in November 1918) utilized the grounds of the former Baldwin Race Track, currently the site of the Santa Anita Park racetrack. Camp Arcadia served as a primary processing center for the California National Guard 143rd Field Artillery Regiment. The camp and adjoining Ross Field also accommodated the 37th Balloon Company commanded by 2nd Lieutenant John H. Bishop.

Lieutenant Cleo J. Ross of the Army's Air Service was the school's namesake. Ross, an observer

RIGHT: Japanese Americans were interred at the **Santa Anita track** during World War II. *Library of Congress*

BELOW: **Camp Arcadia** was the base for the U.S. Army 37th Balloon Company, seen here during an inspection circa 1919. *Library of Congress*

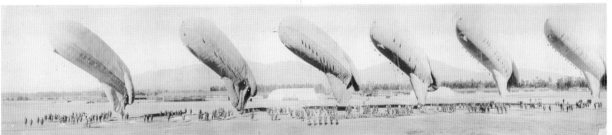

with the 8th Balloon Company, died on September 26, 1918, when his observation balloon came under attack from a German air squadron. Ross was the only balloon pilot killed in action during World War I.

In 1942, the prestigious Santa Anita Park served as the nation's largest processing and assembly area for Japanese Americans. More than 20,000 people were housed here during a seven-month period while they awaited transfer to internment camps.

Barstow

The Marine Corps Logistics Base in Barstow originated as the Marine Corps Supply Center in December 1942. Before that, it had been a U.S. Navy storage facility established in 1941. During World War II, the facility became the largest storage depot for Marine Corps supplies and equipment for forces in the Pacific Theater of Operations.

The base was expanded in 1945 to such a degree that it outgrew its original parameters, and an additional 2,000 acres were annexed from the United States Army Nebo Base in October 1946. The San Francisco supply depot was consolidated with the one at Barstow in 1954. In the spring of 1961, the base also became the site for the Depot Maintenance Activity Center. The present designation as the Marine Corps Logistics Base dates to November 1978.

The base constitutes three interlocking sites: Nebo Annex, Yermo Annex, and a small arms training and practice range. The base sits astride

The expansive military facility at **Barstow** dates to World War II. *Joe Sonderman*

the original course of Route 66 west of Daggett resulting in closure where the old highway connects with the east gate near Nebo Road.

Route 66 traversed a massive training site in World War II. *Library of Congress*

California-Arizona Maneuver Area

At 18,000 square miles, the California-Arizona Maneuver Area/Desert Training Center was the world's largest military facility. First established in 1942, numerous components of the camp continue to serve military-related functions today.

The parameters of the facility roughly extended from near Pomona, California, to near Phoenix, Arizona, and from south of Las Vegas, Nevada, to Yuma, Arizona. Major General George Patton Jr., commander of the I Armored Corps, played an instrumental role in the facility's establishment.

As Route 66 traversed the facility, the small desert communities along that road, such as Essex and Goffs, were greatly impacted by the presence of the training center. Several communities served as anchor points for the establishment of camps, service facilities, airfields, and, in the case of Essex, a POW camp.

Camp Ibis

Located nearly two miles north of the pre-1931 alignment of Route 66 (Goffs Road) and U.S. 95, Camp Ibis served as the headquarters for the 4th Armored Division under the command of Major General John S. Wood until June 1943. It also served as a logistical support center for the California-Arizona Maneuver Area/Desert Training

Center during World War II.

Established on November 8, 1942, the camp also served as a training center where troops learned desert survival skills and armored vehicle tactics. Most units that trained here later served with the 3rd Army under the command of General George S. Patton Jr. in North Africa and the European Theater.

From inception to closure, despite its large size, the camp remained a primitive base. At its height the facility included twenty-eight shower buildings for enlisted men and an additional fourteen for officers, served by a 50,000-gallon elevated storage tank and a 50,000-gallon concrete reservoir. Housing was in tents with wooden frames, and there was a shooting range for small arms, rifles, machine guns, and tanks.

At the end of World War II, the military collected or sold equipment and materials from Camp Ibis and destroyed unexploded ordnance. The camp officially closed on March 16, 1944, at which time it received a surplus designation. On May 31, 1951, the campsite transferred to Bureau of Land Management control.

Essex

Camp Clipper, also designated as Camp Essex, is adjacent to I-40 just northwest of the community of Essex. The first camp here was a temporary facility utilized by the 33rd Infantry Division for exercises for the California-Arizona Maneuver Area/Desert Training Center in 1942. With establishment of a permanent camp near the site and construction of primitive airstrip, it was officially designated Camp Essex. For a brief period, the camp served as a containment facility for Italian prisoners of war captured in North Africa.

Goffs

Established in 1942 on the perimeter of the community of Goffs, Camp Goffs was part of the 12-million-acre California-Arizona Maneuver Area/Desert Training Center. Conceived as a vast training center for the forces of General George S. Patton Jr. before the invasion of North Africa, it represented the largest military exercise area in history.

Camp Goffs utilized the historic school in Goffs but was largely a basic field encampment at the

railhead in this community. Adjacent to the camp was the Goffs Army Ammunition Depot No. 4, a rifle range, and a dramatically enlarged prewar civil airfield.

LEFT: During World War II, a major training facility centered on **Goffs**.
RIGHT: During World War II, the railroad ensured **Goff's** importance to the military. *Library of Congress*

Pasadena

The U.S. Court of Appeals building nestled on the Arroyo Seco, immediately south of the historic Colorado Street Bridge, originated as the Vista del Arroyo Hotel. During World War II, the hotel complex served as a military hospital.

During the late nineteenth and early twentieth century, Pasadena was a resort community for residents of the Los Angeles area and for winter visitors from the East and Midwest who arrived by rail. Built on this site during that period, the La Vista del Arroyo functioned as a boarding house that offered high-quality amenities.

Construction of the current building commenced in 1920 after the original La Vista del Arroyo was demolished. The Vista del Arroyo began as a modest complex, but additions in 1926 and 1930 transformed it into a posh resort reflecting Spanish Colonial architectural elements.

In 1943, the War Department purchased the hotel and converted it into a hospital and office complex. Originally named the Pasadena Area Station

The **Vista del Arroyo** Hotel served as a hospital in World War II. *Library of Congress*

Hospital and later the McCornack General Hospital, the complex served this purpose until 1949.

From 1951 to 1974, it operated as an office complex for various government and military agencies, including the General Services Administration. Closure and abandonment between 1974 and 1982 led to extensive deterioration, with additional damages from arson.

After extensive renovation, it reopened in 1985 as a federal court building. The upper floors were transformed into judges' chambers in the 1990s.

Rancho Cucamonga

The assassination of John Rains, a large property holder near the town of Cucamonga, and the murder of Ramon Carillo, the purported paramour of Rains' wife, Mercedes, ignited tensions between Americans and Californios in the 1860s. To quell the civil unrest that threatened development and farm production in the area, the United States Army established Camp Cucamonga near the town of Cucamonga on June 1, 1864.

Initially envisioned as a permanent military reservation, troops stayed only two weeks before receiving orders to relocate. During this short period, John H. Teal wrote extensively in his diary about the area. His journal entries provide the best historical portrait of the area during this period: "The prettiest & most valuable rancho I have seen in the west. There are 160,000 grape vines in the vineyard & apples, apricots, pears, peaches, wild cherries, figs, English walnuts & pomegranates in the orchard and springs that cover about 200 acres in an enclosed pasture of 500 acres, with good houses, cellars, and out houses."

San Bernardino

The namesake for Norton Air Force Base was Captain Leland Norton, a native of San Bernardino. Norton perished during World War II while serving his sixteenth combat mission in the European Theater after anti-aircraft fire disabled his A-20 Havoc over the marshalling yard at Amiens, France, on May 27, 1944.

Before the advent of World War II, the airfield operated as the San Bernardino Municipal Airport. During the summer of 1941, the Army Air Corps assumed management of the facility and transformed it into a training base for pilots.

On March 1, 1942, it received official recognition with the field being renamed San Bernardino Army Airfield and the San Bernardino Air Depot. Extensive renovations and upgrades between 1942 and the spring of 1943 included extended runways, new hangers, and warehouses.

In addition to serving as a training base during World War II, the facility provided administrative and logistical support for the expansive Desert Training Center in the Mojave Desert. In mid-1945, the base also began to serve as a processing and separation center for servicemen being discharged.

The base was transferred to the newly formed United States Air Force in 1948. Renamed Norton Air Force Base in 1950, the base evolved during the late 1940s and early 1950s to meet the needs of the Cold War. In 1953, it served as one of three jet engine overhaul centers and, with its extended runaways, was able to accommodate Strategic Air Command aircraft.

During the 1960s the base's role expanded to include support missions for the Titan and Atlas Intercontinental Ballistic Missile systems. It was deactivated in April 1994, and the facility currently serves as the San Bernardino International Airport. In the early part of the twenty-first century, portions of the complex opened as an industrial complex and distribution center.

Victorville

Originally designated the Victorville Army Flying School upon completion in 1943, and later

known as the Victorville Army Airfield and the Victorville Air Force Base, George Air Force Base received its final designation in June 1950. Its namesake was Brigadier General Harold Huston George, a World War I ace who directed air operations on Bataan at the beginning of World War II.

Construction of the base commenced in 1941 and was designed to serve as a flight training school. Training began at the facility in February 1942, with the first class of flying cadets graduating on April 24, 1942. Additional classes were instituted for training glider operators in 1943 and, after March 1944, for pilots of single-engine pursuit planes such as the P-39 as well as heavy bombers, the B-24 and B-25.

Operations ceased at the base in October 1945, and it became a storage facility for surplus aircraft. After establishment of the United States Air Force in 1948, the 2756th Air Base Squadron was the caretaker for the facility.

Reactivated in 1950 as George Air Force Base, the facility initially operated under Continental Air Command, but on July 23, 1951, the base became a component of the Strategic Air Command. In November 1951, it again underwent leadership transfer, this time to Tactical Air Command.

Officially decommissioned in December 1992, a large segment of the old base currently serves as an urban warfare training center for the United States Army and the Marine Corps. Another segment of the facility serves as part of the three-prison Federal Correctional Complex at Victorville.

Crime and Disaster

Arcadia

In the early morning hours of July 19, 1927, patrolman Albert E. Matthies stopped to investigate three men sitting in a car in the shadows near the intersection of Northview and Laurel. As the officer approached, an assailant in the back seat opened fire, killing Matthies instantly. The suspects fled the scene but were arrested in the stolen car shortly afterwards. Investigators learned

that officer Matthies had interrupted the robbery of the Wigwam Barbeque on Foothill Boulevard (Route 66).

On July 19, 2007, Arcadia Police Chief Robert Sanderson presided over a dedication ceremony commemorating Officer Albert E. Matthies, the only city police officer killed in the line of duty. The ceremony at the intersection of North View and Foothill Boulevard included sub-naming North View as Officer Albert Matthies Way.

On February 25, 1959, officers Bill Mitter and Jack Renner responded to a call pertaining to a robbery in progress at a market on the corner of Santa Anita and Foothill Boulevard. Upon arriving, both officers were wounded in an ambush, and the perpetrators, who were never identified or apprehended, fled east on Foothill Boulevard.

Azusa

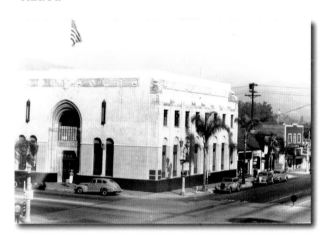

Daring robbers hit the **First National Bank** in **Azusa** several times in the 1940s. *Joe Sonderman*

Helendale

Now erased from the roadside, the Sage Brush Inn near Helendale was a popular roadhouse in the late 1930s and 1940s. In 1938, the sheriff department responded to a disturbance call here, a not uncommon occurrence at the time. According to newspaper accounts, Edith Todd had attempted to "entice" Loren Daniel into a dance. Apparently, Thelma Kelton had similar ideas and attacked Todd. When deputies arrived, they discovered Kelton choking Todd after knocking her to the floor during an assault with a heavy glass ashtray.

Needles

In August 1959, a summer deluge flooded the streets in Needles and extensively damaged the Route 66 infrastructure west to the junction with Highway 95. Six members of a Santa Fe Railroad crew who were dispatched to evaluate track conditions west of town vanished when fast-moving waters in a streambed washed their truck from the road, and only two survived.

Bridge washouts between Needles and Essex forced rerouting of all railroad traffic for weeks. More than one hundred telephone poles were downed in the storm, greatly affecting the area's communications infrastructure.

Similar conditions forced the closure of Route 66 for more than twelve hours and required the construction of detours, which caused traffic to bottleneck for months to come. Incredibly, there were no highway fatalities even though rushing water swept eight vehicles from the road.

San Bernardino

On December 29, 1945, Arthur Eggers murdered his wife, Dorothy, at their Temple City, California, home, dismembered the body, followed Route 66 east, and then disposed of the torso in a ravine. On January 2, 1946, the same day his wife's torso was discovered, Eggers, who was employed in the Temple City Sheriff's substation, filed a missing persons report. According to the report, he had last seen his wife three days prior.

Eggers initially confessed to the murder after his arrest on January 22, claiming that a lengthy history of promiscuity on her part was the catalyst. After providing conflicting details that prompted an intensive search for the missing hands, head, and feet along Route 66 and into the mountains, he recanted the confession, leaving police with little hard evidence.

Persistent investigation determined that Eggers had sold his wife's engagement and wedding rings to a jeweler on Colorado Boulevard (Route 66) in Pasadena for ten dollars and used a fictitious name. Eggers explained that he feared discovery of the rings at the house would implicate him or cause suspicion.

Two weeks later, Eggers sold his car to a deputy at the substation with the promise that problems with the title, in his wife's name, would be resolved shortly. Investigators later learned he had forged his wife's signature, after unsuccessfully attempting to coerce a niece into signing the title.

Aware of the missing persons report filed by Eggers, the deputy became suspicious and requested forensic investigation of the car. Traces of human blood in the trunk led officers to investigate Eggers' home. The discovery of additional blood in the garage proved to be only the first damning evidence. In the cellar, they recovered a .32 caliber pistol that ballistics matched to the two bullets in the torso discovered in Cajon Pass, and a wood saw had bits of blood and bone in the teeth.

The trial in San Bernardino that followed Eggers' arrest and a new confession presented the press with a bizarre story that gripped a public consumed with morbid curiosity. According to transcripts, "Eggers told the jury that his marriage to Dorothy had been a happy one until two years before her death. She then informed him, he declared, that she was starting the change of life and subsequently she had been difficult to get along with. He also mentioned having heard rumors that his wife had gone to dances and picked up men, but because he trusted her he did not give it much thought."

Eggers claimed that, as he approached his home at 1:00 a.m. after an evening shift on the December 28, "I heard the front door slam and saw a man coming from the house, and walk hurriedly down the street." He also claimed that, after entering his house, he discovered his wife naked in the bedroom.

According to further testimony, Eggers grabbed a gun, struggled with his wife, and then fell on her when the gun discharged. Oddly enough, Eggers also claimed to have panicked, drove to Long Beach where he spent the rest of the night, drove home, and went to sleep.

The jury returned a unanimous verdict of guilty of murder in the first degree. An appeal hearing on October 3, 1947, upheld the verdict, and Eggers was executed in the gas chamber at the state prison in San Quentin on October 15, 1948.

Victorville

On February 12, 1960, Dennis Whitney murdered attendant Jimmy Ryan during a robbery at a service station on 7th Street (Route 66) in Victorville. As Whitney explained after his arrest, "I

The **Greenspot Motel** in **Victorville** is associated with the murder of Benjamin Wu. *Judy Hinckley*

did one and I thought I just might as well go on. I planned to kill maybe a dozen or so. I was fed up. I was broke. I thought I'd better get some money somehow."

The robbery and murder in Victorville, as well as the following six murders and robberies in Arizona and Florida, marked the culmination of a criminal career that began in 1955 when at age twelve Whitney was involved in an armed robbery. For the murders in Florida, Whitney received a sentence of life in prison in June 1960.

Film and Celebrity

Amboy

The stark landscapes that embrace Amboy, and international recognition of the town's historic signage and buildings, have ensured a lengthy association with motion pictures and commercial promotions. A partial list of movies with scenes filmed in Amboy include *The Hitcher* (1983), *Kalifornia* (1993), *That Summer in LA* (2000), *Devil Girl* (2007), *The 27 Club* (2008), *Live Evil* (2009), *Beneath the Dark* (2010), and *Lonesome Matador* (2010).

A number of celebrities have also visited Amboy, and Harrison Ford reportedly flew his private plan into Amboy on several occasions.

Apple Valley

Apple Valley, immediately to the north of Victorville, is the site of Murray's Dude Ranch, a historic complex that was destroyed in a training exercise for the Apple Valley Fire Department in 1988. Established in 1926 by Nollie B. Murray, a prominent African American businessman in Los Angeles, Murray's Dude Ranch was promoted as the "The World's Only Negro Dude Ranch."

Through the 1930s and 1940s, the property evolved into a resort that included cottages, swimming pool, stables, and tennis courts. During the 1930s, the ranch served as the setting for four western films with all African American casts and with Herbert Jeffries (billed as Herbert Jeffrey) in the starring role as a singing cowboy. These films were *Harlem on the Prairie* (1937), *Two Gun Man from Harlem* (1938), *The Bronze Buckaroo* (1939), and *Harlem Rides the Range* (1939).

Acknowledging his contributions to film and television, Jeffries is commemorated with a star on the Hollywood Walk of Fame, at 6672 Hollywood

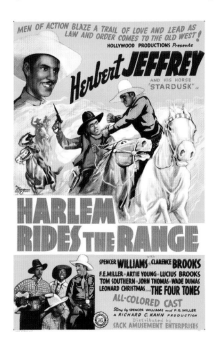

Murray's Dude Ranch in **Apple Valley** served as the set for a series of western films starring Herbert Jeffries.

Boulevard. In 2004, he was recognized for his contributions to the music industry with induction into the Western Performers Hall of Fame at the National Cowboy and Western Heritage Museum in Oklahoma City.

During World War II, Murray's Dude Ranch hosted USO tours for African American servicemen assigned to the military facilities in the Victorville area. It was during these tours that Pearl Bailey became familiar with the ranch. In 1955, Bailey purchased the property with her husband, Louis Bellson, a drummer who had played with the Duke Ellington, Tommy Dorsey, Harry James, and Benny Goodman bands. They maintained operations at the dude ranch until its sale in 1964.

Arcadia

Located at 301 North Baldwin Avenue near the intersection with Colorado Boulevard (Route 66), the Los Angeles State and County Arboretum has been featured in more than 200 movies and television programs, including eight Tarzan films, *The African Queen* starring Humphrey Bogart and Katherine Hepburn, and *Road to Singapore* starring Bob Hope and Bing Crosby. Before a replica was constructed on a Hollywood studio lot, the Queen Anne styled cottage at the arboretum also appeared in the opening scenes of the television program *Fantasy Island*. It was here that Herve Villechaize's character, Tattoo, rang the bell in the tower and yelled, "da plane, da plane."

Numerous movies with horse-racing themes were shot at the Santa Anita Park racetrack. A partial list of these films includes *Charlie Chan at the Race Track* (1936), *The Ex-Mrs. Bradford* (1936), the Marx Brothers' *A Day at the Races* (1937), *Thoroughbreds Don't Cry* (1937), *Hollywood Handicap* (1938), Frank Capra's *Riding High* (1950), and *Seabiscuit* (2005). In addition, celebrities Joe E. Brown, Bing Crosby, Al Jolsen, and Harry Warner were all stockholders in the original racetrack.

Before establishment of Santa Anita Park, a portion of the grounds served as Camp Arcadia and Ross Field during World War I. Camp Arcadia served as a processing center for the California National Guard 143rd Field Artillery Regiment, a unit that had awarded actress Mary Pickford the status of honorary Colonel of the Regiment. The resultant

association led to the unit's unofficial designation as "Mary Pickford's Fighting Six Hundred."

John H. Hoeppel, later a U.S. Representative from California, served at Camp Arcadia during World War I. He later spearheaded efforts to gain approval from Army Chief of Staff General Douglas MacArthur to transfer 183 acres of the Ross Field Balloon School to Los Angeles County.

Restaurants with cultural importance also have links to Route 66 in Arcadia. The first McDonalds to employ the golden arches as an architectural element opened on Foothill Boulevard (Route 66) in 1954.

Bagdad

Bagdad is now a ghost town with few discernable traces to its history that dates back to 1883. The original Bagdad Café, owned by Alice Lawrence and located along Route 66, was the setting for the novel and motion picture *Bagdad Café*, although the actual filming location was the Sidewinder Café in nearby Newberry Springs.

The original **Bagdad Café** in **Bagdad** inspired a book and movie. *Joe Sonderman*

Barstow

The streets of Barstow and the surrounding desert landscapes have appeared in a variety of motion pictures. The film *The Trap*, released in 1959, contains several scenes filmed in the area. Although somewhat obscure today, the movie featured such notable stars as Lee J. Cobb, Earl Holliman, Lorne Greene, and Richard Widmark, as well as future stars like Tina Louis of *Gilligan's Island* fame.

The 1959 film *The Trap* is just one of many movies that have had scenes shot in **Barstow**.

Barstow and neighboring portions of Route 66 also appear in scenes in the 1986 thriller *The Hitcher*.

Beverly Hills

The All Saints Episcopal/Anglican Church at 504 N. Camden Drive (at the corner Santa Monica Boulevard, Route 66) was the filming location for the wedding scene in the 1979 comedy *10* starring Dudley Moore and Bo Derek. The church also held the funeral service for Humphrey Bogart in 1957, with Marlene Dietrich, Danny Kaye, David Niven, Gregory Peck, Dick Powell, and other celebrities in attendance.

The All Saints Episcopal/Anglican Church was the site of Humphrey Bogart's funeral in 1957.

Cajon Pass

The Summit Inn opened in 1952 at the head of Cajon Pass, where the restaurant and service station served as an important stop for travelers climbing either side of the pass. Elvis Presley once stopped here and reportedly kicked the jukebox when he discovered that none of his records was available. Other confirmed celebrity sightings at the Summit Inn include Pearl Bailey, Pierce Brosnan, Sammy Davis Jr., Clint Eastwood, and Frank Sinatra.

Now a shell of its former glory, the **Stone Hotel** in **Daggett** hosted numerous celebrities in its heyday.

Daggett

The forlorn, unassuming Stone Hotel, which dates to the 1880s, welcomed many notable guests during its history, including naturalist John Muir, whose daughter resided in Daggett. One room in the hotel was used as an office by Walter Scott, better known as Death Valley Scotty, a prospector, performer, and con man in the late 1800s and early 1900s. Persistent legend has it that Wyatt Earp ran a faro table in the hotel, but there is no evidence to support the story, although his family did have land holdings in the area.

The Route 66 corridor in Daggett appears in several motion pictures. The list includes *The Grapes of Wrath* (1940), *Bagdad Café* (1987), and *Dead Giveaway* (1995).

Essex

In 1977, the desert hamlet of Essex enjoyed a brief moment of international acclaim when a feature story in the *Los Angeles Times* described Essex as the last community in the continental

The quiet, isolated town of **Essex** was the last community in the United States to obtain television service.

Links to Hollywood history abound along Route 66 in this city. *Judy Hinckley*

United States to be without television service, due to its remote location. As a result of the story, the entire population of thirty-five residents appeared on *The Johnny Carson Show*. This led a manufacturer in Pennsylvania to donate the equipment needed to bring television service to the community.

Goffs

On April 10, 1992, comedian Sam Kinison died in a car accident on U.S. 95 (the pre-1931 alignment of Route 66) between Needles and Goffs, approximately four miles north of the junction with I-40. Kinison was driving to Laughlin, Nevada, in his 1989 Pontiac Trans Am when a pickup truck driven by an intoxicated seventeen-year-old crossed the centerline and struck Kinison's car head on.

Hollywood

The Formosa Café at 7156 Santa Monica Boulevard has humble origins as a small restaurant, the Red Post, housed in a former trolley car. Jimmy Bernstein, a retired prizefighter, established the original restaurant in 1925. Its location across from United Artist Studios along Route 66 (after the realignment of 1936) ensured a brisk business even during the Great Depression. Near-continuous expansion of the property continued through the late 1940s.

As of 2013, the restaurant that opened in 1934 appeared as it did in about 1950. This time

capsule feel and appearance, as well as the autographed photographs hanging on the wall from celebrities such as Humphrey Bogart, James Dean, Elvis Presley, Frank Sinatra, and Elizabeth Taylor, make it a favored stop for enthusiasts of both Hollywood and Route 66.

The restaurant is also associated with key moments and people in cinema history. Sinatra celebrated with chicken chow mein the day after he won an Academy Award for his performance in *From Here to Eternity*. Director Curtis Hanson met with Kevin Spacey and Kim Basinger here and initiated discussions pertaining to their roles in 1997's *L.A. Confidential*. Elvis Presley was a regular customer during the filming of *Kid Galahad*. Clark Gable and Marilyn Monroe often discussed script issues over dinner while working on the *The Misfits*.

In addition, several films were shot here. These include *L.A. Confidential*, *Swingers* (1996), *Still Breathing* (1998), and *The Majestic* (2001) starring Jim Carrey.

Los Angeles

From November 1926 until January 1, 1936, the intersection of 7th Street and Broadway in Los Angeles served as the western terminus of U.S. 66. It was at this intersection that Buster Keaton

filmed the climactic final scenes of *Go West*, released in 1925. In the sequence, Keaton filmed a cattle stampede through Los Angeles using 300 head of steers and cowboys to keep the cattle from veering onto side streets and to control automobile traffic. A number of celebrities, including Fatty Arbuckle, made cameo appearances in the scene.

Located at 6000 Santa Monica Boulevard in the Hollywood District, the Hollywood Forever Cemetery (formerly Hollywood Memorial Park Cemetery) is one of the oldest cemeteries in the city. Established in 1899 on more than one hundred acres deeded by developer Isaac Lankershim and his son-in-law, Isaac Van Nuys, forty acres were sold to Paramount and RKO Studios in 1920, leaving the property at its current size of sixty-two acres. Within the remaining acreage, a section designated the Beth Olam Cemetery served as a dedicated cemetery for the area's Jewish community.

When Jules Roth, a convicted felon, acquired the property in 1939, the cemetery entered a period of decline. Monuments and crypts that marked the final resting places for pioneering developers and Hollywood's elite during the 1910s and 1920s fell into disrepair. Utilization of wells on the property rather than city water resulted in periods of drought that devastated the park. There were also claims of mismanagement of the perpetual care endowment fund.

In the 1990s, the state of California revoked the cemetery's license to sell plots, and in 1997, one year before his death, Roth declared bankruptcy.

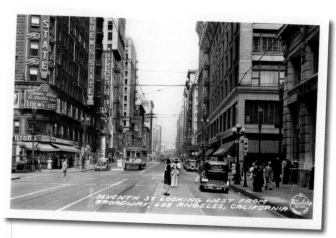

Buster Keaton stampeded cattle through this intersection in the final scenes of *Go West*. *Joe Sonderman*

Tyler and Brent Cassity, funeral home owners from Missouri, purchased the property in 1998.

The new owners transformed the cemetery with extensive renovations that included the addition of state of the art kiosks to play documentaries about the deceased, and the name was changed to Hollywood Forever Cemetery. In addition, they offered organized tours, created a website with short documentaries about celebrities, and created a site map of the cemetery, all of which attracted film and celebrity enthusiasts.

An innovative program called Cinespia was initiated in 2002. The summer evening film festivals, with movies projected on the white marble wall of the Cathedral Mausoleum, attract crowds numbering in the thousands, who arrive with

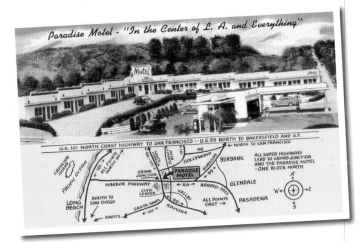

The **Paradise Motel** central location for the ensured its popularity. *Joe Sonderman*

The **Hollywood Forever Cemetery** is a landmark and time capsule of Hollywood history. *Judy Hinckley*

chairs and blankets to sit on the Fairbanks Lawn, as do the music festivals launched here in 2009.

The list of those interred in this cemetery reads like a Who's Who of early Hollywood: Mel Blanc, Cecil B. DeMille, Douglas Fairbanks, John Huston Tyrone Power, Ann Sheridan, and Carl Switzer. Hollywood Forever Cemetery is the final resting place for many non-Hollywood celebrities as well, including Bert Adams, a Major League Baseball player from the 1910s; Elmer Berger, inventor of the rear-view mirror; William Andrews Clark, founder of the Los Angeles Philharmonic; and Benjamin "Bugsy" Siegel, the gangster famous for transforming Las Vegas into a resort city.

In recent years, the cemetery has appeared in many television programs and movies, including several documentaries.

Another film location, at 4720 Eagle Rock Boulevard (the course of Route 66 in 1934), is Pat and Lorraine's Coffee Shop, where several scenes for Quentin Tarantino's 1992 picture *Reservoir Dogs* were filmed.

Ludlow

The Ludlow Café served as a filming location in the movie *Kalifornia* (1993). The café and Route 66 corridor also appear in *Due Date* (2010).

Mining has decimated the Pisgah Crater located west of Ludlow, but the volcano has a place in cinema history. The black sands and cinders at the crater site and surrounding lava fields were used by Clint Eastwood to transform the beach at Leo Carillo State Beach in Malibu into a facsimile of the beaches at Iwo Jima during filming of *Letters from Iwo Jima*, released in 2007.

Monrovia

At the intersection of Royal Oaks and Shamrock (Route 66), a circa-1925 service station retains a great deal of historic authenticity enhanced with the inclusion of period-correct features such as gasoline pumps. The station serves as a backdrop for a number of films set in the pre-1930s period.

Needles

Needles has a surprisingly lengthy association with literature, film, and music. References to the town are as diverse as John Steinbeck's *The*

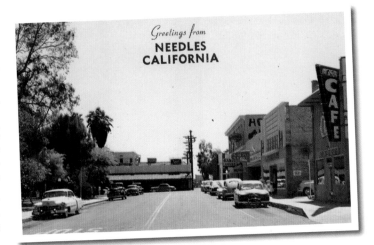

Numerous films have used **Needles** as a setting.
Joe Sonderma

Grapes of Wrath and the lyrics to "Never Been to Spain," written by Hoyt Axton, the title track on a CD released by John Lowery. Among the movies with scenes filmed in Needles are *Two Lane Blacktop* (1971), *Convoy* (1978), *Repo Man* (1984), and *Into the Wild* (2007).

An episode of the television program *Route 66* entitled "The Strengthening of Angels" contains scenes filmed in Needles, as does a second season (1968) episode of *Mission Impossible* entitled "The Town." It was also featured in an episode in the sixth season of *Sex and the City*.

Numerous films used **Needles** as a setting, including 1978's *Convoy*, starring Kris Kristofferson.

Celebrity associations are equally as diverse. Cartoonist Charles Schulz, best known for the *Peanuts* comic strip, lived in Needles in 1928 and 1929. Former First Lady Eleanor Roosevelt once spoke at a forum established by the Needles School District. In late 2000, skateboarder Tony Hawk donated $10,000 for development of the city's skate park and attended the grand opening in January 2004.

The Sidewinder Café, now Bagdad Café, served as a set for a movie by the same name.

Newberry Springs

The most famous movie-related site in Newberry Springs is the Bagdad Café, formerly the Sidewinder Café. The café served as a primary location in the 1987 film *Bagdad Café*. Newberry Springs was also used in scenes for *A Guy Walks Into a Bar* (1997) and *That Summer in LA* (2000).

Pasadena

Built in 1913 to span the Arroyo Seco, the classically styled Colorado Street Bridge developed an unsavory reputation during the Great Depression as a common location for individuals to commit suicide. Ironically, in the classic 1921 film *The Kid*, Charlie Chaplin rescues a suicidal woman on this bridge.

The Colorado Street Bridge also figured prominently in *Roman Scandals*, released in 1933. The film, starring Eddie Cantor, provided Lucille Ball with her first major role in a motion picture.

The historic **Colorado Street Bridge** in Pasadena appears in numerous vintage movies including *The Kid*.

The historic Rialto Theater in South Pasadena is a key location in Robert Altman's 1992 film *The Player*. The movie starred Tim Robbins as an unprincipled studio executive named Griffin Mill.

TOP: Built in 1913, the historic **Colorado Street Bridge** in **Pasadena** appears in the classic Charlie Chaplin movie *The Kid*.

ABOVE: The **Colorado Street Bridge** is listed in the National Register of Historic Places. *Judy Hinckley*

Rancho Cucamonga

Rancho Cucamonga is a community that was created from the combining of Alta Loma, Etiwanda, and Cucamonga in 1977. Cucamonga and Rancho Cucamonga have served as fodder for comedians for decades. Referenced in numerous songs and as the setting for a variety of motion pictures and television programs have ensured extensive name recognition.

On the Jack Benny radio program, Mel Blanc, as an announcer, referenced Cucamonga in the program's introduction. The popularity of the program led to the commissioning of a statue of Jack Benny in Rancho Cucamonga.

Cucamonga is also referenced often in classic Bugs Bunny cartoons, which were created and voiced by Mel Blanc.

Rancho Cucamonga is the principal setting for the motion picture *Next Friday* (2000). Cucamonga is referenced on the *Bongo Fury* album released by Frank Zappa in 1975, a Grateful Dead album released in 1974, and in a Saturday Night Live skit with Justin Bieber in 2013.

Celebrities born in or associated with the city include Matt Rogers, a football coach and host of *Really Big Things* on the Discovery Channel. Destroyed in the 1964 widening of Archibald Avenue was Studio Z, a recording studio owned by Frank Zappa.

The iconic **Wigwam Motel** in **Rialto** served as a set in *Crazy Mama*.

Rialto

Scenes for *Crazy Mama* (1975) were filmed at the now iconic Wigwam Motel located at 2728 W. Foothill Boulevard (Route 66) in Rialto. This motel and the similarly constructed motel in Holbrook, Arizona, were the inspirations for the Cozy Cone Motel in the animated film *Cars*.

San Bernardino

On November 19, 1954, entertainer Sammy Davis Jr. was returning from Las Vegas when he lost control of his car while trying to avoid a collision with a vehicle that had pulled on to Cajon Boulevard (Route 66) from Kendall Drive (City 66). Resultant of the accident, Davis lost his left eye, wore an eye patch for six months after the accident, including during an appearance on *What's My Line*, and was later fitted for a glass eye.

Celebrity association with the city of San Bernardino also includes actors Kirk Harris and Gene Hackman; Merritt B. Curtis, a Brigadier General in the Marine Corps and 1960 candidate for president of the United States; and Robert Waterman, former governor of California. Additionally, the city is the birthplace of golfer Dave Stockton, astronaut Michael R. Clifford, and Derel Parra, a medal-winning speed skater at the 2002 Winter Olympics.

Norton Air Force Base, currently the San Bernardino International Airport, served as a setting for the filming of several television programs. The episode of *The Twilight Zone* entitled "The Last Flight" that aired on February 6, 1960, included scenes filmed here with stunt pilot Frank Tallman. The base also served as a setting for scenes in *The Fast and the Furious* (2001).

Santa Monica

The La Monica Ballroom on Santa Monica Pier opened on July 23, 1924, featuring a prominent Spanish façade and French Renaissance style interior designed by T. H. Eslick. At 15,000 square feet, it was the largest dance floor on the West Coast and could accommodate 5,000 dancers.

In 1948, television broadcasting pioneer and country music performer Spade Cooley began broadcasting a weekly show from the ballroom. By 1950, his *Hoffman Hayride* program had become so popular that an estimated 75 percent of homes in the Los Angeles area with televisions tuned in on Saturday evenings. The show ran until 1954. Cooley and his band had previously played at the ballroom for eighteen

months, beginning in 1943, and broken all attendance records.

In 1955, renovations transformed the ballroom into the Hollywood Autocade, a specialty car museum. Among the vehicles displayed here was Jack Benny's trademark Maxwell.

The first carousel at the Santa Monica pier and establishment of the pier as an amusement park were the work of Charles Loof, a world-famous wood carver and builder who specialized in carousel construction. He built the first carousel at Coney Island in New York in 1876.

The pier's now-iconic carousel has appeared in several major motion pictures, including the 1965 classic *Inside Daisy Clover* starring Natalie Wood and Robert Redford; 1973's *The Sting*, starring Redford and Paul Newman; and *They Shoot Horses, Don't They* (1969) with Jane Fonda.

The pier also served as a setting for several scenes in *Forest Gump* (1994), *The 27 Club* (2008), and *Iron Man* (2008). Other films containing scenes shot on the pier include *Bean*, *Dark Ride*, *Elmer Gantry*, *A Night at the Roxbury*, *Not Another Teen Movie*, *Ruthless People*, and *Titanic*.

In addition, Santa Monica Pier has also been featured in video games, music videos, and television programs. The *Grand Theft Auto* franchise features a pier based on Santa Monica's. It also appears in *Tony Hawk's American Wasteland*.

Along Santa Monica Boulevard (Route 66) are numerous other recognizable film locations, such as Hollywood Star Lanes in 1998's *The Big Lebowski*.

Upland

An eclectic array of sports figures and celebrities were born in Upland. This list includes Eddie Lawson, professional motorcycle racer; Litefoot, a Native American rap artist; Chad Moeller, a Major League baseball player; Tiffany Mynx, an actress and director in the pornographic film industry; and Alexis Serna, a player for the Canadian Football League.

Numerous movies were filmed in **Victorville** and the surrounding area including *It. Joe Sonderman*

Victorville

Locations in and around Victorville have been used in a variety of film shoots. Before World War II, two major films, *Stanley and Livingstone* (1939) and *The Harvey Girls* (1942), contain scenes filmed here.

Victorville served as the fictional town of Sand Rock, Arizona, for the 1953 film *It Came from Outer Space*. The unique rock formations in the surrounding desert also appear in numerous scenes. The 1986 thriller *The Hitcher* starring Rutger Hauer utilized locals as extras and the Outpost truck stop as a primary set. Additional films shot here include *Grand Theft Auto* (1977) starring Ron Howard, Wes Craven's *The Hills Have Eyes* (1977), *Breakdown* (1997), *Contact* (1997), *Face Off* (1997), *Play It to the Bone* (1999), *Kill Bill: Volume 2* (2004), and *The Fast and the Furious: Tokyo Drift* (2006). In addition, the music video for "Times Like These" by the Foo Fighters utilized D Street as a set.

The Green Spot Motel, originally part of the Green Spot Annex, has associations with the motion picture industry. John Houseman and Herman J. Mankiewicz wrote the initial drafts for the *Citizen Kane* script here. In 1982, actress Kay Aldridge acquired the motel with plans to renovate it.

The California Route 66 Museum on D Street (between 5th Street and 6th Street) is located in a building that once housed the Red Rooster Café. Filmed in this café were scenes for the 1980 version of *The Jazz Singer* starring Neil Diamond.

The nearby George Air Force Base has served as a filming location for such movies as *The*

The initial drafts of *Citizen Kane* were written at the **Green Spot Motel**.

Starfighters, *The War of the Worlds*, and *Face Off*, among others. In addition, episodes of the television program *Six Million Dollar Man* contain scenes filmed at the base.

West Hollywood

Established by John "Barney" Anthony in 1927 at 8447 Santa Monica Boulevard, Barney's Beanery is the third oldest continuously operated restaurant in Los Angeles County. Simple and reasonable food, and a charitable owner, made the restaurant a haven for struggling writers, actors, musicians, actresses, and other celebrities during the 1930s.

Barney's Beanery evolved as the business prospered. As late as the 1940s, it still reflected its rural origins and the shoestring budget with which Anthony had started it in 1927. In 1942, journalist Rob Wagner Script described the restaurant as "a little wooden shanty, with a whole row of cheap floor lamps illuminating the counter, and a dinky little bar down at one end."

Described variously as a "Route 66 diner," a "juke joint and pool hall," a "beatnik hangout," and "a place where movie people go to let their hair down," the Beanery became a regular hangout for the rich and famous in the movie industry. During the 1930s, regular customers included John Barrymore, Clara Bow, Errol Flynn, and Jean Harlow. In the postwar years, clientele such as Bette Davis, Clark Gable, and other "A-list" celebrities made the restaurant a favorite destination for tourists looking to spot a movie star.

A key to the restaurant's success and its allure for movie stars was Anthony's generosity. In 1945, an issue of *Hollywood Nightlife* magazine featured a profile of the restaurant and noted that "Barney Anthony is a name known to most writers who at one time or another have been broke in this town. Barney has always made sure they had food and a little cash to tide them over."

In the postwar years and into the 1950s, the restaurant morphed into the sprawling complex that it is today. During this period, Anthony began catering to his celebrity clientele by utilizing modern technologies. An electrical engineering student and itinerant inventor from the University of Southern California installed a gadget similar to a garage door opener in an old-fashioned lantern. Select customers provided with a control could signal the restaurant in advance to let them know how many would be in their party.

Barney's Beanery has a celebrity association spanning decades. *Joe Sonderman*

The modern incarnation of **Barney's Beanery** masks its rural beginnings.

During the counterculture movement of the 1960s, the restaurant began to attract a new kind of celebrity. Janis Joplin favored booth No. 34. Jim Morrison became a regular customer. In 1970, the bands Led Zepplin and Fairport Convention closed out an evening at the world-famous beanery.

Barney Anthony passed away on November 25, 1968, and Erwin Held acquired the restaurant from the estate. Held intended to keep the restaurant as original as possible, but societal changes necessitated adjustments.

A 1958 article in *Torch Reporter* entitled "Barney's Unique Signs" noted that over the bar was a large pink board with black labeling that read, "Fagots – Stay Out." A 1964 *Life* magazine article on the emerging gay culture featured an article with a photograph of a defiant Barney Anthony posing in front of this sign.

On Saturday, February 7, 1970, the Gay Liberation Front led a picket of the restaurant to have the sign removed. Held succumbed and removed the offensive sign.

The restaurant continues to be a favored location for celebrities, Route 66 enthusiasts, and locals. As a result, it still serves as a venue for public protests. In 1999, California initiated a ban on smoking in restaurants and bars. Comedian Drew Carey initiated a protest by inviting press to the bar at Barney's Beanery to watch him and friends smoke.

Two other locations in the immediate area also have celebrity associations. An article in the *Reno Evening Gazette* dated January 13, 1962, chronicles a tragedy that occurred on Santa Monica Boulevard. "Ernie Kovacs, the cigar-chomping comedian who rose to fame in five brief years, was killed early today when his station wagon skidded on wet pavement and smashed into a utility pole. The forty-three-year-old Kovacs, reportedly on his way home alone from a party in honor of Mrs. Milton Berle, was thrown from his car, police said. The smashup occurred shortly before 2 a.m. on Santa Monica Boulevard in West Los Angeles."

At 8431 Santa Monica Boulevard (Route 66) stands the building where Mel Gibson attempts to negotiate with a suicidal man in the 1987 film *Lethal Weapon*.

Transitional Sites

TOP: Bypassed in 1958, this segment near **Victorville** was an original alignment of Route 66.

ABOVE: Route 66 in the **Cajon Pass** with I-15 in the background. *Judy Hinckley*

Barstow–Victorville

The opening of the freeway between Barstow and Victorville (now the course for I-15) on December 13, 1958, resulted in the realignment of Route 66 and the bypass of the segment of that highway that had followed the course of the National Old Trails Highway through the Mojave River Valley. The intersections of the two alignments in Victorville and Barstow reflect stark contrasts in highway engineering as well as societal transportation needs.

Cajon Pass

Route 66's evolutionary history is encapsulated in the Cajon Pass, the primary corridor between the Mojave Desert and the coastal valleys of what is now the Los Angeles metropolitan area. In addition, the pass contains remnants from predecessor roadways, and as a result, more than two centuries of highway engineering are evident within the confines of Cajon Pass.

In addition to traces of the historic National Old Trails Highway—the first professionally surveyed, graded, and oiled highway outside of the greater Los Angeles metropolitan area—there are also original alignments of Route 66. Extensive flooding in 1937 that devastated long sections of the highway resulted in realignment as well as the construction of modern infrastructure.

In the mid-1950s, a dramatic increase in traffic led engineers to transform Route 66 into a four-lane corridor through much of the pass. Initially, this modernized roadway served as the course for the interstate highway system.

One of the best preserved segments of early Route 66, with traces of the National Old Trails Highway as well, can be found between the Cleghorn Road and Kenwood Avenue exits of I-15. A second segment of particular historic interest is located on the east side of the pass at the Cajon Junction (State Highway 138). Here, on a truncated segment of two-lane Route 66, stands a Mormon Trail marker.

Colorado River

This sign welcomed travelers to California and bid them adios. *Steve Rider*

The **National Old Trails Bridge** carried Route 66 traffic until 1947. *Steve Rider*

Devore

Approximately one mile south of the railroad pass near Devore, there is a narrow, short segment of concrete roadway that is possibly the only existing remnant of this type of pavement in California that has a Route 66 association. The roadway served as the course for U.S. 66 as well as the National Old Trails Highway.

Essex

Often mistaken for a decorative wishing well along the roadside in Essex is a unique historic artifact from the infancy of highway development in the Mojave Desert. As part of its efforts to develop an automotive-specific infrastructure in Southern California, the Automobile Club of Southern California drilled this well in the late 1910s along the National Old Trails Highway. The signs advertising "Free Water" provided Essex with an enviable promotional opportunity. The well continued to meet the needs of travelers during the infancy of Route 66 and during the Great Depression.

Goffs

A snapshot of forty years of transportation infrastructure development is preserved in Goffs in the Mojave Desert. Goffs was initially established as a fuel and water stop for the Southern Pacific Railroad in 1883 because of its location at the summit of the grade separating the Colorado River Valley from the Mojave Desert floor to the west, and the town continued to develop as a transportation hub for the region.

In 1893, the Nevada Southern Railway, later the California Eastern Railroad, established a line connecting the mainline of the Southern Pacific Railroad in Goffs with the mining camp of Searchlight, Nevada. As the pioneering automotive highways through the desert developed parallel to the railroad, Goffs became an important junction on the National Old Trails Highway and on the Arrowhead Highway that connected Los Angeles with Salt Lake City, Utah.

The initial alignment of Route 66 in 1926 followed the course of the National Old Trails Highway through Goffs. With realignment of the highway in 1931, Goffs became one of the first Route 66 communities to be bypassed.

The **Figueroa Street Tunnels**, completed in 1936, revolutionized travel in Los Angeles. *Joe Sonderman*

Los Angeles

Considered an engineering marvel at the time of construction, the Figueroa Street Tunnels allowed for consistent traffic flow by incorporating limited-access ramps for exiting or merging. The first three tunnels were completed in 1931, with the fourth opening in 1935.

Officially dedicated in June 1936, the tunnels became a part of the Route 66 corridor that same year. In 1942, the increasing volume of traffic necessitated altering the flow pattern through the tunnels from two-way to one-way northbound traffic only.

The Figueroa Street Tunnels have the rare honor of being an urban location listed as a National Scenic Byway, and they are a Route 66 time capsule from the prewar era.

The intersection of Broadway and 7th Street served as the western terminus for Route 66 until 1936. *Joe Sonderman*

Five distinct alignments of Route 66 between Los Angles and Pasadena reflect the transition of the metropolitan area as well as the evolution of U.S. 66.

The earliest alignment, utilized between 1926 and 1931, followed Fair Oaks Avenue from Pasadena into South Pasadena. From there, U.S. 66 continued southwest on Huntington Drive, which had been built in the late eighteenth century as Adobe Road, and then connected with Mission Road, which followed to Broadway, and ran through the Lincoln Heights District. Until January 1, 1936, the intersection of 7th Street and Broadway served as the western terminus of U.S. 66.

The next alignment of U.S. 66 saw service between 1931 and 1934. This alignment also utilized Fair Oaks Avenue in Pasadena, but only to Mission Street. Then, the highway curved south at Arroyo Drive and then west on Pasadena Avenue. In Garazana, the highway turned southwest

Santa Monica Boulevard in **Santa Monica** served as Route 66 from 1936 to 1964. *Steve Rider*

on what is now Figueroa Street through Highland Park to the Broadway terminus.

The next realignment lasted for only one year. It followed Colorado Boulevard from Pasadena across the 1913 Colorado Street Bridge into Eagle Rock, a community annexed by Los Angeles in 1923, before turning south on what is now Eagle Rock Boulevard. At San Fernando Road, U.S. 66 joined with Highway 99, continued south to Pasadena Avenue, and connected with Broadway. After January 1, 1936, this alignment linked with Santa Monica Boulevard via Sunset Boulevard before terminating at the intersection of Olympic Boulevard and Lincoln Boulevard (US 101A) in Santa Monica.

The next alignment of U.S. 66 occurred in June 1936. It would remain signed as U.S. 66A until 1960. The alignment took Figueroa Street from Colorado Boulevard in Pasadena into the Highland Park District, where it merged with Pasadena Avenue. From 1936 to 1937, the highway crossed the Los Angeles River at this point, but completion of a new bridge resulted in relocation of the highway and Figueroa Street to the southeast. The Figueroa Street Tunnels connected Figueroa Street to Broadway. After 1936, U.S. 66 turned west on Sunset Boulevard at this point before continuing to the western terminus in Santa Monica.

On December 30, 1940, the final realignment of Route 66 took place. At this time, from Colorado Boulevard in Pasadena, U.S. 66 utilized the Arroyo Parkway and the Arroyo Seco Parkway (later the Pasadena Freeway) to connect with Figueroa Street, after 1942. Upon completion, the Hollywood Freeway, with its revolutionary four-level interchange at the junction of the Arroyo Seco Parkway, served as the final addition to this alignment. It would serve as the course of U.S. 66 until decertification in Los Angeles County in 1964.

The **Arroyo Seco Parkway** is a transitional alignment of Route 66 and a scenic byway. *Joe Sonderman*

Pasadena

Considered California's first modern limited-access freeway and the first west of the Mississippi River, the nine-mile-long Arroyo Seco Parkway (renamed the Pasadena Freeway in 1954) opened on December 1, 1940. It is the only National Scenic Byway fully contained within a metropolitan area.

The parkway was the culmination of a joint venture between the cities of Los Angeles, Pasadena, and South Pasadena. Immediately after the celebratory opening attended by California Governor Culbert Olson, Arroyo Seco was incorporated into Route 66, bypassing the earlier alignments that utilized Figueroa.

From January 1, 1964, through December 31, 1974, the intersection of the Arroyo Parkway and Colorado Street served as the western terminus of U.S. 66. Complete decertification of U.S. 66 in California occurred on January 1, 1975.

A view of the freeway that supplanted the **Arroyo Seco Parkway**.

Parks add a period feel to the **Colorado Street Bridge** in **Pasadena**.

The historic Colorado Street Bridge, which carried Route 66 traffic across the Arroyo Seco in Pasadena until completion of the Arroyo Seco Parkway in 1940, was built in 1913. At the time of its completion, the ornate 150-foot-high span earned international acclaim as an engineering marvel, as it was the highest concrete bridge in the world.

Designed by engineer John Drake Mercereau, the bridge's unique 50-degree curve to the south at mid-span, its graceful and ornate arch supports, and other architectural details remain largely intact. The bridge is listed on the National Register of Historic Places and was designated a Historic Civil Engineering Landmark by the American Society of Civil Engineers.

After realignment of Route 66, the bridge continued to serve an integral part in the traffic control grid within the ever-crowding urban environment of the Los Angeles area. The heavy flow of traffic and damage from the 1989 Loma Prieta earthquake led to the bridge's closure and subsequent $27 million dollar renovation.

TOP: **Colorado Boulevard** served as the course for Route 66 in **Pasadena**. *Joe Sonderman*
ABOVE: The **Colorado Street Bridge** carried Route 66 traffic until 1936. *Judy Hinckley*

California palm trees grow next to the famous sign at the entrance to **Santa Monica Pier**. © *iStock.com/David G. Freund*

CALIFORNIA

Crime and Disaster

Film and Celebrity

Transitional Sites

The **Colorado Street Bridge** in Pasadena. *Page 225*

The 1959 film *The Trap* had scenes shot in **Barstow**. *Page 210*

The **Stone Hotel**

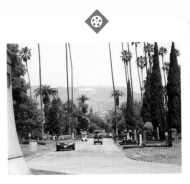

The **Hollywood Forever Cemetery**. *Page 223*

The **Arroyo Seco Parkway** in Pasadena. *Page 232*

Barstow

Lenwood

Hodge

Helendale

Dag

66

15

Oro Grande

395

Victorville

Cajon Summit

Cajon Jct.

Devore

215

San Bernard

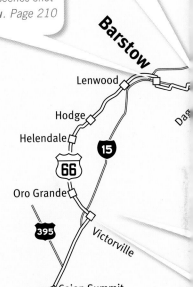

210

Pasadena

Arcadia
Monrovia
Durante
Irwindale
Azusa
Glendora
San Dimas
La Verne
Claremont
Ontario
Rialto
Fontana

101

101

5

Highland Park

Eagle Rock

605

10

15

10

215

Hollywood

66

Beverly Hills

LOS ANGELES

10

110

710 5

405

Santa Monica

405

The **Figueroa Street Tunnels** in **Los Angeles**. *Page 231*

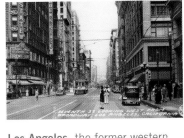

Los Angeles, the former western terminus of Route 66, featured in the final scenes of *Go West*. *Page 223, 231*

The
Pag

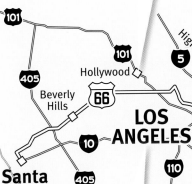

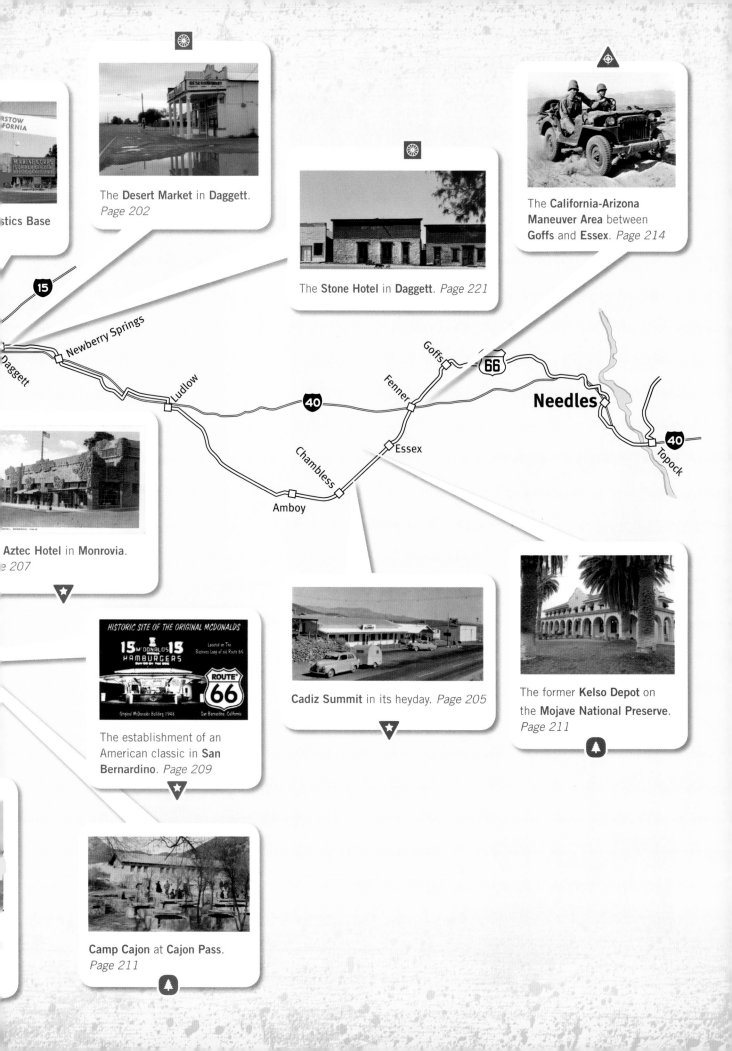

The **Desert Market** in **Daggett**. *Page 202*

The **Stone Hotel** in **Daggett**. *Page 221*

The **California-Arizona Maneuver Area** between **Goffs** and **Essex**. *Page 214*

Aztec Hotel in **Monrovia**. *Page 207*

The establishment of an American classic in **San Bernardino**. *Page 209*

Cadiz Summit in its heyday. *Page 205*

The former **Kelso Depot** on the **Mojave National Preserve**. *Page 211*

Camp Cajon at **Cajon Pass**. *Page 211*

CALIFORNIA

⊗ Pre-1926 Historic Sites

▽ Landmarks

🔔 Parks

◬ Military

The **Vista del Arroyo Hotel** in **Pasedena.** *Page 216*

Casa del Desierto in **Barstow.** *Page 204*

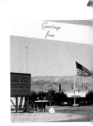
The **Marine Cor** at **Barstow.** *Pag*

The iconic **Hollywood sign.** *Page 206*

The **Santa Anita track** in **Arcadia.** *Page 210*

Barstow

Lenwood
Hodge
Helendale
66
15
Oro Grande
Victorville
395

Cajon Summit
Cajon Jct.

210
Pasadena
Monrovia
Irwindale
Azusa
Glendora
San Dimas
La Verne
Claremont
Ontario
Devore
215
Rialto

Eagle Rock
Highland Park
Arcadia

101
101
5
Hollywood
405
Beverly Hills
66
LOS ANGELES
10
405
10
Santa Monica
110
710
5
605
10
15
Fontana
10
San Bernardi
215

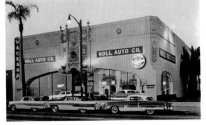
The **Packard dealership** in **Santa Monica.** *Page 208*

Japanese Americans were interred at the **Santa Anita track** during World War II. *Page 213*

U.S. 66 in Californi officially christened **Rogers Highway** in *Page 209, 235*

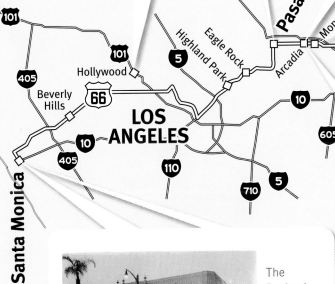

gett. *Page 221*

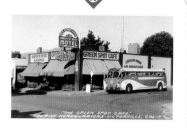

The **Sidewinder Café**, now **Bagdad Café** in **Newberry Springs**. *Page 225*

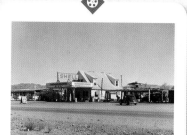

The original **Bagdad Café** in **Bagdad**. *Page 220*

Numerous films have used **Needles** as a setting. *Page 224*

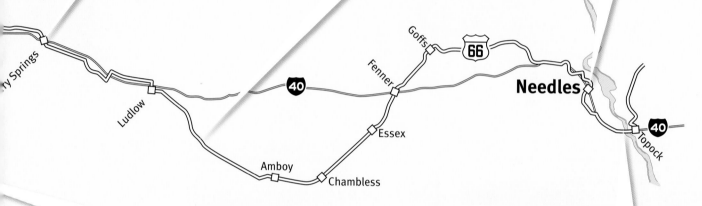

Goffs

66

Fenner

40

Ludlow

Essex

Needles

Amboy

Chambless

Topock

40

ry Springs

Herbert Jeffrey filmed at **Murray's Dude Ranch** in **Apple Valley**. *Page 219*

The well-known sign on the banks of the **Colorado River**. *Page 230*

Wigwam Motel in **Rialto**.

The **Greenspot Motel** in **Victorville**. *Page 219*

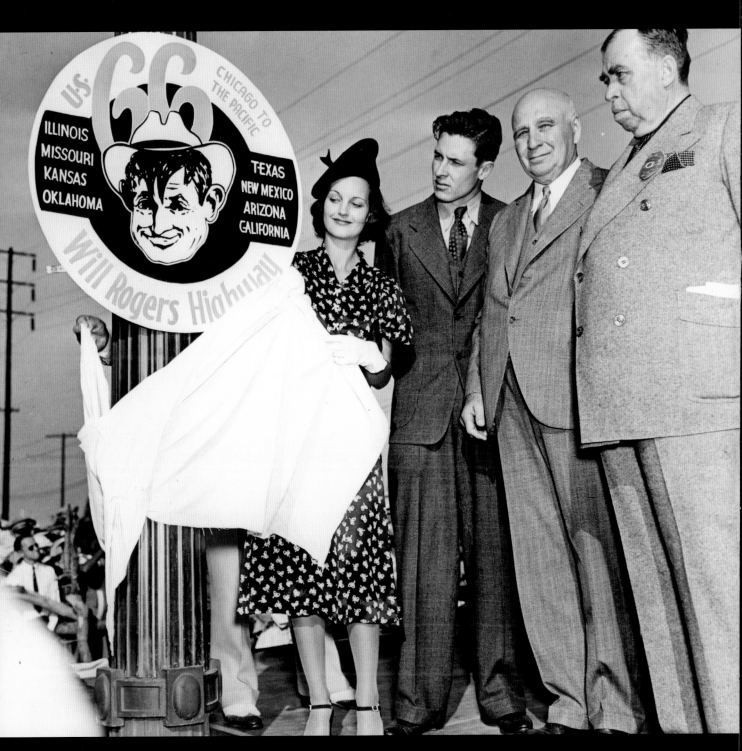

US 66 in California was officially christened **Will Rogers Highway** in 1952. *Steve Rider*

ILLINOIS

TEXAS